RAINBOW LIKE AN EMERALD

Stained Glass in Lorraine
in the
Thirteenth and Early Fourteenth Centuries

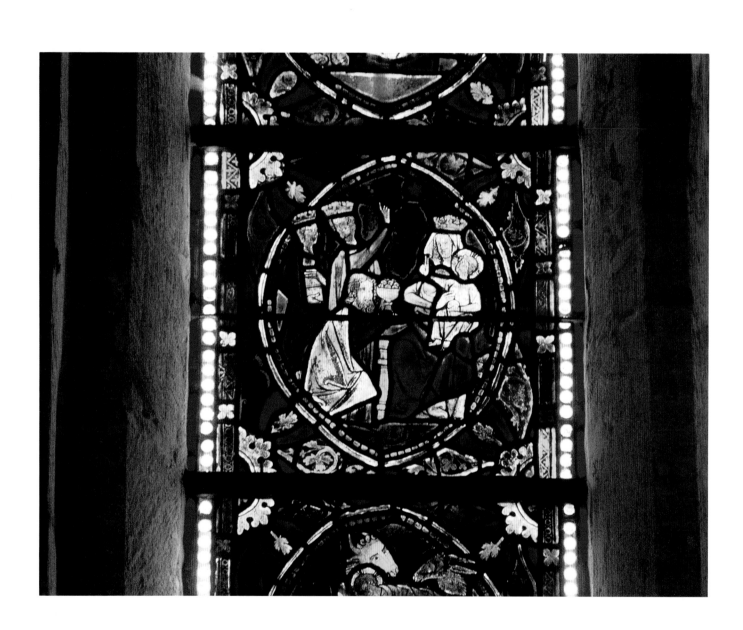

RAINBOW LIKE AN EMERALD

Stained Glass in Lorraine

in the

Thirteenth and Early Fourteenth

Centuries

MEREDITH PARSONS LILLICH

Published for
COLLEGE ART ASSOCIATION
by
The Pennsylvania State University Press
University Park and London
1991

Monographs on the Fine Arts
sponsored by
COLLEGE ART ASSOCIATION
Volume XLVII
Editors, Isabelle Hyman and Lucy Freeman Sandler

Library of Congress Cataloging-in-Publication Data

Lillich, Meredith P.
 Rainbow like an emerald : stained glass in Lorraine in the
thirteenth and early fourteenth centuries / Meredith Parsons
Lillich.
 p. cm.—(Monographs on the fine arts ; 47)
 Includes bibliographical references.
 ISBN 0-271-00702-8
 1. Glass painting and staining, Gothic—France—Lorraine.
2. Glass painting and staining—France—Lorraine. I. Title.
II. Series.
NK5349.A3L675 1991
748.594'38'09022—dc20 90-6755

It is the policy of The Pennsylvania State University Press to use acid-free
paper for the first printing of all clothbound books. Publications on uncoated
stock satisfy the minimum requirements of American National Standard for
Information Sciences—Permanence of Paper for Printed Library Materials,
ANSI 239.48—1984.

Frontispiece. Adoration of the Magi. Ménillot-près-Choloy (Meurthe-et-Moselle). After 1263

For Wolfgang Stechow (1896–1974)

CONTENTS

LIST OF ILLUSTRATIONS

Figures

Plates

INTRODUCTION

After this I looked, and, behold, a door was
opened in heaven . . . and there was a rainbow . . . ,
in sight like unto an emerald.
 Revelation 4:1–3 (King James)

THE turbulent history of northeastern France has left us only meager remains of the Gothic stained glass that once embellished the handsome regional architecture of thirteenth-century Lorraine. This slight legacy has, moreover, suffered from a benign neglect compared to the scholarly attention lavished on the several rare panels surviving from the twelfth century in Lorraine, as well as the province's recognized school of fifteenth- and sixteenth-century windows.[1] Only in 1983 were the Gothic windows of the four *départements* (Meurthe-et-Moselle, Moselle, Meuse, and Vosges) catalogued by art historians for the Inventaire régional in the exhibition "Le Vitrail en Lorraine du XIIe au XXe siècle."[2] Jean Lafond omitted any reference to Lorraine in the introduction to his article on Normandy 1250–1300, as well as in his study of French fourteenth-century glass,[3] operating under the belief that Lorraine (and, with more justification, Alsace) was, for the cultural historian, not French but German.

The glass in this book is not German. The francophone border in the Middle Ages followed the peaks of the Vosges Mountains, and indeed in modern times has not budged by over three miles (see map, Fig. 8, page 72).[4] Though still nominally part of the Holy Roman Empire at the beginning of the thirteenth century, Lorraine spoke French and increasingly looked to France for its cultural standards. By the reign of Philippe le Bel at the end of the century, the metamorphosis was complete. While Alsatian stained glass cannot be understood without reference to the large patterns of German development in the medium, the windows of Lorraine belong, properly speaking, to the history of the craft in France.

Marcel Aubert came to this realization in publishing the Gothic fragments in Metz Cathedral and suggested a dependence on Champagne, the province bordering to the

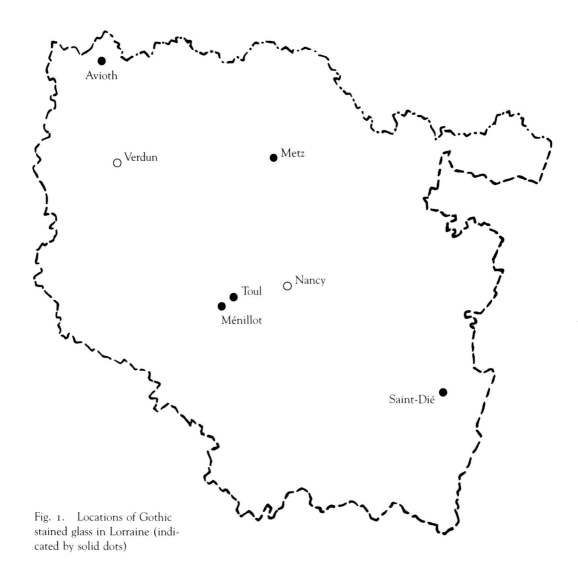

Fig. 1. Locations of Gothic stained glass in Lorraine (indicated by solid dots)

west.[5] The basis for his suggestion seems to be the appearance of the handsome greens of Lorraine (impervious to weathering) in Gothic windows of some *champenois* monuments, notably the cathedral of Châlons-sur-Marne. It is certainly possible that glaziers in Champagne bought glass in Lorraine, historically a glassmaking center and unquestionably active in such industry and commerce before the fourteenth century.[6] But such a relationship goes in the other direction. A stylistic debt of Lorraine to Champagne does not logically follow and indeed is impossible to establish. It is conceivable that this is the accident of fate, since no large, many-paneled figures survive (if indeed any ever existed) from thirteenth-century windows in Lorraine, while almost no small-scale glazing remains in the cathedrals of Reims and Châlons-sur-Marne. But what there is does not resemble

the Lorraine medallions studied in this book, nor does the remaining small-scale glass of the cathedral of Troyes, nor of rural *champenois* chapels in the Marne such as the château at Baye, Francheville, and Compertrix. Aubert's hypothesis collapses under scrutiny.

The exceptional greens that Aubert had noted deserve scientific study beyond the capabilities of the present author. It is not uncommon for the greens to be the only glass in a *lorrain* window completely untouched by the destructive deterioration referred to as weathering. In their capacity to withstand weathering they resemble the well-publicized twelfth-century blue soda glasses of Saint-Denis and York, although chemically they differ markedly from soda glasses. Dr. Robert Brill of The Corning Museum of Glass has collected data on similarly unweathered greens in medieval stained glass in Austria and East Germany.[7] These greens are not soda glasses, but differ from normal medieval potash-glass in having notably high lead contents, from over 20 percent to 48.1 percent. While lead makes a glass appear more brilliant and sparkling, because its refractive index is higher, it does not necessarily produce a more durable glass, though that seems to be the case with Brill's samples. Lead isotope analyses indicate that the lead in Brill's high-lead medieval glasses came from quite varied regional sources. The jury is still out, and scientific data on the durable and handsome greens of Lorraine would be a welcome addition to the evidence.

While the unusual greens seem to relate medieval windows in Lorraine to Germanic lands, and while their style and formal characteristics had roots in France, I should stress that Gothic stained glass in Lorraine is not a provincial outpost of East or West but *sui generis*. The earliest Gothic fragments to survive—the Saint Paul scenes now installed in Metz Cathedral, as well as the first campaign at the cathedral of Toul—look to northern France for figure style while retaining the rich decorative vocabulary of Romanesque Alsace, but already several *lorrain* characteristics appear. In later *lorrain* stained glass, the French models that can be suggested for borders, grounds, and medallion shapes are from Burgundy to the southwest and date within the first half of the thirteenth century. Some distinctive features of the renowned Gothic glass of Saint-Urbain de Troyes in southern Champagne, such as the wide borders and the precocious *damasquiné* grounds, are coeval or even possibly later than examples in Lorraine. Thus the French forms appear to have rooted early and quickly in Lorraine; from the 1250s until the advent of silver stain about 1325, the peculiar glazing combinations of the region simply cannot be explained by reference to somewhere else. It seems honest as well as just to recognize them for what they are—the *lorrain* regional style.

Most probably its distinctive look was dictated by the equally localized Gothic architecture, of which the source monument is Toul. This group has received increasing recognition from architectural historians recently. Based on the concept of a gigantic enlargement of the radiating chapels of Reims, the *toulois* Gothic buildings have a "giant order" two-part elevation with interior passage, the fenestration consistently doublet-and-rose. To provide the resulting, exaggeratedly vertical lancets with attractive yet legible glazing,

lorrain designers retained elaborate broad borders framing a single column of scenes, presented in simple, repeating medallion shapes. Color was used in the focal axes of the church, while grisailles filled the less visible lateral windows of choir and transept. Such a stark contrast, a "summer-and-winter" style, had appeared briefly in Paris in the 1240s at Saint-Germain-des-Prés.[8] Indeed Reims Cathedral, glazed with grisaille in the transepts and in the choir bays at the crossing, may have generated the format. But such borrowed ideas were absorbed and adapted to the regional architecture of Lorraine by mid-century. Their development thereafter, in saturated color harmonies resplendent with strong yellow and pure red, soft blue, and most notably the region's handsome greens, is truly the Gothic style of Lorraine.

The Gothic stained glass of Lorraine has been ignored, no doubt, because so little of it remains. In addition to the "normal" processes of time and weather and the changes of fashion that occurred throughout France (most notably in the Age of Enlightenment), the province of Lorraine—always situated on the borders of great powers, though not always the same ones—seems to have faced war or at least armed conflict on the average of once a generation since the time of Caesar. Textual evidence is meager, for example, the remark by Richer of Senones (whose chronicle of about 1255 is heavily used in chapter IV) that, in his time, the prior of the Benedictine abbey of Xures decorated the church with stained glass, "et picturis fenestrisque vitreis decoravit."[9] No glass program survives in its entirety and some, particularly at Metz, are now lost beyond retrieval.

This book presents all the Gothic stained glass that remains in Lorraine (see Fig. 1): at Toul Cathedral, Saint-Gengoult in Toul, the rural parish of Ménillot just outside Toul, at Saint-Dié in the Vosges, the pilgrimage church of Avioth, and the various groups now installed in Metz Cathedral, with appendixes dealing with the debris at Sainte-Ségolène in Metz, at Ecrouves, and at the Cistercian abbey of La Chalade. The biggest and happiest surprise of my research was the discovery that so much of the evidence could be reconstructed concerning these largely fragmentary ensembles, and could still speak to us so clearly. Though many patches of the puzzle remain—and will remain—blank, some of the outlines are strong, and some of the precious detail still commands the power to astonish us and the charm to delight us.

I am grateful for the support of this research, begun on a Fulbright senior research fellowship to Paris (fall 1983) and a grant-in-aid from the American Council of Learned Societies (1985). A Syracuse University Senate Committee on Research Award in 1987 provided further support, as well as a visitorship to the Institute for Advanced Study in Princeton (summer 1987), where chapter IV was written. Dr. Jane Hayward first set me onto Toul, and a section of chapter III was part of the Festbündel presented to her in 1987 and was published thereafter in the *Art Bulletin* and in translation in *Le Pays Lorrain*. Most of the writing was done during a senior fellowship at the Center for Advanced Study in the Visual Arts, National Gallery of Art, Washington, D.C. (1987–88).

I

TOUL CATHEDRAL

*Un enfant de Toul pouvait succéder par tous les pays
. . . sans être tenu, ni réputé aubain en aucun lieu.*
Du Pasquier, Mémoires *(after Martin)*

Toul Cathedral (Meurthe-et-Moselle), which with Verdun and Metz formed the famous Trois Evêchés of Lorraine, has emerged in recent scholarship as the source monument for a large and distinctive group of Gothic architecture, with examples on both sides of the Rhine.[1] The design of the chevet of Toul combines the traditional Romanesque plan of imperial churches, of towers flanking an unaisled choir, with detail from the ambulatory chapels of Reims, enlarging the latter into a "giant order" that dominates the elevation (Fig. 2 and Plate I.1). The Gothic chevet of Toul, begun about 1221 and vaulted along with the transept by the end of the century, is pivotal in chronology as well as in location, since Haute-Lorraine began the thirteenth century as part of the Empire and ended it under the strong influence of Philippe le Bel, king of France.[2] One would like to know if the cathedral of Toul was as influential in Gothic stained glass. While Alsatian glazing remains Germanic in cast, in thirteenth-century Lorraine—sharing a similar Romanesque tradition—precocious French borrowing soon undergoes a complete transformation, only partially mimicking French practice.[3]

The condition of the Gothic glass remaining at Toul is so mangled and fragmentary that it has heretofore discouraged such an inquiry. All that remains from the thirteenth century is a group of drastically cut-down figural scenes and some wide borders which, since the early nineteenth century, have occupied two eastern bays in the chapels that constitute the ground floor of the choir's flanking towers (Bays 7 and 8) (see Fig. 2). There is also a little darkened grisaille *in situ* in the traceries of the first nave bay on the south (Bay 18), followed in the fourteenth century by the grisailles of the nave clerestories.[4] This study will attempt to reconstruct the original location and program of the thirteenth-century glazing of Toul, by close examination of what remains and by

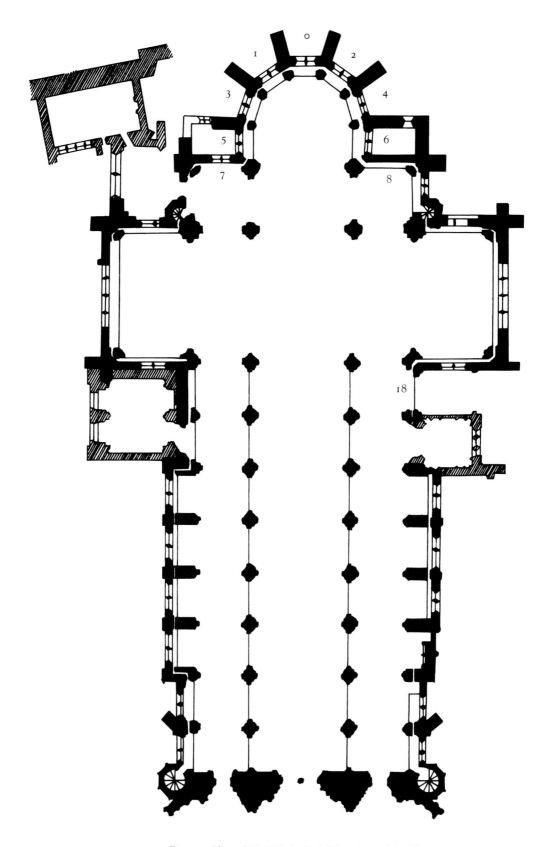

Fig. 2. Plan of Toul Cathedral (Meurthe-et-Moselle)

assessment of the monument's history and archives. Toul emerges as a pivotal monument for Gothic glazing as well as for architecture in northeastern France.

Location and Reconstruction of the Gothic Glazing Program

The choir of Toul is lit by seven immensely elongated, doublet bays, only the axial trio of them visible even from a vantage point as close as the transept. Morel, writing in 1841, stated that the debris now glazing Bays 7 and 8 in the choir's flanking chapels had been moved there in 1836 from one of the "invisible" collateral windows of the choir.[5] Two other early reports, by Grille de Beuzelin (1837) and by the Baron Guilhermy (1828 and 1852)—as well as the undocumented but heavy restoration, now increasingly obvious in the two bays as the ancient glass weathers and darkens—suggest that we do not now see them as they were in 1836. At present, each lancet contains a wide border of medieval origin, within which is a narrow border of obvious modern fabrication, surrounding a vertical column of figural panels that have been severely truncated on all sides, eliminating all traces of their original medallion framing, as well as much of the scenes themselves (see Plate I.2). A great amount of glass, perhaps half, is weak modern restoration, undocumented and heavy-handed work that seems to date from the late nineteenth century.[6]

Grille de Beuzelin in 1837 reported:

> Il en reste une fenêtre dans chacune des trois absides de la première période, à dessins de tapisserie orientale, entourant des comparimens ronds ou octogones qui renferment des sujets composés de très petites figures.[7]

> ("An early window remains in each of three apse bays [?], with borders like oriental textiles, surrounding round or octagonal compartments containing subjects composed of very small figures.")

Thus in 1837 the Gothic glass retained its round or octagonal medallion frames and apparently occupied three windows rather than two. On Guilhermy's first visit to Toul in 1828 he seems not to have noticed any thirteenth-century glass, no doubt because it was still grouped in the "invisible" bays of the choir. He rewrote his notes following a second visit in 1852, noting Gothic fragments "of rather good workmanship" in both the north and south chapels (Bays 7 and 8), as well as in the rosace over the axial bay (Bay 0), where he found an enthroned Christ holding the orb, the four evangelists, an angel, and other subjects.[8] These tracery panels now occupy the rosace of Bay 7 in the north chapel, where also appears a Massacre of the Innocents that Guilhermy had seen in the south

chapel. What was the date and reason for their undocumented removal, and, by extension, of the late nineteenth-century tampering with the Gothic glass?

The history of the three axial bays makes this fairly clear. In the nineteenth century they were still filled with Renaissance glazing of "peu de valeur," bearing the date 1567.[9] These bays were heavily damaged in the war of 1870 and replaced, in 1874 and 1876, with new glass on cartoons of Steinheil and A. de Balthasar executed by the restorer Leprévost, glass that is still in the church.[10] It seems likely that Leprévost's presence at Toul was the occasion for a general housecleaning and renovation of the choir windows, allowing him the opportunity to remove and keep some of the fragments, as he was known to have done on other occasions.[11]

Two elements that he removed from Toul Cathedral can be identified in a "collector's panel" (Plate I.3) on exhibition in the Musée lorrain in Nancy, incorrectly catalogued as "probably from Metz Cathedral":[12] a piece from the border of the right lancet of Bay 7, and a lozenge-shaped panel of the Virgin and Child, no doubt originally one of the lozenges from the tracery rosaces of the Toul choir bays. The other two elements making up the "collector's panel" can also be identified; they were removed by Leprévost from the church of Saint-Gengoult in Toul in the 1870s.[13] The concocted panel thus comes from Toul, not Metz, and of its four elements three (nos. 62, 63, and 65–66) can be positively recognized and traced among the old glass first inventoried for the Ministry in 1884 by Lucien Magne. Magne listed panels, presumably removed from their monuments as stopgaps, which he found remaining "deposed and usually forgotten in the restorers' studios," and he exhibited them that year at the Union centrale des arts décoratifs, again at the Exposition of 1900, and finally at the Trocadéro in 1910.[14] In his catalogue for the Trocadéro collection he lists the Toul fragments with measurements (right column below) and correct provenance:[15]

Cathédrale de Toul

no. 62	Vierge à l'Enfant (Panneau en losange)	0.42	0.42
no. 63	Bordure colorée. Fleurs et entrelacs	0.26	0.44
no. 64	Vitrail légendaire en débris [now lost]	0.45	0.39

Eglise Saint-Gengoult de Toul

no. 65	Bordure	0.49	0.18
no. 66	Bordure	0.50	0.19
no. 67	Grisaille à points et filets colorés . . . 2 panneaux	0.81	0.42

The two panels of no. 67 may now survive as the grisaille fragment in the "collector's panel," or they may have been from a complete grisaille lancet that Leprévost had

removed from a choir chapel of Saint-Gengoult and had photographed while it was in his studio (Plate II.19). The lancet has recently been recovered and restored to Bay 5 of that church.[16]

The three Renaissance bays in the Toul Cathedral apse, which Leprévost replaced in the mid-1870s, by all accounts had been quite ordinary; possibly they had resembled the glazing of the Bishops' Chapel (1524–33), which contained heraldic motifs and name inscriptions against clear glass.[17] That is certainly the conclusion we can draw from the account of Vincenzo Scamozzi, who visited Toul on 4 April 1600 and noted: "Le vetriatte sono quasi tutte bianche de cristali . . ." (The windows are almost all white as crystal [white glass]).[18] Toul was glazed in grisailles except for its terminal walls, and it seems likely that the three axial bays had received new windows in 1567 because the colored glass previously there had been damaged.

It is the premise of this study that the apsidal glass presumably damaged in 1567 consisted of heavily colored Gothic medallion windows and that, following the damage and then replacement with Renaissance designs, the remaining Gothic debris was collected and removed to the "invisible" lateral bays of the choir—where it remained until 1836. The disaster that had damaged it before 1567 can be identified, without the exercise of too much imagination, as the collapse of the south tower flanking the choir, on 7 October 1561.[19] Significantly, it was the south tower that fell, since the investigation of the iconographic program below will suggest that, of the three axial windows, only the glass that was probably in the north bay (Bay 1) escaped in any significant amount.

The Probable Iconographic Program

The Gothic fragments of Toul include two border designs, only one of them heretofore noted or photographed, and thirty-six truncated figural scenes, plus twelve small panels grouped in the irregularly shaped tracery lights. All are heavily restored, presumably by Leprévost, though he seems to have copied the old glass pieces—many probably broken or becoming opaque—with reasonable accuracy. The newly identified border occupies the right lancet of Bay 7; a small piece of it has been mentioned above as a part of the "collector's panel" in the Musée lorrain (Plates I.28a and I.3; compare Plate I.1).[20] A stylistic comparison of the two border designs makes possible a hypothesis concerning the dating of the Gothic glass at Toul and will appear in the next section of this chapter. The twelve tracery lights include a Coronation of the Virgin (lozenge) and three enthroned Christs (one of them a lozenge), as well as angels and four lobes of the evangelists (Plate I.5a). Guilhermy saw the evangelists, with one of the enthroned Christs and an angel, in

the axial bay traceries, and the divergent styles and repetitious subjects of the group suggest that all originally provided color accents in the chevet's traceries. The thirty-six figural scenes will yield a great deal more concerning the program of the chevet.

The panels have been so drastically cut down that only a few subjects can be identified positively, among them the Flight to Egypt, Massacre of the Innocents, and Dormition of the Virgin, all noted by Guilhermy. Other nineteenth-century authors contented themselves with noting that the subjects came from the life of Christ and the Old Testament, and only with Clanché's guidebook in 1918 was an attempt made to name specific subjects, the guesses including Jesus and the Church, Cain, the curing of a leper, and the sterile fig tree.[21] These identifications, mostly fanciful, have been parroted until the present; only Schiffler, in 1977, noted correctly, in passing, the Creation scenes and the Offering of Abraham.[22]

My hypothesis is that all thirty-six scenes came from three series, the subjects drawn from Genesis (Creation and the Joseph narrative), the lives of the Virgin and Christ, and the cathedral's patron Saint Stephen. Proving the identifications of the fragments in these cycles will obviously be impossible in most cases, but I propose to show, based on comparisons from medieval art, that all thirty-six figural groups at Toul *could* belong to one of these three subjects. Based on encyclopedic programs such as the sculpture of Chartres, where the Old Testament occupies the north and the saints of Ecclesia the south, placement of the Toul cycles was arguably as follows: the Virgin and Christ in the two lancets of the axial bay, beneath the enthroned Christ and evangelists that were still in the traceries there when Guilhermy made his notes; the Genesis cycle in Bay 1 to the north; and the window devoted to Saint Stephen opposite, in Bay 2 on the south. Thus Toul Cathedral, which was copied in reduced form in the architecture of Saint-Gengoult in Toul, is probably also the model for the latter's apsidal glass.[23] The Saint-Gengoult chevet (see Fig. 5) has five bays rather than seven and colored medallions in only the axial bay, one lancet of which is devoted to the life of Christ and the other to the patron saint of the church (Gengoult). The bays flanking this axial window had grisailles,[24] as did, most probably, the "invisible" bays of the longer choir of Toul Cathedral.

I will list the Toul fragments below with suggested identifications from the three cycles of Genesis, the Virgin and Christ, and Saint Stephen. In the many cases where the identification remains questionable, close comparative examples from medieval art are provided. Each panel is identified with its present location (Bay 7 or 8), followed by the lancet (A = left, B = right) and the panel, numbering from the bottom up; thus 8/B4 refers to the fourth panel from the bottom, right lancet of Bay 8. Since the subjects from the lives of the Virgin, Christ, and Saint Stephen are least problematic, they will be listed first. Of the Genesis scenes, by far the greatest number seem to present a Joseph cycle—a cycle that must have been even more extensive originally, judging by the extraordinary height of the Toul apsidal bays.[25]

Bay 0 (axial)—The Lives of the Virgin and Christ

The lead lines indicate that these panels were probably round medallions.

Flight to Egypt (7/A5) (Plate II.4a)
Massacre of the Innocents (7/A6) (Plate II.5a)

These two scenes compare closely with those in the axial bay of Saint-Gengoult (Plates II.4b and II.5b)[26] and were probably adapted from the same patternbook. In both Flights to Egypt, Joseph carries a pole over his shoulder with a long cloth draped over it, and he turns his head to look back at the Virgin and Child. In both Massacres a soldier holds a child by the hair and pierces its midsection with his sword while the mother stands facing him, her arm(s) raised. At his feet lies a child's head (or several). The cathedral's panel includes another soldier-child-mother group to the right, while Saint-Gengoult adds a different group to the left.

Dormition of the Virgin (7/A7) (Plate I.4a)
Coronation of the Virgin (7/A8) (Plate I.4b)

Both scenes probably copy the iconography established in the twin tympana of the south transept of Strasbourg Cathedral, c. 1230 (Plate I.4c).[27] In the Toul Dormition, Christ stands behind the bed blessing his mother's corpse while holding her nude, praying soul in his draped left arm. Peter and Paul flank him behind the bed, and two beardless, haloed figures appear before it.[28] The Virgin's soul is shown nude in bay 42 of Chartres (1205–15).[29]

The Coronation depicts Christ and the Virgin on the same bench; he blesses her with his right hand while crowning her with his left. Unlike standard French Gothic practice, which follows Psalm 44:10 ("The queen stood on thy right hand"), at Toul and Strasbourg the Virgin sits at Christ's left, that is, on the right side of the composition. Thus Toul can be added to the group discussed by Verdier, many from eastern France or Germany, in which the Virgin appears on Christ's left. Verdier relates both the Dormition and Coronation subtypes to the *Song of Songs:*

> The enthronement of the Virgin at Christ's left is just a specific case of the extension of the iconography of the *Song of Songs* into that of the Coronation. The right hand of Christ in the tympana of Dijon, Strasbourg, Bourges, Metz, makes the gesture of benediction, as in the monuments where Mary is already crowned. The gesture of coronation is, as it were, secondary. . . . The enthronement of the Virgin at the left of Christ follows the *elevatio animae* in the *koimesis* (Dormition), where Christ, blessing his mother, holds in his left arm the soul which has just left her body.[30]

Another such Coronation appears in the stained-glass rosace originally in the axial traceries of Notre-Dame-la-Ronde, in the south aisle of Metz Cathedral, possibly contemporary with Toul (Plate VI.3a).[31]

? Christ healing or raising a figure (7/B7) (Plate I.27a)

Christ's gesture and the small roll he carries resemble many images of him in the Raising of Lazarus and other healing miracles.[32] His halo is scalloped like others in the series; while it is not cruciferous as in the Dormition, neither is the halo of the Christ enthroned (on a modern rainbow) in the traceries. The precise miracle cannot be identified because the figure being healed (bearded, nude, eyes closed) is a modern restoration, as is the piece of lime-green bedding adjoining his chest. The authentic green bedclothes that remain, however, establish that the figure was in bed. The subject may have been the Raising of the Son of the Widow of Naim or of Jairus's Daughter, scenes that, at Monreale, closely resemble each other.[33]

Christ enthroned holding the orb and blessing (7/B8)
The four evangelists with their symbols (7/lobes of rosace)

These panels were seen by Guilhermy in the rosace of Bay 0. The evangelists sit at desks writing on scrolls; a contemporary example is the fragment from the Chartres choir screen now in the Louvre, showing Matthew writing and his angel facing him.[34] At Toul, Matthew's angel holds a scroll with his name: S MAT HEVS (Plate I.5a). It is the only inscription in the Toul fragments and contributes to their dating, since the letters are all clean, blocklike, well-spaced capitals. The Toul inscription includes no uncials, and only the *H* and straight-backed *E* are joined. Even the earliest inscriptions at Reims include a few uncials, as do the Strasbourg panels, dated around 1230–35; the Matthew inscription in Saint-Gengoult uses uncial *t, h,* and *e* (Plate I.5b).[35] Thus the cathedral's inscription, unlikely to date after the 1230s, joins other evidence discussed below in establishing the era of the first glazing campaign at Toul.

Bay 2 (south)—The Life of Saint Stephen

The cathedral of Toul is dedicated to Saint Stephen. The bishop Saint Gérard (963–94), builder of the tenth-century cathedral, had obtained relics of Stephen from Metz.[36] Stephen appears in the fragments vested as a deacon and tonsured, as is standard in Gothic art.

Stephen before the Sanhedrin (7/A4) (Plate I.6a)

Acts 6:12, 7:1. Stephen (right) stands holding a book, as in bay 13 of Chartres (1220–

25), before a seated figure who crosses his legs, as at Notre-Dame in Paris, the south transept tympanum (1260–65).[37] (Plate I.6b)

The burial of Stephen (7/B6) (Plate I.28a bottom)
Acts 8:2—"And devout men carried Stephen to his burial and made great lamentation over him." Three unhaloed figures (two of them bishops, one of whom is blessing) appear behind Stephen's corpse. The three figures in bay 13, Chartres, take similarly symmetrical positions, while on the Notre-Dame tympanum (Plate I.6b) the attending figures include a priest and acolyte officiating.[38]

Bay 1 (north)—Genesis: Creation Cycle

Leading indicates that the medallions in this bay were probably polygonal.

Third day: God creates the plants (7/A1) (Plate I.7a)
Genesis 1:11–12. God (right) stands and gestures toward a variety of plants on the left. Contemporary thirteenth-century examples include the Oxford *bible moralisée* (Oxford, Bodl. 270b, fol. 4r) and the Bible of Robertus de Bello (London, Brit. Lib., Burney MS 3, fol. 5v).[39]

Sixth day: God creates Adam (7/A2) (Plate I.7b)
Genesis 1:26–27. A composition similar to Toul, in which God stands touching Adam, who appears as a half-figure emerging from the ground, is in the Prodigal Son window of Bourges.[40]

Eve with Cain and Abel in her lap (7/B5) (Plate I.8a)
Genesis 4:1–2. Eve is seated frontally; Cain (left) grabs Abel's arm while each reaches to the other's head. While scenes of Eve nursing a child are most common, occasionally she is shown with two, as on the facade relief of San Zeno, Verona, where both children nurse while Eve tries to spin.[41] Eve holds Cain and Abel in her lap in a related relief from the Porta dei Mesi of Ferrara Cathedral (Plate I.8b), now in the Museo del Duomo, as well as in the stained glass at the cathedral of Auxerre contemporary with Toul.[42]

God rebuking Cain (7/A3) (Plate I.9a)
Genesis 4:9–12. God's head and hand emerge from a cloud to the right; Cain (left) stands holding a staff; part of Abel's body can still be seen stretched on the ground. The mosaics of the Florence baptistery include all these elements as well as the tree. The

Psalter of Saint Louis (Plate I.9b; Paris, Bib. nat., ms lat. 10525, fol. 2) is comparable except for the omission of Abel's body in its cramped space.[43]

Abraham sacrificing the ram (8/B2) (Plate I.10)

Genesis 22:13. The figure is haloed, suggesting that he is the major patriarch, Abraham; no haloed figures appear in the Joseph cycle below, which includes figures of the patriarch Jacob. Only very elaborate cycles include Abraham's sacrifice of the ram following the drama involving Isaac, among them the fourteenth-century Queen Mary Psalter (London, Brit. Lib., Royal ms 2 B.VII), where Abraham and the burnt offering appear on folio 9r and, in the following image on folio 9v, Abraham gestures up at God.[44] Toul combines the two.

Bay 1 (north)—Genesis: Joseph Cycle

The jumbled sequence of the severely cut-down figural groups at Toul has obscured their sense almost completely. My recognition of a lengthy and extremely elaborate Joseph cycle results from a painstaking accumulation of details for which parallels exist in other medieval artworks depicting the Joseph story. The following comparisons are not "sources" for the Toul cycle; rather, they are evidence of medieval models or traditions for Joseph scenes, traditions that the Toul cycle drew upon and which have allowed its identification.

? Jacob instructing Joseph to go to his brothers (7/B4) (Plate I.11a)

Genesis 37:13–14. Among the elaborate Joseph cycles where this scene is included is bay 41 at Chartres.[45] Vikan notes that in "almost every visualization of the episode, Jacob sits to the left while Joseph stands (or walks) at the right," and he illustrates an example from the Cotton Genesis recension in which Jacob sits gesturing and Joseph has a long staff, as at Toul.[46]

Joseph joins his brothers (8/B3) (Plate I.11b)

Genesis 37:17. This is the standard form for the scene: Joseph (left), carrying a pack on a stick over his shoulder, faces several brothers, one of them holding a staff. See, for example, an early thirteenth-century psalter (Trinity College, Cambridge, ms B.11.4) and the Salisbury chapterhouse reliefs of c. 1280 (Plates I.11c,d).[47]

Joseph's brothers show his coat to Jacob (8/B7) (Plate I.12a)

Genesis 37:32. This standard scene only occasionally includes a woman (probably Leah), as at Toul; other examples include the first Joseph window at Poitiers Cathedral, the Florence baptistery mosaics, and the Salisbury chapterhouse reliefs (Plate I.12b).[48]

Joseph is imprisoned by Potiphar's guard (7/B3) (Plate I.13a)

 Genesis 39:20. The guard (left) and Joseph are at the prison door. Other thirteenth-century examples that show the butler and baker within the prison, as at Toul, are bay 41 of Chartres, the Oxford *bible moralisée* (fol. 25v), the Salisbury reliefs, and the Queen Mary Psalter (fol. 16v) (Plates I.13c,d and I.14 top).[49]

? Joseph in prison (7/B2) (Plate I.13b)

 Genesis 39:21–23, 40:1–4. Silver stain, which was first used in stained glass in the fourteenth century, appears on all three heads, indicating that they come from an old restoration (when the drapery also appears to have been overpainted). This work probably dates from after 1353, when "Jaquos de la Mothe, verriers demorant a Toul," contracted with the canons, for the rest of his life, to repair the cathedral windows.[50] In spite of the restoration, the similarity of the left and center figures to the guard and Joseph in the previous scene (Plate I.13a) suggests that this group depicts Joseph in prison, in charge of the prisoners: "The chief keeper of the prison . . . delivered into his hand all the prisoners that were kept in custody; and whatsoever was done was under him" (Genesis 39:21–22). Only extremely elaborate cycles, such as the Moralized Bible, contain scenes referring to this verse.[51]

The butler, reinstated, offers Pharaoh the cup (8/A2) (Plate I.15a)

 Genesis 40:21. Pharaoh's head and the top of the scepter are disfiguring replacements of differing periods. In Gothic glass at Poitiers and Auxerre the expanded scene takes place at table. Examples limited to two figures and the cup, as in the surviving fragment at Toul, include the Oxford Moralized Bible, the Salisbury reliefs (Plate I.15b), and the Queen Mary Psalter (fol. 16v) (Plate I.14).[52]

? Pharaoh tells his dream to the wise men (8/B8) (Plate I.2 bottom)

 Genesis 41:8. The figures stand before the crowned, seated Pharaoh. The first one, bearded, touches the cord of his mantle in the customary aristocratic gesture;[53] the second, beardless, has uncovered, shoulder-length hair (and hence is not a woman) in an elegant, curled hairstyle. The fragment, like all the Toul glass, has been cut down; if the butler (or Joseph) originally appeared to the right (compare I.17b top row), the scene would be one of those regularly illustrated in the story (Genesis 41:9–13 or 25–28).

Joseph is honored, riding in Pharaoh's second chariot (8/A8) (Plate I.16a)

 Genesis 41:43. Joseph gestures from the chariot (left); at the right a figure (the head is an old, crude restoration) with the horse turns back toward him. Close examples occur in several manuscripts of the *Histoire universelle* studied by Buchthal (Plate I.16c).[54]

? Honor guard for the previous scene (7/B1) (Plate I.16b)
> Two knights in chain mail with shields, on horseback, one with a gonfalon banner. One of Buchthal's manuscripts of the *Histoire universelle* includes a mounted honor guard with gonfalon banners as well as a group of armed soldiers in chain mail with shields (Plate I.16d; Dijon, Bibl. mun., MS 562, fol. 51r, c. 1260/70). A figure with gonfalon also appears in the Santa Restituta relief in Naples.[55]

Pharaoh gives Asenath to Joseph in marriage (8/B5) (Plate I.17a)
> Genesis 41:45. A similar frontal, symmetrical grouping of the scene appears in the fourteenth-century Padua historiated Bible (Plate I.17b bottom right; Rovigo, Biblioteca dell' Accademia dei Concordi, MS 212, fol. 32v).[56]

? Joseph goes throughout Egypt inspecting the granaries (8/A6) (Plate I.18a)
> Genesis 41:46. Joseph holds a short wand of authority and gestures; included are a figure behind him and several horses (one horse's head, but several raised front legs are shown). In very extended cycles Joseph sometimes appears on horseback or in a carriage drawn by horses, inspecting and buying grain; see, for example, the Munich Psalter (Munich, Bayerische Staatsbibl., Clm. 835, fol. 15) and the Psalter of Saint Louis (Plate I.18b left; Paris, Bib. nat., MS lat. 10525, fol. 23v).[57]

Joseph collects grain for Pharaoh (8/B10) (Plate I.19a)
> Genesis 41:47–49. Joseph (left) stands holding a wand or scroll. A workman with a grainsack over his shoulder climbs stairs to the top of a silo. While workmen similarly bearing sacks are routine for this scene, occasionally the granary is shown, as here, as an elevated silo. In the Santa Restituta relief in Naples and the Oxford Moralized Bible (fol. 28r), figures lift grain to the top of a vertical structure, while in the trecento Padua Bible in Rovigo (fol. 33r) (Plate I.19b left), workmen with sacks on their backs climb stairs.[58]

Pharaoh tells a figure asking for grain to go to Joseph (8/B9) (Plate I.2 top)
> Genesis 41:55. A figure with a basket (left) stands before Pharaoh, seated crosslegged and gesturing. This rare scene occurs in the extraordinarily detailed Padua Bible (fol. 33r), where a crowd of Egyptians is depicted (Plate I.19b right).[59]

Jacob sends his sons to Egypt to buy grain (8/B6) (Plate I.20a)
> Genesis 42:1–2. Jacob sits in an architectural setting, holding a tau-staff and gesturing at two of his sons. He has a similar tau-staff in the Chartres window (Plate I.20c).[60]

The brothers go to Egypt to buy grain (8/A3) (Plate I.20b)

Genesis 42:3. The brothers, on horseback, arrive at a city. Five brothers' heads and several horses are indicated. At Chartres three brothers appear, on camels (Plate I.20c).[61]

Joseph provides his brothers with grain (8/A4) (Plate I.21a)

Genesis 42:9. Two brothers stand before Joseph with a sack. This rare scene occurs in the Manchester Picture Bible (John Rylands Library, MS fr 5, fol. 34v) and the Oxford Moralized Bible (fol. 29v) (Plate I.21b), both of which attempt to show all the brothers.[62]

The brothers tell Jacob that Benjamin must go to Egypt (8/A7) (Plate I.23a)

Genesis 42:29–34. Two brothers (left) stand before Jacob, seated with his tau-staff. See the Oxford *bible moralisée* (fol. 30r) (Plate I.23c left), where the brothers carry grainsacks.[63]

The brothers, returning to Egypt, give Joseph a present (8/A5) (Plate I.22a)

Genesis 43:26. Two brothers present a gift to Joseph, seated with a staff in an architectural setting. The "gift" is a recent restoration but probably copied from the original, since it resembles the brothers' gifts in a window at Canterbury (Plate I.22b; north choir aisle n:XV [9]).[64] Their offering, according to Genesis 43:11, consisted of fruits, balm, honey, spices, myrrh, nuts, and almonds.

Joseph dines with his brothers (8/A10) (Plate I.23b)

Genesis 43:32–34. Although the dinner was not often depicted in Early Christian Joseph cycles,[65] it is common in Gothic art and normally takes the form shown at Toul, the table placed frontally, the brothers behind it, and Joseph to one side. Among numerous examples, see bay 41 of Chartres, the Manchester Picture Bible (fol. 37r), and the Oxford *bible moralisée* (fol. 30r) (Plate I.23c right).[66]

? Jacob, dying, instructing his sons (or Death of Jacob) (8/B1) (Plate I.24a)

Genesis 49:1–29. Three brothers appear as half-figures behind the bed; the turned-back covers are of vair. Since the head of the bedridden figure has been lost, it is impossible to know whether the figure was shown still alive (compare the Oxford Moralized Bible, fol. 34r) or dead (see the Pamplona Bible of 1194–1234, Amiens, Bibl. comm., MS lat. 108, fol. 37r, and the *Histoire universelle* in Brussels [Plate I.24b], Bibl. Roy. 10175, fol. 84r, c. 1270/80).[67]

Death of Joseph (8/A9) (Plate I.25a)

Genesis 50:26. Five figures and two sets of gold candlesticks surround the body. Although the head and nude chest of the corpse are modern, a comparably "youthful"

patriarch appears in the Oxford Moralized Bible (fol. 35v) (Plate I.25c), and comparable nude corpses are in the Brussels *Histoire universelle* (fol. 61v, Death of Isaac) and the Manchester Picture Bible (fol. 44r, Death of Jacob).[68]

? Joseph buried in Egypt (8/A1) (Plate I.25b)

 Genesis 50:26. More commonly the entombment of Joseph shows the body in the tomb.[69] However, the standard "patriarch entombment scene" not infrequently depicts a closed tomb, as in the Entombments of Noah and Abraham in the Pamplona Bible at Harburg (fols. 11v, 24v).[70]

While only one Toul fragment (8/B4) (Plate I.26) does not appear in this list,[71] it is clear that only a small number of these suggested identifications are secure. Many of the heads are copies by Leprévost, and a few others seem by their style to be replacements of much more ancient date. Nonetheless, a core of unquestionable identifications establishes that the subjects of the Creation, Joseph, the Infancy, the Virgin's triumph, and Saint Stephen existed in the Gothic choir of Toul.

A program of three axial bays glazed as I have hypothesized would present a normal iconographic program for the thirteenth century: Christ at the center, the Old Testament to the north, and the Church on Earth on the south. It is significant that the longest remaining cycle, which—whether or not I have guessed correctly at many of the Joseph scenes—undeniably illustrated Genesis, would by "Gothic logic" have occupied Bay 1 on the north, the side customarily reserved for *ante legem*.[72] The collapse of the choir's south tower would, arguably, have damaged the glass least on the north. Thus only a few scenes remain from the proposed axial and south windows, while the doublet lancets of the Creation and Joseph, more likely to have occupied the north bay, comprise perhaps twenty-three of the existing thirty-six fragments.

Joseph was a popular cycle in Christian art from the fifth or sixth century on, and among the most frequent subjects in thirteenth-century glass; medallion windows exist at Chartres, Bourges, Auxerre, and Tours, and two bays are devoted to Joseph at both Rouen and Poitiers.[73] The Toul fragments differ in detail from all of these and compare with some of the most elaborate Gothic cycles to survive. It would be of the greatest interest to compare Toul to the immense bay treating Genesis in the Sainte-Chapelle (c. 1245), which probably predated Toul by less than a decade. Unfortunately, most of the Sainte-Chapelle bay is modern; of its ninety-one scenes, only seven remain, four from the Joseph story.[74]

If the Toul cycle occupied one lancet of a doublet bay, as suggested, the extreme height of the Tour choir would allow a cycle of over thirty scenes, more than appeared in any of the Gothic Joseph windows, including even the Sainte-Chapelle.[75] None of the comparisons with such extended cycles as the Moralized Bible or the Salisbury reliefs (based in part, as Blum has demonstrated, on a Middle English romance) suggests a hypothesis of

such a source. Thus the Toul artist probably had to augment standard scenes (from a patternbook or a manuscript cycle made available to him) with designs of his own making based directly on the biblical text. Gothic artists were less practiced in such procedures, and it is the more surprising, the Toul cycle having suffered so drastically throughout its history, that his work survives as a recognizable Joseph narrative.

Observations on Style and Dating

Old sources credit Bishop Roger d'Ostenge de Marcey (1230–53) with the glazing of the choir of Toul:

> Rogerus . . . fenestras etiam vitreas coloribus variis nobiliter depictas, in cancello hujus ecclesiae sitas fieri jussit ex suo, sumptibus non parvis.[76]

> ("Furthermore, Roger . . . ordered made, at no small expense to himself, stained glass windows of many colors and admirably painted, placed in the chancel of his church.")

The dating can be further refined. Although elected in 1230, Roger faced opposition and was not consecrated until 6 April 1232.[77] Thereafter, civil conflicts in 1243 forced the bishop into an exile from which he only managed to return at Pentecost of 1251. Since the glazing no doubt progressed little while its donor was abroad, the art historian has two periods to consider, from the middle of 1232 to 1243, and from mid-1251 until Bishop Roger's death on 1 January 1253 (n.s.). Stylistic analysis of the figural fragments, as well as the borders, suggests that some glazing remains from both periods.

The figural panels group themselves into two general types. The lobes of the evangelists and the cycles of the Virgin and of Creation (Plates I.4a,b, I.5a, I.7–10, II.4a, and II.5a) are rather nice examples of the first type, which is related to the classic Gothic drawing of the north of France. The Toul figures have large heads and big chests, and the drawing on faces and draperies is achieved by fine as well as heavy lines augmented by a competent use of wash (Plate I.27a). The artist is capable of considerable grace and dignity; his faces, while somewhat stolid, frequently could be called handsome, and his slightly wooden postures display a ceremonial composure. The chesty bodies with large heads, and the classic canon of facial features, find their closest comparison in the Braine-Soissons-Laon group of the early thirteenth century.[78] The Toul drapery has, however, lost all trace of the "wet drapery" look, the fine line painting related to the so-called "Year 1200" style and out of fashion in all media after about 1220. A comparison can be made to one of the rare northern windows dated to the 1230s, the large figure of Saint Marcel at Saint-

Quentin (Aisne), with similar chesty body and classic features. Grodecki, in dating Saint Marcel about 1225–30, added that "one must admit however that . . . the drapery painting has undergone some changes more characteristic of a later period (1230–35?)."[79]

The first glazing campaign of Toul is a retarditaire and somewhat provincial example of this classic northern Gothic style, which had already spread beyond Toul to Lausanne Cathedral. The rose of Lausanne,[80] glazed by *Petrus de Arraz* (Arras) from about 1230 to the *terminus ante quem* of the 1235 fire, has not yet shaken off all vestiges of the "Year 1200" drapery style. The increased linearity and economy of drapery painting at Toul place it after Lausanne, perhaps not before the late 1230s, to its own *terminus ante quem* of Bishop Roger's exile in 1243.

The Stephen and Joseph scenes at Toul (Plates I.6a and I.11–26), on the other hand, while undoubtedly based on this first style, exhibit a much cruder touch. In the second style the heads tend to be smaller and the figures often are stiff and doll-like, their gestures unfocused, their facial features exaggerated or angular. The painting is sketchy and careless (Plate I.27b). In general the impression is of naive, untutored production capable at its best of immediacy and a childish narrative charm. It seems clear that this less "professional" production is based upon the types of the first group, but the resemblance is not close enough to require a hypothesis of artists working side by side. The orientation of the first group is toward the classic canon achieved by northern French glaziers before 1230, while the sketchiness of the second group relates it to the development of glass in Paris and Burgundy, following the Sainte-Chapelle in the mid-1240s, in the direction of rapid drawing. In short, the Toul glass of the axial bay and of the Creation scenes (as proposed above) probably dates before the exile of 1243, while the remainder of the work was completed after the bishop's return in the early 1250s (compare Plates I.27a and b).

There are also two distinctive border designs, which differ from one another even more obviously than do the figural types. The border now in the north chapel, right lancet (Plate I.28a), is slightly wider (over 20.5 cm, including the pearled filet) and is distinctly Romanesque and Germanic in type, with gold and olive-green foliage against a red ground, a blue fleuron accenting each unit. The Romanesque borders of Strasbourg Cathedral, dated about 1200, are *sui generis* (Plate I.28b); a Strasbourg border of about 1230–35, around the Saint Christopher in the south transept clerestory, is a mutilated design made up of elements similar to Toul.[81]

A larger amount remains of the second border type at Toul (just over 19 centimeters wide) (Plate I.2), a rising symmetrical pattern of bushy but still abstract foliate forms from the mainstream of French High Gothic decoration (Chartres, Bourges). The ground is blue and the leaves gold, pinkish, and white with red accents. While borders of such size were no longer in vogue by the mid-1240s in Ile-de-France glazing, in Burgundy and Lorraine wide borders remained in use much later, for example, at Saint-Urbain de Troyes (c. 1270) and even later at Saint-Dié in the Vosges.[82] Thus the two Toul borders also fit a scenario of production begun in the 1230s, completed in a new mode after 1250.

The lancets of the three doublet bays of the Toul apse are approximately 118 centimeters wide (Plate I.1 right), considerably narrower than the chapel bays that now contain the glass fragments. The original design, with wide borders of 19 to 20 centimeters on each side, could not have accommodated any of the elaborate star patterns associated with the High Gothic of Chartres and Bourges. Rather, a single column of medallions, round or polygonal, would have totally filled the available space inside the borders. Such is the appearance of the glass at Saint-Gengoult, where round and polygonal medallions reappear and where scenes pile up in the exaggerated height of the apse lancets between borders of a width astonishing for a date of 1260 and beyond (Plate III.1).[83] Saint-Gengoult, based on the architectural model of the cathedral, probably maintains the patterns and general aspect of its Gothic glazing as well.

An *Ecole de l'Est?*

If my hypothesis of two glazing campaigns at Toul is correct, the first before 1243 and the second begun during 1251, then their differences invite some attention. The figures in the first group, for example Plates I.10 and I.27a, are undeniably northern French in cast, but the so-called Romanesque border that probably accompanied them could only have been made by someone from the Empire (Plate I.28a). Thus the first glazing of Toul embodied, as did the architecture itself, a merging of Germanic and Gothic French forms, the former traditional and the latter clearly more prestigious in both media. At least the choice of a "French" glazier for the figural scenes and a Rhinelander for the unfigured borders suggests such a judgment.

While the glass produced after 1251 (Stephen and Joseph cycles) does not show such stylistic polarization, neither is it simply closer to the French canon of its time (Plate I.2). The stage is set for the development of a Lorraine style, which—since the region has suffered such constant devastation throughout history—now can be only partially appreciated, most notably in the several late thirteenth-century campaigns at Saint-Gengoult. Just as in the region's architecture, the stained glass of the second half of the century is "French" but distinctive in type, a true regional idiom.

A number of glaziers, among them artists of first rank, produced glass at Saint-Gengoult and nearby Ménillot in the generation following Bishop Roger's death.[84] At least one of them was resident in Toul and has left his name—Thierias li varriers (Thierry the Glazier)—in a *censier* of the bishopric from around the midcentury.[85] Glassmaking, which was to become a specialty of Lorraine by the end of the Middle Ages, is first mentioned at this time and has hardly been studied.[86] Marcel Aubert was the first to suggest an *Ecole de l'Est*, an eastern school of Gothic glazing, largely destroyed by war, which he considered *champenois* in origin and marked by the use of beautiful greens.[87] The

color harmony of the Toul fragments is distinctive: soft grayed blue, saturated and often streaky red, pasty white, a lot of rose-brown, a strong gold-yellow, and several beautiful greens that survive totally untouched by weathering. Most notable is a limpid, pale green that the glazier does not hesitate to employ for important areas such as the Virgin's robe. This study of the Toul Cathedral glazing establishes a platform for future analysis of this Eastern School and for Aubert's assessment of its origins in Champagne.

From 1250 to 1275 the Empire languished under the Interregnum. Thibaut II of Bar (1239–91) had already begun the introduction of French modes into the region, and from 1251 until 1303 the remarkable Duke Ferri III of Lorraine was to maintain a consistent tilt toward France without disengaging himself from the affairs of the Hapsburgs.[88] It is hardly surprising that Bishop Roger's first glazing looks, like Janus, both east and west, and that his final glass before his death in 1253 puts to selective use the arts of the encroaching Capetian realm.

II

MÉNILLOT AND
SAINT-GENGOULT (TOUL):
STEMMA TULLENSIS

Let that which is lost be for God.
—Spanish proverb

THE Gothic stained glass of Toul Cathedral, with the exception of the abused frag-
ments discussed in chapter I, has been lost since the sixteenth century—perhaps now, as
the proverb would have it, glazing the windows of the heavenly mansions. Nonetheless,
this chapter will attempt to establish that its immediate regional prestige is, in a manner
of speaking, a matter of record. From the quarter century between 1250 and 1275 three
copies survive, in local glazing, of the life of Christ from the cathedral's axial bay: one
predictably in the axial bay of Saint-Gengoult, Toul, architectural clone of the cathedral;
another an unsuspected gem adorning the axial bay of the humble rustic chapel of
Ménillot; and a third, possibly the closest replica of all, repeated at Saint-Gengoult in the
south chapel. The Flight to Egypt and Massacre of the Innocents are the only scenes to
survive among the debris of the cathedral, and the three dependent cycles vary in length
as well as condition. It will be argued, however, that their surviving images allow for a
hypothesized reconstitution of the model, the christological cycle of Toul Cathedral, and
for the establishment of a *stemma* charting the relationships among the copies, in much
the same way that a lost textual source can be posited from existing manuscript witnesses.
A list of all scenes extant (Fig. 3) presents the data, and a diagram of the *stemma* (Fig. 4)
shows what this chapter will attempt to make of it.

	Toul Cathedral [Bay o] 1230s	Saint-Gengoult Bay o Infancy Master 1255–61	Ménillot 1263f.	Saint-Gengoult Bay o Gengoult Master late 1260s	Saint-Gengoult Bay 8 Genoult Master c. 1270–79
Annunciation			X		X
Visitation			X		X
Nativity		X	X		X
Adoration of Magi		X	X		X (2 panels)
Presentation in Temple		X	X		X
Flight to Egypt	X	X			
Massacre of Innocents	X	X (2 panels)			
Entry to Jerusalem					X
Betrayal					X
Appearance before Pilate			X	X	X
Flagellation			X	X	X
Carrying of the Cross			X	X	X
Crucifixion			X	X	X
Three Mary at the Tomb		X	X		
Noli me tangere				X	
	2 panels	7 panels	10 panels	5 panels	12 panels

Fig. 3. Extant scenes of the life of Christ in Toul Cathedral, Ménillot, and Saint-Gengoult (Bays o and 8)

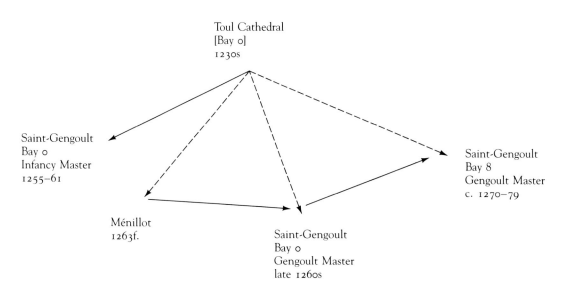

Fig. 4. Stemma showing the interrelationships of cycles of the life of Christ at Toul Cathedral, Ménillot, and Saint-Gengoult (Bays o and 8)

Ménillot-Juxta-Choloy

The most handsome Gothic stained-glass painting in Lorraine fills an axial doublet-and-rose bay in the village church of Ménillot-près-Choloy (frontispiece, Plates II.1 and II.2), six kilometers outside Toul (Meurthe-et-Moselle).[1] This beautiful window has been known since at least 1865, when Olry included it in his departmental inventory, noting "stained glass, very remarkable, said to be 13th century, rather well preserved."[2] The tiny village, with a modern population of around 265,[3] was known from the eleventh until at least the sixteenth centuries—in a variety of spellings—as Maniletum-juxta-Choleyum and has now been incorporated into its neighbor as Choloy-Ménillot (canton of Toul-Nord) (see Fig. 1).[4]

In recent literature Ménillot's Gothic masterpiece remains perfunctorily inventoried but "unsung."[5] This study will attempt to date it more precisely, hypothesizing from archival sources, to place it formally and iconographically within the context of Gothic glass in Lorraine, particularly in relation to the nearby examples in the cathedral and Saint-Gengoult in Toul, and—in analyzing the style—to sing the praises of this magnificent and influential thirteenth-century glazier. We may well recall the advice of Jean Lafond, from his study of rural windows in Normandy from the same decades:

> It is important, I believe, to emphasize the excellent quality of these village windows, not without recalling that stained glass always remained an urban production. . . . Whether it was destined for a great church or a humble sanctuary, the same men produced it. . . . Moreover one does not find in stained glass—aside from a few rare exceptions—the gaucherie and archaism so frequent in the construction, or in the sculpted and even painted decoration, of country churches. Thus one may grant the same attention to rural windows as to the others.[6]

A Proposed Date and *Raison d'être*

The small round-headed windows and limited wall-buttressing of the simple, wide-nave church of Ménillot offer the art historian little to go on in dating its construction (Plate II.1). The architecture is generally rural Romanesque, with slight Gothic alterations evident in the polygonal chevet, such as the vaulting. The doublet-and-rose window that houses the Gothic glass here under discussion is, however, clearly an insertion aggrandizing the axial bay (Plate II.2). Documents suggest about 1265 as the most propitious moment for such expenditure and display.

A document of 1069 published by Dom Calmet recorded exchanges of rights and

property in Ménillot, including the *capella,* between the bishop of Toul and the Augus-
tinian abbey of Saint-Sauveur, located at a considerable distance east in the Vosges
Mountains.[7] Saint-Sauveur acquired more properties in Ménillot in 1206, and in 1256
the seneschal of Toul, Fulcho, and his wife, Odilia, established their anniversaries at the
abbey by a gift of even more extensive rights and *biens* in the village.[8] The chapter of
Toul, much closer to Ménillot, had received the gift of properties there from a "Foulques,
chevalier"—related to Fulcho?—in 1172.[9] Finally in March 1263, numerous documents
unequivocally set forth an exchange between the same two ecclesiastical institutions, the
abbey of Saint-Sauveur to receive Bauzement and the chapter of Toul Cathedral to gain
Ménillot and another village, excepting only one-half the value of a mill held by Hugues,
curé of Ménillot, for his lifetime.[10] Ménillot belonged to the Toul chapter in 1303, 1402,
and still in 1580.[11]

Thus 1263, when Ménillot came under the control of the chapter, is a watershed in the
history of the tiny rural community, likely to have been celebrated by the commissioning
of an enlarged Gothic doublet window, complete with handsome glazing, at the axis of
the church. The 1260s were a good time for the diocese. In November 1261 Bishop Gilles
de Sorcy had been able to purchase the county of Toul.[12] The Ménillot window was
probably in place well before the bishop's death (March 1269) set off a decade and a half
of civic and internal strife involving the chapter of Toul.[13] A date in the mid-1260s is also
suggested by the style of the stained glass.

Stylistic Touchstones

Although the church of Ménillot is dedicated to the Virgin of the Assumption, the axial
window depicts ten of the most standard scenes from the life of Christ, five in the left
lancet presenting an Infancy cycle and those on the right the Passion (Plate II.2). The
scenes occupy almond-shaped medallions bordered by a simple white filet and gold
pearling; between the medallions, against a saturated red ground, foliate *bosses* in the
corners unite adjacent panels. The narrow lancets do not allow for much of an outer
border, only a thin filet of relieved (stick-lit) patterns of pearling and foliage punctuated
at intervals by simple cassettes of "nailhead" rosettes. The color harmony includes strong
red, saturated in the grounds and more thin and streaky for figures, blatant gold-yellow,
and soft grayed blue in several intensities, with accents of a thick pasty white, soft
pinkish-tan and brown, and most important, a magnificent emerald green. This is the
typical coloring of Lorraine, where the marvelous greens, untouched by weathering, can
range from clear pale tones to the rich emerald of Ménillot, which later dominates the ex-
voto window in Saint-Gengoult's north chapel.[14]

Almond-shaped medallions in simple frames, against a ground of foliate ornament

forming corner bosses where the panels conjoin, appear in Lorraine as early as the first decades of the thirteenth century, in the earliest glass fragments preserved in Metz Cathedral. These are a series from the life of Saint Paul, patron of the Metz chapter, now patched into the later traceries of the cathedral's south transept (Bay 14) (Plate VI.1)[15] and probably originating in Saint-Paul, the chapter's chapel in the cloister (destroyed in 1754).[16]

Also in Metz and closer in time to the Ménillot window are the damaged stained-glass remains surviving in Sainte-Ségolène, where ten such almond medallion frames appear in a patchwork now filling the north choir chapel (Bay 9) (Plate II.3).[17] The narrow border of these medallions, red with white fleurs-de-lys, is clearly a heraldic reference, one that provides a hypothetical dating of 1251–54 (see Appendix V). Both the Ménillot and Sainte-Ségolène borders are also comparable to generic types repeated in many variations in the north nave aisle of Strasbourg Cathedral,[18] while the meager survivals of thirteenth-century glazing at Metz Cathedral include stick-lit pearling and foliage, as well as nailhead cassettes, familially related to the Ménillot borders.[19]

The color at Sainte-Ségolène, if any kind of judgment is valid from what remains, was reduced to soft blue, white, and clear light green, a harmony found earlier in transitional panels at Strasbourg, such as the two Saint Johns.[20] The corner bosses are dry and abstract, not yet touched with the nascent naturalism of Ménillot, and the painting of the two or three figures extant at Sainte-Ségolène remains firm and emphatically linear in the tradition of what Grodecki named the *art roman tardif*. Thus if the dating I have suggested for the almond-medallions of Sainte-Ségolène, around 1251–54, is accurate (see Appendix V), the generic similarity of glazing format with Ménillot suggests that the latter's glazier was at home in Lorraine, while the date of after 1263 that I have suggested for his work would allow for the unquestionable advance in his approach to the messine canon of panel design.

He is, however, such a skilled and sophisticated designer that only general contemporary references are possible for his figural composition and painting style.[21] The Ménillot Master's figures do not suffer from a Parisian anemia. While they are by no means stocky, they tend toward solid classical proportions that in French Gothic art send one's thoughts to Reims. An example is the angel on the Resurrection tomb (Plate II.6c); another is the Virgin holding the Child before the magi (frontispiece, Plate II.8a). There is a love for, an emphasis on, broad mass, articulated by lean, economical line (for example, the legs of the Virgin under the Nativity bedcovers, Plate II.7b). The artist uses the stiff broken folds (*bec débordant*) fashionable in his generation. Except on the saturated red glass, he applies a shading wash that augments the line by paralleling it at a slight distance, thereby producing a clear highlight immediately adjacent to the line. Such elegant drapery washes appear in the contemporary Parisian mainstream, for example, the apostles thought to come from the lost royal Château de Rouen (Cluny Museum, c. 1260–70) and the Adoration of the Magi preserved at Saint-Sulpice-de-Favières.[22]

The Ménillot artist, however, commands these influences and builds his compositions with a mastery that far surpasses the typical anecdotal, decorative mode employed by his contemporaries for the christological cycle. His beautifully equilibrated scenes have true monumentality, achieved by triangular, pyramidal structure—a compositional device offering very solid grounding within the pointed almond shape. The Visitation (Plate II.15b) is only the most obvious and least subtle of his compositions. There is always a strong central vertical core to the design, in most cases a mass or at least a line, but if need be a void (as in the Annunciation, Plate II.15a). The central core is more stable, stiffer and more blocklike, than the framing forms, firmly anchoring the compositional center of gravity. The solidity thus established is all the more remarkable since the figures in most scenes float in the blue space, on no ground line at all. While great stability and repose are achieved at the core of the design, outer figures are more slender, twisting, move-mented forms, well adapted to the almond frame. The voids—united by their blue color—are as important as the masses, and the master uses piquant or intensely directed gazes not simply for charm or narrative vivacity but to underline his compositional focus.

The spiritual achievement must be acknowledged, as for example, in the Flagellation or Carrying of the Cross (Plates II.11a and II.12a), where the unmoving, unmovable Christ at the core of the composition exists in a timeless blue space, his jittering antago-nists fluttering like so many moths against the Light. The scenes of Christ's life, presented without benefit of ground line or mound, in anchored triangular compositional structures, become ideograms of considerable meditative power. Color is equally important in the window's spiritual dimension. The joyous color harmony of the Infancy lancet, achieved by an emphasis on red and gold, contrasts notably with the Passion lancet's subdued tones. More dominated by the soft binding blue of the grounds, the mood of the Passion is further quieted through the conscious increase of soft brown by means of rosettes, missing from the Infancy scenes but added to the midpoints of the Passion cycle's almond frames. It is Gothic design of remarkable sophistication and control.

The decorative bosses in the corners of the panels and the delicate stick-lit patterns of the outer border combine a few lingering abstract palmettes with a larger growth of lively, quasi-naturalistic vegetation. Such a combination is typical of the 1260s, for example, in grisaille, another indication that the Ménillot Master is in no sense behind the times. Nothing approaching his art had been seen in Toul before, not in the two glazing campaigns of 1232–43 and 1251–53 at the cathedral and not in the only glass at Saint-Gengoult that could possibly predate him (for example, Plates II.4b and II.9a); located in the traceries and Infancy scenes of the Saint-Gengoult axial bay, it is very close to the second cathedral style, which is to say, quite naive and untutored and probably dating in the mid- to late 1250s. If the Ménillot Master's formal panel layout resembles Metz, his figural conception and proportions seem to indicate Reims, and his exquisite draperies look to the Parisian mainstream. At any rate, once in the Toulois he adapted himself to the task at hand, and in the process was to alter fundamentally the course of Gothic

glazing at Saint-Gengoult. There the hallmarks of his art—the broad drapery style with shaded folds, and delicate, feathery foliate patterns for ornament—appear in the second campaign and develop in the succeeding decades into a mature and truly regional style.

The Iconographic Stemma: Ménillot and Saint-Gengoult Bay 0

Although Ménillot is dedicated to the Virgin of the Assumption, its Gothic glass depicts the life of Christ, culminating in the Resurrection. Most probably the window, which I have suggested was commissioned about 1263 by the chapter of Toul Cathedral, intentionally replicated the christological cycle that, I believe, originally occupied the cathedral's extremely elongated axial bay.[23] While this hypothesis cannot be tested by direct comparison, since the two Infancy scenes and various tracery subjects surviving from the cathedral bay were not among the elements included in the much smaller cycle at Ménillot, a more complex stemma can be established based on the christological iconography of Saint-Gengoult (see Figs. 3 and 4). Two christological cycles remain there, in the tall axial window (Bay 0, right lancet) and in the south chapel (Bay 8).[24] The two relate to Ménillot as well as to the cathedral; indeed, the dates that I have suggested for the glazing campaigns of the latter two monuments can provide a more precise chronology than hitherto has been possible for Saint-Gengoult, for which no archival documentation exists.

The present church of Saint-Gengoult (Fig. 5) was built east to west, the first campaign (chevet and chapels) starting around the mid-thirteenth century, the transept added in the fourteenth century, and the remainder completed even later.[25] Villes believes that construction on the chevet began very near 1250 and proceeded quickly, in five or six years, and he has compared the architectural forms to the cathedral cloister and its sculpted portal, finished before 1269. The glazing of Saint-Gengoult's axial bay probably began as soon as the templates for the window were available. The stained glass in its traceries (Plate I.5b) is the work of the same clumsy, provincial painter who produced the second cathedral group of 1251–53, and it repeats the same vague and repetitious themes from the cathedral's axial bay traceries, work of the first cathedral campaign of the late 1230s: an enthroned Christ blessing and holding the orb, surrounded by the evangelist symbols, angels with crowns and incense, and the like.[26]

I will call this artist of the first Saint-Gengoult campaign the Infancy Master, although his glass includes not only the traceries just mentioned and six surviving Infancy scenes, but a medallion of the Three Marys at the Tomb as well. He is most probably the second cathedral glazier of 1251–53, and his work for Saint-Gengoult probably copies the cathe-

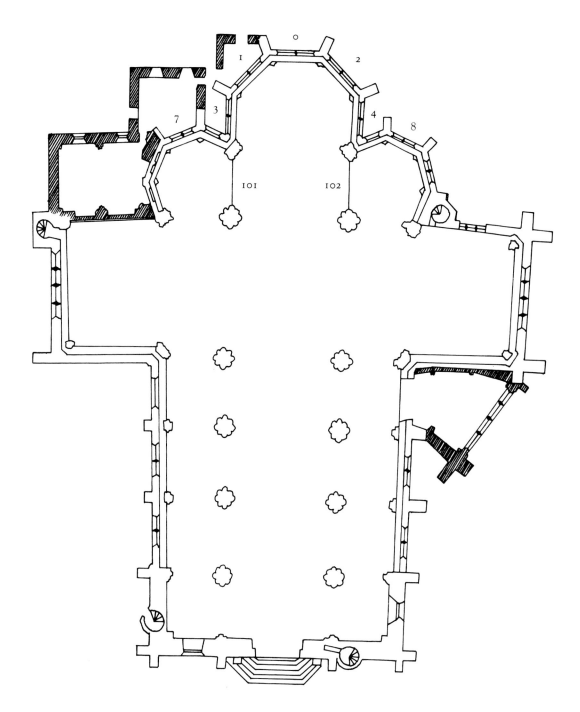

Fig. 5. Plan of Saint-Gengoult, Toul (Meurthe-et-Moselle)

dral glass produced by his predecessor there in the 1230s. At least we can assume this for the two christological scenes for which the cathedral glass survives: the Flight to Egypt and the Massacre of the Innocents (Plates II.4a and II.5a).[27] Their similarity to Saint-Gengoult (Plates II.4b and II.5b) is not a matter of the same cartoon but more generally of works derived from the same patternbook, or perhaps of the later glazier sketching scenes already installed in the cathedral and using them for inspiration.

If, in spite of the ubiquity of such christological scenes in medieval art, this similarity be acknowledged, then the medallion of the Three Marys at the Tomb that is part of the Infancy Master's work at Saint-Gengoult gains importance (Plate II.6a). While its presumed source no longer survives at the cathedral, it does resemble the same scene at Ménillot (Plate II.6c). And since the rest of the Passion scenes that comprise Saint-Gengoult Bay 0, completed by a later artist, also resemble Ménillot, a stemma can be established in which the cathedral's axial christological cycle is the original "text," imitated with greater or less precision by several artists: the Ménillot Master, the two Saint-Gengoult artists who produced the axial bay, and finally the glazier of the reduced christological cycle in Saint-Gengoult's south chapel (see Fig. 4). Such remarkable authority of the Toul Cathedral model over time is indeed noteworthy.

Before proceeding on this assumption, I offer a comparison of those scenes found both at Ménillot and in Saint-Gengoult's Infancy series,[28] concentrating on the differences rather than on the manifold similarities of format and detail. The heavy restoration in Saint-Gengoult's axial bay will be noted only as it involves the iconography under discussion.

> *Nativity* (Plates II.7a [bottom] and II.7b)—Saint-Gengoult adds a serving maid tending a fire at the bottom left; the Virgin and Child do not merely exchange glances as at Ménillot, but awkwardly reach out for each other's hands.[29]
>
> *Adoration of the Magi* (Plates II.7a [top], frontispiece, II.8a)—At Ménillot the Virgin is crowned. At Saint-Gengoult the first magus's doffed crown is shown at his feet, while the Virgin awkwardly grabs the orb held (in both scenes) by her Son.[30]
>
> *Presentation in the Temple* (Plates II.9a and II.9b)—The Saint-Gengoult maidservant juggles a candle, as well as the basket of doves found in both scenes, while the Child wriggles to touch his mother's chin in a maneuver that seems sure to land him on the floor.[31] At Ménillot, Simeon's feet (cut off by the frame at Saint-Gengoult) are bare.
>
> *The Three Marys at the Tomb* (Plates II.6a and II.6c)—Ménillot's sleeping soldier is multiplied into three at Saint-Gengoult, where, also, the Angel carries a scepter.

In general, the scenes so handsomely focused and monumentalized by the Ménillot Master receive, in the hands of Saint-Gengoult's Infancy Master, additions, including

gestures and postures, of a fussy and anecdotal nature. He crunches the figural groupings into his roundel frames with greater or less success and, as one would expect, employs the standard ground line or mound, which the Ménillot Master abandons in order to strengthen his work's spiritual power.

The Infancy Master's series probably was produced around 1255 to 1260, that is, following his completion of the cathedral glazing for Bishop Roger de Marcey (d. 1253), and before the Ménillot Master arrived in the Toulois around 1263. Indeed the Infancy Master may have died before 1263, since his axial window thus begun for Saint-Gengoult was completed later by a very different artist, one who had learned from the Ménillot Master how to paint rich, stiff-fold draperies with handsome washes and relieved highlights augmenting the line.

The extreme contrast of the two glaziers in Bay 0 of Saint-Gengoult is evident in the color and decorative ornament as well as the figural painting (compare Plates II.6a and b). The Infancy Master uses red sparingly and his rare greens are a dark emerald, while his successor is lavish with red and uses only a pale, clear green. The round medallion frames, now alternating white and yellow,[32] have the straightforward folk accent of the Infancy Master, while the magnificent wide borders (Plate II.5b) and the corner bosses between medallions are elaborations of the delicate stick-lighting and feathery, naturalistic foliage introduced at Ménillot. It is quite likely that only part of Saint-Gengoult's axial glazing was accomplished when the Infancy Master left or died, somewhere around 1260, and that the window was finished, assembled, and installed near 1270 by an artist trained by the Ménillot Master.

But he is not the Ménillot Master. This artist will be dubbed the Gengoult Master since, in addition to the borders and foliate grounds of Bay 0 and the five scenes completing the Passion, he produced the entire matching lancet, an extended series devoted to the life of the patron Saint Gengoult. While the challenge to depict the patron's legend in such detail capitalized on his narrative and anecdotal skills, the familiar and more profound Passion subjects were trivialized by his touch. A comparison of the four scenes found in both Ménillot and Saint-Gengoult—both series probably based on the lost cathedral window—makes clear the distinction between artists as well as their common source. The scenes are: Christ before Pilate, the Flagellation, the Carrying of the Cross, and the Crucifixion (Plates II.10a,b; II.11a,b; II.12a,b; and II.13a,b).

Very few details have been altered; most notably, at Saint-Gengoult the crucified Christ wears a crown of thorns and the cross is a clear, pale green (Plate II.13b). But the Gengoult Master's figures are scrawny, wizened little creatures, boneless and stiff even when abundantly swathed in gorgeously massed and shaded stiff-fold draperies. Their often comatose expressions have none of the Ménillot Master's immediacy or focus. Indeed the designs have no focus at all, either in formal arrangement or color, and make no particular use of the round medallion field. The monumentality and containment of

Ménillot have evaporated; postures are contorted and gestures extended to provide move-mented, zigzagging silhouettes. As an example, the Christ before Pilate, at Ménillot (Plate II.10a), stands planted like a rock, the silly little executioner who pushes at this immovable object and the posturing, finger-pointing Pilate offering no real contest. At Saint-Gengoult a larger, more menacing Pilate and an executioner whose arm encircles Christ's slender shoulder reduce the latter to an ungainly and hapless teenager caught raiding the cookie jar (Plate II.10b).

Saint-Gengoult's Bay 0 is an elongated doublet-and-rose window probably reflecting the cathedral's choir program in miniature (Plate III.1). The traceries and the christologi-cal cycle of the right lancet seem firmly based on that source, while the matching lancet presents the church patron just as the cathedral depicted its patron Saint Stephen. Although an undocumented restoration at Saint-Gengoult, probably by Leprévost in the 1870s, has replaced much of the glass with copies, little of Bay 0's program has been lost. Out of fifteen possible scenes in each lancet, twelve survive from the christological cycle and all fifteen of the life of Saint Gengoult (to be discussed in chapter III). The lowest panel in each lancet, blocked by the Baroque dado, is now filled with plain glass. Several restorers' rearrangements have left one Gengoult panel at the top of the christological lancet, and one modern panel depicting the Baptism has been inserted.[33] In Bagard's description of 1859, preceding the addition of the Baptism panel, all the present christological scenes seem to be accounted for.[34]

Two very different glaziers produced Saint-Gengoult's Bay 0. A hypothesis of their contributions suggests that the Infancy Master, who had finished the glazing of the cathedral choir, began the glazing at Saint-Gengoult as soon as the architect's templates were available, about 1255, and that he produced, for Bay 0, the tracery glass and the medallions of the Infancy and the Three Marys at the Tomb, as well as the images of the Holy Face (Plate III.3), which will occupy our attention in chapter III. The remainder of the window was, I believe, completed by the Gengoult Master probably in the late 1260s: the rest of the Passion scenes and the life of Saint Gengoult, as well as the wide borders and foliate surrounds in which the medallions are set. His work dominates the bay, and it announces the triumph of the Ménillot Master's art in the Toulois.

Yet Another Life of Christ

Another replica of the lost christological window of Toul Cathedral occupies Bay 8 in Saint-Gengoult's south choir chapel (see Fig. 5). The window is a much-truncated form of the doublet-and-rose bays in the apse, with six scenes of the Infancy and six of the Passion arranged at present as chronologically ordered events running across both lancets,

bottom up. Although this is unlikely to have been their original arrangement, the panels are in reasonably good condition in spite of numerous restorations, which will be charted below as evidence permits.[35]

Bay 8 was the first Saint-Gengoult window to be restored in the nineteenth century, probably in the year 1859. Evidence before that date—an 1837 drawing (Plate II.14a) and a description by Balthasar published in 1853[36]—establishes that only eight of the present twelve scenes were then visible, in a different order, above the Baroque marble *revêtement* of the chapel. While the restoration was privately funded and thus not documented in the Monuments historiques, the dossiers there include an 1851 letter from the curé stating that the stained glass needed to be releaded; in 1861 a plea from the mayor for other restorations affirms that all local monies had been "absorbés par la réparation d'un vitrail," which must have been Bay 8.[37] Abbé Bagard's article of 1859 concludes with an impassioned plea for restoration (pp. 83–85), which he suggests should start with the south chapel glass. However, his description of Bay 8 (p. 49) seems to reflect the "after" rather than the "before" state of affairs since the previous eight scenes have been interleaved with four not previously noted.[38] Thus the undocumented restoration seems to have taken place *in* 1859, when the glazier Mansion of Toul is known to have been active in the church.[39]

What was the original arrangement of scenes? While it is not possible to establish it beyond question, the most reasonable hypothesis would be that the Infancy occupied the left lancet and the Passion the right, as at Ménillot. The 1853 description and 1837 drawing verify such an arrangement in the right lancet (Plate II.14a): Entry to Jerusalem, Betrayal, Flagellation, and Crucifixion. Bagard's 1859 list simply inserts a scene at the bottom and the Appearance before Pilate (as at Ménillot, Plate II.2) before the Flagellation. In the left lancet the early descriptions were less logical: the Visitation and Presentation in the Temple, at the bottom, followed inexplicably by the enthroned Virgin and Child (no doubt part of the Adoration of the Magi scene), and the Carrying of the Cross in the lancet head. Like Ménillot, the original sequence probably was: Annunciation (listed there by Bagard), Visitation, Nativity,[40] Three Magi and enthroned Virgin and Child (at Ménillot these are combined in one medallion), and Presentation in the Temple (filling the lancet head as at Ménillot). The strong resemblance of figural arrangements to those at Ménillot reinforces this hypothesis, while the two scenes of the Massacre of the Innocents (Plate II.5b), placed one above the other in Saint-Gengoult Bay 0,[41] establish a precedent for thus stacking the adoring magi and adored Virgin and Child. Surely the most likely moment of rearrangement would have been during the installation of the Baroque marbles, when the most damaged glass panels in each lancet of Bay 8 probably were hidden behind the new dado.[42]

Bay 8's place in the stemma of Toul Cathedral is significant, since it seems to reproduce, more accurately than either Ménillot or Saint-Gengoult Bay 0, the general, formal arrangement of the model. This is true even though the forms have been updated in style. The

octagonal medallions of Bay 8 (Plate II.14b) recall the octagonal scenes recorded by Grille de Beuzelin in the cathedral apse.[43] The wide borders are a peculiar hybrid best understood as a stylish Rayonnant version of an early thirteenth-century Romanesque type. The red ground replicates that of the Romanesque border remaining from the cathedral's first campaign (Plate I.28a),[44] while the reversing pattern is very close to the earliest border surviving at Metz, that of the Saint-Paul fragments, which predate the early Toul Cathedral glass by possibly a decade (Plate VI.1).[45] The only element of the design that seems straightforwardly contemporary with the fabrication of Bay 8 is the simple lozenge diaper surrounding the medallions, standard in the aftermath of the Sainte-Chapelle at such monuments as Tours and the upper ambulatory of Le Mans in the 1260s.[46]

The scenes are intimately related to the other monuments in the stemma. Two subjects—Annunciation and Visitation (Plates II.15a,b and II.16a,b)—survive only at Ménillot and Bay 8, where, as noted in the work of the follower of the Ménillot Master in Saint-Gengoult Bay 0, the Saint-Gengoult scene is based on the Ménillot design but "fusses" it up, adding the Holy Ghost to the Annunciation, a tree and building to the Visitation, and generally breaking down the Ménillot Master's majestic pyramidal structures. This is also true in the three scenes of Bay 8 that survive at Ménillot and also in the early work of Saint-Gengoult's axial bay, by the Infancy Master: Nativity, Adoration of the Magi, and Presentation in the Temple. The relationships are only slightly more complex:

> *Nativity* (Plates II.7b,c)—Bay 8 follows Ménillot in omitting the Infancy Master's serving maid and fire, but copies the Infancy Master's gestures of Mother and Child reaching to touch each other.
>
> *Adoration of the Magi* (Plates II.8a,b)—Bay 8 follows Ménillot in the details of the Virgin's crown and the first magus's chalice-like offering. Since the Bay 8 scene is expanded over two medallions, the artist has given the Virgin a flowering stem to hold, while the Child stands erect on her knee; his kings also spread out to fill up the space.
>
> *Presentation in the Temple* (Plates II.9b,c)—Bay 8, like Ménillot, shows Simeon barefoot and the Child standing on the altar. (The scene is reversed in Saint-Gengoult Bay 0.)

Most fascinating are the four scenes of Bay 8 that appear both at Ménillot and in the later work of Bay 0, by the Gengoult Master: Appearance before Pilate, Flagellation, Carrying of the Cross, and Crucifixion. Indeed, both Bays 0 and 8 were probably works of the Gengoult Master.

> *Appearance before Pilate* (Plates II.10a–c)—Bay 8 and Bay 0 are practically identical in the figures of Christ and the executioner. Pilate's arm gestures in Bay 8

copy Ménillot. The draperies are more elaborate and a gaggle of supernumerary
executioners is added.

Flagellation (Plates II.11a–c top)—the Bay 8 Christ's posture differs from both Bay
0 and Ménillot, while the Bay 8 executioners replicate Bay 0.

Carrying of the Cross (Plates II.12a–c)—the Bay 8 executioners are identical to
those in Bay 0, except that the left one now wears chain mail. Christ's grasp on
the cross, in Bay 8, copies Ménillot.

Crucifixion (Plates II.13a–c)—Bay 8's Saint John is like Bay 0, while the Virgin
and Christ appear as at Ménillot.

The color harmony of Bay 8 is very close to Bay 0, both in the tones used—soft blue and
strong gold, with white and pure red accents, and a light, pale green—and in the amounts
distributed over the whole. Bay 8 makes greater use of the lovely green, probably indicat-
ing a development of the glazier's preference.

My conclusion is that the Gengoult Master, whom I have tried to characterize as a
trainee of the Ménillot Master, made both Bay 0 and Bay 8. The drapery painting is very
close, and the faces as well; in general, their resemblance can be compared to a pair of Van
Eyck Madonnas, or views by Cézanne of Mont Sainte-Victoire. This brings up the puzzle
of why he would have made a christological window for Bay 8 so close in time to his
completion of the same for Bay 0, and the solution is no doubt that he was paid to do so. In
a bourgeois church like Saint-Gengoult,[47] donors no doubt established the subjects, and
nothing could be more appropriate than the life of Christ! All the better if it be a stylish,
up-to-date replica of the venerable cycle from a generation earlier in the cathedral.

Vetriatte Bianche de Cristali

Another element of the cathedral glazing that was adopted at Saint-Gengoult was grisaille.
While almost none remains in the cathedral from the thirteenth century,[48] a few windows
and some old photographs provide evidence of the grisailles of Saint-Gengoult. The earliest
is Bay 101, a short doublet-and-rose window above the north chapel (see Fig. 5). Its grisaille
pattern presents angular, interlocking strapwork and foliage of a quasi-naturalistic cast, not
yet "growing" vertically, against a crosshatched ground (Plate II.17). While dating
grisailles on stylistic grounds is an imprecise science at best, none of the standard develop-
ments of the 1260s appears in this design; a comparison *grosso modo* with the various
grisailles of Chartres Cathedral would place it after the earliest (c. 1235–40) and before
bays 48, 50, and 51 (c. 1260–70), most closely approximating the characteristics of bay 47.
I have argued elsewhere that bay 47 was a work of 1259.[49] Grisaille such as Saint-Gengoult
Bay 101, Chartres bay 47, and the coeval windows of the Chartres sacristy is independent of

the panel format—lacking any strong central accent in each panel—and the glaziers, as Viollet-le-Duc put it, "zebra-stripe it with red and blue filets."[50]

If a date in the vicinity of 1259 is to be accepted for Saint-Gengoult Bay 101, then it must also apply to the wide border, which, there and in Bay 102 where the grisaille is lost, consists of alternating gold fleurs-de-lys on blue and gold castles on red, emblems of Louis IX.[51] Narrow borders alternating *France* and *Castille* had appeared in bays C and O of the Sainte-Chapelle[52] and a similar wide border frames the Theophilus window in the choir clerestory of Troyes Cathedral, also from the 1240s, where Lafond believed that it signified a royal donation.[53] While it has been firmly established that the *France/Castille* borders so popular in the 1250s and 1260s do not indicate a royal donation, they do evidence, at the least, a political sympathy or interest. An example coeval with Saint-Gengoult is in Gassicourt, the tiny priory near the Seine patronized by Guy de Mauvoisin, one of Louis IX's intimates at home and abroad; in Lorraine one could mention Saint-Dié, where Duke Ferri III had established his son as provost.[54] Thus *France* and *Castille* in Toul hint at some political agenda.

While the diocese of Toul was part of the Empire during this era, the bishop requested and received, from time to time, the support of the strong arm of the duke of Lorraine or the count of Bar—both of whom maintained a tilt toward France. The bourgeois of Toul, in their long struggle for independence, may have taken heart in October 1255, when these two sometime protectors of their adversary, the bishop, mutually agreed not to support him. This thaw continued until September 1261, when Ferri III of Lorraine actually signed a treaty with the *toulois* to defend them with armed force against "their enemies."[55] Within a month, however, Bishop Gilles de Sorcy had forced an annulment of the treaty, and during the remainder of the decade, until his death in 1269, it is unlikely that the emblems of the kingdom of France would have been so proudly displayed in the windows of Saint-Gengoult. Thus a date from 1255 to mid-1261 for the installation of the early grisaille seems most reasonable, making it coeval with the first work of the Infancy Master in Bay 0.[56]

The remainder of the surviving grisailles of Saint-Gengoult are stylistically homogeneous designs of near 1270. Two single grisaille lancets of identical pattern and in generally good condition were moved in 1898–1902 to the outer lancets of Bays 1 and 2, where they flank the modern medallions installed there at that time by Albert Bonnot.[57] An earlier photograph shows their original installation, immediately flanking the heavily colored Bay 0 (the lives of Christ and Saint Gengoult). Each grisaille now contains, about halfway up the lancet, a rather small standing figure under canopy. While the two figures are probably by the Gengoult Master, it is possible that they were set into the grisaille lancets by the restorer Leprévost in the late nineteenth century.[58] One, with crown, book, and sword (Plate II.18a), has been identified as Saint Catherine, not unlikely since the church had her relic.[59] The other figure is a secular martyr in vair-lined cloak, holding a palm (Plate II.18b); although the silver-stained face (a stopgap or ancient repair) seems

to have stymied identification, the saint is unlikely to be anyone other than Saint Gengoult himself, customarily shown, as here, wearing a noticeable hat.

The grisaille pattern is typical of the late 1260s: a panel-by-panel design, each one organized around a colored central *bosse;* the foliage composed partly of dessicated palmettes and partly of quasi-naturalistic leafage and growing, against a crosshatched ground, more or less upward from small "flowerpots" at the base of each panel. Thus the panels have a bottom and a top, and could not be installed sideways or upside down without doing violence to the design.[60] Similar flowerpots appear in grisailles from the axial chapel of Sées Cathedral, about 1270–80, but only in the lowest panel of the lancet, and with foliage of more advanced naturalism rising more emphatically upward around a dryer, more petrified filet pattern.[61] Among the grisailles from Saint-Urbain de Troyes (c. 1265–75) are designs of a general similarity. Thus a date around 1265–70 is more probable, exactly contemporary with the proposed dating of the Gengoult Master's completion of the axial bay. The grisailles of Bays 1 and 2 have his lovely borders of gaily colored, feathery, stick-lit leaves, and appear to be an integral part of his initial campaign, finishing and installing Bay 0 and no doubt flanking it with handsome *vetriatte bianche de cristali.*

Closely related grisailles from Saint-Gengoult, recently discovered in storage in Toul Cathedral, were reinstalled in Bays 5 and 6 (north and south chapels) in 1989.[62] Each lancet is of considerable historical and stylistic interest, all the more because they have been lost and unknown until the present. They were probably removed by Leprévost around 1875.[63] A photograph taken in his studio of the Bay 5 lancet was published by Lucien Magne in 1885 and again in his catalogue of the 1900 international exposition in Paris (Plate II.19).[64] The grisaille design is very close to Bays 1 and 2. The forms have become more angular, the border thinner and dryer, and the central *bosses* more simple, but the unusual flowerpots reappear at the bottom of each panel.

A dating only slightly after the apsidal campaign seems appropriate, both for the recently rediscovered Bay 5 grisaille—which develops the patterns of the apse (Bays 1, 2) toward angularity and simplicity—as well as for the christological cycle of Bay 8, which does the same relative to Bay 0. Only one clue to dating presents itself, the fleur-de-lys inserted into the minor tracery lights of Bays 7 and 8 (Plate II.14a) and decorating the *fermaillets* of the Bay 5 grisaille. Bishop Gilles de Sorcy kept the town under his thumb until his death early in 1269, but thereafter, until 1279, the town was bishopless and in anarchy, its communal hopes risen phoenixlike from the flames. As before, the fleur-de-lys may reflect the political landscape during those ten years. Thus a date in the 1270s suggests itself for the Gengoult Master's second life of Christ in the south chapel (Bay 8), for Bay 7, and for the now-reinstalled chapel grisailles of Bay 5.

The recent discovery of the Bay 6 grisailles, totally unrecorded heretofore, is of even greater significance. While generally related to the crosshatched grounds and densely interlocking networks of filets of circles and quatrefoils in Bays 5, 1, and 2, the recovered

panels of Bay 6 (Plates II.20a,b) have a much more robustly painted border of more naturalistic leaves, as well as grisaille foliage augmented with unusual sprigs of tiny berries and—even more noteworthy—with charming and forceful grotesque monsters. Monsters appear occasionally in Germanic Cistercian grisailles from around the same period. Those from the rose of Schulpforta have been dated about 1260, and the earliest at Altenberg from about 1300, in the north transept window, followed by two bays in the north nave aisle of about 1310–20.[65] The only surviving French Cistercian grisailles from the same years are in Lorraine, at La Chalade (Meuse), dated 1307–14 and including among the designs a pattern featuring monsters (see Appendix VII).[66] The La Chalade monster-grisaille is, however, much closer to the German examples than to its non-Cistercian predecessor in Lorraine at Saint-Gengoult.

The glazier who painted the vigorous borders of Bay 5 and the imaginative grisaille berries and monsters appears nowhere else at Saint-Gengoult. One could make too much of the absence of fleurs-de-lys in his lancet, suggesting a date after the renewed political control of the town by a new bishop in 1280, were it not for the reappearance of this fascinating and creative artist just a few years thereafter at the ducal site of Saint-Dié in the Vosges, the subject of chapter IV. His "Germanisms" there seem to come from Alsace. His vocabulary of berries and twisting leaves on leaf-scarred branches, his emphatic figural outlines, vigorous growing hair, and distinctive eye lining, are as unmistakable as the strong focus and creative flare of his art (Plates IV.23b,c). What luck to have, recovered and reinstalled, his handsome Saint-Gengoult grisaille! With it the program of Saint-Gengoult, of saturated color and flanking grisaille maintained through many decades and by several distinctive artists, provides us a reasonable facsimile of the innovative, now-lost choir ensemble of Toul Cathedral.

The Weight of the Past

The prestige of the cathedral of Toul and its stained glass—which can be assumed from the glowing praise of it on the tomb of the donor Bishop Roger de Marcey[67]—is further witnessed by so many copies ranging over nearly half a century. There can be little doubt that Toul set the fashion in Lorraine. While the briefest comparison of the copies underlines their differences and development in style, yet the reliance on the model, a work of the 1230s, can also be conceived as a constraining factor. The stylistic mismarriage that is evident in Saint-Gengoult Bay 8, where early border types and medallion shapes, albeit "modernized," encompass wispy Rayonnant figures lost in shaded stiff-fold draperies, is the final and perhaps inevitable result. What these glaziers' other works looked like, those not based on a dictated and venerable source, is an equally fascinating topic that will be pursued in chapter III.

III

SAINT-GENGOULT (TOUL): POPULAR PIETY

What we teach is one thing, what we tolerate is another, . . .
and what we are obliged to put up with is yet another.
—*Saint Augustine*, Contra Faustum *xx, 21 (trans. Wilson)*

THE commune of Toul was struggling for control of its fate during exactly the same decades when glaziers were ornamenting its churches. The dating of the cathedral glazing in chapter I was based on the presence (or absence) of the documented donor, Bishop Roger, forced into exile by the townspeople for eight years of his reign.[1] His successors reigned no more peacefully. The next bishop, Gilles de Sorcy, fled as the citizens besieged, then pillaged and burned, his palace; later, following his death, they again destroyed it, the cathedral gates, archives, and treasure, and imprisoned several canons. Conrad Probus, named bishop in 1279, was not able to enter or control the town until 1285. Martin has explained the role of the collegiate community of Saint-Gengoult in this conflict:

> The center of communal life was the neighborhood of Saint-Gengoult. There, one was at a reasonable distance from the bishop's palace and the cathedral. The two groups of canons were, to a degree, rivals: an untimely peal of bells, a collision of processions, a question of precedence or custom, who knows? would suffice to rekindle the warfare. The canons of Saint-Gengoult were thus the natural partisans of our bourgeois; the similarity of quarrels would make a similarity of interests.
>
> The *hôtel de ville* was located on the square . . . opposite the canons' enclosure; their church tower served as the town's belfry (*bancloche*). . . . It was there that were celebrated the town's religious ceremonies; in the cloister, the magistrate presided over official business (*bannaux*) and, in the adjoining square, were held the fairs, markets and assemblies of the people.[2]

One side of the relationship has been examined in chapter II, where the immense prestige of the cathedral building and glazing established them as models to be replicated and, if possible, modernized and surpassed. Thus the choir and chapels of Saint-Gengoult, begun around 1250, copied and refined the plan and elevation of the cathedral choir, and the glazing of the collegiate church—christological cycles, grisailles—copied and modernized the cathedral's much-admired choir glass.

The other side of life in a bourgeois parish differs radically from that of the diocesan center, reflecting the concerns of folk religion as actually practiced by the laity and tolerated or consciously ignored by their priests. Though folklore and popular piety have been the objects of scholarly study, their manifestations in Gothic religious art are not often recognized and will repay our attention.[3]

The apsidal program of Saint-Gengoult (Fig. 5 and Plate III.1) follows that of the cathedral in presenting the life of Christ and the life of the church patron. But whereas the cathedral patron was Stephen, Ecclesia's great protomartyr, the name-saint of Saint-Gengoult was a figure typical of romance or even scatological *fabliaux*. This chapter will examine, chronologically in order of its creation, the stained glass in Saint-Gengoult that reflects popular religion: the Holy Face of Christ, good for indulgences; the tale of Saint Gengoult, the cuckolded aristocrat; and the ex-voto window donated by two Toulois youths saved from a fire.

Three Veronicas

In the uppermost tracery light of Bay 0 is a small bust of Christ (Plate III.2a), seemingly repeating in close-up the enthroned Christ immediately beneath it in the rosace (see Plates III.1 and III.2b). Even more repetitious and inexplicable seem the two large-scale busts of Christ occupying the uppermost medallions of the double lancets below (Plates III.3a,b), where they top the lives of Saint Gengoult and Christ and are encircled by identical round borders. Balthasar in 1853 called these busts Peter and Paul, while Bagard in 1859 dismissed them as "two busts nearly alike: we don't understand their meaning at all. . . ."[4] But the three busts (Plates III.2a and III.3a,b), which are among the finest creations of the first glazing campaign at Saint-Gengoult produced by the Infancy Master about 1255–60, all have cruciferous haloes, clearly establishing that each of the three depicts Christ. Each image includes his rigidly frontal, staring face, neck, and the upper part of his garment, hemmed with an ornamental band that makes an angular turn at each shoulder.[5]

Though the Holy Face has been virtually unknown in thirteenth-century stained glass, Beer has published two examples of about 1260, thus approximately contemporary with Saint-Gengoult, from the region around Zurich: a roundel now in the Schweizerischen

Landesmuseum, Zurich, and a tracery light in the cloister of Wettingen (Plate III.4).[6] Neither is what might be termed a "pure" example since the Landesmuseum roundel includes a rigid, blessing hand in the middle of the chest, while the Christ bust at Wettingen is paired with a bust of the Virgin in matching tracery lights.

Fourteenth-century stained glass in the Upper Rhineland occasionally includes the Holy Face, normally shown as it appeared on countless sudarium images that began to proliferate around the first Holy Year jubilee in 1300—the haloed face in isolation, sometimes on a veil.[7] The earliest Gothic example of a Holy Face in isolation, without neck or garment, has been believed to be that of the Psalter of Yolande de Soissons, about 1275–85, which Gould has related to the Byzantine mandylion type rather than to the sudarium relic in Rome.[8] The earliest example of the Holy Face on a cloth or veil seems to be the Gulbenkian Apocalypse of the 1260s, but the image clearly has a neck.[9]

The Holy Face shown as a bust as at Saint-Gengoult—including the neck and usually the top of the garment, and omitting reference to the sudarium cloth—most commonly has been associated by art historians with English thirteenth-century manuscripts, where seven very close examples occur.[10] The earliest are two drawings in Matthew Paris's *Chronica majora,* dated 1240–51, and a related leaf inserted into the Arundel Psalter.[11] The second Matthew Paris drawing accompanies his chronicle for the year 1216, where he explains why such pictures were then gaining popularity.

In 1207 Innocent III had instigated an annual procession of the Veronica sudarium between Saint Peter's and the hospital of the Holy Ghost, on the first Sunday after the octave of Epiphany. During the procession in 1216 the image suddenly flipped upside down, and the pope, interpreting this as a sign of divine displeasure, composed a prayer to honor the Veronica and granted ten days' indulgence for its recitation. Matthew Paris finishes his narration of these events by noting that many people memorized the prayer and, to aid their devotions, made pictures of this kind (*in hoc modo*).[12] The indulgence was increased to forty days during the reign of Innocent IV (1243–54) in conjunction with the introduction of the hymn *Ave facies praeclara.*[13]

Indeed, in many psalters the Veronica image accompanies a prayer text and often a specific mention of the indulgence. This is true not only for the English manuscripts already mentioned but also for a Swiss psalter of about 1260 (Plate III.5), approximately contemporary with the Saint-Gengoult window: Besançon, Bibl. mun., MS 54, fol. 18r (probably from the Cistercian nunnery of Bonmont near Geneva).[14] However, while the Veronica image was clearly considered useful for devotions, Flora Lewis has pointed out that "the indulgence was, strictly speaking, simply for the recital of the prayer, not necessarily before an image of the Veronica, and there is some evidence that the prayer circulated unaccompanied."[15] She gives examples of manuscripts specifying that the indulgence is granted to those who recite the prayer "au sacrement" or before the cross, as well as a fourteenth-century book in which the indulgenced prayer is illustrated not with a Veronica but with a depiction of the elevation of the host. In other words, there was a

belief—no doubt encouraged by the clergy—that in order to receive the indulgence one needed to say the prayer while at mass, and the Veronica image may have served as a useful reminder not to forget to do so. In this light it is easier to appreciate the function of the imposing Veronicas in the axial window of Saint-Gengoult.

But why are there so many of them? While the upper tracery light is no doubt too small to carry great significance, the two large, nearly identical busts in the lancet heads seem somewhat repetitive and unimaginative (Plates III.3a,b). Conceivably the artist could have provided Trinity references in his three lights. Or, at least in the two lancet heads, he could have paired a bust of Christ with a bust of the Virgin, as was done in the Hildesheim Psalter from about 1235 and in the stained-glass traceries of the Wettingen cloister, both approximately contemporary with Saint-Gengoult.[16] Such paired busts appear in fourteenth-century painting and become common thereafter. They have been studied by Pächt, who noted that Andrew of Crete (c. 726) mentions such companion icons painted by Saint Luke and preserved in Rome and Jerusalem.[17] But the Saint-Gengoult glazier chose not to pair busts of Christ and the Virgin, but to depict Christ's bust twice. While his solution is unique and seemingly rather uninspired, perhaps there is more to his twin busts than meets the eye.

What Did Christ Look Like?

The thirteenth century was the era when individualizing and specifying became important concerns. This is true in art, for example, as iconographers first developed precise, unique attributes for each apostle,[18] and it is equally true in society at large, the nobility adopting distinctive coats of arms and common men—at least in urban England and France—beginning to use specific surnames to identify themselves more accurately.[19] What Christ had actually looked like, while he lived as a man on earth, clearly began to capture the popular imagination.

Two declared portraits reached northern France just before the Saint-Gengoult window was designed: the Edessa mandylion, included among the relics purchased from Baldwin II by Louis IX and installed in the Sainte-Chapelle treasury in Paris by 1241,[20] and the Holy Face of Laon, sent by Jacques Pantaléon (a native of Troyes, who from 1260 to 1264 was to reign as Pope Urban IV) to his sister Sybille, abbess, and her Cistercian nuns at Montreuil-en-Thiérache near Laon in 1249.[21] Both were Byzantine paintings, the Sainte-Chapelle icon ("sanctam toellam tabulae insertam" in Baldwin's Golden Bull) lost in the French Revolution and the Holy Face of Laon now preserved in Laon Cathedral. The latter, a Slavic icon of possibly the twelfth century and considered by Grabar to be the finest exemplar of the type established by the mandylion of Edessa, is a panel painting depicting a diapered cloth bearing the dark-toned, haloed face of Christ in isolation, with

no neck. Thus, although it began to produce miracles in northern France as early as 1262,[22] neither the Laon icon nor its probable model, the lost icon of the Sainte-Chapelle, can be the precise source for the Saint-Gengoult stained glass.

Many art historians, particularly those working with the English Veronica illuminations, have grappled with the problem of the source of the Holy Face shown as a bust, with neck and garment, a type they assume to have been introduced or even invented by Matthew Paris. Nigel Morgan, following Pächt, has suggested that Matthew Paris's prototype was a Roman mosaic that once formed part of the triumphal arch in S. Giovanni in Laterano.[23] Flora Lewis considers Matthew's drawings as "close-ups" of contemplative subjects such as the Christ in Majesty and she denies that he had the intention of reproducing a specific image.[24] Indeed her theory seems particularly applicable to the small Veronica in the uppermost light at Saint-Gengoult, which seems to enlarge a detail of the enthroned Christ of the rosace directly beneath it (Plate III.2a,b), as though one had taken two photographs of the same object with different camera lenses.[25] While Suzanne Lewis has sought to relate Matthew Paris's drawings to specific models at his abbey of Saint Albans, she believes that the bust type was probably based on the textual description of the Veronica in Rome by Gervase of Tilbury (*Otia imperiale* III.25, dated c. 1211–15):[26] "The Veronica, then, is a true picture of the incarnate God shown as a shoulder-bust, in the basilica of S. Peter . . ." (see Appendix I).

Matthew Paris never went to Rome, but certainly he must have talked with people who had been there and seen the Veronica. Indeed, several German busts of Christ closely resemble his and suggest that all may reproduce the famous Roman relic, for instance, the Christ bust in the Hildesheim Psalter of about 1235, slightly predating the English examples,[27] and a *Zackenstil* fresco in Sankt Pantaleon, Cologne.[28] Another German example, which shows the head of Christ isolated, without a neck, appeared at the top of the gigantic Ebstorf world map, begun around 1230.[29] Gervase of Tilbury, whose eyewitness description of the Roman Veronica appears above, may have ended his days as provost of Ebstorf, and it has been suggested that the Ebstorf map was his last work, completed after his death in 1235.[30] In any case the map is extremely important, since its Holy Face is the only example to include—as does Matthew Paris's second drawing—the Alpha and Omega flanking Christ's head. Breitenbach, in making this comparison, went further:

> The similarity between this head [on the Ebstorf map] and the drawing in Matthew Paris' chronicle is so strong that one feels tempted to speculate that Gervasius, who frequently visited his native England on diplomatic missions, may indeed have been the transmittor of the Veronica image to St. Albans.[31]

So what is (or was) the appearance of the Veronica that Gervase had seen in Rome? In the early thirteenth century pilgrims to Rome venerated two miraculous images of Christ.

Both are described by Gervase of Tilbury (Appendix I) and also by his contemporary, Gerald of Wales (d. c. 1223), in *Speculum ecclesiae,* Gerald calling the one at Saint Peter's the Veronica and the one at the Lateran the Uronica[32] (see Appendix II).

The image at Saint Peter's, documented from the early twelfth century or before, was believed to be the miraculous veil impressed with the image of Christ's face and preserved by the woman Veronica, which had cured the Emperor Tiberias. Gervase described it as a bust portrait "painted on a panel," while Gerald stated that no one saw it "except through the curtains which are hung before it." Woodcuts from about 1475 to 1525 illustrating editions of the guidebook *Mirabilia Romae* (Plate III.6) show it being displayed— presumably with the curtain off—to the faithful by three clerics, and it seems to be in a frame masking all but the head, in the manner of a Byzantine icon.[33] Although reported lost in the sack of Rome in 1527, it or a substitute has continued to be displayed up to the twentieth century, and indeed is masked by such a gold sheet cut out to reveal only the face. Reports since the sack of Rome, from Luther (1545) through Wilpert (1916), have uniformly described the face as so black that the features could not be made out.[34] Possibly it survived in 1527—as many scholars believe—but in a charred and blackened condition. Wilpert believed that a painted bust image had been glued to the face in the late twelfth century and destroyed in the sack of Rome, while the supporting panel survived. Thus in the Gothic period, unburdened by such an icon frame, the Veronica in Saint Peter's may well have appeared as a bust with neck and chest as described by Gervase.

The "Uronica," in the Sancta Sanctorum chapel of S. Giovanni in Laterano, is a panel painting by a Roman artist of about 500, believed, from the twelfth century on, to have been painted by Saint Luke. Though full-length, probably originally depicting Christ enthroned, by the twelfth century it was in such a ruinous condition that it had been covered by a silk curtain under Pope Alexander III (1159–81), and later hidden up to the neck by an ornamented, gilt-silver cover added in restorations under Innocent III (1198– 1216).[35] The existing head (Plate III.7), which Wilpert considered to be twelfth century, is a "restoration" painted on canvas and glued over the original surface of the panel.[36] Hence the Romanesque cast of the face, unforgettable for its immense staring eyes. In the early thirteenth century both Gervase and Gerald reported that, since the gaze was so terrifying that worshippers looking too closely were "in danger of death," the pope had ordered the image veiled.[37] Thus the Sancta Sanctorum image, as revealed to the faithful from about 1200, was a bust—the panel covered by a gilt-silver sheath revealing only the twelfth-century staring head. Authoritative evidence survives showing us its appearance in the late Middle Ages: four scenes depicted on the small hinged door of gilt-silver (*portacina*) added in that era to Innocent III's silver cover (Plates III.8a,b). The four scenes take place in the Sancta Sanctorum with the image in full view, and in all four it appears as a bust with neck and garment.[38]

These two sacred portraits of Christ—the Veronica in Saint Peter's and the image in

the Sancta Sanctorum of the Lateran—must have resembled each other closely enough in the Gothic era for them to be accepted as authentic portraits of the same man. If Wilpert is to be believed, both had received newly glued-on heads just before 1200; thus both would have been legible images, when their curtains were withdrawn. And the neck and garment and staring eyes of the "Uronica" survive to suggest to us the general appearance of them both—close to the frontal bust type of Holy Face with hallucinatory gaze current in thirteenth-century England, Germany, Switzerland, and eastern France. Saint-Gengoult, Toul, is unusual only in outdoing the others by replicating both Roman cult images for the faithful (Plate III.3).

The *prévôt* in charge of Saint-Gengoult automatically served as *archdiacre* of the cathedral, that is, second in power to the bishop in the diocese. In 1253 or 1254, as the Gothic church of Saint-Gengoult was rising, the cathedral's canons sent their archdeacon Robert d'Aix to Rome to solicit confirmation of their newly elected bishop.[39] Another outcome of his trip to Rome is probably the insertion into the new axial window at Saint-Gengoult—which he served as provost—of the two Roman images of Christ that, no doubt, he had recently visited.

Patron Saint of Cuckolds

Paired with the life of Christ in the axial bay is the most extended sequence in existence in any artistic medium of the life of Saint Gengoult, the church's patron (Plate III.1). All the more surprising, the cycle has been unknown to iconographers and does not appear in any of the standard lexicons; moreover, it is earlier than any listed cycle.[40] All fifteen of the original scenes survive, though out of order, one of them now at the end of the christological lancet. They are as unusual as the life of Christ is familiar. Indeed they are unique—the longest visual cycle of Gengoult's life in art, not only from the Middle Ages but the Renaissance and Baroque eras as well, when he enjoyed considerable popularity in several regions. The story of the saint is a tale of gossipy charm and crude, folkloric melodrama that seems to have fascinated the glazier a good deal more than the life of Christ. His designs—which could only be his own inventions—have met the challenge. Legible and entertaining, the Gengoult Master's lancet achieves a narrative triumph.

While there is historical evidence for the existence of Gengoult (d. 760), a Burgundian nobleman in the service of Pepin the Short (751–68),[41] his *vita* of the late ninth or early tenth century is totally fabulous.[42] Gengoult's cult eventually spread from Varennes in Burgundy, original site of his miracle-working tomb, as far as England and Italy, and has received considerable attention from German folklorists.[43]

The church of Saint-Gengoult in Toul, his largest in France and among the earliest,

had received a part of the saint's relics from Varennes at the time of its foundation by the Toulois bishop Saint Gérard (936–94).[44] It almost certainly owned a manuscript of the fabulous *vita,* which was recast in slightly augmented form in the late tenth century, possibly at Toul itself.[45] Indeed the window offers further evidence for the localization of *vita* II, since it includes a scene from it, the Miracle of the Candle (Plate III.12), not included in the original text. In the thirteenth century, while Gengoult's life was not included in the *Golden Legend,* it did make a brief appearance in Vincent of Beauvais's *Speculum historiale* (Bk. xxiii, chap. 159).[46]

These accounts vary only minimally, and the story as established by the *vita* and augmented, probably at Toul around the millennium, provides the basis for the description of the medallions below. In brief, Gengoult, trusted retainer of King Pepin, was married to a woman of rank who proved unfaithful with a cleric lover. After having proven her guilt through trial by water of a miraculous spring, he put her aside and withdrew to another castle, where her lover eventually murdered him.

While the other protagonists appear in the window in changing colors, Gengoult can always be identified by his costume: pale green sleeves, a red mantle with a row of white buttons reaching the neck and a short red cape with white lining, a soft brown brimless hat, and a halo. Moreover, except for when he is murdered in bed, he is always accompanied by his horse. The horse, which has caused modern authors some confusion in the identification of scenes, is not so much part of the scenes as it is Gengoult's attribute, much as the keys of Saint Peter. It signifies Gengoult's aristocratic rank,[47] as King Pepin's governor over Burgundy, and by extension it came to figure prominently in his popular cult. Mayer has collected folk processions and customs like the benediction of horses (*Pferderitte, Pferdesegnungen*), and believes that "after Sts Stephen and Martin, Gengoult seems to be the oldest patron saint of horses."[48] While no evidence has survived of such folk practices in Toul, the presence of the horse in nearly all the Gengoult medallions suggests that similar celebrations formed part of the community's traditional customs.

Recent identifications of the Gengoult lancet have attempted to match the images in the medallions with incidents of the story as recounted in standard, popular collections of saints' lives.[49] The results have enjoyed only partial success. While the main story line is clear, precise identifications have often missed the mark, partly because the medallions are now out of order (in relation to the *vita* text), and partly because the scatological scenes of the dénouement have been whitewashed out of recognition in modern hagiographic collections. The glazier clearly had no visual model for such an elaborate cycle, the longest in existence, and relied upon the visual "language" of standard Gothic postures and gestures as signifiers to help communicate the story. The designs are therefore, like much of Gothic art, not so much "snapshots" of the story being acted out as they are ideograms in mime of the themes of each incident. The following identifications, presenting the scenes in their order in the *vita,* will make use of François Garnier's study of Gothic signifiers, *Le Langage de l'image au moyen âge, signification et symbolique* (Paris, 1982); references to Garnier will be

provided for most details and have allowed for more precise identifications. The medallions will be designated with their present location in Bay 0 (see Fig. 5), A and B referring to left and right lancets, numbering from the bottom up.[50]

1—The marriage of Gengoult (A 2) (Plate III.9):[51] *Vita,* chapter 2.

> Gengoult and his wife embrace. Behind him is his horse (as attribute), while behind her is a shorthaired figure resembling her cleric *ami.*[52] The latter holds one arm close to his waist while the other hangs down, both gestures signifying powerlessness (Garnier, 195B, D, F, 214, 215H). While the scene has been identified as Gengoult taking leave of his wife to serve King Pepin, an embrace is not normally a gesture of leavetaking and departure (Garnier, 152–53). The actions of the wife, one arm around Gengoult and the other touching his hip, are normally those of a man taking a wife (Garnier, 195B, C), though they also resemble those of "welcoming" (Garnier, pl. 133; see also scene 11 below). Thus the untextual presence of the *ami* might suggest an identification of the scene later in the story, that is, the unfaithful wife welcoming Gengoult home. However, that event is not dwelt upon in the text, while Gengoult's marriage is a major theme. The author describes the wife as of high rank but unfortunately vain, frivolous, and worldly, stating that God permitted their alliance as a trial of the saint's virtue. Thus her forwardness in embracing her husband, and the inclusion of the *ami,* are probably emblematic of her wicked character.

2—Gengoult leaving to serve King Pepin (A 5) (Plate III.10): *Vita,* chapter 3.

> Gengoult and a companion, on horseback, go left. The saint turns back to grasp the hand of his wife, standing to the right. The horizontal, open hand of the companion indicates the direction they will go (Garnier, 171–72). The (mis)identification of this scene as Gengoult returning from the king's court to Burgundy[53] does not take into account this gesture of "direction," common in Gothic art. Gengoult's posture, turning back, indicates someone parting from a person (Garnier, 153); his hand on his hip or thigh indicates firmness and determination (185), while his wife's open hand, held to her breast and turned out, shows acceptance and recognition of authority (174). Gengoult holds his wife's hand in a gesture often used affirming marriage (205B, C, E, 207G).

3—Gengoult serving King Pepin (A 3) (Plate III.11):[54] *Vita,* chapter 3.

> Gengoult kneels before the king, seated crosslegged, holding a banner. Behind the saint his horse (attribute) appears in an elegant doorway, setting the scene indoors at court. Gengoult's kneeling posture and backwardly inclined head indicate his

submission and respect due a superior (Garnier, 113–14), his open hand also signifying obedience. The king's crosslegged pose is typical in Gothic art of monarchs or judges depicted in the exercise of their official power.[55] Pepin points up and at the banner, his gesture serving both to bring it to Gengoult's attention (165–66) and to give him an order (166), presumably a command to serve and guard it. Pepin's flag is a true *bannière,* a specific narrow, vertical shape that first came into use in the second half of the twelfth century for heraldic display.[56]

As tiny as it is, Pepin's banner is a most important piece of evidence (Plate III.11b). It is decorated with three gold fleurs-de-lys. These are the imaginary arms of Pepin the Short—who, since heraldry did not yet exist in his lifetime, had no real coat of arms—as first recorded in the armorial of the herald Gelre (Claes Heinen), painted between 1370 and 1386.[57] But the glass of Saint-Gengoult predates Gelre by a hundred years. The arms appear in the beginning section of Gelre's work, a genealogy of the dukes of Brabant, who traced their lineage back to Charlemagne, Pepin's son.

Charlemagne enjoyed an enormous vogue in Europe from the fourteenth century well past the Renaissance, based on his inclusion in the popular theme of the Nine Worthies, as well as on his cult as a saint as promoted by Emperor Charles IV of Luxembourg (1346–78), king of Bohemia. Both the cult and the theme of the Worthies had their roots in the region of Lorraine and eastern Belgium, Charles IV having descended from Charlemagne through his ancestor Marie de Brabant, and the Nine Worthies having found their definitive form in a poem (*Voeux du paon,* c. 1312) written by the *lorrain* Jacques de Longuyon for the *lorrain* Thibaut de Bar, bishop of Liège.[58]

But the source of Pepin's coat of arms before the fourteenth century is a more complicated matter to trace, and most significant for an understanding of the Toul glazing program. Without doubt Pepin's arms are related to the imagined arms of Charlemagne, a divided shield (*parti* or occasionally *mi-parti*) composed of the lilies of France and the Germanic eagle of the Empire. Presumably the eagle would have been added upon Charlemagne's coronation as emperor, the fleurs-de-lys thus imagined as his original arms and those of his father, Pepin. The very first blazon of Charlemagne's *parti* shield, as far as is known, appears in *Enfances Ogier,* written by Adenès li rois between 1265 and 1285:

El roi Charlon . . .
Armes parties d'or et d'azur portoit,
Dedenz l'azur flours de lis d'or avoit
Et demi aigle noire sor l'or seoit.[59]

("King Charles . . . bore arms impaling gold and blue. On the blue it had fleurs-de-lys and a black half-eagle was on the gold.")

Adenès was a *trouvère* at the court of Brabant in Louvain, and around 1268–71, the same period that he wrote *Ogier*, Duke Jean I first had the genealogy of the dukes of Brabant composed.[60] Thus Charlemagne and Pepin and their imagined coats of arms were exciting topics at the intellectual court of Brabant around 1270, exactly contemporary with the Saint-Gengoult window. Pepin (REX BIPPINUS PATER KAROLI) and Charlemagne, without benefit of imaginary heraldry, appear as imposing figures amid the famous series of emperors glazing the north nave aisle of Strasbourg; they are works of about 1255/60.[61] The provision of Pepin's "correct" heraldic banner by the Saint-Gengoult glazier a few years later is a clear and undeniable indication of his awareness of contemporary intellectual currents from Brabant.

But who could have told him about Pepin? Nothing about the provincial sociopolitical climate of Toul suggests contact with the sophisticated court of Brabant. But as in the case of the Holy Face, the provost of Saint-Gengoult, Robert d'Aix, would be the most likely candidate. His family seat, unlike the local origins of his successor in office and most bishops of Toul, was in Luxembourg (Esch-sur-Sûre, spelled variously Asch, Aisse, Aixe, etc.), where his father and elder brother Joffroi served as the most trusted counsellors at the count's court.[62] While Toul was in *Haute Lorraine*, ruled by the dukes of Lorraine, Luxembourg was in *Basse Lorraine*, or Lothier, and in the thirteenth century the dukes of Lothier were the dukes of Brabant.[63] When Robert d'Aix died in 1275, in addition to his ecclesiastical benefices in Toul, he held an office at the cathedral of Verdun, where another of his brothers, Jean, had been elected bishop and where both of them were buried.[64] Robert seems to have been the man in Toul— probably the only man—who could have had the wider, Brabantine contacts necessary to explain Pepin's coat of arms.

Thus the provost himself seems to have been deeply involved in the "popular" glass program, a conclusion that will be all the more surprising as we resume the description of the lancet of Saint Gengoult and consider its climactic scenes below.

4—The miracle of the candle (A 1) (Plate III.12): chapter added to *vita* II between chapters 3 and 4.[65]

> Within a three-arched interior, Gengoult sleeps (eyes closed, arm folded, Garnier, 119B) to the left; Pepin, lying to the right, observes an angel descending to relight a long golden candle in the center of the scene. This story, possibly added to the *vita* in Toul, relates that Gengoult, as the king's trustiest man, slept in Pepin's tent on military campaign. One night the lamp kindled by itself and, after the king thrice blew it out, thrice rekindled, Pepin taking this as a sign of Gengoult's special qualities.

5—Gengoult leaves King Pepin (A 4) (Plate III.13): *Vita,* chapter 4.

Pepin sits to the right, Gengoult stands before him, and at the far left a page holds the reins of his horse. The king appears as a figure of authority, enthroned, crowned, holding a scepter and pointing up; he points with two fingers, a gesture signifying his superior status (Garnier, 165, 167). Gengoult points, with both hands, indicating the direction he will go, while turning back to the king in the posture of leavetaking (165, 171–72, 153). The page is shown in profile to indicate his low status (143–45).

6—The miracle of the spring (A 6) (Plate III.14):[66] *Vita,* chapters 4 and 5.

Gengoult appears to the right on horseback, the horse of a retainer shown behind him. The spring is in the center of the scene, and a servant (or farmer) holding a staff at the left. Gengoult, en route home to Burgundy, bought a fountain from a farmer for 100 sous, the avaricious owner believing understandably that the saint was a fool. Upon his arrival home in Varennes (Haute-Marne), Gengoult thrust his staff into the ground; the following morning, when his servant could find no water for washing, Gengoult ordered him to go pull the staff up. The spring burst forth, drying up in its original location.

The artist has designed an ideogram that combines several moments of the narrative, the purchase as well as the miracle at the removal of the staff from the ground. The appearance of the second horse suggests that Gengoult is traveling, with retainers, and thus making the purchase. The figure to the left, in profile and wearing a short robe and cap with chin strap as an inferior, could be the avaricious farmer, the mutual gestures with raised open hands signifying a sale (Garnier, 174–75). The very important place in the composition of the staff, however, unquestionably refers to the servant and the miracle of the spring gushing forth in its new location.

7—The adultery of Gengoult's wife and her cleric lover (A 7) (Plate III.15 bottom):[67] *Vita,* chapters 4–6.

The lovers are seated in an interior, embracing. The cleric, who has short hair, is not named but is described as "a Judas" (chapter 6).

8—Gengoult hears of his wife's infidelity (A 8) (Plate III.15 top): *Vita,* chapter 6.

Gengoult is seated at the center of the composition, facing a kneeling inferior to the left, holding a scroll; his wife is behind him, at the right. The left-hand figure

appears before Gengoult, as a figure giving good counsel (Garnier, 107–9), but since his news is bad and he himself of inferior status, he is shown kneeling, in profile, with his head inclined back (113, 125, 144–45). Gengoult sits, as the authority figure, his open hand as well as his other hand touching the scroll, both indicating acceptance of what he hears. Behind him, his wife is the designer's most unusual figure—not really part of the scene but a visualization of her guilt. She is not sitting but "en marche" out of the picture, her upper hand indicating the direction of movement and her head turned back in the posture of someone fleeing from a guilty past (151). Since flight is not her response in the story, the artist has chosen the posture to present her guilt.

9—The miraculous trial by water (A 9) (Plate III.16 bottom): *Vita,* chapter 7.

Gengoult stands left, pointing to the spring; to the right are his wife and her lover. His wife having denied the reports of her infidelity, Gengoult told her to put her hand in the water of the fountain to prove her innocence. As she did so the water boiled up and scalded her badly. Gengoult points, ordering her but also accusing her (Garnier, 165), while his raised open hand indicates acceptance of the evidence. The wife's head is lowered in guilt, despair, and/or pain (141). The lover at the right touches his cheek, showing distress (181–83) while holding his wrist, a gesture indicating not only intense grief but also the incapacity to act (198, 201). While Surdel has pointed out that trials by water were in accord with judicial practice when the *vita* was written,[68] such ordeals had been definitively prohibited by Innocent III in 1215,[69] and the story in Gothic times would no longer have had the aura of a judicial procedure. Indeed, the miracle was particularly popular and ultimately became the subject of an Alsatian song, sung to the tune of *O Tannenbaum:*

> Das Brünnelein, das Brünnelein
> Hat Lug und Trug verraten.
> Mein Weib, das schwor: "Wie Gott es weiss!"
> Und tauchte gar das Händchen weiss
> Ins Brünnelein, ins Brünnelein.
> Weiss Händchen war gebraten![70]

("The little fountain has revealed lies and deceit. My wife, she swore 'As God knows!' and plunged her little white hand all the way into the fountain. The white hand was scalded!")

10—Gengoult leaves his wife (A 10) (Plate III.16 top): *Vita*, chapter 8.

> Gengoult, leaving on horseback to the left, turns back toward his wife; her lover is
> behind her. Rather than taking vengeance on her, Gengoult arranged for her to live
> on one of his estates and he withdrew to another residence, near Avallon (Yonne).
> Surdel has pointed out that the return of the wife's dowry was according to feudal
> law, but that by the same code Gengoult was allowed to treat her much more
> cruelly.[71] Gengoult turns back, indicating a scene of parting, and raises his hand in a
> gesture of authority but also of goodwill (153, 175). Both his wife and her lover
> touch their faces with a hand, showing sadness and pain (181–83), while the wife's
> hand placed across her waist strengthens the same meaning (183C, M, N).

11—Gengoult visits his aunts Willegossa and Willetrudis (A 11) (Plate III.17 bottom):
Not in the *vita*, this scene introduces the aunts who will bury Gengoult (chapter 11).

> Gengoult, his horse behind him to the left, is embraced by one of his aunts at a
> doorway, the second aunt behind her reaching to touch his hand. The first aunt's
> embrace is a gesture of welcome and protection (131A, D, 215E), while the
> handclasp of the other indicates a benevolent relationship (208).

12—The murder of Gengoult (A 12) (Plate III.17 top): *Vita*, chapter 9.

> Gengoult, eyes closed and hand to face in sleep (118, 119), is to the right; the
> wife's cleric lover, at the left, strikes with a sword held in both hands. Encouraged
> by the wife, her lover sneaked into Gengoult's bedchamber and struck him with
> the sword hanging there; the saint awoke in time to deflect the blow to his thigh.
> After receiving the last rites he died.

13—The funeral of Gengoult at Varennes, attended by his aunts and two crippled peti-
tioners (A 14) (Plate III.18): *Vita*, chapter 11.

> Gengoult's dead body, eyes closed and hands crossed, lies in state. His first aunt
> embraces his head, while the second and one of the beggars clasp their hands in
> pious supplication. The deformed cripple at the bottom left, shown in profile with
> hair flying, holds hand-crutches.

14—The death of the cleric lover (A 13) (Plate III.19): *Vita*, chapter 12.

> The text states that the lover dies the "death of Arius the heresiarch," who,
> having retired to a public latrine to answer the need of nature, lost his entrails in a

violent dysentery and died instantly (d. A.D. 336).[72] While the thirteenth-century glazier may never have heard of Arius, the presence in the *Golden Legend* of such a punishment for the heretical "pope" Leo, adversary of Saint Hilaire of Poitiers, indicates that such an ignominious end was established in the hagiographic tradition for the church's worst offenders.[73]

The artist has depicted the scene exactly, the cleric appearing in an interior, seated on a latrine with his drawers lowered to his ankles. The expulsion of his entrails is aided by a devil with a rake. Clearly the lover dies unrepentant, as did Arius himself. His open hand indicates acceptance or submission, or possibly even direction (i.e., hell, where the devil came from), while his hand on his thigh affirms "the irreversible character of his determination" (Garnier, 174, 185). He sticks out his tongue in a grimace, about which Garnier comments (137): "Sign of bad feelings, of impiety, of idolatry, of satanism, the stuck-out tongue, rather rarely represented, has a clear and precise meaning."

15—The punishment of Gengoult's wife (B 14) (Plate III.20): *Vita,* chapter 13.

This scene, now at the top of the life of Christ in the neighboring lancet, has been misidentified as, of all things, the Pilgrims on the road to Emmaus![74] Gengoult's wife stands in the center of the scene, a figure to the left earnestly addressing her and one to the right slightly turned away. The text describes how, after miracles began to occur at Gengoult's tomb, a witness told her of them and upbraided her for her behavior. Her furious response was: "Sic operatur virtutes Gangulfus, quomodo anus meus" (roughly: "Gengoult works as many miracles as my ass!"). No sooner said than done—and for the rest of her life, whenever she spoke, she was afflicted with what modern hagiographers refer to as the "shameful inconvenience" or "disgusting infirmity." The artist has clearly represented the story: the witness actively gestures in speech at the left (Garnier, 211), while the figure to the right turns his head as a sign of aversion, one arm hanging down as an indication of embarrassment (151, 214). Clearest of all is the central figure of the adulterous wife. The glazier has dressed her in red in order to show her boiled (red) hand held to her chest, its color her stigma of guilt and its gesture manifesting "the profoundly felt character of a comportment" (Garnier, 184). Even more clearly, her other hand makes the directional gesture, pointing to the *ano sonante.*

Even in the Middle Ages, the story was considered embarrassing or obscene. The Abbess Hrosvitha, whose late tenth-century poem on the life of Gengoult is coeval with the *vita,* concludes her version of the incident with the words: "For from her came forth sounds so disgusting that our tongue abhors to mention them."[75] Several twelfth-century manuscripts of the *vita* contain indications or marginal notes that the chapter should not be

read.[76] Thus it is inappropriate for us to take a virtuous stance about those crude ways of medieval times now being so funny or shocking, for clearly such legends were under censure by educated people even as the legend was being recorded and the stained glass was being designed.

All the more astonishing is the proposed explanation that none other than the provost himself, Robert d'Aix—head of Saint-Gengoult and second to the bishop among the officers of the cathedral—may have been as closely involved in the design of Gengoult scenes as in those of the Holy Face above them.[77] A sense of the sociological climate emerges that is altogether compatible with Toul's situation, provincial and isolated even for medieval Lorraine. While the *collégiale*'s gaily colored axial bay, with its touches of bawdy, is hardly a profound theological statement, no doubt it satisfied the church's bourgeois patrons extremely well. Its life of Christ aped the prestigious window in the cathedral, doing the bishop one better as it were. Its Veronicas were good for indulgences, and there were several of them just as in Rome itself. And the detailed narration of the legend of the patron Saint Gengoult, dwelling on fools outwitted, marital infidelity, and scatological punishments, must even in the thirteenth century—or especially then?—have evoked a guffaw.

The Ex-Voto Window

A final contribution by the Gengoult Master to the decoration of the *collégiale* is Bay 7 (see Fig. 5), a doublet-and-rose window occupying the same location in the north choir chapel as his life of Christ in the south chapel, Bay 8 (discussed in chapter II). The glass presents the lives of an unlikely trio of saints: Nicholas, Agatha, and Agapit. The scenes of Saint Nicholas in the tracery rosace have been generally identified since 1853.[78] Abbé Jacques Choux, in 1970, first published the identification of the cycle in the right lancet as Saint Agatha of Catania, and in 1988 I identified the saint in the left lancet as Saint Agapit of Praeneste (Palestrina) and proposed that the window was an ex-voto donation by the two lay youths who appear in the rosace.[79]

Gothic medallion windows normally conjoin saints' lives only when they have something in common. At Saint-Gengoult, where Bay 8 repeats the axial bay's cycle of Christ, one might guess that Bay 7 would extend the axial bay's life of the patron Saint Gengoult, providing scenes of three other saints whose relics were venerated in the church. But such was not the case. While the popularity of Saint Nicholas in Gothic France was enormous, the selection of three saints normally associated with sites in southern Italy—Bari, Catania in Sicily, and Palestrina below Rome—might suggest that the donor had been a crusader. This is not impossible. However, the choice of these three saints can be

demonstrated to follow a more precise logic: they would be the three saints invoked by a citizen of Toul who had been saved from a fire.

Saint Nicholas

Indeed, two *toulois* citizens were probably saved from fire, represented by two small standing, praying figures in the traceries, in the customary posture of donors, beneath Saint Nicholas's blessing hand (Plates III.21 and III.22). They are dressed in simple lay attire and have the short hair and beardless faces of young men of the period. Nicholas sits enthroned in bishop's vestments and crozier, within an elaborate medallion, a four-lobed square (*carré-quadrilobé*) occupying the large central oculus of the tracery rosace, the six surrounding lobes of which contain scenes of his life. Within the central medallion, small-scale architecture flanks the large, frontally placed saint. On his left (our right) is a structure recognizable as a church, with a nave, entrance portal, and tower, the latter two elements topped by crosses. On the saint's right the building is quite different: it has a large arched opening, framing the two donor figures, beneath a slender yellow tower, the roof of which is completely engulfed in red flames.[80]

One of the famous pilgrimage centers of Saint Nicholas was in the diocese of Toul in Lorraine: Saint-Nicholas-de-Port (Meurthe-et-Moselle), just east of Toul on the route to Strasbourg (Fig. 6). The existing pilgrimage church there, begun in 1481–95, is a handsome flamboyant Gothic structure, "the bulk of which dominates the plain of the Meurthe, an eastern Chartres visible all the way from Nancy to Lunéville."[81] Contributing to its reconstruction was the duke of Lorraine, René II, who—following mass at the church on 5 January 1477—defeated the Burgundians in the Battle of Nancy, in which Charles the Bold died. From that time Saint Nicholas has been honored as the patron saint of Lorraine.[82] His cult in Lorraine is a great deal older. The first church built at Saint-Nicholas-de-Port specifically to accommodate pilgrims was consecrated on 10 October 1101,[83] and a second was constructed adjoining it in 1193. Around 1255 the chronicler Richer, monk of Senones (Vosges), described the thriving cult;[84] a charter of Duke Ferri III mentioned the pilgrims of Saint-Nicholas-de-Port in 1268.[85]

While multitudes of prisoners left iron chains at the church, the most famous ex-voto was certainly a silver ship offered by Queen Marguerite following a violent storm at sea in 1254, when she, Saint Louis, and their company were sailing home from Saint-Jean d'Acre in the Holy Land. Present was the king's chronicler Joinville, who himself vowed to make a pilgrimage to Saint-Nicholas-de-Port and who suggested the queen's pledge to that saint. He describes the object that she had made on her return to Paris, which he delivered, and which probably hung in the church until the sacking by the Huguenots in 1635:

In it were figures of herself, the king, and their three children, all in silver. The same metal was used for the sailors, the mast, the rudder, and the rigging of the ship, while all the sails were sewn with silver thread.[86]

Emile Mâle noted that "people turned to St. Nicholas when in gravest peril."[87] Travelers' perils at sea and on the road, unjust imprisonment and unforeseeable catastrophes, such as house fires,[88] were among the "unmerited dangers" for which Saint Nicholas in Lorraine was particularly efficacious.

The six scenes from the life of Saint Nicholas, filling the lobes of the rosace of Bay 7 of Saint-Gengoult, are absolutely typical of Gothic iconography, though several of them have been misidentified.[89] They begin at the bottom lobe and progress clockwise (Plate III.22):

a. The Fasting Child Saint Nicholas
b. Saint Nicholas dowering the three daughters of the poor man
c. Saint Nicholas selected to be the next bishop
d. Saint Nicholas saving the sailors in a storm at sea
e. Saint Nicholas resuscitating the three boys pickled in the tub
f. Saint Nicholas laid in his tomb

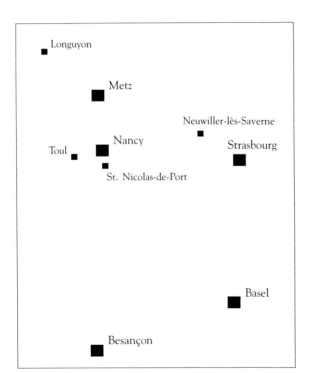

Fig. 6. Location of sites relevant to the ex-voto window of Saint-Gengoult (Bay 7)

All but the pickled boys are found in the *Golden Legend* of Voragine, and earlier in the liturgy and in the late tenth-century Greek *vita* by Symeon Metaphrastes.[90] The scene of the pickled boys, of late twelfth-century origin, was probably the most common episode represented in Gothic cycles.[91] Also, though Voragine relates the story of the dowering of the three daughters as occurring before Nicholas's selection as bishop, it was not uncommon in Gothic art to represent him already vested as a bishop in the dowering scene, as at Saint-Gengoult. A contemporary example occurs in the northwest ambulatory chapel of Sées Cathedral (Orne).[92] The Fasting Child Saint Nicholas was a more popular Gothic theme than has generally been believed; it occurs in stained glass at Chartres, Rouen, and Tours, as well as in several twelfth-century sculptures from northeastern France (Saint-Gengoult in Metz; Notre-Dame-en-Vaux cloister, Châlons-sur-Marne).[93]

At Toul, only the scene of the death of the saint is somewhat unusual, since it copies the format used in the Auxerre window for the scene of the death of the bishop whom Saint Nicholas was selected to replace.[94] More typical is the scene on the Chartres south porch (right tympanum), showing the saint's balm-oozing tomb at Bari with pilgrims huddled beneath it in expectation of a cure. It is understandable that such an explicit reference to a rival pilgrimage site would have been avoided in the diocese of Toul.

Gothic medallion-windows of the life of Saint Nicholas are part of nearly all ensembles of thirteenth-century stained glass, and some churches devote several bays to him. A number of authors have commented on his popularity in glass.[95] The window at Saint-Gengoult is unusual only in that, unlike the windows of Chartres, Bourges, Tours, Auxerre, and so on, it includes, in addition to an image of the praying donors, a visualization of their particular catastrophe. The Saint-Gengoult window is, in other words, an ex-voto, a votive offering given in fulfillment of a vow or pledge. This hypothesis will be pursued below.

Saint Agatha

Beneath the traceries of Saint Nicholas and the donors in their burning building are two lancets, that on the right correctly identified in recent literature as the life of Saint Agatha (Plate III.24). Each lancet contains five medallion scenes, the topmost one slightly truncated by the light's pointed top. The bottom medallion in each lancet is a late nineteenth-century panel, probably the work of Leprévost between 1874 and 1884;[96] a studio photograph (Plate III.23) taken by him showing the window dismounted from the church includes the two new scenes.[97] Parts of the window's foliate border, which I have identified in a composite panel now on exhibition in the Musée lorrain in Nancy (Plate I.3),[98] were probably removed by Leprévost and remained in Paris in Lucien Magne's various displays of medieval glass until at least 1915, when his installation at the Trocadéro was removed during World War I.[99]

Although a description of Saint-Gengoult from 1859 reports five medallions in each lancet, the lower row "rather damaged,"[100] the meaningless iconography of Leprévost's two scenes (Plate III, 23 lower row) cannot have been based on lost originals. Moreover, the late eighteenth-century marble ornamentation in the chapel blinds an area at the bottom of the window that could have held one or even two additional rows of scenes (Plate III.1). Thus the cycle of each lancet's saint's life was originally more extensive.

The four original scenes of the right lancet are enough to provide a definitive identification of the life of Saint Agatha, though now they are out of order. They are now installed from the bottom of the lancet up (Plate III.24):

a. The healing of Agatha's torn breasts by Saint Peter
b. Saint Agatha at her moment of death kneeling in prayer; an angel above; two praying witnesses behind[101]
c. Agatha tortured over burning coals by two executioners
d. Lancet head: Two angels carrying Agatha's soul to heaven

The correct order would be a, c, b, d. The missing lower rows at the beginning of the cycle would no doubt have included the removal of her breasts by torturers, the most common scene of her legend, possibly a scene of interrogation by Quintianus, the consul of Sicily who was her frustrated admirer, and/or Agatha's trial in the brothel. All are reported in the *Golden Legend* and appear in the sporadic cycles of her life in Gothic art, for example, the extensive medallion-window at Clermont-Ferrand.[102]

Why should Agatha appear in the north chapel window of Saint-Gengoult? Although not among the most popular saints of Gothic France, her cult, which had reached Rome very early, was widespread in Europe. The folklorist Van Gennep has puzzled over its uneven, spotty distribution; there was, for instance, no particular interest in Agatha either to the north or south of Lorraine, in Belgium or in Burgundy.[103] However, like Nicholas, Agatha had a cult site not far in Lorraine, north of Toul, in Longuyon (see Fig. 6). Founded by the early seventh century, Sainte-Agathe de Longuyon (Meurthe-et-Moselle) was, by the Gothic era, a collegiate church newly rebuilt and consecrated in 1287.[104] It was thus contemporary with the Saint-Gengoult glass.

Longuyon, however, was never more than a minor regional cult center. More pertinent to the discussion of the ex-voto window in Toul is the conclusion of Van Gennep's study of folk custom:

> The fundamental power of Saint Agatha involves preservation from fire; it certainly dates from the high middle ages. . . .
>
> [All folk customs], at first glance unrelated, seem to be grouped around the central idea that Saint Agatha guards and protects against all that *burns*, such as lightning, manmade conflagrations, the internal burning of colic, inflammation

of wounds and sores, the "feu des plantes" caused by hail and frost that "burns" them, and, without a play on words, the flames of desire which afflict the young. . . . I prefer this explanation, at least for central and western Europe, . . . to that proposed by Thilenius, relating Saint Agatha to Good Fortune of classical antiquity, *Agathè Tychè*.[105]

Among the most widespread and ancient of folkloric customs was the blessing of breads on 5 February, Saint Agatha's feast, to be conserved as a preservative from, or means of extinguishing, fires.[106] Whether through the agency of a *pain de Sainte Agathe* or by more direct invocation, the saint's protection clearly must have saved the two donors of Saint-Gengoult from a fiery death, and their window expresses their gratitude to her, to Saint Nicholas of Lorraine—and to Saint Agapit.

Saint Agapit

The trio of saints in Saint-Gengoult Bay 7 presents a confessor saint (Nicholas), a virgin martyr (Agatha), and, in the left lancet (Plate III.25), a male martyr saint. Study of the church's early history suggests his identity, which is confirmed by the images in the medallions: he is Saint Agapit of Praeneste (Palestrina).

Saint-Gengoult possessed a relic of Saint Agapit probably as early as 1065. A *chart* of that year of Udon, bishop of Toul, dates his reestablishment of Saint-Gengoult following its ruin in the tenth century; and the cartulary of Saint-Gengoult written about 1330 and known as the *Livre du soleil* records that Udon established the offices of Saint Benedict, Saint Vitus, and Saint Agapit of nine lessons, on their feasts, at their altars.[107] While none of these altars can be traced in the present, thirteenth-century church, it is my (unsupported) guess that the altar of Saint Agapit may have occupied the north chapel when the ex-voto window was installed, that is, from the construction of the Gothic choir until the dedication of the chapel to Saint Nicholas in 1315/16.[108]

Saint Agapit does not appear in the *Golden Legend*. The cult of Agapit, like that of Agatha, had reached Rome very early and was, in Gothic Europe, far-reaching, though much less common. The cult site closest to Toul was the cathedral of Besançon in the Franche-Comté (see Fig. 6), where his veneration had been established before the eighth century and where his head was translated to a new building, altar, and ivory reliquary in the mid-eleventh century.[109] If Bishop Udon of Toul, whose diocese adjoined Besançon, was present at the ceremony, he may have taken home for his 1065 refoundation of Saint-Gengoult the relic that is later recorded in their possession.

The life of Saint Agapit in the left lancet, like the Agatha lancet on the right, now consists of five medallions, the top one truncated by the arched lancet head and the bottom one a nineteenth-century design (Plate III.23 right). The four original scenes, now out of order like those of Agatha, are, from bottom up (Plate III.25):

a. The governor Antiochus suffering a seizure and dying from disappointment upon seeing Agapit unharmed by his tortures
b. Agapit hung upside down over flames
c. Agapit, thrown in the arena, causing two lions to lie peacefully at his feet
d. Lancet head: The beheading of Agapit, at age fifteen

The correct order is b, a, c, d. As in the Agatha lancet, the missing medallions at the bottom would have depicted the beginning of the story and may have included Agapit beaten, boiling water thrown on his stomach, or his teeth pulled and jaw broken.[110]

While narrative depictions of Agapit's life in medieval art are almost unknown,[111] several isolated scenes are included in two twelfth-century Swabian manuscripts from Zwiefalten south of Stuttgart. His beheading and his torture upside down over flames occur in the Hirsau Passional (Plates III.26a,b) (Stuttgart, Württembergische Landesbibl., Bibl. Fol. 56, fol. 63v); and Agapit with neck wounds and again the torture upside down over flames illustrate a text of the Usuard martyrology (Plate III.26c) (Stuttgart, Württembergische Landesbibl., Hist. Fol. 415, fol. 56v).[112] The Gothic glazier of Toul may have had to adapt a standard pattern for the beheading—though it is extremely close to the Stuttgart Passional—and for his two medallions in which a stiff, upright Agapit on one side of the composition awkwardly balances an antagonist on the other. But the image of the saint upside down over flames is so unusual and so close to the Swabian miniatures that it seems altogether likely that such a Romanesque image existed in Toul and that the artist was able to copy it.

The choice of Agapit as the third saint in the ex-voto window is thus at once more simple and more difficult of explanation than the choices of Nicholas and Agatha, both saints likely to be invoked by a *lorrain* caught in a life-threatening conflagration. Saint-Gengoult possessed Agapit's relic. But in the meager folklore of Agapit's cult he was invoked not for fires but for teething children, and for stomachache and colic.[113] The vivid and unusual image of Agapit hanging head down in flames must have leapt to mind at the donors' moment of danger.[114] Had they seen it in a conspicuous ornament of Agapit's altar in Saint-Gengoult, and did they pledge the saint, if they were saved, a new ornament for his chapel? What form would such a (probably) Romanesque image have had? Since the two donor figures in the window are depicted as laymen (Plate III.22), who would not have had any familiarity with or ready access to religious office books such as those now in the Stuttgart Landesbibliothek, a further hypothesis is required.

The possible medium of such a lost image of Saint Agapit gives pause. It must have been easily visible to lay parishioners, and memorable in nature. A fresco of about 1065 would have disappeared when the Gothic Saint-Gengoult replaced the eleventh-century church of Bishop Udon, about which nothing is known. Toul, in the eleventh and twelfth centuries, was under the Holy Roman Empire, and thus it is to the East that comparisons must be sought. Panel painting was not, as far as we know, a common

Ottonian or early Romanesque medium in the Empire. The Hirsau Passional of about 1120–40, which contains the images of Saint Agapit cited above (Plates III.26a,b), is frequently invoked in discussions of the dating and style of the prophets windows in the nave of Augsburg Cathedral (Plate III.28).[115] Fragments of similar windows depicting iconic images of saints are not uncommon in the areas adjoining the Rhine, in the Romanesque style of the twelfth century and beyond. A cluster of them is identifiable east of Toul in Alsace: the Wissembourg head, presumably a saint; the lancet of Saint Timotheus from the abbey of Saint-Pierre-et-Saint-Paul in Neuwiller-lès-Saverne (Fig. 6); Saint John Evangelist and Saint John Baptist now reset in the north facade of Strasbourg Cathedral; the window of Sainte Attale (Plate III.27) (destroyed by hail in 1719) of the nunnery church Saint-Etienne in Strasbourg.[116] While the rigid, frontal saint often presents a palm or scroll, some attempt at identification, predating the Gothic development of attributes, does occur in such Romanesque iconic images: Jonah at Augsburg emerges from his whale (Plate III.28); the Magdalene of Weitensfeld in Carinthia carries a censer and an ointment jar; the "Charlemagne" bay from Strasbourg Cathedral depicts the emperor between two courtiers; a pair of fragments of the thirteenth century that maintain the type presents Saint Paul with a sword and Saint Peter hanging upside down on his cross before a uniformly patterned background (Plate III.29).[117]

The only twelfth-century glass still in existence in Lorraine, at Sainte-Ségolène in Metz,[118] so closely resembles this Rhineland group that it is not unreasonable to hypothesize such a Germanic, Romanesque glazing for the eleventh-century church of Saint-Gengoult, which was replaced by the present Gothic structure. And it is not difficult to imagine a Romanesque window saved from the earlier church and reset into a window of the Gothic building—as happened, for example, at Sainte-Ségolène and also notably at Strasbourg Cathedral.[119] I suggest that it was an image somewhat resembling the crucified Saint Peter (Plate III.29) and that it depicted Saint Agapit upside down over flames. While such a hypothesis is unprovable, it would explain why Saint Agapit came to mind as the donors faced a fiery death—and it would explain their choice of medium for the Gothic ex-voto. For as Toul in the twelfth century turned to the Empire, Toul in the thirteenth century—again like Strasbourg—increasingly took its cue from Gothic France.[120] The donors at Saint-Gengoult probably replaced a small, old-fashioned, Romanesque, Germanic glass panel, made for a previous building, with a new, elaborate, up-to-the-minute Gothic medallion-window of the latest French fashion.

The three saints in the Toul window—Nicholas, Agatha, and Agapit—would be an inexplicable group except as a votive offering. Saint-Gengoult only possessed relics of Agapit, the least well known of the trio. Nicholas and Agatha were honored at cult centers nearby, that of Nicholas the closest and already famous by the 1280s, while Agatha's was rebuilt in that decade. Nicholas was the great protector of the young and universally invoked by those in great and unforeseen peril, Agatha was a specialist in fires, and Agapit—who had himself hung upside down over flames—was martyred at age

fifteen. Are they not the logical protectors of the youthful donors shown in the flaming building in the window's traceries?

Ex-voto art, "intended as thank offerings for rescue from a particular danger, or as requests for the fulfillment of some need," has been studied in ancient civilizations, as have the examples of popular folk arts that appear in Christian Europe from the late fifteenth century up to the present.[121] Braunfels has stated that Christian ex-votos predating the fifteenth century were normally commissions and, thus, fine art rather than folk art. They have not been studied as a group or type, and indeed such a study would be difficult, since each ex-voto springs from a highly particularized event. But whether destroyed or simply unrecognized, no other ex-votos are known in medieval stained glass. The Saint-Gengoult window with its youthful donors and its strange combination of saints is a rare survival of what must not, after all, have been so uncommon in Gothic parish life—an offering of thanks from the faithful for prayers answered in distress.

The Gengoult Master on His Own

The ex-voto window has been no more securely dated in the past than any of the other glazing at Saint-Gengoult. A fleur-de-lys lurking in its traceries, as in Bay 8, allows a general dating after 1269 (death of Bishop Gilles de Sorcy) until 1285, when Bishop Conrad Probus was finally able to enter and control the commune.[122] A more precise date would be of the greatest interest, since in this bay the Gengoult Master, free at last from the long shadow of Toul Cathedral, employs a number of forms uncommon and not easily traceable to a precise source. His medallions (Plates III.24 and III.25) have foliate grounds and their frames sprout out in foliage that fills the surrounds; they are a *carré-quadrilobé* shape (combination of square and quatrefoil) but of an unusual, even peculiar type; and the great rosace of Saint Nicholas in the traceries (Plate III.22) has multiple frames embellished with stick-lighting, of a type found first in Alsace and always associated with Germany. An analysis of these forms will follow, with the goal of isolating the most probable explanation for their appearance together here.

It is generally believed that foliate, *damasquiné* grounds occur in France and England up to around 1200,[123] but appear with some regularity throughout the thirteenth century only in German glass, for example, at the Elisabethkirche, Marburg (c. 1240), at Bücken (c. 1240–50),[124] and at Erfurt. Examples there are the Saint Francis cycle in the Franciscan church (c. 1230) and the lost Annunciation and Crucifixion from the Dominican church (c. 1275–80).[125] Such grounds have a foliate pattern scratched from a matte painted on the glass, a technique called stick-lighting. In Troyes in southern Champagne, beautiful *damasquiné* grounds were part of the decorative vocabulary of the famous *membra disjecta* found in the cathedral and dated about 1170–80. A few fragments of the early

thirteenth century survive in Lorraine, the Saint Paul glass in Metz Cathedral (Plate VI.1).[126] Roughly coeval with Saint-Gengoult's Bay 7, *damasquins* reappear in Troyes, in medallions of the life of Christ at Saint-Urbain (c. 1270–80), noteworthy because they decorate not only grounds of blue but also of red and green.[127]

The so-called living border, that is, a medallion frame that sprouts the foliage which fills the surround, was used at Canterbury and in French art about 1225 at Saint-Germain-lès-Corbeil (Essonne)[128] and had become a commonplace in German typological windows by 1300. More significant, perhaps, is its use in the second quarter of the century in Burgundy, at Auxerre and Notre-Dame, Dijon.[129] It should also be noted that the wide outer border of Saint-Gengoult Bay 7 (Plate III.23), a fairly general French type, had also appeared at Auxerre.[130]

The *carré-quadrilobé* frame, like the *damasquiné* ground, had appeared early in French Gothic glass, in the Prodigal Son window of Sens Cathedral (c. 1210–20).[131] However, that early example as well as the numerous French designs that reappear about 1270— Gassicourt, Fécamp, Dol Cathedral, and Saint-Urbain in Troyes—all place the form with the square canted as a lozenge and the quatrefoil "sitting on its buttocks."[132] The *carré-quadrilobé* medallions at Saint-Gengoult are different (Plates III.24 and III.25); they are turned so that the square sits solidly on one side and the quatrefoil lobes extend horizontally and vertically. While among the vast assortment of tortured shapes created to frame German Gothic medallions it is possible to locate at least a few comparisons, such as Marburg (c. 1240) and the Augustinian church at Erfurt (c. 1300);[133] the closest example to Saint-Gengoult is again in Burgundy, at Saint-Julien-du-Sault (c. 1245–50).[134]

The Saint-Gengoult window simply does not look German, and while its various features—*damasquiné* ground, living borders, square-oriented *carré-quadrilobé* medallions— all have a notable development in German Gothic, the closest German examples are later. The presence of these design elements at Burgundian sites and nearby at Troyes, preceding or contemporary with their use at Saint-Gengoult, suggests that the Gengoult Master may have added them to his patternbook while in Burgundy.

The elaborate multiple frames with handsome stick-lit ornament filling the interstices, in the tracery glass of Saint-Gengoult Bay 7 (Plate III.22), are, however, unquestionably related to thirteenth-century glazing practice in the Rhineland. While Strasbourg could be mentioned, the closest comparison is the typological window from the Dominican church of Cologne (c. 1280), now in the Stephanuskapelle of the cathedral.[135] While the production of the doublet-and-rose Bay 7 is "of a piece" and unquestionably the work of a single glazier, the different stylistic orientation of the ornament, in the lancets below and traceries above, is hard to explain. The Gengoult Master was a copier—of the Ménillot Master's draperies, of the Infancy Master's round medallions, and over and over, of the choir glazing of Toul Cathedral. On the evidence of Bay 7 it is hard to imagine that he had not traveled to the Rhineland as well as to Burgundy. The only viable alternative, as a hypothesis, is that the patterns had come to him, as it were—put another way, that

glaziers from both East and West had once endowed Lorraine with Gothic stained glass that man and nature have now totally obliterated.

While the figural compositions of Bay 7 follow the strong central focus that served the Gengoult Master so well in his life of Saint Gengoult, the color harmony has changed. The window glows in a rich harmony of red and green, the latter a handsome medium emerald far deeper than the clear light green he had introduced into the Infancy Master's axial bay and had then increased in amount in the color gamut of Bay 8. Here again the closest reference is the Dominican church in Cologne.[136]

But Saint-Gengoult Bay 7 is by no means just a German creation *manqué*. The Germanic triangular-backed throne in the Fasting Child lobe (Plate III.22 bottom) had already appeared in Lorraine at Metz (Plate VI.3a).[137] The attractive wide borders, the straightforward repeated medallion shapes piled up one over the other, the clarity and legibility of the cleanly differentiated elements of the design (borders, medallions, surrounds), and the stories of direct and popular appeal have no close antecedents in either Germany or Burgundy. Nothing resembles Saint-Gengoult Bay 7 but another glazing in Lorraine, the fragments of the 1280s in the collegiate church of Saint-Dié (see chapter IV), like Saint-Gengoult one of the architectural clones of Toul Cathedral. While the necessary proofs of the assertion have been destroyed, what we have in these precious survivors is probably best identified as the regional style of Gothic stained glass in Lorraine.

IV

SAINT-DIÉ (VOSGES): PATRONAGE AND ANTI-SEMITISM

Pour les Juifs, Louis IX n'est pas Saint Louis.
—Blumenkranz

SAINT-DIÉ (Vosges) in Lorraine is best known to historians as the source of the humanist publication first proposing the name America for Amerigo Vespucci's new land.[1] By then the religious community of Saint-Dié had been in existence for more than eight centuries, and its fine ensemble of medieval architecture remains today, heavily but handsomely restored after the town was dynamited to rubble in 1944 by the departing German army (Plate IV, 1).[2] More recently, Saint-Dié has become familiar to architectural historians for the aborted urban plan of Le Corbusier, who would have bedecked the village with skyscrapers.[3]

Among the precious debris of stained glass to survive the turbulent history of northeastern France is a small group of Gothic glass panels at Saint-Dié. Included, besides an enigmatic fragment of architectural canopy, are eight medallions and their three surrounding ground patterns, and three border designs including heraldic motifs (Plates IV.3 and IV.4). These survivors are of the highest interest for their typical *lorrain* formal characteristics, for their high quality, for their evidence of aristocratic patronage, for their stylistic links both to Alsace and the Ile-de-France, and for their unique iconography. Based on a chronicle written about 1255, they offer the only known medieval cycle of the life of Saint Dié (Deodatus) and include scenes of current anti-Semitic incidents in the town of Saint-Dié. The latter medallions—like the famous window of the Sainte-Chapelle in Paris showing Louis IX bringing the Crown of Thorns to France[4]—depict that rarest of subjects in thirteenth-century glass: a contemporary event.

Another *Toulois* Chevet

Saint-Dié, founded in the seventh century as an abbey under the Rule of Saint Columbanus, had become by the medieval period a powerful college of thirty canons

under a *grand prévot* (provost) owing allegiance directly to the Holy See. Its church had been rebuilt after the millennium by Béatrix, widow of the duke of Lorraine and sister of Hugues Capet, and one of its provosts had risen to the papacy and sainthood as Saint Leo IX (1048–54). Following a fire, probably in 1155, was built the Romanesque complex that remains today: the Romanesque nave of Saint-Dié and the smaller church of Notre-Dame lying to the north. The two are now joined by a handsome *flamboyant* cloister, and an unpleasant Baroque facade of 1711 has replaced the west nave wall of Saint-Dié.[5]

The Gothic chevet and transepts (Plate IV.2), original home of the stained-glass panels that are the subject of this study, have been dated within the second half of the thirteenth century on the basis of style and by inferences drawn from a series of *charts* dating consecrations of altars and papal indulgences.[6] These can be interpreted against the historical background of the thirteenth century in Saint-Dié, a period of constant strife between the canons and their provosts, between the chapter and the dukes of Lorraine based in Nancy—who appointed the provosts, often from among their immediate family—and, in larger terms, between the Empire and the Capetian kings of France.

In the thirteenth century the canons of Saint-Dié were not known for their spirituality. One of their disputes with the duke concerned who had authority over their numerous bastards born on chapter land.[7] In 1252, in an apparent attempt to reform their lax lifestyle, the Dominican cardinal Hugues de Saint-Cher, as papal legate, arrived and issued a reforming Rule for the chapter; a week later the cardinal accorded indulgences to visitors to Saint-Dié on certain feasts.[8] Since previously absence of most of the canons from daily office had been common, Grandidier is no doubt correct in assuming that only following the cardinal's edicts would there have been any need to enlarge and update the sanctuary structure.

By 1274 the cardinal's actions were bearing fruit. In that year a series of thirty-two Marian miracles were recorded at Saint-Dié.[9] In 1283 the bishop of Toul consecrated several altars, locations unidentified.[10] Finally in 1288 a bull of Nicholas IV specifically mentions lavish construction under way and the chapter's need for funds, authorizing a collection in the dioceses of Toul, Metz, and Basel:

> Nobis exposuit ecclesiam ipsam, cui longinqua vetustate ruine paratam reedificare ceperint, opere plurimum sumptuoso, nec ad consumationem ipsius operis ejusdem ecclesiae proprie suppetant facultates. . . .[11] (Rieti, 8 October 1288)

> (It was explained to us that they began to rebuild the church, ready to collapse from great age, by extremely sumptuous work and that their own resources did not suffice to complete that work.)

The same pope followed this bull the succeeding year with an accord of indulgences to visitors to Saint-Dié (5 December 1289).[12] A new silver reliquary for the patron saint's

remains—dated by tradition "au temps du Pape Nicolas 3,"[13] whose name was mistakenly related to the bulls of 1288 and 1289—probably marked the completion of the Gothic building campaign, when funds would have been freed for such a treasured object. Nicholas IV reigned to 1292.

Such papal indulgences have usually been interpreted by art historians as a *terminus post quem*.[14] An almost parallel case occurred at La Trinité in Vendôme, where the papal bull of 1308, mentioning lavish work in progress, was so taken. Recent work on La Trinité proves conclusively, with heraldry, archival documentation and the like, that the choir glass was under way in 1280 and was completed before 1290, when the donor, the princess Jeanne de Châtillon, turned her attention and resources to other projects.[15] Like the Vendôme bull, the Saint-Dié bulls are probably close to *termini ante quem* as far as the glass is concerned. This hypothesis will be investigated below, and we shall see that it is possible to pinpoint the dating of the Gothic construction and glazing much more precisely within the established chronology outlined above.

In the thirteenth century the town of Saint-Dié was divided into two sections controlled by the chapter and by the administrator of the duke of Lorraine. In 1196 Emperor Henry VI, passing through on his way to crusade, had renewed the protection and privileges granted the chapter by previous emperors and had established his cousin, Duke Simon II of Lorraine, as his deputy (*avoué*). The incident was depicted in a fourteenth-century fresco located on the wall of the chevet: Henry VI, shown twice, gives Duke Simon the glove symbolic of his charge while receiving his oath before the chapter's provost, Mathieu, Simon's nephew (left); and (on the right) the enthroned emperor gives the symbolic golden ring to Saint Dié himself.[16] In reality, however, the chapter and the duke's successors sparred unceasingly throughout the thirteenth century and beyond in an uneasy coexistence marked by tension, distrust, and strife.

In the half century of interest to this study, the long-lived Duke Ferri III was excommunicated three times for onerous or rapacious imposts against Saint-Dié: in 1254, while still a minor under his mother's regency; in 1268; and again in 1291–92.[17] As early as 1255 the duke's pet project was the construction of fortified walls and moats around the town, to be financed chiefly by a heavy tariff on wine transport, and a year before the excommunication of 1268 he had even signed an accord with the chapter agreeing to three years of this tax for this purpose.[18] Following his 1268 excommunication, his tactics shifted to a policy of donations and appeasement. In 1272 he promised to defend the chapter against its unpopular provost,[19] and in 1277, after the latter's death, he achieved the election as provost of his own son Ferri, though still a minor and not in sacred orders.[20] A new era of greater cooperation dawned, to last a decade or more. In 1281, for example, the chapter under Provost Ferri agreed with the duke, Ferri's father, to the objectionable wine tax for two more years in order to complete construction of the walls.[21]

The implications are several. The presence in Saint-Dié of masons in the duke's employ, before and after 1280, as well as the presence of his young son in pseudo-

authority over the chapter, strongly suggests that the new *toulois* chevet of Saint-Dié was in construction at the same time, that is, from after Provost Ferri's arrival in 1277 to after the papal indulgences of 1289. This hypothesis is corroborated by the pope's mention of construction well under way in 1288, by the silver *chasse* of that era, and, as we shall see below, by heraldry in the stained-glass fragments. The duke's last excommunication, in 1291/92, would also seem to indicate that the honeymoon was then over.

Recent architectural studies in the regional Gothic architecture of Lorraine concur in such a dating. Architectural historians now recognize the cathedral of Toul as the key monument of the region and group under its influence a large number of monuments both local and at some distance in Germany.[22] Both the plan and elevation of these *toulois* churches are distinctive. The apse, which has no ambulatory, often precedes a choir bay with aisles that serve as the opened lower floor of flanking towers (see Figs. 2 and 5). This refinement is absent in the reduction of the *toulois* design at Saint-Dié, where the flanking structures—possibly added—are not towers but low, walled-off rooms unconnected with the main space (see Fig. 7). While the *toulois* plan represents a gothicization of the Ottonian type of Sankt Maximinus at Trier, the *toulois* elevation borrows in a most inventive manner from Reims. The apse resembles a colossal version of one of the Reims radiating chapels, marked by an interior *rémois* passageway in front of tall doublet-and-rose lancets of equally obvious *rémois* parentage. The unaisled transept is tall and projecting with interior passage, and its facades each contain a single broad, traceried bay of numerous lancets. The Saint-Dié east end (Plate IV.2) is a minuscule version of this distinctive *toulois* architecture, adapted rather successfully to the heavier forms and to the scale of the existing Romanesque nave, which apparently was never intended to be replaced.

Comparable to Saint-Dié in the *toulois* family are (1) the choir of Saint-Maurice d'Epinal (see Fig. 8), for which a 1265 call for funds may be invoked; and (2) Saint-Gengoult in Toul, where the choir reflects local forms of the 1260s and the transept, built next, does not (yet) reflect the sophistication of the Strasbourg facade chantier (1277f.). Villes[23] would prefer a scenario in which the chevet construction of nearby Saint-Maurice at Epinal would have provided the stimulus—and perhaps masons—for the Gothic work at Saint-Dié, at which site the last of the construction undertaken (the transepts) would reflect tracery forms previously used in the Saint-Gengoult transept. Thus a campaign at Saint-Dié beginning with the choir well after 1277, and finishing with the transepts by 1290, fits all recent architectural analyses of regional monuments. The stained glass of Saint-Dié is also, without much doubt, a product of the 1280s, indeed from after 1285 to perhaps 1289.

Vicissitudes of the Stained Glass

The surviving stained glass of Saint-Dié[24] represents a small fraction of the original ensemble. The eight remaining medallions represent two series: (a) five octafoil medal-

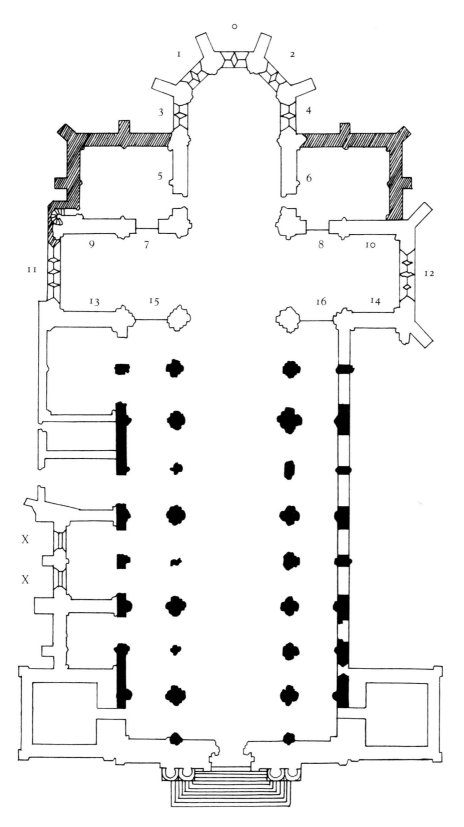

Fig. 7. Plan of Saint-Dié (Vosges). Bays marked X are present locations of the Gothic stained glass

lions from the life of Saint Dié (Plate IV. 3), the three earlier scenes of the narrative on a diaper ground of gold castles on red (*Castille*) and the two later scenes on the fleurs-de-lys of *France*; and (b) three medallions (Plate IV.4), two of which include a figure in a medieval Jew's pointed hat, each scene framed in a quatrefoiled circle surrounded by vigorous foliage. Remains of three borders, coeval with the medallion panels, can be similarly grouped: (a) two foliage borders with birds and coats of arms, one on a blue ground and the other on red; and (b) a border of large five-petaled heraldic roses. In addition, there remains one tantalizing fragment of an architectural canopy. All this debris has, since 1901, been grouped in a chapel off the north nave aisle[25] in a tasteful arrangement close enough to the viewer to allow full appreciation of these handsome and unusual designs (Fig. 7, bays marked X).

The original location of the glass is undocumented. By the mid-nineteenth century, when it was first mentioned, it was parceled out among the tracery quatrefoils surmounting the windows of the chevet and transepts, above lancets filled with stiff, dry, "gothick" grisailles of probable eighteenth-century design (Plate IV.5).[26] Baron Guilhermy, in 1852, counted ten such windows and listed among their contents several scenes still in existence, plus a now-lost Crucifixion and scraps of "bishops, monks, angels, other figures."[27] It seems likely that the severe damage to the church from a storm and fire in 1554 and

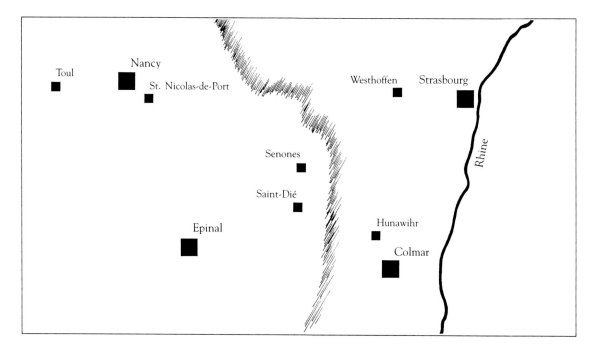

Fig. 8. Location of sites in Lorraine and Alsace relevant to Saint-Dié. The shaded line is the francophone border

from a fire caused by Swedish troops in 1636 had left little glass intact, and that parts of the remaining debris were installed in the traceries during the eighteenth century, probably when the chevet received its stucco facing in 1748 (visible in Plate IV.6).[28] A master glazier named Augustin, living in Saint-Dié in the 1750s,[29] may be hypothesized as the craftsman involved, both in the adaptation of the medieval glass to the tracery quatrefoils and in the fabrication of the "gothick" patterns for the lancets below.

A photograph of 1893 shows the axial bay (Plate IV.5); in the lancets are the "gothick" designs that have not survived two world wars, and in the center of the tracery quatrefoil above, the lost Crucifixion noted by Guilhermy. Surrounding the Crucifixion in the four lobes of the quatrefoil can be identified fragments of the heraldic rose border still in existence. Another nineteenth-century photograph (Plate IV.6) shows the northwest bay of the chevet with similarly patterned lancets, but the square center of the surmounting quatrefoil has been removed. The medieval panels were probably dismounted in 1893,[30] and they were arranged and installed in the tasteful compositions in the north nave in 1901, as an accompanying inscription (Plate IV.3, right) now informs us. Between those dates they were exhibited at the *Exposition universelle internationale* of 1900 in Paris.[31]

The eight medallion panels (Plate IV.7) have survived to the present in remarkably fine condition.[32] The pieces of border have suffered only slightly more. With this existing glass can be grouped, in addition to the lost Crucifixion in the 1893 photograph, a damaged quatrefoil and four smaller figural fragments (Plate IV.8) that were donated to the Musée municipal of Saint-Dié, published in 1936 and lost in 1944.[33] Thus Guilhermy's list of ten is at present accounted for, either in existence or by photographs. Measurements suggest their nineteenth-century locations. Each transept has four bays (Fig. 7 and Plate IV.2), shorter but wider than those of the apse; the eight existing medallion panels, each of which retains its surrounding ground, would fit the transept traceries but are too large for those of the apse.[34] The museum's lost fragments (Plate IV.8) probably occupied the five smaller apse traceries. The Crucifixion (Plate IV.5) once in the axial bay is the major loss in modern times, and perhaps it may turn up someday on the market.

But can the original medieval placement of the Saint-Dié glass be suggested? Basing a hypothesis on the assumption that the remaining medallion panels (46 cm wide) and their borders (16 cm each) were originally together, they would—with irons, leads, and flanking filets—more likely have filled lancets in the hemicycle (c. 100 cm wide) than the wider ones of the transepts (Plate IV.2). It seems reasonable that the cycle of the life of Saint Dié, from which five scenes survive, occupied one of the church's three axial hemicycle bays. They are doublet-and-rose windows; thus the scenes on *Castille* grounds were probably in one lancet and those on fleurs-de-lys in the other. A related program appears in Saint-Gengoult in Toul, the sole church in the *toulois* group to retain much of its medieval glazing ensemble, where one lancet of the axial bay depicts the life of Saint Gengoult (Plate III.1).[35] The remainder of the Saint-Gengoult choir was glazed in

grisaille. It is probable that the choir of Saint-Dié was likewise, since in the eighteenth century damaged grisailles, possibly turning brown and opaque, would more likely have been thrown out and replaced, while colored fragments were carefully preserved and reused.

The three Saint-Dié medallions showing medieval Jews, as well as the heraldic rose borders, probably occupied another hemicycle bay; their measurements, identical to the cycle of the life of the saint, suggest that all were made for locations of similar dimensions. Since the Saint-Gengoult hemicycle contains only three long bays in comparison with Saint-Dié's five (see Figs. 5 and 7), it would not be surprising if the latter's colored-glass program was somewhat more extensive. The iconography of the "Jewish medallions," as we shall see, logically extends the theme of the Saint Dié *vita* cycle. The former relate to the chapter and the income that helped finance the Gothic rebuilding—the recent history of the Saint-Dié abbey—just as the patron saint's window celebrates its founding.

The Medallions of the Life of Saint Dié

The historical Saint Dié (Deodatus) who founded the abbey in 669 and died in 679 was a bishop, possibly Irish.[36] He was first called bishop of Nevers, an unproven identification that has become general, in a narrative of mid-tenth-century composition, and almost no details of his life predate the *Vita Deodati*,[37] written a century later by an anonymous monk of Moyenmoutier (Vosges) near Saint-Dié. This work of "pious elegance and the charm of a romance" contains a statement that it was presented in 1049 to the pope, Saint Leo IX, and that he ordered a public reading; indeed, since Leo IX had served Saint-Dié as provost, he may have encouraged the composition of the *vita*. Its author's sources were, when documents or oral tradition failed him, three divine inspirations in dreams. "Thus," observed Pfister, "the life of Saint Dié is the work of a visionary."[38]

Around 1255 this romantic hagiography was recast again by Richer, monk of the abbey of Senones (Vosges) (see Fig. 8) near Saint-Dié.[39] Richer embroidered on the *Vita Deodati* by invention and by the absorption of additions from a twelfth-century text written at the abbey of Ebermunster.[40] He also rearranged Saint Dié's travel itinerary, from the bishop's retirement from Nevers to his founding of Saint-Dié, as follows: Nevers, Romont, Haguenau, Ebersheim (Ebermunster), Katzenthal (Wilra), Hunawihr, and finally the banks of the Meurthe where he builds the chapel of Saint-Martin, location of his hermit cell, and many churches, including the two at his monastery of Saint-Dié.[41] There he serves as abbot for eleven years until his death at an advanced age.

No other images of the saint's life exist from the Middle Ages with which to compare the Saint-Dié cycle of glass (Plates IV.3 and IV.7a–c and g–h). To identify the scenes,[42] I

have compared the stories with the dictionary of gestures published by the French se-
mioticist François Garnier; and to arrange the scenes in sequence, I have used the
itinerary of the monk Richer of Senones, since his text was demonstrably the source for
one of the matching "Jewish medallions," as we shall see below. The scenes of the life of
Saint Dié thus arranged divide into a group of the saint's early life and a late group. These
groups correspond with the medallions on castle grounds and on fleurs-de-lys.

I have suggested that they occupied one of the axial doublet lancets in the hemicycle,
the scenes with *Castille* grounds in one lancet and those on fleurs-de-lys in the other. And
they probably read bottom to top as at Saint-Gengoult. From the early group on castle
grounds the following three medallions remain.

Scene A: Miracle of the beam at Romont (Plate IV.9)

> Two carpenters in short tunics holding axes (right) inform Asclas, in a vair-lined
> robe (left), of the miracle.
>
> Gold castles on red ground; octafoil frame; scene on *damasquiné* blue ground.
>
> Asclas, one of two brothers inheriting Romont (Vosges, canton of Rambervillers),
> was building a house there. For three days the carpenters tried to raise the roof
> beam, which proved too short or warped. While they were resting Saint Dié
> passed by; learning of their difficulty, he set the girder in place and continued on
> his way. The carpenters informed Asclas, who pursued him and, in gratitude,
> donated his property to the holy man, arranging for usufruct during his lifetime for
> an annual payment to the saint of five silver pieces.

While the identification of the two carpenters with their axes is straightforward, the
exact moment in the story can be pinned down with the aid of Garnier's semiotic analyses
of medieval images.[43] Asclas's inclined head and his gesture, palms open and together,
indicate humility and a ready acceptance of what he hears. His gesture is normally related
to a superior listening to an inferior; his superior status, indicated by his three-quarter
pose and vair-lined robe, contrasts obviously with the inferior position of the carpenter,
shown by his short garment and profile head. Therefore the scene, without much doubt,
illustrates the moment when the carpenters informed their employer of the miracle rather
than other confrontations between them that have been suggested.

Pfister points out that, while Romont was never a property of the chapter of Saint-Dié,
the chronicler Richer (Bk. 1, chap. 4) notes that the canons received the five yearly
pieces of silver into the twelfth century.[44] The incident is a hagiographic invention to
explain that state of affairs.

Scene B: Hunus and Huna beg Saint Dié to remain with them at Hunawihr (Plate IV.10)

> Hunus in cap and vair-lined cloak, and Huna, head veiled, stand to the right, looking at the saint and gesturing; the saint in miter, crozier, and nimbus, eyes cast down, makes a gesture of refusal (left).

> Gold castles on red ground; octafoil frame; scene on *damasquiné* blue ground.

> Saint Dié took up residence at the mythical Wilra, between the villages of Ammerschwihr and Ingersheim (Haut-Rhin, canton of Kayserberg). Although the local people were suspicious of his intentions, the lord Hunus and his wife Huna befriended him and he baptized their son. Although they offered him asylum in their villa, Hunawihr, he preferred to leave the hostile area for a place of greater solitude.

Hunus's gesture with several fingers raised and hand partially closed implies "an idea or an intention that is proposed" and his other hand, open and downturned, indicates rejection and resignation. Saint Dié's inclined head no doubt shows sadness since the text declares that all wept.[45]

The author of the *Vita Deodati* probably invented the names Hunus and Huna after Hunawihr in Alsace, where the chapter of Saint-Dié held possessions, as it did at Ingersheim and Ammerschwihr (see Fig. 8). In the sixteenth century the mythical Huna was canonized. Her tomb and that of her husband were in the crypt of the church of Hunawihr until the Reformation.[46]

Scene C: Satan drives the people of Wilra to harass Saint Dié (Plate IV.11)

> Saint Dié with miter, crozier, and nimbus (left) is confronted by two gesturing men in hats (right). A demon whispers to the central figure, in a vair-lined robe and holding a stick (or baton?).

> Gold castles on red ground; octafoil frame; scene on *damasquiné* blue ground.

This scene is part of the narrative of Scene B and could as easily precede it. The inhabitants of Wilra, fearing that the saint's proposed monastery would usurp their properties, disputed and threatened him. The text specifically mentions the devil as instigator, as well as the social status of the disputants.[47]

The gesture of the figure to the right, pointing with one hand to a finger of the other, indicates argumentation; the pointed finger of the saint's other antagonist is a more

general sign, of giving an order or command. Saint Dié's open hand indicates his accep-
tance of the situation.[48]

The two surviving scenes on fleurs-de-lys grounds are as follows.

Scene D: The annual reunion of Saint Dié and Saint Hidulphe (Plate IV.12)

Saint Dié with miter, crozier, and blue nimbus, followed by his monks, meets
Saint Hidulphe with miter, crozier, and yellow nimbus, followed by his monks.

Gold fleurs-de-lys on blue ground; octafoil frame; scene against red ground.

Saint Dié founded the abbey of Saint-Maurice (later to be named Saint-Dié) on
the banks of the Meurthe and became its abbot. Hidulphe, retired bishop of Trier,
was abbot of the nearby monastery of Moyenmoutier. The author of the *Vita
Deodati* introduced the pleasant conceit of a warm friendship between these two
saints, each a retired bishop, and an annual meeting of the two halfway between
their monasteries.

In fact they were of succeeding generations; Saint Dié died in 679, Saint Hidulphe in
707. The text imagines Dié as older and tall but frail, Hidulphe as shorter and stronger.
The glazier has followed these directives and has given each saint a halo color maintained
in the other remaining scene that includes them both. Hidulphe holds his crozier aslant
and blesses his friend, while the older Dié, crozier upright, points a finger vertically in a
gesture of authority.[49]

The reality behind this charming invention was an annual ceremony, normally the
Thursday after Pentecost, when the two communities processed with the tunics (and later
the reliquaries) of their patrons, meeting midway between their abbeys at the chapel of
Béchamp to say mass. The procession was held until the Swedish troops destroyed the
chasse of Saint Dié in 1636.[50]

Scene E: The death of Saint Dié (Plate IV.13)

Saint Dié with miter and blue nimbus, lies in bed, awake; Saint Hidulphe with
miter, crozier, and yellow nimbus, blesses him; sorrowing monks to left and right.

Gold fleurs-de-lys on blue ground; octafoil frame; scene against red ground.

Saint Hidulphe, warned in a dream of the approaching death of his friend, hurried
to his bedside to administer the last rites. The scene takes place in Saint Dié's cell
near the chapel of Saint-Martin, his first foundation on the banks of the Meurthe
and situated about twenty minutes away from Saint-Dié by foot. The last wish of

the older saint was that Hidulphe would become abbot of his monks, which the younger saint agreed to do.[51]

Clearly these five scenes illustrate only a small part of the activities and miracles of Saint Dié. In following Richer's itinerary we perceive long gaps between Romont and Wilra, and again until near the end of the narrative. Without pressing the point too far, one might observe that the five existing scenes of Saint Dié would occur, in a glazed cycle of his life, at either the bottoms or the tops of doublet lancets—areas somewhat less "at risk" in a catastrophe since they would be stabilized on three sides by stonework.[52] This observation reinforces the hypothesis of an original placement of the five remaining medallions of the life of Saint Dié in the two lancets of the axial bay. The other three medallion panels in existence will prove a more challenging—and fascinating—puzzle.

The Medallions of the Jewish Incidents

The cycle of Saint Dié stresses properties or income controlled by the canons of Saint-Dié, a theme that, it can be argued, also forms the basis for the Jewish group (Plates IV.4 and IV.7d–f). I have called these scenes the "Jewish incidents" because two of the three medallions include a prominent figure wearing a Jewish pointed hat.[53] Jews were required, by the Fourth Lateran Council of 1215, to wear a badge or special clothing to distinguish them from Christians. The form of the distinguishing item was left to local ordinance: thus in England (1217) Jews were to wear a white badge in the form of the Tables of the Law, and in different regions of France a felt circle of varying color.[54] In German lands the prescription of the *Judenhut,* or pointed Jewish hat, was only an institutionalization of the distinctive garb that traditionally had been worn by Jewish communities in conformity with rabbinical law.[55] In European medieval art, however, the pointed *Judenhut*—which lends itself to caricature—became the standard signifier of a Jew. The double-line decoration on the hat of the Saint-Dié medallions appears frequently in art, and its peculiar shape—a rolled brim and curved, rather than "oil-can," silhouette—is particularly close to the Jew's hat of French moralized Bible illumination of the mid-thirteenth century.[56]

Although the Jews had been expelled from Lorraine by Duke Simon II (1176–1205), their moneylending activity made them useful for projects of economic expansion.[57] In 1212 Duke Ferri II invited them to Saint-Dié and, since his part of town had no room for them, made an agreement with the canons by which he would construct fifty houses, on the chapter's land, to lodge the Jews as his subjects.[58] It was thus to the canons' advantage to fan the growing anti-Jewish sentiment of the thirteenth century, since houses of Jews expelled from Saint-Dié would revert, along with the land on which they stood, to the chapter.

While previous anti-Jewish stereotypes had been, in Langmuir's categorization, "xeno-

phobic," those of northern Europe in the Gothic period were "chimeric":[59] "These chi-
meric stereotypes . . . depicted imaginary monsters, for they ascribed to Jews horrendous
deeds imagined by Christians, which no Jew had ever been observed to commit." These
imagined misdeeds included magic, host desecration, and ritual murder.[60] Indeed the
chronicle of about 1255 written by Richer of Senones—the same work that includes the
life of Saint Dié—also relates one of the earliest recorded accounts coupling the "blood
accusation" with Passover: at Hagenau in Alsace, he relates, on the day before Passover
(22 March) in 1236, several boys were murdered and their blood collected in waxed bags
while their parents were at church.[61]

The two incidents shown in the Saint-Dié medallions involve accusations of sorcery
and of host desecration. Both stories appear in the seventeenth-century history by Jean
Ruyr, the former incident citing the mid-thirteenth-century chronicle of Richer of
Senones (Bk. IV, chap. 37) and the latter, Ruyr tells us, from local oral tradition, as well
as from a manuscript then lost.[62] It is my assumption that the second story is missing from
Richer's section on "Jewish incidents" because at the time of his writing (c. 1255) it had
not yet occurred. It is an example of host desecration, a form of anti-Semitic accusation
that appeared and developed later than the type of blood accusation Richer relates about
the boys from Hagenau—in fact, well after the establishment of the Feast of Corpus
Christi in 1264.[63] The fear of Jews as sorcerers and magicians was much older. Therefore I
will discuss the Saint-Dié medallion of the Jewish sorcerer first.

The three medallion panels of this group share a common decorative vocabulary; the
medallion frame, a quatrelobed circle, is surrounded by a foliate design of naive charm
and vigor, and encloses a scene taking place against a red ground. The largest of the lost
fragments from the Saint-Dié museum also had such a medallion frame (Plate IV.8), and
on the basis of style the museum fragments can be grouped with the three panels of
"Jewish incidents." All were probably parts of the same window, and suggestions about its
iconographic program will follow the description of the fragments below.

Scene F: The Jewish sorcerer of Saint-Dié (Plate IV.14)

> A sleeping female figure lies at the bottom of the scene; above her are two figures,
> one holding a sword and pointing to a horse-drawn cart (right), while a third
> figure flanks a standing Jew (left center).

> Foliate surround; quatrelobed circle frame; scene on red ground.

> Richer's account (see Appendix III) is as follows. Among the Jews of Saint-Dié
> was a necromancer who had a Christian girl as a domestic servant.[64] One day
> when she came to work he told her to come and eat since there was much work to
> be done. As soon as she did so she fell asleep, drugged. The Jew locked his door,
> took out certain iron tools, opened her thighs and removed her uterus (matrix).

What he wanted it for, Richer says, is unknown. In an hour the girl awoke in pain and, though the Jew tried to quiet her, ran from the house screaming, as yet ignorant of what had happened to her. She ran into a gaggle of Christian matrons who questioned her; she told them that the Jew had somehow caused her an extreme pain in the intestines; the matrons examined her and saw the misdeed. A bourgeois informed Philip, the administrator of the duke of Lorraine, who interrogated the Jew. At first denying it, he finally confessed under pressure from the Christian mob, though he would not declare what his purpose had been. He was nonetheless condemned to death and tied to the tail of a horse to be led to execution. He cried out to the one leading the horse to stop as he had something of importance to say, but the Jews bribed the man not to allow him to speak. He was hanged, and later buried by the Jews in their cemetery.

The artist has designed a composite scene merging several moments of the story (Plate IV.14). Below is the drugged girl, her horizontal posture, closed eyes, and hand under her head indicating sleep.[65] The citizen with the sword points at the horse-cart, leading in the direction of the Jew's punishment; the citizen to the left makes a fist, signifier of hostility and violence, while turning his head away, a sign of aversion.[66] The unhappy Jew lowers his head in a sign of guilt while raising both hands in submission to his fate.[67]

But Gothic artists—who were trained to copy—almost never invented images "out of the whole cloth," as it were, and the probable source of the glazier's design in this case is quite significant. Before launching that investigation, however, I will examine the story for whatever shreds of reality it may contain. Guibert de Nogent (c. 1064–c. 1125), who has the dubious distinction of being among the first anti-Semitic writers to accuse the Jews of witchcraft, tells of a Jewish sorcerer requiring a sperm libation.[68] Contemporary with Richer de Senones's chronicle was the ordinance of Louis IX, upon his return to France from crusade in 1254, commanding Jews to desist not only from usury (as in previous ordinances) but from magic and necromancy.[69] The medieval belief in magic was shared by Jews and Christians alike. As Trachtenberg states:

> Why did the Jews require . . . these organs, then, if not for ritual use? The medieval Christian had no difficulty in supplying the answer. He was too well acquainted with their wide utility not to have imputed a like knowledge to the Jews. . . . One of the most pervasive beliefs . . . of the Middle Ages . . . was in the unexcelled value, for medicinal and magical purposes of the elements of the human body. Medieval magic is full of recipes for putting to occult use human fat, human blood, entrails, hands, fingers. . . .[70]

The organ removed by the Jew of Saint-Dié is nonetheless remarkable and indeed the whole story quite out of the ordinary in comparison with other anti-Semitic incidents of

the Gothic era. Such events normally followed a pattern; they can be, and have been, grouped by theme by scholars who have studied them. The peculiarity of the Saint-Dié episode places it apart. It suggests an abortion gone awry, and some circumstantial evidence exists to support such a hypothesis. Jews were famous in the Middle Ages as physicians, serving both popes and princes.[71] Thirteenth-century ordinances forbidding usury and the hiring of Christian serving girls in Jewish homes also include occasional prohibitions against Christians visiting Jewish physicians.[72]

In Lorraine, and in Capetian France, abortion was not a civil offense.[73] The punishment under canon law was excommunication, but only if the fetus was "ensouled"—at forty days for male embryos and eighty days for female.[74] It was the Christian requirement of baptism for eternal salvation that transformed the issue; abortion was not a question of deprivation of life so much as of deprivation of eternal life for the soul. The penitentials that treated abortion of an ensouled fetus as homicide decreed very minor penance for aborting at the beginning of a pregnancy.[75]

The Talmud contains no punishment for abortion. Rabbinical discussion on the theory of ensoulment often treated the moment of its occurrence and the nature of that soul as among the "secrets of God," not relevant to the question of feticide. The *Yad Ramah,* the Talmudic commentary of R. Meir Abulafia (d. 1244), makes this distinction and concludes that the embryo becomes a person when he is born. Maimonides (d. 1204) ruled similarly.[76] The Talmud mentions surgical instruments for removing an embryo, and Maimonides' Code refers to surgery to abort.[77]

The Jewish sorcerer of Saint-Dié was hanged sometime following 1212, when the Jews arrived there, and about 1255, the date of Richer's chronicle. The second "Jewish incident," not included by Richer, most probably postdates his text, since it exemplifies a slightly later development in medieval anti-Semitism. I would identify the remaining two scenes as illustrations of this event, Scenes G and H.

Scene G: The desecration of a host by Jews of Saint-Dié (Plate IV.15)

> A Jew in pointed hat, shown in profile with caricatured hook nose, stands gesturing before a house (left); a seated bourgeois holds a large number of hosts (right).

> Foliate surround; quatrelobed circle frame; scene on red ground.

> Jean Ruyr, a canon of Saint-Dié who related the story in the early seventeenth century (see Appendix IV), identified his sources clearly. The only written version known to him was a manuscript once owned by the sacristan Nicolas Marquis, who had saved it from a fire in 1554. Ruyr had heard the story from several old canons, whom he names, who disagreed about what became of the desecrated host.

Among the Jews living in Saint-Dié some years after the execution of the sorcerer was a rabbi who, as Easter approached, bribed a Christian and gave him a small box in which to bring him the host he would receive at mass. The Christian did, but so carelessly that the priest serving the chalice suspected something, and the next day, Good Friday, the story reached the provost and chapter. The Christian, interrogated, admitted giving the host to the Jew. The duke's administrator arrested the Jew and demanded that he return it. At this point Ruyr's sources vary: some said the Jew had thrown it in filth to hide or infect it, others that he had thrown it in the fire, others that it was found mutilated and was ceremoniously returned by the authorities to the church. The complaint was presented to the duke of Lorraine, who ordered the Jews involved expelled. Christians took over their abandoned houses, the renter of the house of the rabbi being obliged to provide annually a thousand hosts for the Good Friday mass. The house in question was No. 289 Grande-Rue, and the custom that its rental included provision of the Good Friday hosts was still in force when Ruyr wrote, and indeed until 1789.[78]

The artist has, as in the sorcerer medallion, designed a composite image (Plate IV.15). Its central figure is the Jew, characteristically shown in profile as an infidel, one pointing finger indicating that he is giving an order or instruction, while his other hand is raised in a gesture commonly used in scenes of commerce, buying/selling, etc.[79] He does not look at the seated figure to the right, while the latter seems to look in the direction of the Jew without actually seeing him. They do not seem to be participants in the same scene. Rather, the seated figure holding his pile of hosts is doubtless representative of the Christians later inhabiting the expelled Jew's house and obliged by his crime to provide the chapter an annual paschal contribution of hosts for the mass. The house at No. 289 Grande-Rue is therefore an important element in the story, and it appears to the left: the lower floor of stone, a shuttered window opening from the solar above, under an elaborate tiled roof. In England such medieval stone townhouses are known as "Jews' Houses," and Wood believes that

> there may be some truth in the "Jewish theory" . . . [since] the Jews were accustomed to a higher standard of living than that of their simpler neighbors. . . . The Jews were rich and had more to lose in a fire; also as money-lenders they were unpopular and so liable to attack by the mob. A stone house was thus preferred for protection and comfort.[80]

No medieval houses of Saint-Dié survived the catastrophes of 1554 and 1944, but several two- or three-story stone townhouses of this type survive in Cluny in Burgundy.

Scene H: Citizens inform the duke of the host desecration at Saint-Dié (Plate IV.16)

Two bourgeois (left) stand gesturing before the duke (right), who is seated, crowned, and holding a scepter. The fleur-de-lys at its top is a modern replacement.

Foliage surround; quatrelobed circle frame; scene on red ground.

The duke is crowned as prince of Lorraine. His scepter is now topped by a modern fleur-de-lys; the earlier fleur-de-lys in that position (Plate IV.7f), placed sideways,[81] may have been a stopgap. He points one finger up, signifying authority. The first citizen lowers his head in submission while pointing with one finger at his other hand in the gesture of demonstration or enumeration. His companion's upturned, profile head indicates his inferior status to the duke, while his open hand shows his acceptance of the ruler's authority.[82]

While the host desecration at Saint-Dié cannot be dated, the stained glass is not likely to date past about 1290, thus placing the incident among the very earliest of such events. Despina has noted no texts predating the thirteenth century accusing Jews of host desecration.[83] The story of the presumed earliest incident (at Belitz near Berlin in 1247) was embroidered later and in its original form probably did not concern Jews. An accusation of host desecration, ending in a massacre, in Wittstock (Brandenburg) in 1287 would seem to be the only such event preceding that of 1290 in Paris, the well-known *Affaire des Billettes*. A letter of Boniface VIII in 1295 allowed the construction of the church and cloister of the Billettes on the site of the house of the Jew Jonathan, perpetrator of the crime, who had been tortured and burned at the stake and his wife and children baptized. The Paris story spread quickly. A similar event occurred at Büren (Westphalia) in 1292, at sites in Austria in 1294, and starting in 1298 a veritable epidemic of such incidents throughout the Empire. The mildness of the Saint-Dié story, in which the host does not bleed—which was to become standard[84]—nor are the Jews massacred, is some indication of its early date.

The situation of Jews in thirteenth-century France shifted under successive Capetian monarchs. Louis IX (d. 1270) was a particularly aggressive persecutor; as Blumenkranz put it, "for the Jews, Louis IX is not Saint Louis."[85] Chazan has suggested that the reign of his son Philippe III (1270–85) must have been a welcome respite.[86] Under Philippe IV, who came to power in 1285, the situation again turned tense. Chazan would place the turning point even before the Billettes incident in 1290, in a event around Easter of 1288 in the city of Troyes in Champagne, then joined to the crown by the marriage of Philippe IV with the *champenois* heiress. The situation in Lorraine was a little different from both France and the Empire, and Saint-Dié, French-speaking but located in the traditionally imperial part of the province, may have been far enough from both to escape the hysterias

of each for a time. During the long reign of Duke Ferri III (1251–1303), "his Jews" lived under a policy of benevolent protection/exploitation suiting his purposes of economic expansion.[87] Nonetheless a hypothetical dating for the Saint-Dié accusation of host desecration might place it before the violent atrocities of Troyes (1288) and Wittstock (1287), possibly even within the reign of Philippe III (d. 1285).

Both Jewish incidents were local and recent history when the Saint-Dié medallions were made. While the story of the Jewish sorcerer emphasizes his unrepentance and punishment, the host-desecration story places the focus on the duke's authority and on the chapter's property, the houses built by the duke that reverted, after expulsion of the Jews involved, to the canons. The three medallions that survive clearly are too few to establish the program of the original window, but five lost fragments may be brought into evidence to form a fragile hypothesis.

The Lost Fragments

A photograph published in 1936 (Plate IV.8) is all that remains of these fragments, destroyed with the museum and town of Saint-Dié in 1944.[88] They were related in painting style to the series of the Jewish incidents, and the largest fragment retained the same quatrefoil frame. Three of them showed a bishop saint unbearded and thus not close in type to the bearded and more elongated, sometimes stiff and effete, figures of Saint Dié and Saint Hidulphe in the *Vita Deodati* series (for example, Plate IV.12). Thus the possibility is eliminated that the baptism in the large fragment could represent that administered by Saint Dié to the son of Hunus and Huna. One is therefore searching for a beardless bishop saint revered in Lorraine whose legend relates him to Jews—and that can only be Saint Nicholas.[89]

Centuries before Nicholas became the official patron of Lorraine in 1477, his cult was established and thriving at the pilgrimage church of Saint-Nicholas-de-Port near Nancy (see Fig. 8).[90] Its origin and international fame are mentioned in Richer's *Gesta Senoniensis ecclesiae*, written about 1255, a major source for the two series of medallions already discussed.[91] Richer does not mention, because it had not yet arrived, the pilgrimage church's most famous ex-voto, a silver ship promised by the queen of France, made in Paris and delivered by Joinville following Louis IX's return from the Holy Land in 1254. Nor does he mention the most famous miracle of Saint-Nicholas-de-Port, in 1257,[92] when the crusader Cuno de Réchicourt, who had been imprisoned by the infidels, was transported by the saint to the church while still in his chains. These were displayed from a pillar in the sanctuary amid the numerous ex-voto chains of prisoners already mentioned by Richer.

The *Golden Legend* of Voragine recounts two posthumous miracles of Saint Nicholas involving Jews, their conversion and baptism.[93] I will refer to them by the labels devised by Jones in his study of the Saint Nicholas legend: *Iconia*, the story of the Jew who flogged the saint's statue, and *Broken Staff*, the story of the Jew and the perjured Christian.[94] Saint Nicholas was particularly popular in thirteenth-century stained glass, a fact commented upon by many iconographers,[95] and both *Iconia* and *Broken Staff* appear in two windows dedicated to Saint Nicholas at Chartres (bays 14 and 39, c. 1205–25) and in one at Auxerre (bay 18, before 1250).[96] While *Iconia* is much commoner, *Broken Staff*— which will be more important to the argument below—occurs in glass at York about 1190 and at Beverley about 1230, in a panel at Dreux near Chartres and contemporary with it, in a cloister capital of the same period at Tarragona Cathedral in Catalonia, and at the end of the thirteenth century in a relief of the Angevin era at Bari (Plate IV.7a–g).[97]

The story of *Broken Staff* in the *Golden Legend* relates that a Christian borrowed money from a Jew, swearing on the altar of Saint Nicholas to repay it. Later he insisted he had repaid it, and when ordered to swear to this in court, hid the coins in a hollow staff that he asked the Jew to hold while he gave his oath. The Jew then returned the staff unawares and the Christian, on his return home, lay down to sleep on the roadside and was run over by a cart, killing him and breaking the staff to reveal the gold. The Jew, when pressed to take his money, refused unless Saint Nicholas restore the dead man to life, promising in the event to be converted and receive baptism. And so it was.

It can be seen from Plate IV.17 that the depiction of the traffic accident that forms the climax of the story varied hardly at all in Gothic art: two beasts, driven by a man with a prod, pull a cart, directly under the wheels of which lies the run-over perjurer, coins pouring from his broken staff. It seems just as obvious that this depiction provided the model used by the Saint-Dié glazier, which he adapted and rearranged in the difficult task of designing his medallion of the Jewish sorcerer of Saint-Dié (Plates IV.7d and IV.14). Medieval artists were trained to copy, to model their work on visual sources, and they instinctively sought such images when asked to compose new subjects. The glazier has derived his drugged girl from *Broken Staff*'s run-over perjurer, and his posse of outraged citizens from the driver of the cart that killed him, the driver's prod transformed into a sword. His horse tail and rump are abbreviations of the two beasts pulling the driver's cart. The Saint-Dié glazier has even included details he did not need, such as a wheel from the cart, and beneath it some "cobble stones," transformed from the round, cross-marked coins of *Broken Staff*. Indeed it must be emphasized that his scene (Plate IV.14) could not actually be *Broken Staff*, since that scene in medieval art never varied from York to Bari; the perjurer is always directly beneath the cart's wheels. The examples that make up Plate IV.17 are not selective; they are all there.[98]

There is circumstantial evidence that a Saint Nicholas cycle existed at Saint-Dié, from the church of Hunawihr in Alsace (see Fig. 8), over which the canons had the right of

patronage as early as 1109.[99] At Hunawihr such a cycle in frescoes, dated 1492 and probably whitewashed around 1534–40, during the Reformation, was uncovered in 1879 and misidentified until the local publication by Jean Rott in 1948.[100] It has remained unknown to iconographers. Among the fourteen scenes are three depicting *Broken Staff*: the false oath, the cart accident, and the baptism of the Jew (Plate IV.18a,b). The frescoes of near 1500 incorporate, as might be expected, some modernizations, such as landscape backgrounds, a clean-shaven Jew, a fashionable costume for the perjurer, and his foreshortened pose lying beneath the cart's wheel. Rott was unable to suggest why Saint Nicholas should be featured at Hunawihr. Several details, however, comparable to specific forms in the Saint-Dié "Jewish incidents," suggest that Hunawihr is based *grosso modo* on a lost Gothic cycle of Nicholas at the mother-house of Saint-Dié: the Jew appears in the traffic accident scene, his son is being baptized rather than he, and the baptismal font is not the usual Gothic tub in which a figure sits, but is chalice-shaped, and from it the figure is anointed (compare Plate IV.8).

Although no particular evidence exists of a special veneration of Nicholas at Saint-Dié,[101] the impulse behind the commissioning of a Nicholas window by the chapter can be suggested, and indeed it can explain the inclusion in the cycle of local events concerning "bad Jews" to supplement the "good Jews" converted and baptized by the saint. As Jones has established:

> [Saint Nicholas] symbolically "arrived" when his namesake Pope Nicholas III (John Cajetan Orsini, d. 1280) at long last introduced Reginold's liturgy into the papal chapel. . . . The pope took his papal name, it is believed, because he had been cardinal-deacon of the church of Saint Nicholas in Carcere Tulliano. His bull *Exiit qui seminat* (14 August 1279), prepared with the help of the future Nicholas IV, was drawn in favor of the Franciscans, who . . . were becoming [Saint Nicholas's] friends.[102]

"The extraordinary cult of Nicholas among Franciscans" was reassociated with the papacy in the person of Nicholas IV (1288–92), the first Franciscan pope, believed to have chosen his name to honor his mentor, Nicholas III. And Nicholas IV, it might be said, was the one who made the Gothic Saint-Dié a reality, issuing bulls in 1288 and 1289 to facilitate the extraordinary fund-raising needed to complete its construction.[103]

Of course the reversion of land and houses of expelled or executed Jews to the chapter's control also provided welcome revenues available for the same purpose—particularly if the host desecration had just occurred, as I believe, around 1285. Thus a window devoted to the Saint Nicholas legend would be a likely commission by the canons, and the inclusion in it of local Jewish events—making it, as it were, into a program of "good Jews and bad Jews"—a justification of the chapter's enrichment. And, as we shall see, the heraldic roses in the window's border identify the chapter as donor.

The Heraldry

It comes as a surprise to find that the heraldic borders have never been identified or even mentioned.[104] Panels survive of two designs, one with large white heraldic roses alternating with more routine decorative motifs on a red ground (Plate IV.21), the other a handsome rising, undulating foliate stem laden with grape clusters, inhabited by birds, and bearing coats of arms at intervals (Plate IV.23c). Since coats of arms are unequivocal heraldic emblems this discussion will commence with them.

They are the arms of the duke of Lorraine (Plate IV.19), normally blazoned *d'or à la bande de gueules chargée de trois aiglettes d'argent*.[105] The leading and glass-cutting required to differentiate the red *bande* from the white *aiglettes* at this small scale were beyond the capabilities of Gothic glazing, and the glazier has opted for a simplification. His *bande* is white and his *aiglettes* are outlined on it with grisaille paint.[106]

The duke of Lorraine was not always on good terms with the chapter of Saint-Dié. I have suggested that the most serene period in their relations was when his son Ferri was grand provost, from his election as a minor in 1277 until the early 1290s, when the duke was (again) under excommunication.[107] Indeed the Lorraine arms in the window border are probably those used by Provost Ferri, the duke's son. Although none of his seals has survived,[108] he charged the arms of Lorraine with a bishop's crozier *en pal* as bishop of Orléans after 1297. His equestrian image holds such a shield on the stone cross of Frouard, now reerected in the garden of the Musée lorrain in Nancy (Plate IV.20).[109] The provost preceding Ferri had been of a minor branch of the duke's house that used a heraldic lion, while Ferri's successor had served him as *gouverneur* and was not related to the duke.[110] Thus the stained-glass borders, whether denoting the duke or his son—who as a minor and then an ecclesiastic may never have used differentiated arms before leaving his provostship to become a bishop—would date from after 1277 to about 1290. These borders now frame the medallions of the life of Saint Dié, and it seems likely that they did so originally.

The second border design does not contain a coat of arms but what appears to be an emblem, a large, prominently displayed *rose argent* (Plate IV.21). This border now frames the Jewish incidents and probably did so originally, since it is demonstrable that the roses were emblems of the chapter.

The chapter's coat of arms containing three white roses is first found on a seal of 1429.[111] A late tradition maintained that the chapter had adopted the arms of Richilde, countess of Alsace, who had left the church some land about 1050 and was buried near the high altar. While heraldry as such did not exist in 1050, the story probably has some basis in fact, since Richilde was a niece of the pope Saint Leo IX, a former provost of Saint-Dié of whom they were enormously proud. His counterseal on a bull of 1049 depicts a single rose (Plate IV.22 center left).[112]

A counterseal of a single rose (Plate IV.22 top and bottom), no doubt based on the pope's, served the chapter from 1172 to 1456 to accompany *sceaux aux causes de la Cour* of

the provost (the *Cour spirituelle* of Saint-Dié). Such seals were required on wills, dona-tions, foundations of anniversaries, rents collected, sales by the chapter, payments, recognition of debts, and the like—that is, the chapter's financial business.[113] A more appropriate motif than this single rose to border the cycle of Jewish scenes, both the incidents in the town of Saint-Dié as well as those of the Saint Nicholas legend, can hardly be imagined. *Broken Staff,* after all, concerns the punishment of a perjured debtor! Jones's study of the legend continually emphasizes the saint's popularity with lawyers and judges, merchants and bankers.[114]

A discussion of heraldry should not omit the emblems of *France* (gold fleurs-de-lys on azur) (Plates IV.12 and IV.13) and *Castille* (gold castles on gueules) (Plate IV.9–11) that form the diapered ground surrounding the medallions of Saint Dié. Though nineteenth-century authors were quick to relate them to the reign of Louis IX, it is now well established by scholars of French Gothic glass that no such direct connection is warranted in most comparable examples. Even less do they refer to his mother, Blanche de Castille, as so often misconstrued. Women have no coats of arms, and use those of their father until they are married—when they use those of their husbands, or perhaps those of both husband and father. The castles refer to the claim by the French kings to the crown of *Castille,* which had been offered to Saint Louis's father by one Spanish faction, provided he could come down and take it by force.[115] Saint Louis preferred to avoid war (against other Christians) and married several of his children into the Castilian house in a policy intended eventually to join the two crowns.

The castles and fleurs-de-lys appear in the north rose of Chartres, and grounds formed of these motifs were introduced in the glazing of the Sainte-Chapelle. The expansion of French influence under Saint Louis, not to mention his national and international prestige, contributed fundamentally to the popularity of the motifs, which lessened hardly at all under his son Philippe le Hardi (d. 1285). Beginning with that king's successor, the castles, however, no longer carried any political significance, since Philippe le Bel (1285–1314) was quick to reverse the tilt toward Spain that had marked the foreign-policy aspirations of his grandfather and father.[116] It has been my observation that fleurs-de-lys and castles last on in glazing for about five years, but that in the 1290s they become rarer and are sometimes changed in color to become simple nonheraldic decoration.

As the pure examples found at Saint-Dié are classic in appearance, they probably do not date after the late 1280s. No doubt they express the French connection of Duke Ferri III and his young son, since—after 1285—the latter was, through his mother, Marguerite de Navarre, cousin to the new queen of France.[117] Thus the Saint-Dié glass most probably dates after 1285 and before 1290.

This royal kinship of Provost Ferri has not been recognized sufficiently. Gaston Save has attributed the disappearance of the imperial double-headed eagle from the chapter's seals to the influence of Provost Ferri, pointing out that neither his predecessor nor his successor as provost would have had much interest in suppressing all such traces of the

Empire.[118] But the fleurs-de-lys and castles Save interpreted otherwise. The house of Epinal nearby provided numerous officeholders among the canons of Saint-Dié; Save lists the names, dates, and offices of seven in the late thirteenth century. The arms of the lords of Epinal in Lorraine were *France à une croix d'argent brochant sur le tout,* while those of the town of Epinal were three towers like those of *Castille.*[119] This leads Save to interpret the stained-glass fleurs-de-lys and castles as references to the house of Epinal.[120] Only a trueborn son of Lorraine could indulge in such a fantasy. How much more likely the reverse—that the various motifs in use in Epinal reflected the same rising French sun in Lorraine as did the stained glass of Provost Ferri.

Strasbourg and Westhoffen

The rarity of pictorial arts surviving in Lorraine from the late thirteenth century, as well as the sophistication and high quality of the Saint-Dié panels, accentuates their stylistic importance. Most probably two masters produced these panels, one who might be characterized simply as "French" and the other as "German." This is an oversimplification that their close collaboration renders even less satisfactory, but it will provide a basis for understanding.

The "French" style is only generically so. Certainly the *France* and *Castille* diapered grounds are classic French types that, as discussed earlier, probably do not postdate the late 1280s (Plate IV.3). The border pattern, a foliate stem undulating around a central, rising, vertical shaft, has a venerable history in French glass design, and many examples could be cited. All of them, however, predate the middle of the century, for example, the early thirteenth-century border from Lyon.[121] Borders of such great width, abandoned by the Court style in the 1240s (already at the Sainte-Chapelle), do remain in use in Champagne as late as the 1270s (Saint-Urbain de Troyes), and we have seen them at Saint-Gengoult in Toul. The rather simple medallion shapes, which free-float on a repetitive, diapered ground, are no easier to pin down. Octafoil medallions set against a small-scale repeating diaper appear, like the border design, in early examples at Lyon.[122] Court-style medallions are much more complex in shape, and almost nothing survives at this scale in Champagne. While medallion windows of around 1275–80, in Brittany (Dol) and Auvergne (Clermont-Ferrand), still contain simple shapes free-floating on a lozenge ground,[123] they establish little except a proof that the Saint-Gengoult and Saint-Dié windows are not a complete anomaly for Gothic art of their time. Similarly, the slender, graceful figures of the Saint Dié cycle (Plate IV.23a) and the calligraphic line of the draperies also relate the glazier generally to French art of his time.

The lack of any really close contemporary comparisons in France suggests that the "French" forms had taken root in Lorraine by mid-century, as at Toul Cathedral, and that

what we find developing at Saint-Gengoult and thereafter at Saint-Dié is truly *lorrain* Gothic. A similar phenomenon appeared in architecture, where the doublet window, old-fashioned and discarded by 1240 in the Ile-de-France, remained standard for over a century in eastern France, following the venerable model of the coronation cathedral of Reims. However, such doublet windows, in the Toul architectural group, are vastly elongated, and the resultant openings seem to encourage the stacking up of simple, legible medallion-shapes within very wide borders. It is significant that some of the scenes of the life of Saint Dié have a *damasquiné* ground (Plate IV.7a–c), not a French Gothic technique but already found in the ex-voto window of Saint-Gengoult (Plates III.24 and III.25).[124] Thus the master of the life of Saint Dié was probably a native, possibly, like the masons, a craftsman who was in the employ of the duke of Lorraine.

The familial resemblances of the series of Jewish incidents are otherwise (Plates IV.14–16). The color is much gayer, brightened by a great deal of gold-yellow and by the magnificent, translucent green of Alsace-Lorraine, which weathers hardly at all. In comparison, the color of the medallions of Saint Dié is closer to the classic French harmony where paler yellow serves as an accent and green can be almost nonexistent. The double frame around the Jewish incidents, a quatrelobe that overlaps a circle, is a tame version of the much more tortured and complex multiple-framing in German Gothic glass. Alsatian examples, for example, those from the Thomaskirche in Strasbourg,[125] are simpler than German ones and closer to Saint-Dié. The strong, simple drapery painting (Plate IV.23b) and straightforward facial types are also closer to Alsace than to the more stylized and often caricatural German painting. The virile foliation of the grounds, the stems twisting and overlapping while the leaves always turn, like so many sunflowers, toward the viewer, is also a familiar ornament in Alsace and Germany, where it was to last well into the fourteenth century.[126] The foliate border at Saint-Dié (Plate IV.23c), originally a French design, is a lusty example in this same genre and was probably painted by the "German" glazier.

The finest and most unusual glazing atelier of the Strasbourg Cathedral nave, the shop responsible for clerestory bays SII and NIII (now dated 1245–55), is the source of this vigorous style. Wild-Block has described the sophisticated techniques, and the freedom and movement of design, that mark this atelier, concluding: "It is astonishing that such masterpieces were not imitated at the cathedral and one would love to find the traces of this atelier before and after the execution of these two windows."[127] While there are no birds in their borders, the birds inhabiting their canopywork have long been remarked upon.[128] Both an octafoil frame and a double frame composed of interlocking quatrelobes—similar to both medallion types at Saint-Dié—appear in the traceries of bay SII.[129]

The rosette border of Saint-Dié (Plate IV.21) can also be brought into evidence. Rosettes abound in Strasbourg at all periods, and the alternation is also common, in borders, of such frontal rosettes of heraldic appearance with lozenge ornaments of a stylized, mechanical pattern (for example, the borders of bay NII and of bay NVb and

d).[130] The ateliers of the Strasbourg nave that followed the virtuosic shop of SII/NIII maintained and simplified their forms. With the atelier that produced bay NV about 1260–75, we approach the point of development of the Strasbourg style that is reflected in the Jewish series at Saint-Dié, whose glazier could have found in his Strasbourg patternbook all of the needed elements: double frame, sturdy foliate ground with flattened leaves, borders of rosettes and lozenges, as well as the birds he inserted into the foliate border. He enlarged the rosettes to enormous size since, at Saint-Dié, they serve as the chapter's emblems. And his firm hand and his light approach appear as well in the foliate borders, where those original birds that remain, each different, open their beaks and flex their wings with vigor.

Although the two Saint-Dié glaziers worked together, their work can be factored out as follows. The *lorrain* glazier (Plate IV.23a) produced almost all the Saint Dié *vita*, medallions peopled with slender, lightweight figures that, though slightly stiff and frozen, reflect the mannerisms of the Court style. The superb Alsatian glazier (Plates IV.23b,c), a more talented artist, designed the Jewish scenes and the rosette border, while the foliate border seems to betray a standard design from his colleague's patternbook that he adapted and painted. His figures are larger and more substantial, his line more decisive, and his compositions better adapted to the shape of the frame and much surer in focus. Verve is an elusive quality in artistic creation, but he has it; it relates him to Strasbourg NIII, where the minuscule gargoyles of the vast canopywork panels dribble rainwater from their mouths.[131] He probably served his apprenticeship and began assembling his patternbook while working on the Strasbourg nave.

Since no medallion windows survive from Strasbourg Cathedral, my argument will invoke a rural church nearby that art historians have always placed within Strasbourg's magnetic field, namely, Saint-Martin in Westhoffen (see Fig. 8).[132] The first campaign at Westhoffen is dated about 1280–95, contemporary with Saint-Dié, though its architecture is unrelated and has been called the earliest hallchurch in Alsace.[133] Unquestionably a Strasbourg patternbook provided its stained-glass designs (Plates IV.24a–c): birds in the canopywork, a border of alternating rosettes and lozenges, a foliage ground with twisting stems and flattened leaves,[134] and bright color with much gold and green. Among the glass panels relocated in two choir bays, probably in the early nineteenth century, survive the following panels from the 1280–95 campaign (Plates IV.24 and IV.25): twelve scenes of the life of Christ; four scenes of a bishop saint, possibly Martin; a large standing Saint Nicholas with canopywork containing birds and rain-spouting gargoyles; and a tracery ornament with the glazier's name, "Renbuldus me fecit." The canopies have long been associated with the Strasbourg Cathedral atelier of bays SII/NIII, and Wild-Block has related the large Nicholas to the same shop. She has compared the medallions more generally to Alsatian contemporaries such as Wissembourg and the Strasbourg panels from the Thomaskirche and the lost Dominican church, noting the placement of medallions against a continuous ornamental ground.[135] The Germanic preference for multiple borders also could be mentioned.

But the position of Westhoffen in art-historical literature, firmly within the orbit of Strasbourg Cathedral, is puzzling since the Westhoffen windows are a gauche, rural production touched with charm and naiveté. Its glazier is inept, really a folk artist, and clearly such a country bumpkin would not have been hired even to push a wheelbarrow in the shop of the imperial cathedral at Strasbourg. Moreover, Westhoffen is closer to Saint-Dié than to the purely Alsatian examples recited above. Its medallions are simple shapes and there is little overlap—border, ground, and medallions are each assigned their rational place, mimicking the French accent of Saint-Dié. In short, Westhoffen reflects Strasbourg only indirectly and is best understood as a folkish production of "popular art" based directly on the Strasbourg patternbook used at Saint-Dié. Its great importance to this study is that it fills the gaps in our understanding of the Strasbourg patternbook. To put it another way, while no medallion windows exist from Strasbourg Cathedral, the naive productions at Westhoffen provide a reflection in a glass darkly of what they would have been like and allow us to detect their idiom in the handsome glass of Saint-Dié.

One tiny scrap of large-scale canopywork survives at Saint-Dié (Plate IV.3 upper left),[136] to testify to an original glazing program somehow combining medallions with standing saints, as at Westhoffen. If Saint-Dié's lost canopied saints replicated the Strasbourg nave clerestory, how one aches for the loss.

Lost and Found

But the original glazing of Saint-Dié had been lost by the mid-eighteenth century, when new clear grisailles were made for the church's lancets and only a few Gothic medallions saved to provide spots of color in the traceries above. How and why were these few fragments preserved? A lost Crucifixion without frame, and pieces of the rosette border, were placed in the axial tracery (Plate IV.5); the five lost museum fragments (Plate IV.8), I have suggested, probably filled the remaining apsidal traceries, too narrow to accommodate full-framed medallions; the larger traceries of the eight transept windows probably received the eight medallions we have (Plate IV.7).

Why were these particular medallions saved? Certainly the five presenting the life of the patron saint of Saint-Dié require no explanation, and possibly no others of the series were then extant. The three medallions depicting the Jewish incidents are a much more puzzling survival and suggest that, in the mid-eighteenth century, the canons still understood their subjects. The chapter was, at any rate, still collecting rents on the house at No. 289 Grande Rue; its tenant was required to provide the hosts for Good Friday until 1789.[137]

History flourished at Saint-Dié, which enjoyed a particularly brilliant intellectual climate from the advent of printing until the Revolution.[138] Both of the Jewish incidents

were published in 1634 by the canon Jean Ruyr, who continues to enjoy a reputation as a fine early historian. The thirteenth-century chronicle of Richer never fell into oblivion. It was translated into French in the sixteenth century, and the Latin original was copied and published repeatedly, with some omissions in the *Spicilegium* of Luc d'Achery (editions 1687 and 1723), and in brief passages in Calmet's history of Lorraine, in Grandidier's history of Alsace, by Mabillon, and in various other early scholarly collections.[139] It is reasonable to assume that the three Jewish medallions owed their survival to the fact that the canons of Saint-Dié in the eighteenth century knew and recognized them as local history.

Contemporary events in Gothic stained glass are a novel concept to art historians. One thinks only of medieval saints such as Becket and Francis, and of the purchase by Louis IX of the Crown of Thorns, depicted in the windows of the Sainte-Chapelle and elsewhere. However, Joinville's chronicle of the Crusades relates how a squire fell overboard and, having commended himself to Our Lady of Vauvert, was supported by the shoulders until his rescue. Joinville then concludes: "In honour of this miracle, I have had it depicted on the walls of my chapel at Joinville, as also in the stained glass windows at Blécourt."[140] The income from the Jews' houses in Saint-Dié may have been regarded by the canons constructing the Gothic Saint-Dié as a no less miraculous turn of events.

If, as I believe, the superb glazier of these Jewish incidents (Plates IV.23b,c) had his training at the imperial cathedral of Strasbourg—most prestigious enterprise of its day in the Rhineland—then why doesn't his work look more Alsatian? The only response to this question is that he is a strong and thoughtful artist, the kind who breaks the rules, and often makes the rules. He invented and adapted with great creativity: he put his birds in the borders, not the canopywork; he enlarged the rosettes to monster size to become the emblems of the chapter. A Gothic master was trained, and expected first of all, to copy, and the composition of the Jewish incidents was thus a challenge to which he rose with remarkable aplomb. Most significant for the tenet of this book—that Gothic stained glass in Lorraine forms an authentic regional style—he seems to have studied and learned from the art of his fellow craftsman at Saint-Dié (Plate IV.23a). Together they created a masterpiece in the *lorrain* style, one that was nearly lost and is now, one may hope, at least partially found.

V

SAINT-GENGOULT (TOUL) AND AVIOTH: THE ADVENT OF SILVER STAIN

Ceste l'eglise d'Avioth.
(i.e., it'll never be perfect.)
—*Local saying recorded by Delhotel, 1668*

Mâle's famous aphorism—that nothing resembles thirteenth-century stained glass less than glass of the fourteenth century—holds as true for Lorraine as for the rest of Gothic Europe. Most significant among factors contributing to the sea-change is the introduction of the new technique of silver stain, or *jaune d'argent*, possibly known before 1300 but chiefly disseminated from Paris starting in 1315.[1] In 1315 silver stain was rare in Europe; by 1320 it had begun to appear everywhere; in 1325 it was the norm, and the medium had begun to adopt a new delicacy and lightened palette in response to its potential. While the transition is difficult to establish, it can be traced in two ensembles in Lorraine where *jaune d'argent* makes a tentative appearance within the established color harmonies and forms of traditional Gothic medallions.

First Steps

The earliest silver stain in Lorraine is in five tracery lobes of the south chapel window of Saint-Gengoult (Bay 8) (Plates V.1a,b and V.2). The subject of the traceries is the Last Judgment according to Matthew, and the style and color differ markedly from the earlier panels of the life of Christ filling the lancets below (discussed in chapter II). Both series, however, appear in the 1837 drawing (Plate II.14a).[2] Thus both may occupy their original locations, though stylistically and chronologically they are unrelated.

Although the 1837 drawing is imprecise, it verifies the Christ showing his wounds in the central quatrefoil (now replicated in a totally modern fabrication) as well as its surrounding, more authentic red/blue diaper, and the lobes with angels and the hellmouth

at six o'clock. Discounting the lobe at twelve o'clock, a pastiche of unknown date,[3] the
new style can be studied in the lobes of the hellmouth and of four angels blowing
oliphants to rouse various nude souls (at two, four, eight, and ten o'clock).

While *jaune d'argent* is touched hesitantly and sparingly to the angels' hair and wings,
its usefulness has yet to be explored. Indeed potmetal yellow—which it was virtually to
replace—is among the most important elements of the saturated palette, a gaudy harmony
composed of the primary colors with a little white and brown. The lobes are bordered by
potmetal gold pearling around a red filet, and potmetal gold-yellow appears as crowns,
oliphants, tombs, wings, robes, and so forth.

The *damasquiné* grounds, another ubiquitous element of fourteenth-century design,
also seem experimental in the five lobes. While such foliate grounds had appeared in the
last work of the Gengoult Master in Bay 7 (discussed in chapter III), there the elegant
stick-lit patterns were typical of the *damasquiné* grounds found at Saint-Urbain de Troyes
and in many later examples of small-scale glazing. The lobes of Bay 8, in contrast, have
grounds sticklit with a carelessly drawn, large-scale foliage that is comparable in touch to
the foliate cassettes of the diaper surrounding the central Christ. In the traditional Gothic
red/blue diaper the drawing appears folkish and untutored; in the enlarged *damasquiné*
pattern behind the fragile angels of the lobes, it looks out of place and experimental. Its
scale is inappropriate, resembling patterns used throughout the fourteenth century for the
grounds of large standing-figure designs of multiple panels, in clerestories or facade
glazing. The drawing of the faces in the lobes is also sketchy, to the point of carelessness,
striking a very strange contrast with the weightless angel bodies swathed in robes of deep,
heavily shaded folds, ultimately based on the earlier draperies of the Gengoult Master
below. Indeed the lobes of Bay 8 appear to be trial designs by a glazier no longer part of the
old world but not yet familiar with the new.

Is it possible to date his work more precisely? Only one detail suggests a chronology, the
papal tiara worn by one of the souls rising to the angels' call in the lobe at eight o'clock
(Plate V.2). The tiny gold tiara, of marked triangular shape, is embellished with three
crowns: the so-called *triregnum*. The papal tiara, at least by the thirteenth century, was
decorated with a crown, but the so-called tiara of Saint Sylvester used by Popes Nicholas
IV (d. 1292), Boniface VIII (d. 1303), and at the coronation of Clement V in 1305 was
quite different in shape and decoration.[4] Boniface VIII added a second crown to his tiara,
probably after publication of *Unam sanctam* in 1302; the embellishment of a third crown,
attributed to Benedict XI (d. 1304), was standard with the succeeding Avignon popes.[5]
At the beginning of the fourteenth century the tiara design was gothicized, the crowns
becoming *couronnes fleuronnées* resembling the ducal coronets of heraldry. While the
triregnum was to find its definitive shape only under Benedict XII (1334–42), an inven-
tory at the death of Clement V (1314) lists a tiara decorated with three diadems, which is
again mentioned in the inventory of John XXII (1316–34).[6] Thus it is not unreasonable
to date the tiny three-crowned papal tiara at Saint-Gengoult to around 1315, since only

within the reign of Clement V (1305–14) would descriptions of a three-crowned tiara have become current.[7] It is unlikely to be a coincidence that circa 1315 is exactly the moment one would expect to find the most primitive and tentative experiments in silver stain, a technique which, as I have argued elsewhere,[8] was first popularized from Paris following the death of Philippe le Bel in November of 1314.

Our Lady of Avioth

Avioth (Meuse), situated practically on the Belgian border, is a cluster of houses surrounding a pilgrimage site to a twelfth-century oaken statue of the Virgin. The impressive if somewhat irregular Gothic church includes masonry from every century from around 1250 through the Renaissance and beyond, giving rise to the local saying quoted at the beginning of this chapter. As no documentation exists, stylistic analysis alone has had to serve, and indeed the confusing structure has almost defied consensus.[9] The surviving stained glass, which has received less serious consideration, includes fourteen medallions that provide a precious last glimpse at the Gothic glazing style of Lorraine in actual process of transformation by the new technique of silver stain. Indeed it has not even been recognized previously that *jaune d'argent* appears in them, nor that one of the medallions series is a twentieth-century design.[10]

Although Avioth is the most renowned of the French so-called *sanctuaires à répit*, sites that specialized in the miraculous (and temporary) resuscitation of stillborn infants so that they could be baptized before burial, there is no evidence of the folk practice there before the fifteenth century.[11] Like the Gothic tympanum of the south portal,[12] the fourteen medallions present a standard, though charmingly detailed, life of Christ. These roundels, with a modern Deposition now bringing their number up to fifteen, are reset in clear modern glass in the north nave clerestory nearest the facade, along with three reused tracery quatrefoils depicting two angels censing an enthroned Christ holding the orb and blessing (Plate V.3). It is impossible to reconstruct their precise original location. Avioth sustained continual damage in the religious wars and again during the Revolution, with much eighteenth-century "tidying up" sandwiched between, and in 1819 a violent storm blew out all the windows on the church's north side.[13]

From between 1819–58 until sometime after 1921, the original fourteen roundels were aligned in the present window in a different order, two lancets of seven medallions each.[14] Certainly these small-scale scenes (approximately 30 to 35 cm in diameter) must have been made for lower windows. For one thing, the glazier uses tiny inscriptions for his angelic pronouncements (Plates V.11a,b).[15] But Avioth has only two nave aisle windows, both now walled up. Most likely would be a location in chapels of the ambulatory, which certainly is not as late in date (1375–1400f.) as architectural historians have main-

tained.[16] The ambulatory's axial chapel and the adjoining bay to the north still have precious grisaille debris *in situ* in their tracery lights, and, like the fourteen roundels, these grisailles are datable to the early fourteenth-century transition to silver stain: naturalistic oak foliage set against a traditional cross-hatched ground, with *jaune d'argent* crudely touched only to the acorns (Plate V.4). Immediately adjacent to the ambulatory in the south transept rose are more early fourteenth-century fragments, from a Last Judgment. Thus an ambulatory location seems most likely for the fourteen medallions, but cannot be made more precise.[17]

Seven of the scenes depict Christ's Infancy and the remaining seven his Passion. The briefest comparison to the *stemma* of Toul Cathedral, presented in chapter II, establishes that the christological cycle at Avioth, in the diocese of Trier and geographically remote, is totally unrelated. Avioth includes two scenes not part of any of the *toulois* series (Annunciation to the Shepherds and Last Supper), and the charming detail lavished by the Avioth glazier on his work strikes a mood of greater intimacy with none of the ceremony of Toul. Besides the aforementioned angelic inscriptions, a few iconographic oddities are noteworthy:

> *Flight to Egypt* (Plate V.5a): Joseph sports both a Jewish cap and a halo (as also in the Nativity), while the Virgin, seated on the donkey, nurses the nude Christ child. While the lower part of his body, on modern glass, may not replicate the original, only one previous example of a nursing Virgin in the Flight to Egypt is known, in a frescoed vault of about 1200 at Petit-Quevilly near Rouen (Plate V.5b).[18]

> *Crucifixion* (Plate V.6a): The Virgin swoons in the new Italianate manner, but with good reason, since the *damasquiné* ground below her arm contains a tiny dragon.[19] The *spasimo* of the Virgin occasionally replaces the heroic, impassive Virgin of the *Stabat Mater* below the cross in the second half of the thirteenth century. Von Simson has pinpointed the theological definition of her suffering in the works of Albertus Magnus and Bonaventura.[20] While her posture varies, the Queen Mary Psalter (Brit. Lib., Royal 2.B.vii, fol. 256v),[21] contemporary with Avioth, shows her similarly posed, head averted down and arms spread; however, in the manuscript, and indeed for most *spasimi*, somebody is there to catch her. The Avioth glazier has provided his own reason for the Virgin's swoon, probably adopted from Psalm 90:13: "Thou shalt walk upon the asp and the basilisk." Serpentine creatures wrapped around the base of the cross appear in German art from the ninth century on; the basilisk or dragon, while much rarer, appears there in the Psalter of Yolande de Soissons (Pierpont Morgan M729, fol. 337v, c. 1280–85; Plate V.6b) as well as in a German glass panel formerly in Berlin.[22]

The Marys at the Tomb (Plate V.7a): Only two Marys appear, behind the unexpected figure of Saint John holding his book. While Gothic art shows two Marys (Matthew 28:1) or three (Mark 16:1), the unique appearance of John is probably based upon his Gospel (20:4–5), stating that John beat Peter to the tomb where he stooped down and saw the linen cloths lying there. While the modern angel probably replicates the original, the middle soldier below is a total fabrication, and John's pointing gesture would seem to indicate that the shroud may have occupied that area originally.[23] John is also featured in the Pseudo-Bonaventura *Meditations* of around 1300.[24]

"Romans" and Jews

The soldiers sleeping beneath the tomb, as well as those in the Betrayal of Christ, have captured the glazier's imagination. The former were Roman "regulars" while the latter were Jews, henchmen of the Sanhedrin.[25] But the "Roman emperor" in the early fourteenth century was a count of Luxembourg—Henry VII (d. 1313), married to the daughter of the duke of Brabant, crowned at Aix-la-Chapelle in 1309. His Gothic knights from the Low Countries were the "Roman" troops with which the glazier of Avioth was familiar, no doubt all too familiar. For medieval Lorraine, inconveniently located between France, Burgundy, and the Empire, "war remained, around 1300, the most constant and most characteristic aspect of the region."[26] Avioth was in a particularly hot spot between the Meuse, which Philippe le Bel treated as his border, and the emperor's lands at the Moselle. Avioth's overlord, the count of Chiny, lived nearby at Montmédy and owed feudal service to the counts of Bar to the southwest.[27] Louis V, count of Chiny until 1299 and married to a Bar, had been a peacemaker attempting to arbitrate between the counts of Bar and Luxembourg. Count Louis VI, whose reign (1310–35) encompassed the Avioth glazing campaign, was married to a daughter of the duke of Lorraine, traditional antagonists of Bar who fought regularly for the emperor.

Thus the sleeping soldiers appear as contemporary Gothic knights in full chain mail and helmets (Plate V.7a), the one to the right in the pancake type of *chapel de fer* that Viollet-le-Duc has dated to the early fourteenth century (Plate V.7b).[28] A slightly less flattened and thus earlier *Eisenhut* appears about 1300–1310 in the glass of the Franziskanerkirche at Esslingen, and other examples are in the Manesse Codex.[29] The shields have early fourteenth-century shapes, the heart shape of the one on the left typical of the Low Countries. Excluding the middle soldier, a modern insertion, the shields bear coats of arms of a dragon (left) and *trois annelets* (right). Neither is common in eastern France.[30] Dragons are infrequent in Gothic heraldry, though found occasionally in Germany, the closest to

Avioth being the punning arms of Drachenfels near Cologne. The other coat of arms, *trois annelets,* while less rare, also appears in the counties of Juliers (Jülich) and Berg, both near Aix/Cologne.[31] Thus the glazier has provided his Roman soldiers with all-too-familiar contemporary fighting equipment that identifies them as "the enemy."

The glazier's Sanhedrin henchmen in the Betrayal scene are even more imaginatively garbed (Plate V.8b). Several wear exotic pointed caps reminiscent of the *Judenhüte* of Germany. The scale armor of the man to the left, while archaizing to indicate an event of long ago, also shows that he is "foreign," like an almost identical scale armor worn by the presumably Slavic/pagan opponent of Der Thüring in the Manesse Codex.[32] Helmut Nickel has pointed out that his high-crowned *chapel de fer* resembles headgear in depictions of Mamluks, and that his sword is a single-edged falchion, probably also indicating Eastern connections. The glazier has selected a streaky ruby glass for their heads and helmets, producing a magnificently malevolent effect of nocturnal, sanguinary evildoing.

The Avioth medallions have been dated about 1300 by authors unaware of the existence in them of silver stain.[33] The date is too early for *jaune d'argent* of this proficiency. The earliest experiments at Avioth appear in the grisaille debris in the ambulatory chapels (Plate V.4), their acorns clumsily smeared with stain. In Lorraine comparable grisailles survive at La Chalade (Meuse), a few patterns there abandoning the traditional cross-hatched ground and thus stylistically more up-to-the-minute. Helen Zakin has conclusively dated the La Chalade grisailles, on the basis of heraldry, to a period after 1301 and before 1314, most probably 1307.[34] The donor was undoubtedly Edouard, count of Bar, raised at the court of Philippe le Bel. Silver stain does not yet appear at La Chalade, a place where, given its sophistication and its donor's Parisian connections, one could reasonably expect to find it first. Thus Avioth's tentatively stained grisaille may date around 1315, exactly coeval with the early, hesitant staining in the Saint-Gengoult lobes discussed at the beginning of this chapter.

A *terminus ante quem* can also be substantiated. In a testament of 1327 the bailiff of the count of Chiny, Jacques de Luz, left five sols to the "oeuvre" of Avioth; another similarly small testamentary gift dates 1328.[35] While architectural historians have offered this as proof of ongoing construction, the smallness of the amounts would indicate the opposite—that the first campaign was over and its decoration probably complete well before 1327.[36] Thus Avioth's fourteen medallions are probably works of the years before and after 1320, and the glazier's command of *jaune d'argent* develops visibly within the series, providing a "laboratory example," in the work of a single craftsman, of the introduction of the new technique.

The present situation of the Avioth medallions, extremely heavily restored and installed in a location difficult of access, requires a loud caveat preceding any stylistic assessment. While my observations and slides, made with field-glasses and telephoto lens from the organ loft adjoining the window, have been checked against the evidence of descriptions published in 1858, 1875, and 1903,[37] a definitive judgment on the extent of

restoration awaits an opportunity to examine the panels dismounted on the light-table. A first group of medallions apparently contains no stain at all: the enthroned Christ in the tracery quatrefoil; Last Supper; Betrayal; Flagellation (Plate V.8a–c).[38] The skin color is often tan glass and the general coloration quite dark, with much saturated red and emerald green used for robes against the foliate ground. Closely related in dark coloration is another group where silver stain appears only for haloes or hair (as in the Saint-Gengoult lobes): the tracery quatrefoils of the censing angels; probably the Annunciation, Visitation, and Entry to Jerusalem (Plate V.9 top left); Crucifixion (Plate V.6a); Noli me tangere (Plate V.10).[39] The Flight to Egypt (Plate V.5a) contains only a little more stain, very sloppily applied (for example, to areas on the donkey's head and the Child's halo). Joseph has a tan face; white glass is used for his hat, stained for the halo around it. The Marys at the Tomb (Plate V.7a) shows a much lighter tonality, with much white glass though not yet much *jaune d'argent*, at least in the glass that has survived.[40]

Another group of medallions uses silver stain a great deal more: the Adoration of the Magi (Plate V.9 bottom left), where even though the bottom half of the roundel is new, one can see stain used for hair, haloes, crown, gifts, and the like. Jean Lafond reported that another late technique, that of painting white glass with color *à froid,* was used by the glazier for part of the green robes, the earliest example known to him.[41] The Presentation in the Temple (Plate V.9 bottom right) also uses stain abundantly for haloes, the Child's robe, the basket, and so on, though Simeon's face is of tan glass.

Two final scenes show a use of stain that is so extensive as to alter and lighten the tonality until it begins to approach the delicate white-and-yellow compositions so typical of fourteenth-century glass. In the Nativity, while the Virgin is a modern design, white glass is used for much of the roundel, with silver stain coloring the ox and ass and the drapes of the manger.[42] Finally the Annunciation to the Shepherds (Plate V.11a) also presents an advanced white-and-yellow tonality achieved by a great deal of stain.[43] From these two final works in the Avioth series, the next logical step for a glazier is pure white glass and stain, as in the Canon Thierry strip inserted into the Chartres south transept and dated by inscription 1328.[44]

The End of an Era

Early fourteenth-century stained glass is known that approaches the new white-and-yellow tonality without yet adopting the silver-stain technique, as in bay 18 of Saint-Père de Chartres,[45] as well as glass that tries out the technique while maintaining the traditional style and color saturation of the past, as at Saint-Alban in Brittany.[46] Only one other monument besides Avioth can be mentioned where the art historian can follow the work of a single glazier working traditionally and then experimenting with the new

stain—at Evron (Mayenne), though his silver-stained compositions are now in various American museums.[47] But in the case of Evron, whatever glass the artist may have produced later, when he had achieved full command of the new technique, has not survived or been identified. Avioth is therefore unique, since one watches the glazier, in the course of producing fourteen medallions, work traditionally, then tentatively apply *jaune d'argent,* and finally begin to realize its potential and alter his composition and coloration accordingly.

But his medallions mark the end of an era rather than the dawn of a new day. While his *damasquiné* grounds, coeval with those at Saint-Ouen de Rouen, look forward to a long period of popularity, they had already appeared at Saint-Urbain and in Lorraine in the ex-voto window at Saint-Gengoult in the 1270s,[48] not to mention the numerous examples before about 1220. The plain roundel shapes were even older in Lorraine, established for the axial bay of Saint-Gengoult in the late 1250s probably on the then-venerable model of Toul Cathedral. Also at home in Lorraine are his favorite colors, a brilliant velvety red and rich emerald green.

The Avioth glazier's fascination with drapery, and his lack of interest in facial modeling or expression, also characterize the artist of the silver-stained lobes at Saint-Gengoult discussed at the beginning of this chapter. In both, the once virile Gothic style appears to have lost its homogeneity, the draperies now marked by mannerism and the sketchy faces by dryness and boredom. The Avioth glazier's draperies are defined purely by line, indeed sometimes a mass of calligraphic display, thick and meandering without really attempting to define mass. A fussy example is the angel in the Annunciation to the Shepherds (Plate V.11a), among the last of the medallions to be executed. Caricatured faces (executioners, henchmen) are more successful than the others, which are occasionally just ugly. White glass is not placed to balance or to compose and indeed often creates an imbalance, perhaps a mark of the transitional nature of this art.

On the other hand, the compositions are fairly well adapted to the roundel shape, formed of "parenthesis" curves, though often with no very strong central focus. The designs are thus centripetal rather than centrifugal in movement. Figures often overlap the border, indeed "become" the border, but sometimes strongly frame a void. The lessons of Gothic design—how to adapt a pattern to a medallion shape—have been applied, as it were, without effort but without thought. Medallions were, after 1300, close to an archaism in French glass; the earliest identified examples of silver stain, at York and Cologne as well as at Evron and Le Mesnil-Villeman, are compositions framed in the ubiquitous canopies of fourteenth- and fifteenth-century stained glass. It is somehow fitting that the last medallions to be designed—at Avioth—are at the same time the ensemble wherein, in the course of production, *jaune d'argent* makes a tentative appearance and quickly triumphs.

VI

POSTLUDE:
THE LOSS OF METZ

Time and I can take on any other two.
—Philip II of Spain

WHILE I hope to have established that the monuments in this book still have secrets to share with us, one must finally face the issue of loss—irreparable and irretrievable loss. The cathedral of Metz presents us with such a loss, in a monument that we would assume to have been among the most important sites of glass painting—by its size and importance, not to mention its subsequent devotion to glazing from the 1380s up to the Chagalls, Bissières, and glorious Jacques Villon windows of the present day. But for the thirteenth-century glazing there are no archives, there are no antiquarian descriptions, there are hardly any surviving fragments, and those that remain provide no heraldry, inscriptions, or iconographic detail to support any hypothesizing at all. Time and fashion and war have triumphed.

The loss is all the more sad, since the pathetic Gothic debris now installed in Metz Cathedral ranges from the commencement of the thirteenth century up to the very threshold of silver stain. Certainly glass was made and used in Metz. Customs rates of 1227 list *verre lorrain* among the merchandise entering the city; a confraternity of glaziers paid rental to the cathedral chapter before 1245.[1] Even allowing for the common application of the term *verrier* both to glassblowers and glass painters, and sometimes to merchants who sold glass vessels,[2] we can safely assume that stained glass was designed and installed in Metz during the thirteenth century. That is about all we can assume.

The most damaging "restorations" appear to have been in the eighteenth century, when after 1754 the cathedral's cloister and surrounding buildings were razed to establish the present Place d'Armes. Bégin, in a letter of 1833, reported the butchery thereafter by a glazier named Koepfner, and in 1840 published recollections that the chapter, before the Revolution, had in storage "an immense quantity of glass panels."[3] His fanciful interpretations of designs he considered Carolingian are, alas, useless.

Fragments of Saint Paul

Six truncated scenes from the life of Saint Paul (Plate VI.1), in almond-shaped medallions and wide borders, have been inserted into the tracery lights of Bay 14 (east window of the south transept) since before 1840. Baron Guilhermy noted them in 1848 and 1852 but added that he could not see them because of strong surface light.[4] Evidently a structure outside blinding the bay also provided some protection, since the fragments are now in good condition. They were first identified as the legend of Saint Paul by the Abbé Joseph Foedit around 1905.[5] The probable identifications of the scenes are as follows: Conversion of Paul on the road to Damascus (Acts 9:1–9); Paul blinded, entering Damascus (?); Paul preaching to hostile Jews in Damascus (?); Descent of Paul in a basket from the walls of Damascus (Acts 9:19–25); Paul preaching in Troas, the sleeping Eutychus at the window (Acts 20:7–9); and Paul shipwrecked off the island of Melita (Acts 28:1–7).

The first four scenes occur in generally similar versions in the twelfth-century mosaics of Palermo (the Palatine Chapel) and Monreale and were possibly included (based on a similar model) in the late twelfth-century Alsatian manuscript of the *Hortus Deliciarum* by Herrad of Landsberg, now destroyed.[6] On the other hand, the last two scenes are extremely rare. Each seems in some way related to Gothic illustrations of the Epistles: while the Eutychus story appears in stained glass at Chartres and Rouen, the sleeping youth at the window is found only in two thirteenth-century Bibles in initials commencing the Second Epistle to Timothy; and while no close comparisons can be found showing Paul in a boat, both of these Bible manuscripts include such a ship in the initial to Hebrews.[7] Thus, since without much doubt the complete cycle at Metz included scenes of Paul's martyrdom originally, it must have been quite extensive.

It is generally presumed, since the Saint Paul scenes are earlier in style than the present cathedral, that they originally glazed Saint-Paul, the chapel of the chapter located above the chapterhouse in the cloister. Probably after 1754, when the cloister was razed, the glass devoted to the chapter's patron Saint Paul was chopped up to fit its present location. Elevation drawings of Saint-Paul suggest that the chapel had somewhat resembled a primitive Sainte-Chapelle, and a document of February 1518 establishes that it had stained glass, then being repaired.[8]

How tantalizing are these extraordinary fragments! Aubert correctly recognized lush Romanesque borders, which he compared to Sankt Kunibert in Cologne, but even he was not convinced by the other Rhenish comparisons he could come up with.[9] Such borders also existed at Toul (see chapter I, page 21). But already in the Saint Paul fragments appear a number of features of later thirteenth-century glass in Lorraine, notably the *damasquiné* grounds (as in the ex-voto window of Saint-Gengoult), almond-shaped medallions within a foliate surround (as at Ménillot), and "green glass of an extraordinary limpidity."[10] Most surprising of all under these circumstances is the figure style: nothing

Germanic about it. As at Toul Cathedral, a marriage of East and West is evident, but the French touchstone for Metz is earlier—the Prodigal Son Master at Sens Cathedral, dated about 1210–15.[11]

At Metz the unbearded head type is enlarged and marked by a ceremonial classicism very close to Sens, as are the elegantly proportioned and gracefully draped bodies moving on slender pointed toes. The classicizing modeling defines mass as at Sens, by leaving the protruding areas (knees, shoulders, thighs) clear and unpainted. The coloration of the Sens window, as described by Caviness, is similar: lucid blue grounds (*damasquiné* at Metz), brilliant red in large quantities, hot yellow, some mid-green, and white and pink for the draperies. This palette is altered at Metz only by a larger proportion of hot yellow and, as already noted, of the remarkable soft, limpid green.

The Saint Paul fragments, over a decade earlier than Toul, present a like conjunction of French and Rhenish elements and in an already distinctive *lorrain* guise. With the loss of the chapel of Saint-Paul and in the absence of any archival reference to its construction or glazing, the mystery of how this came to be remains.

Notre-Dame-la-Ronde

Fragments from the axial window of the church of Notre-Dame-la-Ronde, installed since 1887 in two nave bays of Metz Cathedral, survive in much worse condition, drastically restored and overhauled, and now backed with chickenwire and very dirty.[12] This church, which was oriented at right angles to the cathedral nave, occupied the site of the present three western nave bays, and its apse survives as a chapel off the south nave aisle (Plate VI.2). The wall between Notre-Dame-la-Ronde and the cathedral nave (both structures begun during the first quarter of the thirteenth century) was only demolished about 1380 in order to unite them.[13] Nineteenth-century eyewitnesses mention the glass still *in situ* in the axial doublet-and-rose window of the "chapel" until its replacement after 1884.[14] Thereafter, the Coronation of the Virgin (Plates VI.3a–c) surrounded by six angels, which had filled the rosace, was transferred without too much alteration to the traceries of Bay 28, originally part of the same church. The doublet lancets below had contained eighteen figures forming a Tree of Jesse, among them kings, apostles (including Peter and Paul), the Virgin and Child, and Christ. These figures are now piled up in rows in the westernmost bay of the north aisle (Bay 33) (Plate VI.4), totally engulfed by modern surrounds and so heavily manhandled that only a few panels still repay study.

A few remarkable old photographs (Plates VI.5a–d) make possible some stylistic judgments. Hans Wentzel published one of them, the upper panel of the standing Virgin and Child, without comment but with the suggested date of mid-thirteenth century.[15] While his surrounding plates (Freiburg, Naumburg, the Strasbourg glass of 1240–60) do little to

confirm this judgment, we are clearly in the right venue. The high triangular-backed throne of the Metz Coronation is a Germanic type (Plate VI.3a), a more primitive version of the thrones at Sankt Dionys, Esslingen, about 1300.[16] The heavy features and abstract draperies (Plates VI.5a–d), painted with rigid parallel lines, relate the Notre-Dame-la-Ronde figures to the last gasp of Romanesque at Strasbourg, the fragments installed in the north transept and the south rose of about 1235.[17] This idea finds some support in an iconographic detail: the Metz Coronation shows the Virgin seated to Christ's left (Plate VI.3a), as at Toul Cathedral (Plate I.4b). In discussing Toul (chapter I, page 11), I attempted to establish the Strasbourg south transept portals as the source for this variant (Plate I.4c). It is repeated in the sculpted tympanum of Notre-Dame-la-Ronde, where a Strasbourg source seems undeniable.[18]

The color of the Notre-Dame-la-Ronde fragments is far removed from that of the Saint Paul medallions. Medium-blue grounds are nearly overwhelmed by large amounts of pure saturated red, pasty white, and clear yellowish green in the draperies, with brown and a tannish gold used for accents. Again the green—though a different shade from the Saint Paul series—is distinctive. If the stained glass of Notre-Dame-la-Ronde is Alsatian and dates in the late 1230s, then it would offer a most fascinating contrast with the coeval remains of the earliest glazing campaign at Toul. In the absence of an established building chronology for the now largely dismembered Notre-Dame-la-Ronde, and considering the darkened and massively restored condition of its glass, there the matter rests.

Five Roundels in the Nave

Five unmatched medallions are installed in the nave aisles, in the tracery lights of the bays nearest the crossing (Bays 19 and 20). All but one (the Stoning of Stephen) have been there since 1840, when Bégin published descriptions and drawings (Plates VI.6, VI.8a, and VI.10a).[19] It is commonly assumed that they originated in the Gothic cathedral somewhere. While the earliest texts referring to construction are bulls of December 1220, it is now believed that the civic strife in Metz during the second quarter of the century, as well as the bishops' great indebtedness, prevented the project from rising from the ground. Since only in 1257 does another papal bull refer to construction, stained glass designed for the actual building would presumably date no earlier.

Probably the earliest of the five panels is the tiny donor kneeling and holding his window, in Bay 19 (Plate VI.7).[20] While Wentzel stated that donors rarely appear thus in German glass, he cited a few examples in and near Alsace.[21] Like the Notre-Dame-la-Ronde figures, the closest stylistic comparisons are to Germanic glass, in this case to the heavy forms and thick painted line in slightly later works of the 1240s.[22] The little donor is always called a monk since he may be tonsured and wears a hooded robe of the deep

blue that glaziers often provided for Benedictines, but if indeed he is, then his presence in the cathedral is not obviously explained. Perhaps the monk donor may have come, like the Saint Paul series, from one of the nearby churches dismantled after 1754.[23]

The three roundels in the south aisle—the Stoning of Stephen, the Flaying of Bartholomew, and the standing figures of Saints Stephen and Paul, patrons of the cathedral and chapter (Plates VI.8–10)—have usually been grouped together, and indeed they share a similar coloration, featuring hot yellow and pure red against a medium-blue ground.[24] They are, however, works of three different painters, though clearly executing the same head pattern (see Plate VI.9a,b). But the stiff yet mannered and somewhat effete figures of Stephen and Paul (Plate VI.10) have no connection to the movemented designs of the two martyrdoms. Though far from the heavily shaded fold style that developed in Toul in the last third of the century, the simple linear drapery painting of the Stephen and Paul roundel is familially related to the Bartholomew martyrdom (Plate VI.8b), as well as to the earlier noblewoman donor at Sainte-Ségolène, a work probably of the early 1250s (see Appendix V and Plate II.3). Thus it seems possible that the Metz roundels preserve something of the general style of Metz Cathedral during the period of its construction, following the bull of 1257.

The scenes of the Flaying of Bartholomew (Plate VI.8) and Stoning of Stephen appear to be related designs, each based on the display of the martyr forming the horizontal base of the composition, the executioners above active but also balanced and adapted to the roundel shape. Unfortunately the two make a false pair. Although Stephen was the cathedral's name-saint, the only mention of Bartholomew I have uncovered is to a twelfth-century altar not in the cathedral but in Sainte-Marie (Notre-Dame-la-Ronde?).[25] While the local references for the simple, linear drapery of the Bartholomew scene were rehearsed above, the draperies of the Stephen martyrdom consist of many fine lines and include a "flying fold," both characteristic of an early thirteenth-century glazing style. Moreover, the Stoning of Stephen is not in Bégin's drawings or descriptions of 1840 or indeed mentioned by any nineteenth-century author.[26] The one piece of drapery in the Bartholomew roundel that resembles the fine linework of the Stephen martyrdom is a modern replacement for a stopgap that appears there in the 1840 drawing. Thus the Stoning of Stephen may be a forgery or a modern pastiche reusing some old glass, a provisional judgment that could be tested only by close examination of the dismounted panel. If true, it would explain why Stephen's dark green robe is so different from the magnificent greens of other Metz glass.[27]

The fifth roundel (Plates VI.6 right and VI.11), depicted in an 1840 drawing and noted shortly after by Guilhermy, shows the Annunciation, the protagonists and a large flowering plant between them all set directly against a grisaille ground. The grisaille has latticework filets forming lozenges filled with naturalistic leaves of gross scale against a crosshatched ground. The Virgin's head is a stopgap.[28] Although the colors are strong—pure red, dark blue, hot yellow—the grisaille creates a much lighter tonality. Figures set against grisailles occur in German glass with some frequency,[29] and Aubert considered the

small heads and elongated bodies Rhenish, comparing them to the later Virtues at Saint-Etienne, Mulhouse.[30] However, the tiny figures and heavy foliage ground also remind one of the silver-stained lobes of Saint-Gengoult (chapter V). And the elongated forms, swaying postures, and combination of crude facial type (Gabriel) with fussy, illogical drapery painting recall the more interesting artist of Avioth.

As at Avioth, grisaille fragments remain in a few of the tracery lights of the Metz nave aisles (Plate VI.10b). Grisailles also fill the smaller tracery lights of the north nave aisle of Strasbourg, dated 1250–75[31] and thus coeval to construction at Metz. The meager Metz grisailles are not close in style to those of Strasbourg. In the end no comparison is useful and no explanation related to the thirteenth-century nave of Metz possible. The stained-glass program of Metz is simply lost.

Certainly we would command a fuller understanding of the Gothic stained glass of Lorraine were this not so. But the glass that has survived in the region's four *départements* of Meurthe-et-Moselle, Meuse, Moselle, and Vosges—catalogued only in 1983—is therefore the more precious, its testimony of the past the more rare and valuable, its charm the more alluring, its many-splendored power the greater treasure, its safekeeping the weightier charge on future generations.

APPENDIXES

Appendix I

Gervase of Tilbury, *Otia imperiale*, Bk. III, chap. xxv (ed. Gottfried Wilhelm Leibnitz, *Scriptores Rerum Brunsvicensium*, Hannover, 1707, I, 968).

XXV. *De figura Domini, quae Veronica dicitur.*
Porro sunt alii vultus Domini, sicut est *Veronica*, quam quidam Romae delatam a *Veronica* dicunt, quam ignotam tradunt mulierem esse. Verum ex antiquissimis scripturis comprobavimus, hanc esse Martham sororem Lazari, Christi hospitam, quae fluxum sanguinis duodecim annis passa tactu fimbriae dominicae sanata fuit, propter diutinam passionem fluxus carnalis in * * * unde * * * poplitis vena incurvata Veronica dicta est. Hanc ex traditione veterum novimus in tabula pictam habuisse Dominici vultus effigiem, quam *Volusianus amicus Tiberii Caesaris* apud Hierosolymam ab ipso transmissus, ut de factis & miraculis Christi certum signum referret, quo de morbo suo Tiberius curaretur, ab ipsa Martha, licet invita, quorundam subjectione abstraxerat. In cujus direptione Martha contristata vultum hospitis sui secuta traditur Romam venisse & Tiberium in primo Veronicae picturae conspectu curasse. Unde etiam ex tunc longo ante Apostolorum adventum tempore, Christi fides usque adeo Romanis innotuit, quod Tiberius de mansuetissima ove saevissimus lupus effectus perhibetur desaeviens in senatum eo quod, ipso volente suscipere Christi agnitionem dedignaretur, sicut *in libro de transitu B. Virginis*

& gestis discipulorum profusius tractavi. Est ergo *Veronica pictura Domini vera* secundum carnem repraesentans effigiem a pectore superius *in basilica S. Petri juxta valvam* a parte introitus dextra recondita. Est & alia dominici vultus effigies in tabula aeque depicta, in oratorio S. Laurentii, in palatio Lateranensi, quam sanctae memoriae nostri temporis Papa Alexander III multiplici panno serico operuit eo, quod attentius intuentibus tremorem cum mortis periculo inferret. Unumque procul dubio compertum habeo, quod si diligenter *vultum dominicum,* quem Judaeus *in palatio Lateranensi* juxta oratorium S. Laurentii vulneravit, cujus vulnus cruore tanquam recente faciem dextram operuit, attendas, non absimile Veronicae basilicae S. Petri cive picturae, quae in ipso S. Laurentii est oratorio, vultuque Lucano reperies.

Appendix II

Gerald of Wales, *Speculum ecclesiae*, Bk. IV, chap. VI (ed. J. S. Brewer, *Giraldi Cambrensis Opera* IV, London, 1873, 278–79).

. . . De duabus igitur iconiis Salvatoris, Uronica scilicet et Veronica, quarum una apud Lateranum, altera vero apud Sanctum Petrum inter reliquias pretiosiores habetur, primo dicetur.

Lucas vero Evangelista medicus erat, tam corporum egregius quam animarum eximius, et pictor quoque mirabilis; qui cum matri Jesi post ascensionem adhaesisset, inquit ei Maria: "Luca, quare non depingis Filium meum?" Cum ergo ipsa indicante prius singula membra pinxisset, et post multarum deletionum correctiones tandem in unam imaginem conjuncta matri obtulisset, ipsa imaginem diligentius intuita subjunxit: "Hic est Filius meus." Tales fecit duas vel tres, quarum una Romae habetur apud Lateranensem, scilicet in sancta sanctorum. Quam cum papa quidam, ut fertur, inspicere praesumpsisset, statim lumen oculorum amisit, et deinde cooperta fuit auro et argento tota praeter genu dextrum, a quo oleum indesinenter emanat. Haec autem imago dicitur *Uronica,* quasi essentialis. Alia autem imago Romae habetur, quae dicitur *Veronica,* a Veronica matrona quae tamdiu desideraverat et orationibus Dominum impetraverat videre; quae semel exiens a templo Dominum obvium habuit dicentem: "Verona, ecce quem desiderasti." Quem cum intuita fuisset, ipse peplum ejus accipiens impressit vultu suo, et reliquit in eo expressam imaginem suam. Haec in magna similiter reverentia, et a nemine, nisi per velorum quae ante dependent interpositionem inspicitur; et haec est apud Sanctum Petrum. Haec autem illa, ut legitur, mulier fuit, quae tangens fimbriam vestimenti Jesu a sanguinis profluvio curata fuit. Legitur etiam quod eadem mulier post Christi passionem Romam de Hierosolimis venire coacta, eamque secum portare quam relinquere voluit

compulsa, statim ut Tiberio Caesari allata fuit curatus est a morbo incurabili quo laboraverat. Dicunt autem quidam vocabulo alludentes, Veronicam dici, quasi *veram iconiam,* id est, imaginem veram.

Appendix III

Richer of Senones, *Gesta Senoniensis ecclesiae,* Bk. iv, chap. 37 (ed. G. Waitz, *Monumenta Germaniae Historica, Scriptorum,* xxv, 323).

Cap. 37. *De horrendo facto Iudei de Sancto Deodato.*

Iozepho testante didicimus, quod Salomon rex Ierusalem sortilegia et incantationes et auguria adinvenerit, quibus demonia et dracones monstraque venenata voluntati hominum parere noscuntur, quibus incantacionibus gentem Iudeorum dicit esse peritam, ita ut adhuc eisdem incantationibus utantur, sicut in subcedentibus quisque audire poterit. Apud Sanctum Deodatum temporibus nostris multitudo Iudeorum habitabat, inter quos unus erat qui talibus incantationibus et auguriis a contribulibus suis peritissimus habebatur. Huius Iudei domum quedam pauper iuvencula frequentabat et in eadem domo que agenda erant agebat, ut sustentationem victus ibi accipere posset. Enimvero cum quadam die ipsa iuvencula domum ipsius Iudei, ut solebat, intrasset et Iudeus ille iuvenculam illam vidisset, gavisus est valde, quia solus cum sola in domo erat. Et accersita ea, dixit ei: 'Veni et comede paululum, quia te opportet operari'. Et cum illa comedisset et bibisset, ita est incantata, ut dormire videretur nec aliquid sentiret; et cum Iudeus videret, incantationes suas effectum habere, obseratis hostiis accepit utensilia sua ad hoc quod facere volebat preparata, et ad iuvenculam illam accedens, divaricatis cruribus eius, quibusdam ferramentis folliculum illum qui matrix appellatur, in quo infantes concipi solent, de utero illius per naturam extraxit. Hoc facto, matricem illam sibi reservavit. Sed quid inde volebat facere, adhuc nobis incognitum est. Iuvencula vero illa cum per horam ita iacuisset et Iudeus ille quod sciebat ad hoc necessarium esse circa illam fecisset, iuvencula ipsa surrexit, et senciens se intus in corpore lesam, cepit flere. Iudeus vero multa ei promittebat, ut rem silencio tegeret. Illa vero flens domum exivit. Mulieres vero christiane cum vidissent eam de domo Iudei exivisse ita plorando, accesserunt ad eam et interrogaverunt eam, quare fleret. At illa respondit eis, quod Iudeus ille nescio quid cum ea egerat, unde in ventre torqueretur. Mulieres vero ille eam in domum ducentes, studiose eam cirsumspexerunt et invenerunt quod ei acciderat. At vero cum cives illius ville hoc cognovissent, presentaverunt eam cuidam Philipo, qui eo tempore prepositus ducis Lothoringie constitutus erat. Prepositus vero ille vocavit Iudeum ad iudicium, proponens

ei factum. Ille negat; at contra christiani instant et ei invenculam illam lesam ostendunt. Quid plura? Convincitur Iudeus, fatetur se peccasse; iudex inquirit, ad quid hoc volebat; ille noluit confiteri, et sic morti adiudicatur. Equus preparatur, et ad caudam ipsius alligatur. Et cum ita ad patibulum traheretur, Iudeus magna voce clamavit: 'Cessa, cessa, ego aliquid volo dicere'. Ille vero qui in equo sedebat velocius cum equo Iudeum trahebat; quia alii Iudei illi pecuniam promiserant se daturos, ut non permitteret eum aliquid loqui, ne forte aliquid in obprobrium Iudeorum loqueretur. Et ita raptus ad patibulum, capite ad terram verso suspenditur. Sed post biduum a Iudeis redemptus, de patibulo deponitur et nescio ubi tumulatur. Sed credibile est, quod anima eius in inferno sit sepulta. Verumptamen adhuc de nefandissimis Iudeorum actibus aliquid dicamus.

Appendix IV

Jean Ruyr, *Recherches des sainctes antiquitez de la Vosge, province de Lorraine,* Epinal, 1634, 447–50.

Autre impieté commise par les Iuïfs en la Ville de Sainct Diey.

Chap. XVI

La hayne que les Iuïfs ont porté aux Chrestiens, dez le temps mesme que nostre Sauveur Iesus Christ conversoit humainement avec eulx, est si grande, que l'Escriture saincte en fait de tres evidentes demonstrations. Et bien que les Apostres & Disciples de ce Mediateur eternel leur eussent prouvé maintes fois par les Escrits, tant de leur grand Legislateur Moïse, que des Saincts Prophetes, le moyen de se reconcilier à Dieu: Si est ce, qu'une grande partie de ceux qui demeurent obstinez en la dureté de coeur, n'auroient desisté, d'eslancer d'horribles ecclats de leur felonie: Voire iusques à ces derniers Siecles, contre le tres-auguste Sacrement de l'Eucharistie, puis qu'ils ne pouvoient autrement exercer les inventions de leur rage contre Iesus-Christ.

Nous en dirons donc un Exemple de la Tradition de nos Majeurs. Quelques années apres l'execution du Iuïf Necromancien, les autres restans en la Ville de Sainct Diey retenus aucunement en leur debvoir (ce sembloit) de peur d'encourir le chastoy condigne à leurs demerites, croyoient avoir appaisé la mauvaise opinion que le Clergé, & la Bourgeoisie peurent iustement concevoir co(n)tre eulx. Iusques à ce que l'un d'iceux, ou peutestre tous tant qu'ils estoient de cette Synagogue, vont malicieuseme(n)t comploter par un advis Satanique, de suborner un Chrestien, & luy suggerer en ces termes captieux. Voicy (dit un Rabi) les iours de Pasques arriver, que tu iras avec les autres Chrestiens

participer à la communion de Iesus de Nazareth: tu peus bien, si tu veux, nous faire un grand office d'amitié, que nous recognoistrons à ton contantement, & dont voylà des arres (en luy donnant en main quelque chose.) Tu sçais que nous sommes privez de cette Communion, encor qu'a regret, car il nous convient selon nostre Loy, faire des Sacrifices & des Pasques de bien plus grands cousts, que ceux de l'Eglise Chrestienne, Fay nous donc ce plaisir, Qu'aussi tost que tu auras receu l'hostie de la main du Prestre, elle soit par toy subtilement mise en cette boiste, pour la nous apporter entiere. L'autre, soit de simplicité, soit de malice, donnant foy aux parolles affectées de ces Iuïfs, promet de leur satisfaire, & le fait, mais si peu cautement, que le Ministre du Curé, qui luy devoit presenter à boire apres la Communion, l'ayant consideré manier ie ne sçay quoy, & peu attentif à cette pieuse action, se doubta qu'il ne faisoit rien de bon, dont il prit occasion d'en donner advis à son Pasteur, mais ce ne fut à l'instant, de peur de le troubler: Il le remarque seulement. Le lendemain matin qu'estoit le Vendredy Sainct, le mesfait vient aux oreilles du Clergé, voire du Reverend Grand Prevost, qui par l'advis du venerable Chapitre, fait promptement venir ce miserable proditeur, l'interroge, & recognoit avoir porté ce Sacre-sainct Gage de nostre Redemption, en la maison d'un Iuïf ayant sa Residence au mylieu des autres. Le Prevost du Duc sur ce requis va dextrement au lieu designé, se saisit du Iuïf, luy demande ce qu'il avoit fait de la Saincte Hostie, & qu'il la remette en main d'un Prestre qui suyvoit les siens, pour s'en asseurer, si elle estoit en estre, iusques à ce que le Prelat en eust ordonné. L'on a eu plusieurs opinions sur ce fait, & pleust à Dieu que le tout eust esté fidellement redigé en escrit: Car aucuns, comme Iean Basini, & devant luy Hugo Carbanus anciens Chanoines, ont dit, que le Iuïf ayant pressenti cette Recerche, jetta la Saincte Hostie en un lieu sale pour la cacher ou infecter: Autres, que surpris, il la poussa vistement dans le feu. Et aucuns affirmoient qu'elle fut retrouvée, & avec solemnité rapportée en l'Eglise encor que mutilée & decrachée par cêt infect mescreant, precurseur des Lutheriens & Calvinistes, qui long temps apres n'en ont pas fait moins.

Le Duc recepuant la plainte de cette indignité, ordonne que le Iuïf apprehendé subisse le chastoy condigne à son mesfait, & que tous les autres ses consorts soient expulsez de la Ville de Sainct Diey, sans espoir de retour. Il ne nous reste aujourd'huy aucun Escrit de cette histoire, & n'en ay veu cy devant autre qu'un petit Manuscrit en mains du bon Prestre Sacristain de la grande Eglise appellé Nicolas Marquis, qu'il disoit avoir esté sauvé d'une grande Conflagration avenüe de son temps en l'an 1554. Dont les Eglises, maisons Canoniales & la pluspart des Rües bourgeoises furent consumées par le feu. Quoy qu'il en soit, les Chrestiens habiterent les maisons desertes des susdits exilez: Et quiconque à possedé celle du Iuïf prevenu dudit Sacrilege, a esté obligé d'apporter ou d'envoyer à l'offrande de la Messe ou Office du Vendredy Sainct, un millier de petites hosties à consacrer, en memoire de l'impie Attentat dudit Iuïf. Ceremonie qui n'a oncques esté interrompüe, & persevere encor maintenant.

Appendix V

Sainte-Ségolène, Metz:
Probable Donor and Date of the Thirteenth-Century Glass

Sainte-Ségolène was a parish church located just beyond the old Roman walls of Metz, opposite the Porte Moselle. This quarter was enclosed by new walls by 1227, the year the Porte Moselle was dismantled as no longer of use.[1] Thereafter a Gothic church was built for the parish, partly at the cathedral chapter's expense. From about 1845 to 1855 new stained glass was commissioned for the apse, south chapel, and one window of the north chapel. Presumably at this time fragments of medieval glass ranging in date from the twelfth through the fifteenth centuries were regrouped in a patchwork in the north chapel, salvaging several inscriptions and images of donors.[2] Among this debris are ten almond-shaped medallion frames and their surrounds, of mid-thirteenth-century style, with borders of white fleurs-de-lys on a red ground and the kneeling image of a noble-woman (Plate II.3). Since, unlike the twelfth-century fragments that probably had glazed the replaced church, this thirteenth-century debris is stylistically coeval with the existing construction and seems to fit its apertures, the identification of its donor and of the most probable date of her gift provide a useful *terminus ante quem* for the Gothic architectural campaign.

In thirteenth-century Europe the only family recorded to have borne arms of *gules* with *fleurs-de-lys argent* was Wesemaele, the hereditary *maréchals* of the duke of Brabant.[3] While the Wesemaele arms later regularly used the Brabantine type of fleur-de-lys, with couped foot (*pied nourri*),[4] such was not yet the case in the mid-thirteenth century. Arnoul II de Wesemaele (d. 1291) sealed in 1241, 1260–61, and 1276 with fleurs-de-lys *complètes,* as in the Sainte-Ségolène borders.[5] Married and widowed twice, he ended his life as a Templar and grand-maître d'hôtel to the king of France.[6] His second wife was Alix (Aleyde) de Louvain, daughter of the duke of Brabant.[7] He was her third husband, following Arnoul, count of Looz (d. 1223), and Guillaume, count of Clermont and of Auvergne (d. 1245); by the latter she had six children.[8]

Alix de Louvain, a princess of Brabant, having spent several decades of her life far south in the Auvergne, seems to have returned to her homeland upon the death of Guillaume and to have begun settling old business immediately. In 1245 she gave reve-nues to the abbey of Saint-Trond, which her first husband's family served as hereditary *avoué.*[9] In February 1247 she agreed to submit to arbitration a dispute with her first husband's nephew and heir over the return of her dowry.[10] Her third marriage, to Wesemaele, took place early in 1251. As his wife, in April of that year, she ceded her rights in the Auvergne to her eldest son by that marriage, and in December 1251 she attended to more old business by confirming, as widow of her first husband, rights of the

abbey of Herckenrode (Limbourg), his family's traditional burial place.[11] It seems most likely that she also donated stained glass to the new Gothic church of Sainte-Ségolène around that year.

Although I have not succeeded in finding archival proofs, it is probable that the county of Metz had formed part of her previous dowry, mentioned in the documents of 1246 and 1251 as under dispute. While the actual *comté* of Metz no longer existed as a territorial entity by the thirteenth century,[12] its title and revenues survived among the dower rights of Gertrude, daughter of Albert of Dabo (Dagsbourg), a younger son of the line of Brabant. Gertrude was cousin to the duke of Brabant, Alix's father. Before Gertrude's birth in about 1205, her father, whose sons had died tragically, had arranged prematurely to bequeath the *comté* of Metz, among other properties, to the duke, his nephew.[13] The agreement was frozen upon the birth of Gertrude, the *comté* of Metz forming part of her dowry for three marriages. When she died childless in 1225 at the age of nineteen or twenty, there was a mad scramble for her possessions. In October 1223 Gertrude and Alix, then the widow of Arnoul de Looz, had been together for a confabulation, subsequent to which Alix married her second husband (before 3 February 1225), while Gertrude died early that year, before 19 March, when the scramble began over her inheritance.[14]

The parties involved in the struggle eventually included everyone with any interest in Lorraine: the bishop of Metz, who at her death had acted quickly to reunite the *comté* of Metz to episicopal control, the citizens of Metz as constant antagonists of the bishop's power, the duke of Brabant, the duke of Lorraine (heir of Gertrude's first husband), the count of Bar, the count of Champagne (her second husband), and the family of the count of Linange (her third husband). The wars and peace treaties that rapidly succeeded one another culminated in the establishment of communal rule in Metz by 1244, when the city magistrates were in control of the city revenues.[15]

The city of Metz, the most populous in Lorraine, developed in the thirteenth century much like the more well-known Tuscan city-states, with warring families building residence towers and forming antagonistic blood-alliances called *paraiges.* One of the three original *paraiges* and most powerful of them all was that of Porte-Moselle, the *maire* of which enjoyed unique honors and privileges and controlled revenues above all other *paraiges.* More important to this study, the *paraige* of Porte-Moselle used the church of Sainte-Ségolène as its meeting place.[16]

The city magistrates issued a solemn proclamation in 1250 in an attempt to control the continual civic violence, and another in 1254 that established a body to settle disputes between two *paraiges* and forbade individual *paraiges* to conclude alliances with princes.[17] Alix de Louvain, by mid-century returned to her homeland and married to one of its most powerful lords, was in an expansive and peacemaking mood, as established by her actions mentioned above in ceding properties to her son by her second husband and in confirming revenues of Saint-Trond and Herckenrode, abbeys favored by her first husband and his family. Her gift of stained glass to beautify the new Sainte-Ségolène, meeting place of the

ranking *paraige* of the city of Metz—now in firm control of whatever dower rights she may once have possessed there—would be an act in the same tenor, and its most likely and appropriate date about 1250–54, when the city was healing its wounds.

In sum, I believe that the kneeling noblewoman shown in the Sainte-Ségolène fragments—who originally seems to have held a window as donor—is Alix de Louvain, and the red borders with white fleurs-de-lys are her arms following 1251 as wife of Arnoul de Wesemaele.

Notes

1. Jean Schneider, *La Ville de Metz aux XIIIe et XIVe siècles*, Nancy, 1950, 34, also fold-out map at the end of the volume.

2. Al. Huguenin, "Notice historique sur l'église Sainte-Ségolène de Metz," reprint from *Mémoires de la Société d'histoire et d'archéologie de la Moselle*, Metz, 1859, 13–14, 54–55, 57, 63. The visit to the church by the Congrès archéologique in 1846 recorded that "plusieurs de ses fenêtres sont encore ornées d'anciens vitraux du XIVe [sic] siècle." *Congrès archéologique*, XIII, 1846, 106.

3. In addition to Wesemaele, the family of Aguillon in Sussex in England occasionally used *gules trois fleurs de lys argent: Rolls of Arms, Henry III*, Aspilogia II, London, 1967, 127 no. 63. I have searched all references in the ordinary of Léon Jéquier and have examined the thirteenth-century sources he omitted (xxxvi): Léon Jéquier, "Tables héraldiques de dix-neuf armoriaux du moyen âge," *Cahiers d'héraldique*, I, 1974.

4. On the Brabantine fleur-de-lys: Paul Adam, "Quelques figurations particulières de la fleur de lis et leur blasonnement," *Brabantica*, VI, 1962, 217–21.

5. Prinet specifies (with references to Douët-d'Arcq 683, 9875 and de Raadt, IV, 229) that Arnoul II sealed with fleurs-de-lys *complètes*: Max Prinet, "Armorial de France composé à la fin du XIIIe siècle ou au commencement du XIVe," *Le Moyen âge*, XXXI, 1920, 34 no. 102. The question needs study since, while *pieds nourris* appear in Wesemaele arms as early as the Wijnberghen Roll (dated c. 1270–83 for the *marche* of Brabant), several very late armorials maintain the fleurs-de-lys *complètes*, for example, the Codex Seffken: Paul Adam-Even, "Un Armorial français du XIIIe siècle, l'armorial Wijnberghen," *Archives héraldiques suisses*, LXVIII, 1954, 70, no. 1175; *Wappenbuch von der Ersten, genannt "Codex Seffken," der Urschrift aus dem Ende des 14. Jahrhunderts*, ed. Ad. M. Hildebrandt and Gustav A. Seyler, Berlin, 1893, fol. 10r, no. 1.

6. He was never Grand Master of the Temple, a mistake that seems to have originated with F. Christophre Butkens, *Trophées tant sacrés que prophanes du duché de Brabant*, The Hague, 1724, II, 123–26. As a Templar he defended the French queen Marie de Brabant from charges of poisoning her eldest stepson in 1276. See Elizabeth A. R. Brown, "The Prince Is Father of the King: The Character and Childhood of Philip the Fair of France," *Mediaeval Studies*, XLIX, 1987, 325. His career at the French court is mentioned by Joseph Strayer, *The Reign of Philip the Fair*, Princeton, 1980, 144 n. 9, and Jean Favier, *Un Conseiller de Philippe le Bel: Enguerran de Marigny*, Paris, 1963, 73. Favier (n. 1) erroneously cites documents dating 1298–1301 in Jules Viard, *Les Journaux du trésor de Philippe IV le bel*, Paris, 1940, cols. 164, 336, 416, 552, 683. These entries naming an Arnulphus de Wisemale, *miles*, possibly refer to his nephew, who died at Courtrai: see bibliography in Prinet, "Armorial de France," no. 102. The Templar Arnoul de Wesemaele died earlier; a drawing of his tombstone provides the date 1291. See Charles-Victor Langlois, *Le Regne de Philippe III le Hardi*, 1887, rpt. Geneva, 1979, 45 n. 2.

7. Alix was still alive in 1261: Alphonse Wauters, *Table chronologique des chartes et diplômes imprimés concernant l'histoire de la Belgique*, Brussels, 1874, V, 242. She died c. 1265, around the time that Arnoul led an unsuccessful revolt against the installation of Duc Jean I, in which his two brothers were taken prisoner and he and brother Gérard were excommunicated. Recon-

ciled to the ducal court, Arnoul entered the
Temple between 1268 and 1270. See Wauters,
"Le Duc Jean Ier . . . ," *Académie royale des
sciences, des lettres et des beaux-arts de Belgique,
Mémoires couronnés et autres mémoires, Collection
in-8°,* XIII, 1862, 44–49; Wauters, "Suite à ma
notice sur le duc Henri III de Brabant . . . ,"
*Bulletins de l'Académie royale des sciences, des
lettres et des beaux-arts de Belgique,* 2d series, XL,
1875, 364–65, 375–76, 384–85.

8. Christophe Justel, *Histoire généalogique de la
maison d'Auvergne,* Paris, 1645, 54; Etienne
Baluze, *Histoire généalogique de la maison
d'Auvergne,* Paris, 1708, I, 84–85, 99–100, II
(preuves), 89–92, 105, 108. On Alix de Lou-
vain and her three husbands: Père Anselme,
Histoire de la maison royale de France, Paris,
1726, rpt. 1967, II, 329–31, 791.

9. Wauters, *Table chronologique,* IV, 438. On the
avoüerie, see Anselme, 328, 330.

10. The text of the compromise on her dowry is
published in Hippolyte Goffinet, *Les Comtes de
Chiny, étude historique,* Brussels, rpt. 1981 (fac-
simile of six articles 1874–80 of differing pagi-
nation), chap. x (Arnulphe III), 329–30;
Wauters, *Table chronologique,* IV, 491.

11. Wauters, *Table chronologique,* V, 6 (April 1251
chart) and 19 (December 1251 *chart).* The text
of the former is given in Max Prinet, "Sceaux
attribués à des seigneurs de Duras en Guyenne,"
Revue numismatique, XVII, 1913, 558; the text of
the latter is published in J. Daris, "Le Cartulaire
de l'abbaye de Herckenrode," *Bulletin de l'Institut*

archéologique liégeois, x, 1870–71, 475. On the
Looz family members buried at Herckenrode, see
Anselme, 329–31.

12. Schneider, 430, 432; on 95 and 104 he identifies
the revenues, rights, and responsibilities of the
comté. See also V. Chatelain, "Le Comté de Metz
et la vouerie épiscopale du VIIIe au XIIIe siècle,"
*Gesellschaft für Lothringische Geschichte und Al-
tertumskunde, Jahrbuch,* XIII, 1901, 286–89.

13. Gertrude's father also promised a donation of
some of the *terres* to the bishop of Liège:
Butkens, I, 191, 648; Chatelain, 284; Schnei-
der, 102–3, 107 n. 35. See Anselme, 787–91,
for the genealogical relationships.

14. Georges Smets, *Henri I, duc de Brabant, 1190–
1235,* Brussels, 1908, 176–77, 183.

15. The outcome of the dispute over Gertrude's
dower lands is not clearly documented (But-
kens, 191, 651), but the commune of Metz
clearly won control of the former *comté.* On the
factions and alliances warring from 1225
through the 1230s, see Schneider, 107–12,
129–33; Smets, 182–85, 187–89; Marcel
Grosdidier de Mâtons, "Le Comté de Bar des
origines au Traité de Bruges (vers 950–1301),"
*Mémoires de la Société des lettres, sciences et arts de
Bar-le-Duc,* XLIII, 1918–21, 252, 263, 275.

16. Schneider, 118 (towers), 127–28 (definition of
a *paraige),* 125 (meeting places of *paraiges),*
118–22 (development of the three original
paraiges), 78–79 and 433 (special powers of the
maire of Porte-Moselle).

17. Schneider, 133–34.

Appendix VI

Écrouves (Meurthe-et-Moselle):
Probable Date of the Grisaille

The rural church of Écrouves, four kilometers from Toul, was rebuilt in the early thirteenth
century, retaining a twelfth-century tower over the nave bay adjoining the chevet. The
church was later fortified, probably around the mid-fourteenth century.[1] In 1964 grisaille
glass was discovered in the narrow (twelfth-century?) window at the head of the right nave
aisle; the opening probably was blinded in the eighteenth century when a sacristy was built
abutting the corner where the nave aisle meets the choir. The glass has been dated twelfth
or thirteenth century,[2] since it somewhat resembles early Cistercian blankglazing.

But the Écrouves grisaille is more likely to be part of the fourteenth-century campaign of rebuilding, for several reasons. A fresco of the fourteenth century was also found in 1964 covering the wall to both sides of the window and depicting two scenes of the life of Saint Mansuy, bishop of Toul, beneath the Annunciation (the church was dedicated to the Virgin "in her Nativity"). The design of the grisaille glass matches exactly the pattern of zigzag blankglazing (*a bâtons rompus*) in the fourteenth-century nave clerestories of Toul Cathedral, as well as in three fourteenth-century panels dismounted from the transepts (Bays 104–5) and published in 1985 by Dr. Michel Hérold.[3] Comparable blankglazing from the beginning of the fourteenth century is in Mussy-sur-Seine in Champagne, and at Altenberg.[4]

Similar blankglazing from the Ritterstiftkirche, Wimpfen im Tal (now in Darmstadt, Hessisches Landesmuseum), and several churches in Alsace, has been dated to the last quarter of the thirteenth century.[5] In Toul, however, surviving thirteenth-century grisailles at Saint-Gengoult (see Plates II.17, 18, 19 and 20) maintain the French type, including foliage against a crosshatched ground.

Since glass made before about 1300 is much thicker than later glass, the question of a general date could be settled if the glass were dismounted and examined out of the leads. If the leading proves original, its shape would also facilitate a reliable general dating.

Notes

1. For descriptions and drawings of the architecture, see Pierre Simonin, "Écrouves (Meurthe-et-Moselle)," in *Dictionnaire des églises de France, Va: Alsace, Lorraine, Franche-Comté,* ed. Robert Laffont, Paris, 1969, 50; Simonin, "Les Relevés d'édifices anciens," *Le Pays lorrain,* XXXVIII, 1957, 51–53; E. Olry, "Répertoire archéologique de l'arrondissement de Toul, cantons de Domèvre, Toul-Nord, et Thiaucourt," *Répertoire archéologique du département de la Meurthe,* 369–70, published with (and paginated separately from) *Mémoires de la Société d'archéologie lorraine,* 2d series, XIII, 1871; Ernest Grille de Beuzelin, *Statistique monumental.—(Specimen). Rapport à M. le Ministre de l'Instruction publique sur les monuments historiques des arrondissements de Nancy et de Toul (Département de la Meurthe),* Collection de documents inédits sur l'histoire de France, 3d series–Archéologie, Paris, 1837, 107 and Atlas pl. 29.

2. The Écrouves grisaille is illustrated in *Le Vitrail en Lorraine* (as in note 2 of Introduction below),

219, where a thirteenth-century date is suggested; see also Simonin, *Dictionnaire,* 50. A twelfth-century date is suggested by Louis Grodecki, *Le Vitrail roman,* Fribourg, 1977, 151, and Abbé Jacques Choux in *Le Vitrail en Lorraine,* 34.

3. Michel Hérold, "Un Vitrail d'Hermann de Münster à la cathédrale de Toul," *Le Pays lorrain,* LXVI, 1985, 35, 37–39.

4. Mussy: L. Ottin, *Le Vitrail,* Paris, 1896, p. 35, fig. 33. Altenberg: Brigitte Lymant, *Die mittelalterlichen Glasmalerein der ehemaligen Zisterzienserkirche Altenberg,* Bergisch Gladbach, 1979, 63–64, 101–3.

5. Hans Wentzel, *Die Glasmalereien in Schwaben von 1200–1350,* Corpus Vitrearum Deutschland I, Berlin, 1958, 248, 257, Abb. 556–57. See also a panel of Saint Mauritius set on such blankglazing (Nuremberg, Nationalmuseum): Eva Frodl-Kraft, *Die Glasmalerei,* Vienna, 1970, 20, color pl. III; Hans Wentzel, *Meisterwerke der Glasmalerei,* Berlin, 1951, 86, Abb. 51.

Appendix VII

La Chalade (Meuse):
Cistercian Grisailles

The Cistercian abbey of La Chalade in the Argonne forest was a foundation of c. 1127 from Trois-Fontaines (Marne), daughter of Clairvaux. The Gothic church building, which survives with its nave now drastically truncated and fitted with a flamboyant rose from Saint-Vanne de Verdun, has customarily been dated between c. 1310 and 1350.[1] The grisailles associated with this building were restored in 1928 and again after World War II and were published by Helen Jackson Zakin in 1982.[2]

The absence of silver stain corroborates Zakin's suggested dating of 1307–14, based on a study of the coats of arms of France, Bar, and Navarre that graced the apsidal traceries in the nineteenth century (only Navarre survives):

> This heraldic combination . . . could not occur here before 1301. . . . Thibaut's son Henry III [count of Bar] married the daughter of King Edward I of England, with whom he joined in a pact against Philip the Fair. In 1297 Henri attacked the abbey of Beaulieu-en-Argonne. . . . Philip, occupied in Flanders, sent Gaucher de Châtillon, who defeated the count of Bar and took him prisoner. By the Treaty of Bruges, signed in 1301, Henri was forced to do homage to the king of France for all of his allodia, or freely held lands, west of the Meuse. Henri died in 1302, at which time his son Edouard I (1295 or 1296–1336) was six or seven years old. Edouard, who gained control of his territories in 1311, was reared in Paris at the court of Philip the Fair. . . .
>
> Edouard may have given the glass in 1307: in that year Louis le Hutin, eldest son of Philip the Fair and Jeanne of Navarre, was crowned king of Navarre. As count of Champagne, Louis was Edouard's western neighbor; as eldest son of Philip, Louis was Edouard's future suzerain. In 1306, a marriage was contracted between Edouard and Marie of Burgundy, who was Louis's sister-in-law and a granddaughter of St Louis. Evidently the house of Bar wished, at this time, to establish amicable relations with the Capetians.
>
> At the very least, one can say that Edouard probably commissioned the La Chalade glass between the years 1307 and 1314. By 1314, when Louis became King of France, the relationship between the two doubtless would have deteriorated. Margarite, Louis's wife and Edouard's sister-in-law, had been imprisoned for adultery earlier that same year. She died in prison early in 1315, and Louis married Clemence of Hungary in August, 1315. The La Chalade glass, with its coats of arms of Navarre, France and Bar, must predate these events."[3]

A glass commission from Edouard, count of Bar, would not be surprising, since his ancestors, including his grandfather Count Thibaut II, had made many donations to the abbey.[4] Indeed they were most likely the patrons responsible for the new Gothic church, the architectural detail of which Zakin has compared to Mosan buildings such as Sainte-Catherine in Verdun, begun c. 1290–1310.[5]

No other Cistercian grisaille survives in France with which to compare the La Chalade panels. The thickly painted cabbage-leaf foliage and particularly the monsters in the grisailles now set in Bays nV and nIV are not French but Germanic in style, though Zakin could come up with no really close comparisons. Even predating the earliest monster-grisailles at Altenberg (north transept, c. 1300) are German Cistercian examples at Schulpforta (c. 1260).[6]

One of the other La Chalade grisailles (now in sIV) has a simple cassette border of dry, squared-off *quatrefeuilles*.[7] The crosshatched ground, central stem, quasi-naturalistic leaves, and bulged-quarry filets are standard for the final decades of the thirteenth century in France.

Less old-fashioned are the French patterns now in the twin lancets of the axial bay, with unpainted grounds and delicate, naturalistic foliage of ivy and strawberry.[8] The filets are more straightened; indeed, in the left lancet they form a regular latticework enclosing quarries painted with individual motifs in the fourteenth-century manner. These are the La Chalade grisailles for which the 1307–14 date seems indisputable. Their borders are the only designs at La Chalade that can claim an ancestor among surviving Lorraine windows. The fragile bouquets of leaves bear a familial resemblance to the feathery, delicate leafy mixtures filling the borders and medallion-surrounds of the Gengoult Master (Plates II.5b and II.18a), which he in turn had developed from the ornament of the Master of Ménillot (Plate II.7b).

Notes

1. Pierre Simonin, "Lachalade (Meuse)," *Diction-naire des églises de France, Va: Alsace, Lorraine, Franche-Comté*, ed. Robert Laffont, Paris, 1969, A78; see also Marie-Claire Burnand, *La Lorraine gothique*, Paris, 1989, 129–32. For previous bibliography, see Helen Zakin, "Cistercian Glass" (as in chapter II, note 66), 148 n. 2, 150 n. 33.

2. In addition to the article cited in the previous note, see Zakin, "Recent Restorations of the La Chalade Glass," *Mélanges à la mémoire du Père Anselme Dimier*, III (vol. 6), ed. Benoît Chauvin, Pupillin (Arbois), 1982, 767–79.

3. Zakin, "Cistercian Glass," 146–47.

4. Hubert Collin, "Les Débuts d'une fondation cistercienne en Argonne: l'abbaye et l'abbatiale de La Chalade au diocèse de Verdun," *Le Pays lorrain*, LIX, no. 3, 1978, 125–26, 128. Stained glass commissioned by Edouard's grandmother, Jeanne de Toucy, at Saint-Nicaise de Reims c. 1295 was resplendent with coats of arms: Meredith Lillich, "Heraldry and Patronage in the Lost Windows of Saint-Nicaise de Reims," *Actes du XXVIIe Congrès international d'histoire de l'art* (Strasbourg: to appear).

5. Zakin, "Cistercian Glass," p. 145.

6. See chapter II, nn. 65–66.

7. A panel of this grisaille, in the Glencairn Museum, Bryn Athyn, Pennsylvania (Acc. 03.SG.74), is illustrated in *Stained Glass before 1700 in American Collections: Mid-Atlantic and* *Southeastern Seaboard States,* Corpus Vitrearum Checklist II, *Studies in the History of Art,* XXIII, Washington, D.C., 1987, 138.

8. Illustrated in Zakin, "Cistercian Glass," figs. 3, 4; Zakin, "Recent Restorations," figs. 621, 622.

NOTES

Introduction

1. Twelfth century: Louis Grodecki, *Le Vitrail roman*, Fribourg, 1977, 20–21, 149–51, 284–85. Fifteenth/sixteenth centuries: Michel Hérold, "Les Verriers de Lorraine à la fin du moyen âge et au temps de la Renaissance (1431–1532)," *Bulletin monumental*, CXLV, 1987, 87–106; idem, "L'Art du vitrail en Lorraine, son apogée à la fin du moyen âge et au temps de la Renaissance," *Le Pays lorrain*, LXIV, 1983, 5–33; Germaine Rose-Villequey, *Verre et verriers de Lorraine au début des temps modernes (de la fin du XVe au début du XVIIe siècle)*, Paris, 1971; Jean Lafond in Marcel Aubert et al., *Le Vitrail français*, Paris, 1958, 243–44; Elisabeth von Witzleben, *Stained Glass in French Cathedrals*, New York, 1966, 52–53, 63–74.

2. *Inventaire général des monuments et des richesses artistiques de la France, Le Vitrail en Lorraine du XIIe au XXe siècle*, Nancy, 1983. In addition to the catalogue entries, two introductory articles by Abbé Jacques Choux and Michel Hérold touch on thirteenth-century stained glass. See, previously, Choux in Victor Beyer et al., *Vitraux de France du moyen âge à la Renais-

sance*, Colmar, 1970, 119–22; see, more recently, Louis Grodecki and Catherine Brisac, *Le Vitrail gothique au XIIIe siècle*, Fribourg, 1984, 146, 148–49.

3. Jean Lafond, "Le Vitrail en Normandie de 1250 à 1300," *Bulletin monumental*, CXI, 1953, 317–19; idem, "Le Vitrail du XIVe siècle," in Louise Lefrançois-Pillion, *L'Art du XIVe siècle en France*, Paris, 1954, 225.

4. This paragraph is based on Michel Parisse, ed., *Histoire de la Lorraine*, Toulouse, 1977, chaps. VI and VII. The linguistic map is on page 13.

5. Marcel Aubert et al., *La Cathédrale de Metz*, Paris, 1931, xiii and 217.

6. Rose-Villequey, 33–34; Parisse, 197 and fig. 22 (217); see also chapter VI at note 1.

7. Dr. Brill's samples, provided by Dr. Eva Frodl-Kraft and Dr. Erhard Drachenberg, both of the Corpus Vitrearum, come from the following sites: Sankt Michael in der Wachau (c. 1300–1310), Steyr (c. 1300), the Leechkirche, Graz (c. 1300–1350), Sankt Walpurgis bei Sankt Michael, Leoben (c. 1290), Erfurt Cathedral (c. 1370), Halberstadt Cathedral (c. 1400–1435), and Magdeburg Cathedral (undated).

8. The "summer-and-winter" format, which appeared in Paris in the decade when theological

antagonism to the Pseudo-Dionysian aesthetic first encouraged the introduction of large areas of grisaille into church interiors, was copied in the triforium of Tours Cathedral but was not otherwise popular in western France. See Meredith Lillich, *The Armor of Light*, Berkeley, in press.

9. Richer of Senones, *Gesta Senoniensis ecclesiae*, Bk. IV, chap. 43, ed. G. Waitz, *Monumenta Germaniae Historica, Scriptorum*, XXV, 323. On Richer's chronicle, see chapter IV, note 39.

Chapter I: Toul Cathedral

1. On the architecture of Toul: Alain Villes, *La Cathédrale de Toul: Histoire et architecture*, Metz, 1983, and Villes, "Les Campagnes de construction de la cathédrale de Toul. Première partie: Les campagnes du XIIIe siècle," *Bulletin monumental*, CXXX, 1972, 179–89; Rainer Schiffler, *Die Ostteile der Kathedrale von Toul und die davon abhängigen Bauten des 13. Jahrhunderts in Lothringen*, Cologne, 1977.

2. See generally chapters VI and VII of *Histoire de la Lorraine*, ed. Michel Parisse, Toulouse, 1977, with bibliography.

3. Louis Grodecki, *Le Vitrail roman*, Fribourg, 1977, chap. VI and 230–33; Louis Grodecki and Catherine Brisac, *Le Vitrail gothique*, Fribourg, 1984, 146–49, 190–98.

4. The Toul glass is catalogued in *Le Vitrail en Lorraine du XIIe au XXe siècle*, Inventaire général des monuments et des richesses artistiques de la France, Nancy, 1983, 352–56. The grisaille: Michel Hérold, "Un Vitrail d'Hermann de Münster à la cathédrale de Toul," *Le Pays lorrain*, LXVI, 1985, 37–39; see Appendix VI above.

5. Abbé Morel, "Notice historique et descriptive de la cathédrale de Toul," in A.-D. Thierry, *Histoire de la ville de Toul et de ses évêques*, Paris, 1841 (published at the end of vol. II and paginated separately), 9, also 16 mentioning restoration and releading in 1836. Less precise accounts are found in: Abbé C. G. Balthasar, "Notice historique et descriptive sur la cathédrale de Toul (deuxième partie)," *Revue archéologique*, V/I, 1848, 148; C.-L. Bataille, *La Cathédrale de Toul, offerte aux visiteurs . . .* , Toul, 1855, 48–49.

6. My hypothesis is presented below. In the lack of archival documentation for nineteenth-century restorations, it should be stated that glaziers were active at Toul in 1863, in 1874–76, and in 1881–86 (see *Le Vitrail en Lorraine*, 352). The report of Olry in 1870 is perhaps significant since he mentions thirteenth-century glass only in the north chapel window (Bay 7). Perhaps the south bay (Bay 8) was dismounted for restoration as he wrote? See E. Olry, "Répertoire archéologique de la ville, des faubourgs et du territoire de Toul," *Répertoire archéologique du département de la Meurthe*, 224, published with (and paginated separately from) *Mémoires de la Société d'archéologie lorraine*, 2d series, XII, 1870.

7. Ernest Grille de Beuzelin, *Statistique monumentale.—(Specimen). Rapport à M. le Ministre de l'Instruction publique sur les monuments historiques des arrondissements de Nancy et de Toul (Département de la Meurthe)*, Collection de documents inédits sur l'histoire de France, 3d series–Archéologie, Paris, 1837, 103. Morel (9) is in error in stating that Grille de Beuzelin missed the thirteenth-century glass.

8. Guilhermy's notes on Toul are in Paris, Bibl. nat., N. Acq. fr. 6110, fols. 55r–58r.

9. Balthasar, 148; Guilhermy, fol. 57v; Olry, 224; Morel, 9; Ferdinand de Lasteyrie, *Histoire de la peinture sur verre*, Paris, 1853–57, 118.

10. Steinheil's name appears on Bay 1 and Balthasar's on Bay 0. Leprévost's designs are published in Jules Roussel, *Les Vitraux*, vol. 3, *Vitraux de XIIIe au XVIe siècle*, Paris, 1913, pl. 82.

11. See, for example, Virginia Raguin, *Stained Glass in Thirteenth-Century Burgundy*, Princeton, 1982, 67–69, 121–22.

12. Rez-de-chaussée, salle 1; catalogued in *Le Vitrail en Lorraine*, 296, height 1.05 m—width 0.75 m. The panel (Virgin and Child, two border types, and some grisaille) is not among the stained glass in Lucien Wiener, *Musée historique lorrain au palais ducal de Nancy, catalogue des objets d'art et d'antiquité*, Nancy, 1895, 151–52. All elements except the grisaille were in the Trocadéro in 1910; see notes 14 and 16 below.

13. See chapter III at notes 96–99.

14. Lucien Magne, "Le Musée du vitrail," *Gazette des beaux-arts*, XXXIV, October 1886, 297–311, quoted on 310. On the vicissitudes of Magne's group of refugee panels, many of which are traceable from 1884 to 1910, see Louis Grodecki, "La Restauration des vitraux du XIIe siècle provenant de la cathédrale de Châlons-sur-Marne" (1954), reprinted in *Le Moyen âge*

retrouvé, Paris, 1986, 292–93. He states that the Trocadéro glass was dismounted from 1915–1920 and again in 1937.

15. Lucien Magne, *Palais du Trocadéro, Musée de sculpture comparée, Galerie de vitraux anciens, notice sommaire*, Paris, 1910, 7.

16. The grisaille lancet removed and photographed by Leprévost, now restored to Saint-Gengoult Bay 5, is discussed in chapter II, page 38.

17. On the Renaissance glass in the three axial bays, see note 9 above; also Grille de Beuzelin, 101. On the glass in the *Chapelle des évêques*: Gustave Clanché, "Les Deux chapelles Renaissance de la cathédrale de Toul," *Revue lorraine illustrée*, VIII, 1913, 18 n. 3 and 16 (watercolor by M. Stein, also reproduced by Villes [1983], 196). No eyewitnesses mention a Baptism of Christ, which is presumed to be lost from Bay 0 (*Le Vitrail en Lorraine*, 355).

18. *Vincenzo Scamozzi, Taccuino di Viaggio da Parigi a Venezia (14 marzo–11 maggio 1600)*, ed. Franco Barbieri, Venice, 1959, 57 (fol. 22). Scamozzi's manuscript is in the Museo civico of Vicenza. The parts of it concerning Lorraine were discussed by Paulette Choné, "La Lorraine vue par un architecte italien: Le voyage de Vincenzo Scamozzi, 28 mars–15 avril 1600," *Le Pays lorrain*, LXIII, 1982, 65–88.

19. Jean Vallery-Radot, "Toul," *Congrès archéologique*, XCVI, 1933, 234; Villes (1983), 173–75, 200–201. The choir towers appear in an engraving (not totally reliable) published in 1510 by Jean Pèlerin, a canon of Toul: Gaston Save, "La Cathédrale de Toul en 1510," *Bulletin des Sociétés artistiques de l'est*, July 1897, 101–2. Villes believes that the three axial bays were raised in the early sixteenth century (see note 25 below) and theorizes (197) that the Renaissance windows were needed thereafter. If the three bays were raised, however, their Gothic traceries were carefully dismantled and reused (as an economy?), and Gothic glass could as easily have been taken down and reused with minor augmentations.

20. This border was not photographed for the Archives photographiques when the glass was dismounted during World War II, and the photomontages in that collection were assembled in error, using duplicated photographs of the other border. That procedure was also followed in making up the photomontages of the triforium of Tours Cathedral (Indre-et-Loire), where the existing traceries of one of the five bays actually contain the coats of arms of the donors: Meredith Lillich, "The Triforium Windows of Tours," *Gesta*, XIX/1, 1980, 29–35. In the cases of both Tours and Toul, old photographs establish that the omitted pattern actually occupied the window before the war and is not a recent insertion. On the "collector's panel" in Nancy, see note 12 above.

21. Gustave Clanché, *Guide-express à la cathédrale de Toul*, Nancy, 1918, 47, 59.

22. Schiffler, 245 n. 278.

23. On the architecture of Saint-Gengoult, see the works cited in note 1 above. On its glass, see *Le Vitrail en Lorraine*, 357, where the axial medallion window is dated c. 1260–70.

24. By the nineteenth century only two grisaille lancets remained in the tall choir bays, one to each side of the axial window; see illustration in *Bulletin monumental*, XCVI, 1933, 261. In 1898–1902 these grisailles were moved to the adjoining lancets and their places were taken by new colored medallions. See *Le Vitrail en Lorraine*, 357.

25. This statement is true even if, as Villes believes, the three axial bays were raised in the early sixteenth century. Their original height would have been equal to the choir's existing collateral bays (Bays 4–7). See Villes (1983), 169–73; his photograph on page 66 allows a comparison of the heights of the north chapel bay on the left (where the fragments have been since 1836) and the choir lancets, both original height (center) and presumably raised (right). Even the center bay is nearly three times the height of the short chapel bay.

26. The Saint-Gengoult panels are catalogued in *Le Vitrail en Lorraine*, 357; Toul Cathedral in *Le Vitrail en Lorraine*, 353.

27. Willibald Sauerländer, *Gothic Sculpture in France 1140–1270*, London, 1972, 442, pls. 130 and 131.

28. These two beardless, haloed figures appear to be misunderstood adaptations of the mysterious female figure in the Strasbourg tympanum. For varying hypotheses of the figure's identity, see Philippe Verdier, *Le Couronnement de la Vierge*, Montreal, 1980, 143–44; Louis Réau, *Iconographie de l'art chrétien*, vol. II, *Iconographie de la Bible*, Pt. 2, *Nouveau Testament*, Paris, 1956, 608; Joseph Duhr, "La 'Dormition' de Marie dans l'art chrétien," *Nouvelle revue théologique*, LXXII, 1950, 145.

29. Elisabeth von Witzleben, *Stained Glass in French Cathedrals*, New York, 1968, pl. XXI.

30. Verdier, 150; his discussion of Strasbourg begins

on 143. In tracing the origins of the Strasbourg Coronation, Verdier missed a stained glass panel of c. 1180, moved from the cathedral to the Musée de l'Oeuvre Notre-Dame, showing Christ (left) standing and crowning, with his right hand, the standing figure of the Virgin or Ecclesia (center); a figure on the right of the composition has been lost. See Christiane Wild-Block in Beyer et al., *Les Vitraux de la cathédrale Notre-Dame de Strasbourg*, Corpus Vitrearum France IX–1, Paris, 1986, 566–69, pl. XVI.

31. Verdier (145–46) listed the tympanum of Notre-Dame-la-Ronde at Metz Cathedral (see also Sauerländer, 496), but not the stained glass, which since the late nineteenth century has been in Bay 28: see *Le Vitrail en Lorraine*, 253–58, 264. The tympanum is illustrated in Amédée Boinet, "Metz," *Congrès archéologique*, LXXXIIIe, 1920, following 30. The rosace glass of Notre-Dame-la-Ronde has not been studied and has only been illustrated in *La Cathédrale de Metz*, Guide officiel de l'Oeuvre de la cathédrale, Metz, 1983, 36. Among the Toul fragments is another Coronation, of standard type, now in the rosace of Bay 7; it is very heavily restored, but the crude faces resemble old restorations, possibly of the fourteenth century.

32. See, for example, Gertrud Schiller, *Iconography of Christian Art*, Greenwich, Conn., 1971, I, pl. 508 (Maximian's throne, Ravenna), 551 (Monreale mosaics).

33. Schiller, 179–81; Réau, 384–86. For Monreale, see Otto Demus, *The Mosaics of Norman Sicily*, New York, 1950, pl. 86A–B.

34. Sauerländer, 440, ill. 61.

35. Hans Reinhardt, *La Cathédrale de Reims*, Paris, 1963, 185, pl. 42 (south transept); *Strasbourg Corpus Vitrearum*, 49, 57, 129–39; the Saint-Gengoult inscription is unpublished. On lettering and the increasing use of Lombardic uncials: Meredith Lillich, *The Stained Glass of Saint-Père de Chartres*, Middletown, Conn., 1978, 29–31.

36. Abbé Jacques Choux, "La Cathédrale de Toul avant le XIIIe siècle," *Annales de l'est*, 1955, reprinted in *La Lorraine chrétienne au moyen âge*, Metz, 1981, 284.

37. Chartres: Yves Delaporte, *Les Vitraux de la cathédrale de Chartres*, Chartres, 1926, pl. CXIX. Notre-Dame: Sauerländer, pl. 269.

38. Delaporte, pl. CXX; Sauerländer, pl. 269.

39. Oxford Bible: Comte Alexandre de Laborde, *La Bible moralisée conservée à Oxford, Paris et Londres*, Paris, 1911–27, pl. 4. Robertus de Bello Bible: Eric G. Millar, *English Illuminated Manuscripts from the Xth to the XIIth Century*, Paris, 1926, pl. 68.

40. Charles Cahier and Arthur Martin, *Monographie de la cathédrale de Bourges*, Paris, 1841–44, pl. VI.

41. Trude Krautheimer-Hess, "The Original Porta dei Mesi at Ferrara and the Art of Niccolò," *Art Bulletin*, XXVI, 1944, fig. 4 (Ferrara), fig. 10 (San Zeno).

42. Raguin, 139. According to Réau, a capital in the thirteenth-century cloister of Tarragona depicts Cain trying to prevent Abel from nursing: Réau (cited in note 28 above), Pt. I, *Ancien Testament*, Paris, 1956, 94. In a fourteenth-century window of Saint-Etienne, Mulhouse, Eve nurses Abel and spins while holding the wrist of the toddler Cain next to her: Jules Lutz and Paul Perdrizet, *Speculum Humanae Salvationis*, Mulhouse, 1907, II, pl. 101 (cf. pl. 4).

43. Florence: Antony de Witt, ed., *I Mosaici del Battistero di Firenze*, IV, *Le Storie della Genese e di Giuseppe*, Florence, 1957, pl. IX. Saint Louis Psalter: *Le Psautier de saint Louis . . . manuscrit latin 10525 de la Bibliothèque nationale de Paris*, introd. Marcel Thomas, Graz, 1970, pl. 2.

44. Sir George Warner, *Queen Mary's Psalter*, London, 1912, pls. 16, 17.

45. Delaporte, pl. CLXII.

46. Gary Vikan, "Joseph Iconography on Coptic Textiles," *Gesta*, XVIII/1, 1979, 100, fig. 6 (post-Byzantine manuscript).

47. Trinity College Psalter: Millar, pl. 68. Salisbury: Pamela Z. Blum, "The Middle English Romance 'Iacob and Iosep' and the Joseph Cycle of the Salisbury Chapter House," *Gesta*, VIII/1, 1969, 18–34, fig. 2. Many other examples could be mentioned.

48. De Witt, pl. XXIX; Blum, fig. 4. The Poitiers window is unpublished.

49. Delaporte, pl. CLXIII; de Laborde, pl. 25; Blum, fig. 8; Warner, pl. 30.

50. The document (Arch. dépt. Meurthe-et-Moselle G 70) is published with the date 1360 by Abbé Pierre-Etienne Guillaume, "La Cathédrale de Toul," *Mémoires de la Société d'archéologie lorraine*, 2d series V 1863, 99–100; see also Rose-Villequey (as in note 1 of Introduction), 222 (1353) and 277 (1360).

51. Oxford, Bodl. 270b, fol. 25v: de Laborde, pl. 25.

52. Raguin, pl. 30; de Laborde, pl. 26; Blum, fig. 8; Warner, pl. 30. Poitiers is unpublished.

53. Roger Adams, "The Chartres Clerestory Apostle Windows: An Iconographic Aberration?" *Gesta*, XXVI/2, 1987, 141–50.

54. Hugo Buchthal, *Miniature Painting in the Latin Kingdom of Jerusalem*, Oxford, 1957, pl. 96b (Brussels, Bibl. Roy., MS 10175, fol. 73r, c. 1270/80), pl. 96c (London, Brit. Lib., Add. 15268, fol. 58r, 1280s), pl. 151e (Paris, Bib. nat., MS fr 20125, fol. 68v, before 1250).

55. Emile Bertaux, *L'Art dans l'Italie méridionale*, Paris, 1903, reissue 1968, II, 776, pl. XXXIV. The Dijon manuscript is illustrated in Buchthal, pl. 96a.

56. Gianfranco Folena and Gian Lorenzo Mellini, *Bibbia istoriata padovana della fine del trecento: Pentateuco–Giosuè–Ruth*, Venice, 1962, pl. 64.

57. Munich Psalter: Nigel Morgan, *Early Gothic Manuscripts, 1190–1250*, London, 1982, no. 23, pl. 78. Saint Louis Psalter: *Psautier*, pl. 23.

58. Bertaux, pl. XXXIV; de Laborde, pl. 28; Folena and Mellini, pl. 65.

59. Folena and Mellini, pl. 65.

60. Delaporte, pl. CLXIV.

61. Delaporte, pl. CLXIV.

62. Robert Fawtier, *La Bible historiée toute figurée de la John Rylands Library*, Paris, 1924, pl. XXXV (reprint of *Société française de reproductions de manuscrits à peintures, Bulletin*, 1923). The Oxford Bible is illustrated in de Laborde, pl. 29r.

63. De Laborde, pl. 30.

64. Madeline Caviness, *The Early Stained Glass of Canterbury Cathedral, Circa 1175–1220*, Princeton, 1977, pl. 48.

65. Barbara Drake Boehm, "The Program of the Leningrad Joseph Pyxis," *Gesta*, XXVI/1, 1987, 13.

66. Delaporte, pl. CLXIV; Fawtier, pl. XXXVII; de Laborde, pl. 30.

67. De Laborde, pl. 34; François Bucher, *The Pamplona Bibles*, New Haven, 1970, II, pl. 93; Buchthal, pl. 101b.

68. De Laborde, pl. 35; Buchthal, pl. 92b; Fawtier, pl. XL.

69. See, for example, the Oxford Moralized Bible (de Laborde, pl. 35) or the Padua Bible (Folena and Mellini, pl. 75).

70. Harburg, Oettingen-Wallerstein Collection, MS I, 2, Lat. 4°, 15 (1194–1234): Bucher, pls. 23, 48.

71. In panel 8/B4, two figures resembling Joseph's brothers stand and gesture before a seated figure holding a scroll(?), possibly Joseph. The face of the latter, probably an old restoration and no doubt a stopgap in its present position, is red. It may have come from a seraph (a red-faced seraph appears in the axial traceries of Saint-Gengoult) or possibly from the angel of the Resurrection,

following Matthew 28:3. Examples include the Ingeborg Psalter, illustrated in color in Jean Porcher, *Medieval French Miniatures*, New York, 1960?, pl. XLI, as well as a list in Hanns Swarzenski, *Die lateinischen illuminierten Handschriften des XIII. Jahrhunderts*, Berlin, 1936, 158 n. 4.

72. Emile Mâle, *Religious Art in France: The Thirteenth Century*, ed. Harry Bober, Princeton, 1984, 7: "The north, the region of cold and night, was usually devoted to the Old Testament."

73. Raguin, 148.

74. Louis Grodecki in Marcel Aubert et al., *Les Vitraux de Notre-Dame et de la Sainte-Chapelle*, Corpus Vitrearum France I, Paris, 1959, 94–106 (Bay 0) and 337, pl. 97 (Cluny Museum).

75. The rationale for such an extended Joseph cycle at Toul is unclear. An inventory of 1662 listed among the relics part of Saint Joseph's belt, given to the cathedral by the chapter of Joinville at an unknown date. Whether the Genesis patriarch or Mary's husband was the Joseph in question is not established. See Henri Lepage, "Notes pour servir à l'histoire de la cathédrale de Toul," *Journal de la Société d'archéologie et du comité du Musée Lorrain*, I, 1852–53, 215.

76. *Schedulae*, fifteenth-century manuscript published in Dom Augustin Calmet, *Histoire ecclésiastique et civile de Lorraine*, 1st ed. Nancy, 1728, IV (preuves), col. 181. Also *Gallia christiana*, XIII, Paris, 1874, col. 1015; Benoît Picart, *Histoire ecclésiastique et politique de la ville et du diocèse de Toul*, Toul, 1707 (rpt. 1977 as *Histoire de Toul*), 447.

77. The data in this paragraph are from Abbé Eugène Martin, *Histoire des diocèses de Toul, de Nancy et de Saint-Dié*, Nancy, 1900, I, 290–96. Bishop Roger's choir glazing was almost surely complete on or shortly after his death, since his successor, Gilles de Sorcy, who also faced opposition, still had not been consecrated in March 1255, and once in office his palace was besieged and demolished and he too forced to flee (Martin, 297 n. 3, 317–18). No such hiatus is evident in the Joseph fragments.

78. Grodecki and Brisac (as in note 2 of Introduction), 33–43; see also 50–51 (Notre-Dame rose). The latest of these windows is dated c. 1225.

79. Grodecki and Brisac, 43; Elisabeth von Witzleben, *Stained Glass in French Cathedrals*, New York, 1968, color pl. XXVII.

80. Ellen J. Beer, *Die Glasmalereien der Schweiz vom*

12. bis zum Beginn des 14. Jahrhunderts, Corpus Vitrearum Schweiz, I, Basel, 1956, 69–71, pls. 3–39, color pls. 4, 5. See also Jean Lafond, "Les Vitraux anciens de la cathédrale de Lausanne," *Congrès archéologique,* CX, 1952, 120, 129.

81. *Strasbourg Corpus Vitrearum,* fig. 16 nos. 11–13 (now lost, see p. 571), no. 14 (20 cm wide, now in Musée de l'Oeuvre Notre-Dame in a nineteenth-century composite panel, p. 557 and fig. 551); Saint Christopher, p. 103 and fig. 77 (the border now cut two-fifths in width).

82. On Saint-Urbain de Troyes: Grodecki and Brisac, 168–71, 264; Eva Frodl-Kraft, *Die Glasmalerei,* Vienna, 1970, fig. 30. On Saint-Dié: *Le Vitrail en Lorraine,* 155, 329; chapter IV below.

83. *Le Vitrail en Lorraine,* illustrations on 35, 358, 360, top of 155 (color).

84. On Ménillot, see *Le Vitrail en Lorraine,* 36, 212; and Abbé Jacques Choux in Victor Beyer et al., *Vitraux de France au moyen âge à la Renaissance: Alsace, Lorraine, Franche-Comté,* Colmar, 1970 121, pl. 158. Both publications date it too late.

85. Paris, Bibl. nat., N acq fr 11819, fol. 4r, Censier de l'évêché de Toul. On the cover is written in a later hand: "Carthulaire tres precieuxe contenant le détail de toutes les Rentes Seigneurialles et autres revenus del Eveché de Toul. Ecri vers l'an 1250." The censier has been dated as late as c. 1285.

86. *Histoire de la Lorraine* (as in note 4 of Introduction), 197, 217 (economic map); Rose-Villequey, 31–34.

87. Marcel Aubert et al., *La Cathédrale de Metz,* Paris, 1931, 216–18.

88. *Histoire de la Lorraine,* 177–79, 192.

Chapter II: Ménillot and Saint-Gengoult (Toul)

1. I would like to thank Abbé Pierre Velten, priest of Ménillot, for his gracious reception, interest, and help.

2. E. Olry, "Répertoire archéologique des cantons de Colombey et Toul-Sud," *Répertoire archéologique du département de la Meurthe,* 98, published following and paginated separately from *Mémoires de la Société d'archéologie lorraine,* 2d series, VII, 1865. Probably the window had just

been restored, since the Christ before Pilate panel bears the signature "Mathieu 1864."

3. Population of 268 in 1802 and 273 in 1931: Raymond Aubry, *Foug et ses environs,* Pont-à-Mousson, 1931?, 44–45. Population of 261 in 1903: Adolph Joanne, *Géographie de Meurthe-et-Moselle,* Paris, 1903, 67.

4. Mansionile juxta Cauliacum (1069): Calmet, *Histoire de Lorraine,* IV (preuves), col. 465. De Manilleto supra Choleium (1303), de Manilleto juxta Choleyum (1402): Auguste Longnon, *Pouillés de la province de Trèves,* Paris 1915, xlv–xlvi, 290, 321. Le Mesnillot-près-Challot (1516): Henri Lepage, *Dictionnaire topographique du département de la Meurthe,* Paris, 1862, 90. Numerous other examples and spellings occur in unpublished sources.

5. Abbé Jacques Choux, "Lorraine," in *Vitraux de France du moyen-âge à la Renaissance: Alsace, Lorraine, Franche-Comté,* Colmar, 1970, 121 and pl. 158 (very dark color plate); *Le Vitrail en Lorraine,* Inventaire général des monuments et des richesses artistiques de la France, Nancy, 1983, 36, 59, 66, 212 (dark illustration).

6. Jean Lafond, "Le Vitrail en Normandie de 1250 à 1300," *Bulletin monumental,* CXI, 1953, 320–21.

7. The nature of the exchange is unclear in light of the clear documentation of the transfer of properties in 1263 (at note 10 below). Calmet, IV (preuves), col. 465, and related references in two charters of 1065 (cols. 456, 459); Abbé Edmond Chatton, "Histoire de l'abbaye de Saint-Sauveur et de Domêvre 1010–1789," *Mémoires de la Société d'archéologie lorraine et du Musée historique lorrain,* XLVII, 1897, 22, 42.

8. The 1206 acquisition appears in *Gallia christiana,* XIII, Paris, 1874, col. 1359. The 1256 gift is Arch. dépt. Meurthe-et-Moselle H 1440; see also Chatton, 359 (erroneously dated 1250) and appendix, iv.

9. Arch. dépt. Meurthe-et-Moselle 2 F 6, fol. 40v, dated 10 January 1171 o.s.

10. Arch. dépt. Meurthe-et-Moselle 2 F 5, fol. 24v; G 1384, p. 80, no. 70 bis; H 1440 with incorrect date *anno CC.XLIII;* also *Gallia christiana,* XIII, col. 1359; Chatton, 81, 359, and appendix, iv–v.

11. Longnon (as in note 4 above); Aubry, 45.

12. *Gallia christiana,* XIII (preuves), cols. 528, 529 (nos. LXXIV, LXXV); Eugène Martin, *Histoire des diocèses de Toul, de Nancy et de Saint-Dié,* Nancy, 1900, I, 318 (*erratum* in n. 2: for 1161, read 1261).

13. Martin, 320–27. Following the death of Bishop

Gilles de Sorcy, a disputed election kept the office vacant until Pope Nicholas III imposed the German Franciscan Conrad Probus in 1279. Probus was not able to establish control over the town until 1285.

14. On the greens of eastern France, see, for example, Marcel Aubert and Jean-Jacques Gruber in Aubert et al., *La Cathédrale de Metz,* Paris, 1931, 217.

15. *Le Vitrail en Lorraine,* 262, illustrated on 35, 257; Aubert, 216–18, pl. xxxiv A; André Bellard, *La Lanterne de Dieu: Cathédrale de Metz, vitraux,* Metz, 1962, first and second unnumbered plates (general view and detail). The Saint Paul fragments, identified by Abbé Foedit in 1905, were described in their present location in 1840: Aubert, 217; Emile Auguste Bégin, *Histoire de la cathédrale de Metz,* Metz, 1840, I, 118–19.

16. Saint-Paul, a thirteenth-century structure on the upper floor above the chapterhouse on the cloister's west side, was described as having had three large choir bays and eight tall, narrow bays on each side of the nave: Bégin, II, 381–82. A plan showing its location, and elevation and section drawings, are reprinted in Aubert, 25–26, from *Histoire générale de Metz par des religieux bénédictins . . .* (1769–90). The stained glass of Saint-Paul was repaired in 1518: Jean-Baptiste Pelt, *Etudes sur la cathédrale de Metz: Textes extraits, principalement des registres capitulaires (1210–1790),* Metz, 1930, 54, no. 206. The cloister and surrounding small churches were razed in 1754 to establish the Place d'Armes: *Dictionnaire des églises de France, Va: Alsace, Lorraine, Franche-Comté,* ed. Robert Laffont, Paris, 1969, 95. See also chapter VI, page 104.

17. *Le Vitrail en Lorraine,* 274–75. Sainte-Ségolène came into the possession of the chapter of Metz in 1227 and is generally considered to have been rebuilt around 1250: *Dictionnaire des églises, Va,* 99. The north choir chapel of the Virgin was rebuilt in 1804, and the thirteenth-century fragments were described there by Al. Huguenin, "Notice historique sur l'église Sainte-Ségolène de Metz," reprint from *Mémoires de la Société d'histoire et d'archéologie de la Moselle,* Metz, 1859, 13–14, 51. See Appendix V for their probable donor and date.

18. Victor Beyer et al., *Les Vitraux de la cathédrale Notre-Dame de Strasbourg,* Corpus Vitrearum France ix–1, Paris, 1986, fig. 132 (especially nos. 13, 41) and fig. 133c.

19. *Le Vitrail en Lorraine,* 37, 260.

20. Louis Grodecki, *Le Vitrail roman,* Fribourg, 1977, 171.

21. Compare Sainte-Vaubourg near Rouen, consecrated 1264 (Lafond, 328–33, 345), and reused panels at Evreux, which include those of a transept chapel founded in 1261. Cf. Louis Grodecki and Catherine Brisac, *Le Vitrail gothique,* Fribourg, 1984, fig. 150.

22. Grodecki and Brisac, figs. 149, 134; also the Passion Master at Gassicourt. See Lillich, *The Armor of Light,* chap. iii (in press). Such drapery washes appear in the Rhineland at Freiburg Cathedral (enthroned figures from the south rose, touched by Zackenstil angularity, dated mid-thirteenth century): Hans Wentzel, *Meisterwerke der Glasmalerei,* Berlin, 1951, 88, pl. 82.

23. On the axial bay of Toul Cathedral, see page 11 above; on the dating of Ménillot, see page 26 above.

24. The stained glass of Saint-Gengoult is catalogued in *Le Vitrail en Lorraine,* 357–61. Unfortunately, the only published illustration from the christological lancet of Bay 0 is the modern panel of the Baptism. See note 33 below.

25. On the architecture of Saint-Gengoult: Alain Villes, *La Cathédrale de Toul: Histoire et architecture,* Metz, 1983, 210–25 passim; Rainer Schiffler, *Die Ostteile der Kathedrale von Toul und die davonabhängigen Bauten des 13. Jahrhunderts in Lothringen,* Cologne, 1977, 127ff.

26. At Saint-Gengoult there are more lobes (eight compared to the cathedral's six) and they are smaller. The ox and eagle are totally modern. Matthew's winged man and the lion are generally similar to the cathedral, and the evangelists themselves, shown writing at desks in the cathedral traceries, do not appear at Saint-Gengoult. Neither the cathedral nor Saint-Gengoult Bay 0 is, as sometimes stated, a Last Judgment program. The angels do not carry instruments of the Passion or indeed anything besides crowns (sometimes in partially veiled hands) and incense; all angels with trumpets are modern. Among the Saint-Gengoult lobes is a supplicating Virgin beneath the Christ (as in the Last Judgment in the traceries of the great east window of Dol Cathedral), an enthroned Ecclesia with book (compare Toul Cathedral's restored lobe of Christ with book), and a modern Christ on a rainbow showing his wounds (compare to the cathedral's similar lobe, also heavily restored).

27. My comparison of these scenes at the cathedral and Saint-Gengoult is on page 11.

28. The six surviving Infancy scenes in Bay 0, Saint-Gengoult, were probably augmented at least by an Annunciation and Visitation. The lancet (which contains the life of Christ) now preserves twelve of its original fifteen scenes.

29. Since this panel is now more than half covered by the Baroque dado, my examination was made from the exterior (at a distance) and from Archives photographiques photographs. The lower part of the roundel is modern, except near the fire; the new piece of glass at the Child's shoulder does not alter the gesture I have described.

30. The piece of glass on which is painted the orb held by the hands of the Virgin and Child is modern, as is all the adjacent drapery, except the gray-blue of the Child's chest. Thus the gesture may not be copied entirely accurately. The kneeling magus's cigar box full of coins is also a new piece of glass.

31. The Child's draperies are new at Saint-Gengoult, so his original contraposto may not have been so severe.

32. These white and yellow frames now alternate both vertically and horizontally. Since more than half of them are totally modern, such an alternation cannot be established for the original installation. Indeed the remaining old frames of the Infancy Master's scenes are all yellow: Adoration of the Magi, Flight to Egypt, Massacre of the Innocents, Three Marys at the Tomb. There are only seven old frames extant in the entire christological lancet, and seven (plus a few pieces) in the neighboring lancet of Saint Gengoult's life.

33. Although the Baptism was described as "almost all new" by Véronique Duroy de Bruignac, "Les Vitraux de la fin du moyen-âge dans la collégiale Saint-Gengoult de Toul," Mémoire de maîtrise d'histoire de l'art, Université de Nancy (1973), it was the panel selected to illustrate the lancet in Le Vitrail en Lorraine, 358. On the rearrangement of the scenes of the life of Saint Gengoult, see chapter III, page 55.

34. Abbé Bagard, "Notice historique et descriptive de l'église Saint-Gengoult de Toul," Mémoires de la Société d'archéologie lorraine, 2d series, 1, 1859, 47–48. He listed fourteen scenes above the Baroque dado, which were, from bottom up: Adoration of the Magi, Flight to Egypt, Massacre of the Innocents, Presentation in the Temple, "Jésus traîné par des soldats" (probably the existing panel of Herod's soldiers, part of the Massacre), Christ before Pilate, the Carrying of the Cross, the Flagellation, the Crucifixion, the Three Marys at the Tomb, Noli Me Tangere, "Lit de parade où repose le corps d'un défunt: à côté, une personne en prières" (probably the badly damaged Nativity), "Jésus et les disciples d'Emmaus. (Douteux.)" (this scene is the punishment of Gengoult's wife from the Saint Gengoult lancet), and "Jésus et la Samaritaine, près du puits de Jacob" (probably the miracle of the spring from the Saint Gengoult lancet). Inexplicably, in 1853 Balthasar reported only twelve scenes in each lancet of the axial bay, and said he couldn't recognize any of them: Abbé Balthasar, "La Collégiale de Saint-Gengoult de Toul (Meurthe)," Revue archéologique, x, 1853, 23.

35. Parts of Bay 8 are illustrated in Le Vitrail en Lorraine, 35, 360. The traceries, which present a Last Judgment, include silver stain and thus date a generation or more later; possibly they occupied a different window originally. They will be discussed in chapter V.

36. Balthasar, 24. The drawing was published by E. Grille de Beuzelin, Statistique monumentale. Atlas, Arrondissements de Toul et de Nancy, Documents inédits sur l'histoire de France, 3d series, Paris, 1837, 38. In the same year, he called the medallions hexagonal(!): Grille de Beuzelin, Statistique monumentale.—(Specimen). Rapport à M. le Ministre de l'Instruction publique sur les monuments historiques des arrondissements de Nancy et de Toul (Département de la Meurthe), Paris, 1837, 12.

37. Monuments historiques, Dossiers for Saint-Gengoult, Toul: "Mémoire sur l'église St. Gengoult de Toul, presenté à son Excellence Monsieur le Ministre d'Etat par Mr. Ch. F. Déguilly," dated 8 June 1861.

38. Bagard, 49. The restoration seems to have been under way as his article went to press. The twelve scenes he describes are not in their present order, and there is no way to establish whether they were in fact installed as he lists them and later rearranged, or installed as at present (i.e., in a different way than he had presumed they would be).

39. In 1859 the parishioners commissioned Mansion to make a now-lost window of the Virgin and Child and Saints Joseph, Gengoult, and Gérard: Le Vitrail en Lorraine, 360.

40. Bagard, 49, omits the Nativity altogether but inserts here a Circumcision (not to be confused with the Presentation in the Temple, which he also lists), otherwise unknown. Since the top of the Virgin's body and that of the swaddled Child

are modern, it is likely that the Nativity panel was damaged when Bagard saw it and that he confused its subject.

41. A contrary argument could be made, however, on the basis of Le Mans Cathedral, Bay 105, where the two scenes of the Adoration of the Magi (side by side) interrupt the regular ordering of scenes bottom up in each lancet. See *Les Vitraux du centre et des pays de la Loire,* Corpus Vitrearum France, Recensement II, Paris, 1981, 251. The window dates in the late 1250s: see Meredith Lillich, "The Consecration of 1254: Heraldry and History in the Windows of Le Mans Cathedral," *Traditio,* XXXVIII, 1982, 346.

42. The lower panels may also have been blinded by the roof of an adjoining shop; at present, an only slightly sloping roof still masks the lower half of each bottom panel. The scenes within the medallion frames presumably would be interchangeable during a releading. While the medallions in the lancet heads are cut at the top by the wide border, by overlaying on a photo of the Presentation in the Temple—which I suggest was originally in the lancet head—the present truncated shapes of the two lancet-head medallions, it can be seen that the entire Presentation would have fitted except for the maid-servant's head (which is now modern and overlaps the filet border). The problem would be eliminated if one could rely on the 1837 drawing—which unfortunately is not very precise—since it shows the scenes in the lancet heads unframed.

43. See chapter I at note 7. Simple octagonal frames appear at Le Mans (bay 107), c. 1255–60: Grodecki and Brisac, figs. 118–19.

44. See chapter I at note 80.

45. See above at notes 15–16. The Saint-Paul borders at Metz Cathedral are illustrated in Aubert, *Cathédrale de Metz,* pl. XXXIV, A.

46. Illustrated in Recensement II (as in note 41), fig. 102, 229.

47. See chapter III at note 2 and passim.

48. See chapter I at note 18. Bay 18 in the cathedral's south nave aisle retains some grisaille debris in the traceries: *Le Vitrail en Lorraine,* 354 (this bay is located incorrectly as a clerestory, on the plan on p. 352).

49. Meredith Lillich, "A Redating of the Thirteenth-Century Grisaille Windows of Chartres Cathedral," *Gesta,* XI/1, 1972, particularly 13, 14, 17. Delaporte bay numbers are used; see the plan at the beginning of the article.

50. Eugène Viollet-le-Duc, *Dictionnaire raisonné de l'architecture française du XIe au XVIe siècle,* Paris, 1875, IX, 455 ("Vitrail").

51. Pinoteau has established that the castles do not signify Blanche de Castille, as so often has been maintained, but to the pretentions of Saint Louis, his father and his children, to the throne of Castille: Hervé Pinoteau, *L'Héraldique de saint Louis et de ses compagnons,* Les Cahiers nobles, XXVII, Paris, 1966, 8. See discussion in chapter IV, page 88.

52. Marcel Aubert et al., *Les Vitraux de Notre-Dame et de la Sainte-Chapelle de Paris,* Corpus Vitrearum France I, Paris, 1959, pls. 18, 71, and 76.

53. Jean Lafond, "Les Vitraux de la cathédrale Saint-Pierre de Troyes," *Congrès archéologique,* CXIII, 1955, 48.

54. The Gassicourt border is illustrated in Joan Evans, *Cluniac Art of the Romanesque Period,* Cambridge, 1950, frontispiece (the figure is modern, but the border is based on original fragments in bays 1 and 2). On Gassicourt, see Meredith Lillich, *The Armor of Light,* chap. III. On Saint-Dié, see chapter IV below.

55. Martin, 318–19. Indeed, the first official to excommunicate the townspeople following the September 1261 treaty was the *archidiacre,* who by office also served as provost of Saint-Gengoult.

56. See page 32 above.

57. *Le Vitrail en Lorraine,* 357; the medieval grisaille is illustrated on 358.

58. On Leprévost's activity at Saint-Gengoult, see below. These two figures appear in the grisailles in pre-1898 photographs, for example, the one published by Jean Vallery-Radot, "Toul," *Congrès archéologique,* XCVI, 1933, 261. However, no nineteenth-century writer mentions them. There is some indication of rearrangement where the canopies meet the grisaille panel, and the figures are much smaller in scale than in medieval windows in which a colored figure appears in a grisaille surround. Cf. the axial chapel and clerestories of Auxerre (Raguin, pls. 3, 82, 84); also Linas (Essonne) and Brie-Comte-Robert (Seine-et-Marne) in *Les Vitraux de Paris, de la région parisienne, de la Picardie et du Nord-Pas-de-Calais,* Corpus Vitrearum France, Recensement I, Paris, 1978, 82, 89–90.

59. Bagard, 19, 23. Her attributes include crown, book, and sword, according to Louis Réau, *Iconographie de l'art chrétien,* III, *Iconographie des saints,* Paris, 1958, I, 265. A standing Saint

Catherine with crown appears in the Cistercian church of Neukloster, c. 1240/50: Wentzel, pl. 39. A crowned Saint Catherine with sword, c. 1310–30, from Wood Walton, Cambridgeshire, is in the Stained Glass Museum at Ely: *Age of Chivalry*, London, 1987, 445. On the omission of Catherine's wheel attribute, see Lillich, *The Stained Glass of Saint-Père de Chartres*, Middletown, Conn., 1978, 145–46.

60. This has not, of course, prevented inattentive restorers from doing so, and in fact both lancets are in need of careful reinstallation. On grisaille development, see Lillich, "Grisaille Windows of Chartres Cathedral," 12, 14; Lillich, *Saint-Père*, 26–28.

61. The flowerpot motif seems to be "on the way out" at Sées, and it is absent from the grisailles of Saint-Gengoult Bay 6 discussed below. On Sées: *Stained Glass before 1700 in American Collections: Mid-Atlantic and Southeastern Seaboard States*, Corpus Vitrearum Checklist II, *Studies in the History of Art*, XXIII, Washington, D.C., 1987, 100, 135 with bibliography.

62. For help, information, and photographs of these grisailles, I would like to thank Michael Cothren, Michel Hérold, Benoît Marq, Catherine Brisac, and Anne Prache. Another related grisaille survives, the small fragment in the "collector's panel" in the Musée lorrain, Nancy: see chapter I at notes 12, 13.

63. The Saint-Gengoult grisailles are mentioned by Balthasar (as in note 34), 24; and in the dossiers on Saint-Gengoult at the Monuments historiques there is a request of August 1874 for funds to restore "the two medallion windows and the two grisailles matching them in size and epoque" in the north and south chapels. Leprévost exhibited tracings of Saint-Gengoult grisailles in the 1884 exhibition: Lucien Magne, *Huitième exposition de l'Union centrale des arts décoratifs, Section des Monuments historiques. Vitraux anciens, Catalog*, Paris, 1884, 42 no. 34 (unillustrated).

64. Leprévost's photographs, clearly taken in the studio, entered the Archives photographiques in Paris in 1910 as MH 15.364 and 15.365. Lucien Magne published photo MH 15.364 twice: Magne, *L'Oeuvre des peintres verriers français . . .*, Montmorency-Ecouen-Chantilly, Paris, 1885, xxi, fig. 13; and Magne, *Vitraux à l'exposition universelle internationale de 1900, à Paris, Musée rétrospectif de la classe 67, Rapport*, Saint-Cloud, 1902, 21, fig. 7 (upside down). After the 1900 exposition closed, Magne was authorized to organize the stained glass in a

gallery of the Trocadéro. His 1910 catalogue of the Trocadéro is reprinted and discussed in chapter I at notes 14, 15.

65. The Schulpforta grisailles are published in *Mittelalterliche Glasmalerei in der Deutschen Demokratischen Republik*, Katalog zur Ausstellung im Erfurter Angermuseum, Berlin, 1989, 18–19, no. 10. The Altenberg grisailles are published by Brigitte Lymant, *Die mittelalterlichen Glasmalereien der ehemaligen Zisterzienserkirche Altenberg*, Bergisch Gladbach, 1979, Abb. 36, 43, 73 (drawing). I would like to thank Dr. Arnold Wolff for his generous assistance on Altenberg.

66. Illustrated in Helen Jackson Zakin, "Cistercian Glass at La Chalade (Meuse)," *Studies in Cistercian Art and Architecture*, I, ed. Meredith Lillich, Kalamazoo, 1982, fig. 7; Zakin, "Recent Restorations of the La Chalade Glass," *Mélanges à la mémoire du Père Anselme Dimier*, III (vol. 6), ed. Benoît Chauvin, Pupillin (Arbois), 1982, figs. 617–18.

67. Quoted in chapter I, page 19.

Chapter III: Saint-Gengoult (Toul)

1. For data in this paragraph, see Martin, 294–95, 317, 322–27. He devotes a large section of his first volume, comprising nine chapters, to "L'agitation communale."

2. Martin, 305–6.

3. The element of popular piety is very important in the glazing at Sainte-Radegonde, Poitiers, contemporary with Saint-Gengoult: see Lillich, *The Armor of Light*, chap. IV.

4. Balthasar, 23; Bagard, 47.

5. The garment in the uppermost light, a modern restoration, is less angular but does retain a sort of hem-band.

6. Ellen J. Beer, *Die Glasmalereien der Schweiz vom 12. bis zum Beginn des 14. Jahrhunderts*, Corpus Vitrearum Schweiz I, Basel, 1956, 75–76, pl. 42, and 84–85, pls. 47, 48. See also Jane Hayward, "Glazed Cloisters and Their Development in the Houses of the Cistercian Order," *Gesta*, XII, 1973, 99, fig. 9 (dating Wettingen c. 1280).

7. Beer, 84 n. 253, lists several fourteenth-century windows, to which could be added: Saint Cath-

erine chapel of Strasbourg Cathedral, c. 1340–45, illustrated in *Strasbourg Corpus Vitrearum*, fig. 504–5 (bay Chap s V); Sankt Leonhard im Lavanthal, illustrated in Walter Frodl, *Glasmalerei in Kärnten 1150–1500*, Vienna, 1950, fig. 98 (window 9); tracery light in the axial clerestory of Evreux, 1334–40, discussed by Jean Lafond, "Le Vitrail du XIVe siècle," in Louise Lefrançois-Pillion, *L'Art du XIVe siècle en France*, Paris, 1954, 232 n. 28. On the sudarium and the 1300 jubilee, see among others: André Chastel, "La Véronique," *Revue de l'art*, nos. 40–41, 1978, esp. 71–72; Paul Perdrizet, "De la Véronique et de sainte Véronique," *Seminarium Kondakovianum*, V, 1932, 1–15, esp. 4. On the history of jubilee years, see "Holy Year," *New Catholic Encyclopedia*, New York, 1967, III, 108.

8. But see the Ebstorf map, probably earlier: note 29 below. On the Psalter image (Pierpont Morgan, MS M 729, fol. 15), see Karen Gould, *The Psalter and Hours of Yolande of Soissons*, Cambridge, Mass., 1978, 81–94, fig. 7.

9. Suzanne Lewis, "*Tractatus Adversus Judaeos* in the Gulbenkian Apocalypse," *Art Bulletin*, LXVIII, December 1986, 565–66 and fig. 24.

10. On the three earliest examples, see note 11 below. The other four (three of them psalters) are listed in S. Lewis, 565; two are illustrated in Peter Brieger, *English Art 1216–1307*, Oxford: 1957, pls. 52a and 53. Sometimes grouped with these manuscripts is the Christ bust on the Ascoli-Piceno cope, of *opus anglicanum*: Brieger, 211; A. Grace Christie, *English Medieval Embroidery*, Oxford, 1938, pl. XLIII. Susan Kyser, whose 1989 master's thesis at Syracuse University studied this cope, has provided me with several very useful references. All the English examples show Christ's neck, and all but Brieger's plate 53 (inserted leaf in the Westminster Psalter, London, Brit. Lib., Roy 2 A XXII, fol. 221v) show the garment, with a decorated band forming a sharp turn at the shoulders as at Saint-Gengoult.

11. Nigel Morgan, *Early Gothic Manuscripts, 1190–1250*, London, 1982, nos. 24 and 88, pp. 72–73, 137–39, pl. 307; all three are illustrated in Flora Lewis, "The Veronica: Image, Legend and Viewer," *England in the Thirteenth Century*, Proceedings of the 1984 Harlaxton Symposium, ed. W. Mark Ormrod, Woodbridge, Suffolk, 1986, figs. 1–3.

12. F. Lewis, 102; Gould, 86 n. 53, gives the Matthew Paris text (*Chronica majora* III.7). The prayer text is given in full in Solange Corbin de Mangoux, "Les Offices de la sainte face," *Bulletin des études portugaises et de l'Institut français au Portugal*, n.s., XI, 1947, 28–29.

13. Karl Pearson, *Die Fronica*, Strasbourg, 1887, 69; Perdrizet, 6.

14. Victor Leroquais, *Les Psautiers manuscrits latins des bibliothèques publiques de France*, I, Mâcon, 1940–41, 81–86; Hanns Swarzenski, *Die lateinische illuminierten Handschriften des XIII. Jahrhunderts*, Berlin, 1936, 50f., 126–28, no. 46, illustrated pl. 94 no. 555; Beer, 88, fig. 38. Other manuscripts that include the prayer and/or reference to the indulgence: Arundel Psalter (Morgan, 72–73), Lambeth Psalter (Brieger, 173 n. 3), Westminster Psalter (Gould, 87 n. 53), Yolande de Soissons Psalter (Gould, 82), Psalter-hours from Arras (Paris, Bibl. nat., MS lat. 1328, fol. 229v). On the Arras Psalter, dated late thirteenth century to c. 1310, see Victor Leroquais, *Les Livres d'heures manuscrits de la Bibliothèque nationale*, I, Paris, 1927, xlvf., 149–50, no. 61; John Plummer, *The Glazier Collection of Illuminated Manuscripts*, New York, 1968, 30.

15. F. Lewis, 100 n. 4, also 102–3.

16. On Wettingen, see note 6 above. On the Hildesheim Psalter (Donaueschingen, Fürstich-Fürstenbergische Hofbibliothek, Cod. 309), fol. 33v (bust of the Virgin) and fol. 34r (bust of Christ): illustrated in Arthur Haseloff, *Eine thüringisch-sächsische Malerschule des 13. Jahrhunderts*, Strasbourg, 1897, rpt. 1979, pl. XL nos. 93 and 94; see also Renate Kroos in *Ornamenta Ecclesiae*, Schnütgen-Museum catalogue, Cologne, 1985, III, no. H 64, p. 162, illustrated on 166.

17. Otto Pächt, "The 'Avignon Diptych' and Its Eastern Ancestry," in *De Artibus Opuscula XL, Essays in Honor of Erwin Panofsky*, ed. Millard Meiss, New York, 1961, 402–21, esp. n. 55, also at nn. 72, 73. Pächt, who did not know the thirteenth-century Germanic examples, built a complicated but unconvincing hypothesis for a pre-Iconoclast Byzantine source related to the Holy Sepulcher, Jerusalem. On his own evidence an equally strong hypothesis could be made for Rome. An image of the Virgin painted by Saint Luke was venerated in Saint Peter's, not far from the Veronica image of Christ, by at least c. 1375, when it is mentioned in the "Mirabiliana": *Mirabilia Urbis Romae, The Marvels of Rome . . . ,* ed. and trans. Francis Morgan Nichols, London, 1889, 126 (the sudarium is on 128 and the Lateran image on 132).

18. Emile Mâle, *Religious Art in France: The Thirteenth Century*, Princeton, 1984, chart on 308–9; Lillich, *Saint-Père*, 96–98, 117–21.

19. On heraldry and rolls of arms: Ann Payne, "Medieval Heraldry," in *Age of Chivalry*, ed. Jonathan Alexander and Paul Binski, London, 1987, 55–59; references in Meredith Lillich, review of Folda, *Crusader Manuscript Illumination at Saint-Jean d'Acre 1275–1291*, in *Art Bulletin*, LX, 1978, 162–63. On surnames, see the references in Meredith Lillich, "Gothic Glaziers: Monks, Jews, Taxpayers, Bretons, Women," *Journal of Glass Studies*, XXVII, 1985, 77 n. 24.

20. The literature of the mandylion of Edessa, now identified as the icon from Constantinople sold to Saint Louis in the thirteenth century, is vast. See Steven Runciman, "Some Remarks on the Image of Edessa," *Cambridge Historical Journal*, III, 1931, 251; Gould, 89–90; Perdrizet, 1–2; Corbin, 5–8; Henri Stein, *Le Palais de Justice et la Sainte-Chapelle de Paris*, Paris, 1912, 145–46.

21. Illustrated in Gould, fig. 65. The basic study is André Grabar, *La Sainte face de Laon: Le mandylion dans l'art orthodoxe*, Prague, 1931; on the liturgy, see Corbin, 43–55.

22. Grabar, 9.

23. Morgan, 73, 139; Pächt, 407–8.

24. F. Lewis, 102.

25. Another stained glass panel that seems to be a "close-up," in F. Lewis's sense, is the roundel in the Schweizerischen Landesmuseum (c. 1260), illustrated in Beer, pl. 42 (a bust of Christ including a large blessing hand).

26. S. Lewis, 565–66; Gould, 86 n. 52; Pächt, 408–9. See also Suzanne Lewis, *The Art of Matthew Paris in the "Chronica Majora,"* Berkeley, 1987, 128–29, 422–23. Appendix I below contains the complete passage from Gervase of Tilbury, *Otia imperiale* III.25, as published by Gottfried Wilhelm Leibnitz, *Scriptores Rerum Brunsvicensium*, Hannover, 1707, I, 968.

27. See note 16 above.

28. Beer, 85; illustrated in Paul Clemen, *Die Romanische Monumentalmalerei in den Rheinlanden*, Düsseldorf, 1916, I, 461, fig. 331, dated after 1216.

29. Walter Rosien, *Die Ebstorfer Weltkarte*, Hannover, 1952, esp. 31–35, n. 39. The Ebstorf world map, destroyed in 1943, was an immense exemplar of the type known as the "T and O" map, with Christ's head added at the top, his hands at either side, and his feet at the bottom. The entire map is illustrated in the *Encyclopedia of World Art*, New York, 1960, III, pl. 494

(bottom left); the head is illustrated in Edgar Breitenbach, "The Tree of Bigamy and the Veronica Image of St. Peter's," *Museum Studies* (Art Institute, Chicago), IX, 1978, 36, fig. 6.

30. See Rosien and Breitenbach. Gervase was an English nobleman, educated in Italy, who served several princes in southern Europe before entering the service of Emperor Otto IV. After Otto's defeat at Bouvines in 1214, Gervase seems to have followed him into retirement in Lower Saxony and ended his days as a canon. See H. G. Richardson, "Gervase of Tilbury," *History*, XLVI, no. 157, June 1961, 102–14; also Henry William Carless Davis, "Gervase of Tilbury," *Encyclopaedia Britannica*, 11th ed. Cambridge, 1910, XI, 907–8, who states: "We do not know what became of Gervase after the downfall of Otto IV. But he became a canon; and may perhaps be identified with Gervase, provost of Ebbekesdorf, who died in 1235." Gervase was in England after becoming a canon, when Ralph of Cogglehall reports a conversation with him: Radulphi de Coggeshale, *Chronicon anglicanum* . . . , ed. Joseph Stevenson, London, 1875, 122–24 (fols. 90r–91r).

31. Breitenbach, 36–37.

32. Appendix II presents the complete text as published in *Giraldi Cambrensis Opera*, ed. J. S. Brewer, IV, London, 1873, 278–80. The literature on the two Roman images is vast. In addition to the rich documentation in S. Lewis, 566, and F. Lewis, 103, this section has drawn on material in all the authors cited above (Gould, Pächt, Chastel, etc.). The basic study, reprinting all the texts, remains Ernst von Dobschütz, *Christusbilder*, Leipzig, 1899.

33. On editions of the *Mirabilia* and their woodcuts, see Max Sander, *Le Livre à figures italien depuis 1467 jusqu'à 1530*, Milan, rpt. 1969, IV, lxxvi–lxxviii. Two of the woodcuts are illustrated in Sander, VI, nos. 760 and 761; a third in Carlo Enrico Rava, *Supplement à Max Sander, Le Livre à figures italien de la Renaissance*, Milan, rpt. 1969, no. 53; and a fourth appears in Hans Belting, *Das Bild und sein Publikum im Mittelalter*, Berlin, 1981, 35, and in A. Pietro Frutaz, "Veronica," *Enciclopedia cattolica*, XII, Vatican City, 1954, col. 1300 (reprinted from the facsimile edited by Christian Hülsen, Berlin, 1925). A fifth, unpublished as far as I know, is found on fol. 16v of an incunabulum in the Library of Congress, Goff M–602 (Rosenwald Incun. 1497.I 5). All woodcuts show the Veronica in a frame, and all but the first (the Gotha

blockbook) show the face with a distinct (metal?) halo.

34. Joseph Wilpert, *Die Römischen Mosaiken und Malereien der kirchlichen Bauten vom IV. bis XIII. Jahrhundert*, Freiburg im Breisgau, 1916, text vol. II, 1123–25. Reports of the Veronica's appearance in modern times are collected in F. Lewis, 105–6, and Gould, 86 n. 51. No one seems to have suggested the possibility of damage in 1527 by fire.

35. The basic study is Joseph Wilpert, "L'Acheropita ossia l'immagine del Salvatore nella cappella del *Sancta Sanctorum*," *L'Arte*, X, 1907, 161–77 and 247–62; he altered his conclusions slightly in 1916 (see note 34 above). Innocent III's silver cover is illustrated in Wilpert (1907), fig. 9; a careful comparison with fig. 8 (the image as it appears now with Baroque putti at the top of the gilt cover) indicates how much was probably exposed. The present halo is fifteenth-century. Wilpert considered the twelfth-century head "di una grande bruttezza" (174). The frontal pose and enlarged eyes may have characterized the sixth-century original; compare the bust of Christ in the Pontianus catacomb (c. 650), illustrated in Sergio Bettini, *Frühchristliche Malerei und frühchristliche-Römische Tradition bis zum Hochmittelalter*, Vienna, 1942, pl. 97.

36. Marangoni noted this when he examined the panel in 1746: Giovanni Marangoni, *Istoria dell' antichissimo oratorio, o capella di San Lorenzo nel patriarchio lateranense . . .* , Rome, 1747, 89.

37. See Appendixes I and II, also Wilpert (1916), 1110.

38. Wilpert (1907, 251) dated the *portacina* mid-fourteenth century; in 1916 (1112) he dated it fifteenth century.

39. Père Benoît Picart, *Histoire ecclésiastique et politique de la ville et du diocèse de Toul*, Toul, 1707 (rpt. 1977 as *Histoire de Toul*), 165. On the status of the provost of Saint-Gengoult as archdeacon of the cathedral, see Martin (as in note 12 of chapter II), 214. The provost's trip to Rome took place between Bishop Gilles de Sorcy's election in early 1253 and his eventual consecration in mid-1255 (Martin, 296–98).

40. In addition to the bibliography in *Lexikon der christlichen Ikonographie*, ed. Wolfgang Braunfels, Freiburg im Breisgau, 1974, VI, col. 349–50, see Hiltgart Keller, *Reclams Lexikon der Heiligen und der biblischen Gestalten*, Stuttgart, 1984, 242–44. The only depictions of Gengoult's legend to predate the Saint-Gengoult glass are some tentatively identified groups on the twelfth-century

sculpted frieze at Lautenbach in Alsace: *Alsace romane*, La Pierre-qui-vire, 1965, 255, pl. 95; the cult at Lautenbach is discussed in Médard Barth, "Heiligenkulte in Elsass . . . ," *Archives de l'église d'Alsace*, III, 1952, 36–39.

41. The historical data are collected by Jean Marilier, "Gengolfo, santo," *Bibliotheca sanctorum*, Istituto Giovanni XXIII della Pontificia Università Lateranense, Vatican, 1965, VI, cols. 127–28; Fridolin Mayer, "Der heilige Gangolf, seine Verehrung in Geschichte und Brauchtum," *Freiburger Diözesan-Archiv*, n.s., 40, 1940, 90–92.

42. Assessments of the historical inaccuracy of the *vita* have remained fairly constant: *Histoire littéraire de la France*, Paris, 1742, VI, 180–81; *Butler's Lives of the Saints*, ed. Herbert Thurston and Donald Attwater, New York, 1963, II, 272.

43. See the bibliography in Hanns Bächtold-Stäubli, *Handwörterbuch des Deutschen Aberglaubens*, Berlin, 1930, III, cols. 289–90. Alsatian studies are particularly rich, for example, the works cited above by Barth and Mayer.

44. On the foundation of Saint-Gengoult, see Martin, 162–64. The relic is identified as part of the skull by Mayer, 101, and as an arm by Bagard (as in note 34 of chapter II), 10 (but see 23, where the cranium is mentioned).

45. The *vita* is edited by Wilhelm Levison in *Monumenta Germaniae Historica, Scriptorum rerum Merovingicarum*, Hannover, 1919, VII, 142–74. On *vita* II, see also Mayer, 94–95. Around the same time (c. 980) Hrosvitha of Gandersheim wrote a poem on the saint's life, probably based on *vita* I, but changing the location of his tomb (in error) to Toul: *Hrotsvithae Opera*, ed. Paul Winterfeld, Berlin, 1902, 35–51.

46. Vincent de Beauvais, *Speculum quadruplex*, IV: *Speculum historiale*, 1624, rpt. Graz, 1964–65, 955. The legend never lost its popularity. A late fifteenth-century manuscript (Paris, Arsenal, MS 3684, fols. 57, 58) gives Vincent of Beauvais's version in French: see Alain Surdel, "La Légende de saint Gengoult au XVème siècle," *Etudes touloises*, no. 19, 1980, 21–29. *Vita* I was edited by Laurentius Surius in his *Historiae seu vitae sanctorum*, 1570–75, rpt. 1875–80, V, 322–26; a 1705 version by Martin von Cochem, the *Gangolfusbüchlein*, has been edited by R. Aichele, Karlsruhe, 1925; see also the outrageous "Lay of St. Gengulphus," among *The Ingoldsby Legends* by the British humorist Richard Harris Barham (d. 1845), published in

countless editions. I am grateful to Ted Dalziel for showing me his copy.

47. *La Revue lorraine populaire*, no. 39, April 1981, illustrates two sculptures of Saint Gengoult on horseback (110–11) as well as the sixteenth-century window at Saint-Gengoult, Bay 116 (cover illus. in color; see also *Le Vitrail en Lorraine*, 361).

48. Mayer, 132–39 (quoted on 138).

49. *Le Vitrail en Lorraine*, 357; Jacques Bombardier, "Analyse de la verrière centrale de l'abside de la collégiale Saint-Gengoult de Toul," *Etudes touloises*, no. 19, 1980, 16–19; Véronique Duroy de Bruignac, "Les Vitraux de la fin du moyen-âge dans la collégiale Saint-Gengoult de Toul," Mémoire de maîtrise d'histoire de l'art, Université de Nancy (1973). The window is also mentioned in Grodecki and Brisac (as in note 2 of Introduction), 148, 262.

50. The lowest panel, behind the Baroque dado and filled with modern clear glass, will be ignored in the numbering.

51. Color illustration on the cover of *La Revue lorraine populaire* (1981).

52. Neither the wife nor lover is named in the *vita* or in Vincent de Beauvais. Her name is given as Ganea in some modern accounts.

53. See note 49 above.

54. See note 51 above.

55. Garnier, 229; Henry Martin, "Les Enseignements des miniatures: Attitude royale," *Gazette des beaux-arts*, series 4, IX, 1913, 173–88.

56. D. L. Galbreath, *Manuel du blason*, new ed. Léon Jéquier, Lausanne, 1977, 28, fig. 12 (seal of 1162).

57. Since the banner is too tiny to allow the glazier to lead gold lilies into a blue ground, he drew the three lilies on yellow glass and painted the remainder of the flag with a matte. On the arms of Pepin, see Louis Carolus-Barré and Paul Adam, "Les Armes de Charlemagne dans l'héraldique et l'iconographie médiévales," *Mémorial d'un voyage d'études de la Société nationale des Antiquaires de France en Rhénanie*, Paris, 1953, 298, 303, nn. 131, 178. Their work has been basic to my discussion below. The Armorial Gelre (Brussels, Bibl. Roy., MS 15652–56) has been edited by Paul Adam-Even, *L'Armorial universel du héraut Gelre* (1370–1395), corrected offprint of *Archives héraldiques suisses*, Neuchâtel, 1971. While Pepin's banner of three fleurs-de-lys, at Saint-Gengoult, predates the fourteenth-century poem by the hermit of Joyenval that presumably invented the legend of the miraculous origin of the three lilies of France, Max Prinet has established the use of three lilies by c. 1225: "Les Variations du nombre des fleurs de lis dans les armes de France," *Bulletin monumental*, LXXV, 1911, 469–88. On the legend, see Gerard Brault, *Early Blazon*, Oxford, 1972, 210.

58. Carolus-Barré, 289–91, 298–99.

59. Lines 4999 and 5004–6 of *Les Enfances Ogier par Adenés li Rois*, ed. Aug. Scheler, Brussels, 1874, 148. See also note 58 above.

60. Carolus-Barré, 304 n. 7. The text is edited by Ioh. Heller, "Genealogiae ducum brabantiae," in *Monumenta Germaniae Historica, Scriptorum*, Leipzig, 1925, XXV, 385–404 (nos. XI–XIII). See also Robert Folz, *Le Souvenir et la légende de Charlemagne dans l'Empire germanique médiéval*, Paris, 1950, 377–78, 441, 538 (thanks to Elizabeth A. R. Brown for this reference).

61. Victor Beyer et al., *Les Vitraux de la cathédrale Notre-Dame de Strasbourg*, Corpus Vitrearum France IX–1, Paris, 1986, 154, 163–68 (bay n: IV).

62. On Robert d'Aix: Jules Vannérus, "Les Anciens dynastes d'Esch-sur-Sûre," *Ons Hémecht*, XIII, 1907, 411–13, and XIV, 1908, 367. On the brilliant careers of his elder brother Joffroi and their father, Robert (d. 1262): Jacques Bretel, *Le Tournoi de Chauvency*, ed. Maurice Delbouille, Liège, 1932, lxxix; Auguste Neyen, "Histoire des seigneurs et du bourg d'Esch-sur-Sûre dans le canton de Wiltz, Grand-Duché de Luxembourg," *Publications de la Section historique de l'Institut royal grand-ducal de Luxembourg*, XXXI, 1876, 190–211 passim. For the genealogy: Michel Parisse, *La Noblesse lorraine XIe–XIIIe s.*, Paris, 1976, II, 28.

63. The capital of the dukes of Lorraine was Nancy, just east of Toul. While the residence of the dukes of Brabant was Louvain, they also served as the emperor's hereditary *avoué* (first minister) in the royal seat of Aachen: see Edmond de Dynter (d. 1448), *Chronica nobilissimorum ducum Lotharingiae et Brabantiae . . . cum aliis codd. mss. edidit ac gallica Johannis Wauquelin*, ed. Pierre F. X. De Ram, Brussels, 1854–60, II, 432–33, 711–13.

64. On Robert's older brother Jean, bishop *élu* of Verdun (1245–53): Nicolas Roussel, *Histoire ecclésiastique et civile de Verdun*, Bar-le-Duc, 1863, I, 304–5; Neyen, 194–96; Vannérus, XIII, 373–79, and XIV, 367. Unfortunately the sires of Assche, among the *magnates Brabantiae* in the thirteenth century, are totally unrelated; their genealogy appears in Christophre Butkens, *Trophées tant sacrés que prophanes du duché de*

Brabant, The Hague, 1724–26, II, 72–73, 159, and Supplément I, 158–59.

65. Levison, 152, 154, 159 n. 4, 167. On *vita* II, note 45 above.

66. Illustrated in color in *Le Vitrail en Lorraine*, 155.

67. See note 66 above.

68. Surdel, 29 n. 14.

69. John W. Baldwin, "The Intellectual Preparation for the Canon of 1215 against Ordeals," *Speculum*, XXXVI, 1961, 613–36.

70. Mayer, 129.

71. Surdel, 29 n. 15.

72. E.-H. Vollet, "Arianisme," *La Grande encyclopédie*, III, Paris, n.d., 892.

73. *The Golden Legend of Jacobus de Voragine*, ed. Granger Ryan and Helmut Ripperger, New York, 1969, 91; Surdel, 29 n. 18.

74. Most recently in *Le Vitrail en Lorraine*, 357.

75. Lines 575–80 of Passio Sancti Gongolfi Martiris, translated by M. Gonsalva Wiegand, O.S.F., *The Non-Dramatic Works of Hrosvitha*, Saint Louis, Mo., 1936, 121.

76. Levison, 147 and nn. 5, 6; Mayer, 96–97 n. 12.

77. On Robert d'Aix and the Veronicas, see page 47 above; on him and Pepin's heraldic banner in the Gengoult lancet, page 51.

78. Abbé Balthasar, "La Collégiale de Saint-Gengoult de Toul (Meurthe)," *Revue archéologique*, X, 1853, 23. However, all the Saint Nicholas scenes were not identified correctly until 1988 (see note 79).

79. The following discussion of the ex-voto window reproduces my argument in "The Ex-Voto Window of St.-Gengoult, Toul," *Art Bulletin*, LXX, 1988, 123–33; it appeared in French translation in *Le Pays lorrain*, LXX/4, 1989, 225–32. Agatha was identified in Victor Beyer et al., *Vitraux de France du moyen âge à la Renaissance*, Colmar, 1970, 121.

80. The flaming tower was discussed and illustrated in Eugène Marin, "L'Iconographie de saint Nicolas," *Les Marches de l'est*, 3e année no. 9, 15 December 1911, 334–35.

81. Charles Williams Jones, *Saint Nicholas of Myra, Bari and Manhattan: Biography of a Legend*, Chicago, 1978, 277. On the architecture, see André Philippe, "Saint-Nicolas-de-Port," *Congrès archéologique*, XCVI, 1933, 275–300.

82. The literature on Saint Nicholas and Lorraine is enormous. See among other studies: Pierre Marot, "A quelle époque saint Nicolas devint-il patron de la Lorraine," *Mémoires de l'Académie de Stanislas*, 1930. Jean Ruyr, a reputable historian of the early seventeenth century, stated

that the dukes of Lorraine took Saint Nicholas as patron from the year 1120; see Abbé J.-B.-Edmond L'Hote, *La Vie des saints, bienheureux, vénérables et autres pieux personnages du diocèse de Saint-Dié*, Saint-Dié, 1897, I, 62–63.

83. Abbé Jacques Choux, "Paroisses nouvelles dans le diocèse de Toul à la fin du XIe siècle," *Revue historique de la Lorraine* (1949), reprinted in *La Lorraine chrétienne au moyen âge*, Metz, 1981, 108 and n. 5. Jones (1978), 140–44, discusses the cult of Saint Nicholas in the diocese of Toul as early as c. 1000.

84. See *Textes d'histoire lorraine du XIe siècle à nos jours*, Nancy, 1931, 18–20, no. 15; Richer has been edited by G. Waitz in *Monumenta Germaniae Historica, Scriptorum*, XXV, 283–84.

85. Jean de Pange, *Catalogue des actes de Ferri III, duc de Lorraine (1251–1303)*, Paris, 1930, 66, no. 330.

86. *Joinville and Villehardouin: Chronicles of the Crusades*, trans. M. R. B. Shaw, Baltimore, 1963, 321–22. See also Emile Badel, *Le Voeu de St Louis à l'église de Saint-Nicolas-de-Port*, Nancy, 1918, 1–3, 24; P. de Boureulle, "Jean de Joinville, compagnon et historien de saint Louis, à propos de saint Nicolas de Lorraine," *Bulletin de la Société philomatique vosgienne*, XIV, 1888–89, 71–102.

87. Emile Mâle, *Religious Art in France, The Thirteenth Century*, Princeton, 1984, 327. See also Eugène Marin, *Saint Nicolas, évêque de Myre (vers 270–341)*, Paris, 1917, 175–80.

88. Marin (1911), 355, and Pierre Marot, "Le Culte de saint Nicolas en Lorraine, son origine et son évolution," *Arts et traditions populaires*, II, 1954, 167.

89. The 1911 article by Marin, which lists them correctly and illustrates two of them, was not used by the catalogue entry in *Le Vitrail en Lorraine*, 358, or by Véronique Duroy de Bruignac (as in note 49 above).

90. For the liturgy, see Charles Williams Jones, *The Saint Nicholas Liturgy and Its Literary Relationships (Ninth to Twelfth Centuries)*, Berkeley, 1963, 42–46. For the Greek vita, see Jones (1978), 24f., 50–51, 53–58, 58–60, 64–65. For Voragine: *The Golden Legend* (as in note 73), 16–24.

91. Mâle, 286–87; Jones (1978), 128–40.

92. Illustrated in Jean Lafond, "Les Vitraux de la cathédrale de Sées," *Congrès archéologique*, CXI, 1953, 71.

93. Virginia Egbert, "St. Nicolas: The Fasting Child," *Art Bulletin*, XLVI, 1964, 69–70. On the

twelfth-century sculptures: *Radiance and Reflection: Medieval Art from the Raymond Pitcairn Collection*, New York, 1982, 82–83; Léon Pressouyre, "St. Bernard to St. Francis: Monastic Ideals and Iconographic Programs in the Cloister," *Gesta*, XII, 1973, 77.

94. Virginia Raguin, *Stained Glass in Thirteenth-Century Burgundy*, Princeton, 1982, fig. 62. The Chartres tympanum, showing the saint's miraculous tomb at Bari, is illustrated in Mâle, 328.

95. Mâle, 327; Jones (1978), 259; Raguin, 158–60.

96. An 1874 request for funds to supplement a local subscription for the restoration of the chapel windows is in the Monuments historiques in Paris: Dossiers for "Toul, Eglise St Gengoult et cloître (Meurthe-et-Moselle)." In 1884 the catalogue of a Paris exhibition lists tracings by Leprévost from Saint-Gengoult: Lucien Magne, *Huitième exposition de l'Union centrale des arts décoratifs, Section des Monuments historiques. Vitraux, anciens, Catalog*, Paris, 1884, 42 no. 34 (unillustrated).

97. MH 15 365 (photo entered the Archives photographiques in 1910). On Leprévost's studio photographs, see chapter II, page 38.

98. See chapter I, page 8. The borders are nos. 65 and 66 in Lucien Magne, *Palais du Trocadéro, Musée de sculpture comparée. Galerie des vitraux anciens. Notice sommaire*, Paris, 1910.

99. The Saint-Gengoult glass can be positively identified in Magne's exhibitions from 1884 through 1910. They are discussed by Louis Grodecki, "La Restauration des vitraux du XIIe siècle provenant de la cathédrale de Châlons-sur-Marne," *Le Moyen âge retrouvé*, Paris, 1986, 292–93.

100. Abbé Bagard, "Notice historique et descriptive de l'église Saint-Gengoult de Toul," *Mémoires de la Société d'archéologie lorraine*, series 2, I, 1859, 48; on 44 and 85 he discusses the marble ornamentation that blocks the lower parts of the windows in the north chapel and the apse.

101. Witnesses are occasionally included in textual sources and works of art, but not usually the angel. Agatha's closed eyes in the Saint-Gengoult scene establish it as the moment of her death.

102. An excellent study of the iconography is Magdalene Elizabeth Carrasco, "An Early Illustrated Manuscript of the Passion of St Agatha (Paris, Bibl. nat., MS lat. 5594)," *Gesta*, XXIV/1, 1985, 19–32. On Clermont-Ferrand, see Henry du Ranquet, *Les Vitraux de la cathédrale de Clermont-Ferrand*, Clermont-Ferrand, 1932, 243–56 and drawing.

103. Arnold Van Gennep, "Le Culte populaire de sainte Agathe en Savoie," *Revue d'ethnographie et des traditions populaires*, 5e année no. 17, 1924, 36.

104. The *collégiale* of Longuyon is noted even in such a general iconographic guide as Louis Réau, *Iconographie de l'art chrétien*, III, *Iconographie des saints*, Paris, 1958, I, 28. Early studies on the church are summarized by Ch. Rohault de Fleury, *Les Saints de la messe*, Paris, 1894, II, 54–56; a better critique is provided in Léon Germain, *La Paroisse de Longuyon et son église collégiale Ste Agathe*, Montmédy, 1890, 1–11.

105. Van Gennep, 28–29, 34.

106. Van Gennep, 30f; Baudot and Chaussin, *Vies des saints et des bienheureux*, Paris, 1936, II, 117.

107. Fol. 2v of the *Livre du soleil* (Arch.nat. LL 986). On the cartulary, see Eugène Martin, *Histoire des diocèses de Toul, de Nancy et de Saint-Dié*, Nancy, 1900, I, 163 n. 2; Henri Stein, *Bibliographie générale des cartulaires français*, Paris, 1907, 527, no. 3846; Calmet, II, col. 308. On the chart of 1065 and the list of Saint-Gengoult's relics, see Bagard, 11 and 23.

108. See Bagard, 26 (foundation of Saint Nicholas chapel in 1315); 44 (foundation 1316).

109. P.-A. Pidoux, *Vie des saints de Franche-Comté*, Lons-le-Saunier, 1909, 152–53. I am grateful to Dr. Nigel Morgan for his help in establishing the rarity of Saint Agapit images.

110. The texts of Agapit's passion published in *Acta Sanctorum*, 18 August, III, 532–39, all fabulous, are discussed in "S. Anastase, martyr de Salone," *Analecta bollandiana*, XVI, 1897, 490–92. See *Butler's Lives of the Saints* (as in note 42), III, 345.

111. I have found only one thirteenth-century example, in a collection of saints' lives in French: Paris, Bibl. nat., N Acq Fr 23686, fol. 110v. Five scenes of Saint Agapit appear, including three of those in the Saint-Gengoult window—of which two are the beheading and torture upside down over flames found in the twelfth-century Hirsau Passional discussed below (see note 112). The French manuscript does not relate directly to Saint-Gengoult and, of course, could stem from an earlier Latin text such as Hirsau. It is dated c. 1295 (probably too late) by Alexandre de Laborde, *Les Principaux manuscrits à peintures conservés dans l'ancienne Bibliothèque impériale publique de*

Saint-Pétersbourg, Paris, 1936, I, 11–12. The French language of the text is located in Paris, or at least central France/Champagne, by Paul Meyer, "Notice d'un légendier français conservé à la Bibliothèque impériale de Saint-Pétersbourg," *Notices et extraits des manuscrits de la Bibliothèque nationale . . .* , XXXVI, 1899, esp. 691.

112. *Suevia Sacra*, exhibition catalogue, Augsburg, 1973, 179, no. 175, 182–83, no. 182. On the Hirsau Passional: Albert Boeckler, *Das Stuttgarter Passionale*, Augsburg, 1923, 51–52, figs. 103 and 111. On the Usuard martyrology: Karl Löffler, *Schwäbische Buchmalerei in romanischer Zeit*, Augsburg, 1928, 40–41, 52–53.

113. Paul Perdrizet, *Le Calendrier parisien à la fin du moyen âge*, Paris, 1933, 206, no. 18; Cl. Chastelain in M. Ménage, *Dictionnaire étymologique de la langue françoise*, Paris, 1701, I, xlviii; Réau, III/I, 27.

114. While I have been unsuccessful in tracing the occurrence of a fire in Toul c. 1280, there is mention of fire insurance. In May 1272 the abbey of Saint-Mansuy in Toul agreed to furnish the cathedral chapter a building near the marketplace to be used part of the year as a furriery, the chapter agreeing during those months to cover, for the building, one-half the risks of fire: Arch. dépt. Meurthe-et-Moselle 2 F 5, fols. 32v–33r.

115. Louis Grodecki, *Le Vitrail roman*, Fribourg, 1977, 50–54, 269; *Suevia Sacra*, 217–24, nos. 228–30 with bibliography.

116. The Wissembourg head (Musée de l'Oeuvre Notre-Dame, Strasbourg) presumably comes from Saint-Pierre-et-Saint-Paul, Wissembourg (Bas-Rhin): Grodecki, *Vitrail roman*, 49–50, 295. The panel of Saint Timotheus (Cluny Museum, Paris) comes from the chapel Saint-Sébastien at Neuwiller (Bas-Rhin), where a copy of it is now in place: *Vitrail roman*, 54–56, 285. The two saints John were originally in the chapel of Saint John in Strasbourg: *Vitrail roman*, 169–71, 292. The window of Ste. Attale in Saint-Etienne, Strasbourg, was in the south transept above the *Puit de Sainte Attale*; her tomb was below in the crypt. Only the apse and transept of Saint-Etienne survived World War II; constructed after 1172, the church closely resembled the Hirsau-group abbey of Schwarzach east of the Rhine. See X. Ohresser and E. Macker, *L'Eglise Saint-Etienne de Strasbourg*, Strasbourg, 1935.

117. The Augsburg prophet window of Jonah is illustrated in Grodecki, *Vitrail roman*, 51. The Magdalene from Weitensfeld (Klagenfurt Diözesanmuseum): *Vitrail roman*, 185. The "Charlemagne" window (Musée de l'Oeuvre Notre-Dame, Strasbourg): *Vitrail roman*, 173. Saint Peter crucified (Städelsches Kunstinstitut, Frankfurt): Museum für Kunst und Gewerbe Hamburg, *Meisterwerke mittelalterlicher Glasmalerei*, Hamburg, 1966, 44–49 with bibliography. Wentzel (as in note 22 of chapter II) illustrates many such iconic images: 17, 21, 23, pls. 8, 23, 26, 34.

118. Grodecki, *Vitrail roman*, chap. VI ('La Lorraine, l'Alsace et la région rhénane au XIIe siècle'), begins with Sainte-Ségolène.

119. The Romanesque glass reused at Strasbourg is discussed in *Strasbourg Corpus Vitrearum* (as in note 61), 23–38.

120. Michel Parisse, *Histoire de la Lorraine*, Toulouse, 1977, chap. VI, "L'Apogée féodal (XIIe–XIIIe siècles)," 153–88.

121. On ex-votos, see the discussion and bibliography by Wolfgang Braunfels, forming part of the article "Devotional Objects and Images, Popular," *Encyclopedia of World Art*, New York, 1961, IV, cols. 376–77, 380–81; bibliography by Stephen Wilson, *Saints and Their Cults*, Cambridge, 1983, 350–52.

122. Martin, 320–27.

123. English examples occur at Canterbury, Trinity Chapel, bay n:IV (before 1207), and at Lincoln. See Madeline Caviness, *The Early Stained Glass of Canterbury Cathedral, Circa 1175–1220*, Princeton, 1977, 80–82, pls. 159–60. The latest of the French Romanesque examples appear to be the two interpolated medallions from a Last Judgment (c. 1200) found in the Sainte-Chapelle: the Resurrection of the Dead is illustrated in Grodecki, *Vitrail roman*, 117; a drawing of the matching panel of Saint Michael weighing souls, now lost, is in Ferdinand de Lasteyrie, *Histoire de la peinture sur verre*, Paris, 1853, pl. XXVII.

124. Wentzel, 85–86, pls. 36, 44, 45.

125. Wentzel, pl. 66 and fig. 15; Erhard Drachenberg, Karl-Joachim Maercker, and Christa Schmidt, *Die mittelalterliche Glasmalerei in den Ordenskirchen und im Angermuseum zu Erfurt*, Corpus Vitrearum DDR I/I, Berlin, 1976, Abb. 53, 55–57 (Franciscan church) and Abb. 217–18 (Dominican church, destroyed 1945).

126. For Metz, see chapter VI, page 104; illustrated in *Le Vitrail en Lorraine*, 35, 257. On Troyes:

Elizabeth Pastan, "Fit for a Count: The Twelfth-Century Stained Glass Panels from Troyes," *Speculum*, LXIV/2, 1989, 338–72. A similar stick-lit checkerboard ground appears in the choir clerestory glass of Reims, behind the angel in bay N V, dated 1245–55: illustrated in Eva Frodl-Kraft, "Zu den Kirchenschaubildern in den Hochchorfenstern von Reims," *Wiener Jahrbuch für Kunstgeschichte*, XXV, 1972, fig. 36.

127. The Entry to Jerusalem, illustrated in color in *Vitrail français* (as in note 1 of Introduction), pl. VIII; the Washing of the Feet, Grodecki and Brisac, *Vitrail gothique*, pl. 162; a drawing of Christ among the Pharisees is in Eugène Viollet-le-Duc, *Dictionnaire raisonné de l'architecture française du XIe au XVIe siècle*, Paris, 1875, IX, 432.

128. Canterbury, Trinity Chapel: Caviness, pls. 162, 164, 167, 169. Saint-Germain-lès-Corbeil, bay 100: Recensement I (as in note 58 of chapter II), pl. XIV. For the term "living border," see Raguin, 93 n. 171.

129. Raguin, pls. 8, 13, 146.

130. Raguin, pl. 50 (bay 75, Saint Catherine).

131. On the *carré-quadrilobé*: Georges Marçais, "Le Carré quadrilobé, histoire d'une forme décorative de l'art gothique," *Etudes d'art publiées par le Musée national des beaux-arts d'Alger*, I, 1943, 67–79. Sens is illustrated in Grodecki, *Vitrail roman*, pl. 11.

132. All are illustrated in Grodecki and Brisac, *Vitrail gothique*: Gassicourt, 251, Fécamp, 146, Dol, 164, Saint-Urbain de Troyes, pl. 162. Other examples of this type of frame include Notre-Dame, Dijon (c. 1230s), and the interpolated medallions in the north rose of Notre-Dame (dated "slightly later than the rose" of c. 1255), illustrated in *Notre-Dame* Corpus Vitrearum (as in note 4 of chapter IV), pl. 6.

133. Marburg: Wentzel, pl. 37. Erfurt: Corpus Vitrearum DDR I–I, Abb. 143, 148, 150, etc.

134. Raguin, pl. 104. English examples: the north rose of Lincoln, pl. 1 of Nigel Morgan, *The Medieval Painted Glass of Lincoln Cathedral*, Corpus Vitrearum Great Britain–Occasional Paper III, London, 1983; the Clare Chasuble, in Donald King, *Opus Anglicanum: English Medieval Embroidery*, London, 1963, no. 30, 19–20.

135. Herbert Rode, *Die mittelalterlichen Glasmalereien des Kölner Domes*, Corpus Vitrearum Deutschland IV–I, Berlin, 1974, Taf. 53, 55, 65, etc., and pp. 83–91. On Strasbourg: Victor Beyer, "Les Roses de réseau des bas-côtés de la cathédrale . . . ," *Bulletin de la Société des amis de la cathédrale de Strasbourg*, VII, 1960, 63–96.

136. Rode, Farbtaf. 5 (no. 13).

137. See chapter VI at note 16.

Chapter IV: Saint-Dié (Vosges)

1. On the *Cosmographiae Introductio* (1507) published by canons of Saint-Dié in service to Duke René of Lorraine, see among other studies: Lucien Gallois, *Americ Vespuce et les géographes de Saint-Dié*, Nancy, 1900; Gaston Save, "Vautrin Lud et le Gymnase vosgien," *Bulletin de la Société philomatique vosgienne*, XV, 1889–90, 253–98.

2. Saint-Dié gained cathedral status in 1777, reinstated in 1824. Photos after the destruction of November 1944 show the Romanesque nave walls and the Gothic supports of the chevet still standing to the level of the vault springers: Albert Ronsin, *Saint-Dié des Vosges, 13 siècles d'histoire: 669–1969*, Saint-Dié, 1969, 107; Georges Baumont, *Saint-Dié des Vosges*, Saint-Dié, 1961, 428.

3. All that Le Corbusier built was the *Usine verte Claude et Duval*, quai du Torrent. Ronsin, 119–33, discusses the destruction and reconstruction of the town.

4. Marcel Aubert et al., *Les Vitraux de Notre-Dame et de la Sainte-Chapelle de Paris*, Corpus Vitrearum France I, Paris, 1959, 295–309 (bay A). Dr. Linda Papanicolaou has published two medallions from a related Crown of Thorns window at Tours, now in the Metropolitan Museum: "Stained Glass from the Cathedral of Tours: The Impact of the Sainte-Chapelle in the 1240s," *Metropolitan Museum Journal*, XV, 1981, 53–66. Troyes Cathedral has a window devoted to relics translated at the fall of Constantinople in 1204: André Marsat, *Cathédrale de Troyes, les vitraux*, Troyes, n.d., 67–68.

5. Documentation is provided in Georges Durand, *Eglises romanes des Vosges*, Paris, 1913, 314–17. On the Romanesque architecture, see most recently Hans-Günther Marschall and Rainer Slotta, *Lorraine romane*, La Pierre-qui-vire, 1984, 197 and 215–24, pls. 74–90.

6. These documents are discussed by Durand, 315–16, and by Daniel Grandidier, "L'Architecture gothique à la cathédrale de Saint-Dié," Mémoire de maîtrise d'histoire de l'art, Université de Nancy II (1979), 148–49. My interpretation varies somewhat from theirs.

7. In 1249 an accord was reached with Duke Mathieu II disallowing his right over the "bâtards des prêtres et clercs, nés sur les terres du chapitre": Arch. Vosges G248; Paul Boudet, *Le Chapitre de Saint-Dié en Lorraine des origines au seizième siècle*, Epinal, 1923, 46 and n. 4.

8. The text of the cardinal's Rule for Saint-Dié (Arch. Vosges G335 no. 1) is published in the seventeenth-century manuscript of François de Riguet, *Mémoires historiques et chronologiques pour l'insigne église de Saint-Diey en Lorraine*, ed. A. Contal, Saint-Dié, 1932, 255–56. It is chiefly concerned with absences and residence requirements. For the indulgences, see Riguet, 254–56; Durand, 315 n. 7, citing the *Livre rouge* (fourteenth-century cartulary), now entered the Arch. Vosges as G2688.

9. Riguet, 274–75.

10. *Livre rouge*, fol. 102v; text published by Jean-Claude Sommier, *Histoire de l'église de Saint Diez*, Saint-Dié, 1726, 416–17; also in Riguet, 282.

11. *Livre rouge*, fol. 18v; Durand, 316 and n. 1. See note 12.

12. Arch. Vosges G242 no. 11; Augustus Potthast, *Regesta Pontificum Romanorum*, rpt. Graz, 1957, II, no. 23132. The text is published by Jean Ruyr, *Recherches des sainctes antiquitez de la Vosge, province de Lorraine*, 2d rev. ed., Epinal, 1634, 450–52. As Potthast points out, Ruyr—followed by later chroniclers, Riguet in the late seventeenth century (278) and Sommier in 1726 (156)—attributed these bulls to Nicholas III rather than Nicholas IV, and thus dated them erroneously to 1278–79.

13. The *chasse*, destroyed by Swedish troops in 1636, was still in existence when Ruyr wrote about it. He records the tradition and suggests c. 1281 on the basis of the papal indulgences of "1279" (see note 12). On the reliquary: J.-B.-Edmond L'Hote, "Les Reliques de Saint Dié, évêque de Nevers," *Analecta bollandiana*, XI, 1892, 77–78.

14. See note 6 above for the dating of the architecture of Saint-Dié. The glass has most recently been dated "vers 1300": *Le Vitrail en Lorraine du XIIe au XXe siècle*, Inventaire général des monuments et des richesses artistiques de la France, Nancy, 1983, 329.

15. See Meredith Lillich, "The Choir Clerestory Windows of La Trinité at Vendôme: Dating and Patronage," *Journal of the Society of Architectural Historians*, XXXIV, 1975, 238–50; Lillich, *Armor of Light*, chap. VII; Jean-Bernard de Vaivre, "Un Représentation de Pierre d'Alençon sur les verrières de la Trinité de Vendôme (circa 1280)," *Bulletin monumental*, CXL, 1982, 305–13.

16. Saint-Dié was nominally subject to the Empire until 1218, after which date the duke of Lorraine was vassal to the count of Champagne. The fresco is illustrated and described by André Philippe in M. Deshoulières, "Saint-Dié," *Congrès archéologique*, XCVI, 1933, 176–79. See also Boudet, 41 with bibliography; E. L., *La Semaine religieuse*, 1901, 358–59; Arthur Benoit, "L'Empereur Henri VI dans les Vosges, Saint-Dié–Bruyères (juin 1196)," *Bulletin de la Société philomatique vosgienne*, XI, 1885–86, 119–35. A copy of the fresco was made in 1604; the latter disappeared in 1748 beneath the Baroque stucco installed in the chevet. The 1604 copy, studied in the late eighteenth and nineteenth centuries, was taken to represent a lost stained-glass window. The fresco, rediscovered when the stucco and stalls were removed in 1901, over-restored thereafter, and destroyed in 1944, is at present represented in the chevet by a modern copy.

17. Arch. Vosges G249(17) (25), G242(9); Jean de Pange, *Catalogue des actes de Ferri III, duc de Lorraine (1251–1303)*, Paris, 1930, nos. 44, 60–62, 334, 975, 1054, 1056; Boudet, 47–51.

18. Boudet, 49. The text is published in Sommier, 154–55, and in Riguet, 268.

19. De Pange, no. 426. In 1266 the canons had taken their complaints about Provost Jean de Fontenoy to Pope Clement IV (Arch. Vosges G242). Duke Ferri's courting of the chapter had begun by 1271, when he promised yearly donations: text published in L. Duhamel, *Documents rares ou inédits de l'histoire des Vosges*, Epinal, 1868, I, 121; Riguet, 272f.

20. The bull delivering Jean XXI's dispensation (January 1276 o.s.) makes it clear that the chapter wanted the young Ferri because they thought his family connections would protect their interests (Arch. Vosges G242). The text is published in Sommier, 414–16, and Riguet, 275–76. The young Ferri was already a canon of Toul.

21. Text published in de Pange, nos. 644–65; Riguet, 279.

22. The following discussion relies on: Rainer Schiffler, *Die Ostteile der Kathedrale von Toul und die davonabhängigen Bauten des 13. Jahrhunderts in Lothringen*, Cologne, 1977, esp. 183–92; Alain Villes, *La Cathédrale de Toul: Histoire et architecture*, Metz, 1983, esp. 220–25; Villes, "Les Campagnes de construction de la cathé-

drale de Toul, Première partie: Les campagnes du XIIIe siècle," *Bulletin monumental*, cxxx, 1972, 179–89. For a synopsis of the subject of Toul cathedral and the *toulois* group of monuments, see Marie-Claire Burnand, *La Lorraine gothique*, Nancy, 1980, 20–27, 35.

23. Villes (1983), 212, 221–24.

24. *Le Vitrail en Lorraine*, 329 and color pl. on 155. Color plates appear in: Albert Ronsin, *Saint-Dié*, Colmar, 1972, 27; André Laurent, *Saint-Dié, Cathédrale, Notre-Dame et son cloître*, Lyon, 1968, opposite 8.

25. The chapel windows were rebuilt after 1944 following the dimensions of the stained glass, which had been in storage during the war. I owe this information to Daniel Grandidier, who learned it from Piantanida, the company that did the restoration work after World War II. The glass, adapted and augmented to fit the chapel lights in 1901, was removed and releaded during 1918–20.

26. Similar patterned windows of eighteenth-century date in Lorraine are discussed and illustrated by J. Barthélemy, "Notes sur quelques vitraux d'art populaire," in *Art populaire de Lorraine*, ed. Jacques Choux and Adolphe Riff, Strasbourg, 1966, 235–39.

27. Paris, Bibl. nat., N. acq. fr. 6108, fols. 32v and 33r. The year before Guilhermy's visit, M. de Caumont stated that some stained-glass debris could be seen in the windows: "Rapport verbal sur une excursion archéologique en Lorraine . . . , le 24 décembre 1850 . . . , St-Dié-Cathédrale," *Bulletin monumental*, xvii, 1851, 245.

28. Durand, 316. On the 1748 renovation, see note 16 above.

29. See Ronsin (1969), 64–65. One of the glazier's many children was to achieve some fame as a portrait miniaturist in Paris: Jean-Baptiste-Jacques Augustin (1759–1832). Thieme-Becker, *Allgemeines Lexikon der bildenden Künstler*, Leipzig, 1908, ii, 249–50.

30. The glass was described as dismounted and awaiting its new chapel installation in: Gaston Save, "Iconographie et légendes rimées de la vie de Saint-Dié," *Bulletin de la Société philomatique vosgienne*, xx, 1894–95, 7; Save, "Vitraux du XIIIe siècle à la cathédrale de Saint-Dié," *Bulletin des Sociétés artistiques de l'est*, September–October 1895, no. 9, 115; A. S., "Une Visite aux églises de Saint-Dié (Vosges)," *Revue de l'art chrétien*, xliii, 1900, 42 n. 1.

31. One of the medallions is illustrated in *Vitraux à*

l'exposition universelle internationale de 1900, à Paris, Musée rétrospectif de la classe 67, Rapport de M. Lucien Magne, Saint-Cloud, 1902, 20, 23, fig. 6. They are listed in *Exposition universelle internationale de 1900 à Paris, Rapports du jury international, Groupe XII, Première partie*, Paris, 1902, 32–33.

32. Photogravures of the eight medallions, made from prerestoration photographs by Victor Franck, were published twice by Gaston Save (see note 30). Photographs after restoration were published by Jules Roussel (as in note 10 of chapter I), Paris, 1913? iii, pl. 68. In 1984 I examined the glass inside and outside from a ladder and found a minimum of modern restoration. I am grateful to the staff of the Presbytère de la cathédrale for their kind cooperation.

33. Georges Baumont and A. Pierrot, *Iconographie de Saint Dié*, Mulhouse, 1936, 3, pl. XVII, nos. 21 and 22. The five fragments were given to the museum by Marc François, whom I have not been able to trace. Daniel Grandidier, Conservateur-Adjoint of the Musée municipal of Saint-Dié, has informed me that the five fragments illustrated by Baumont were lost in 1944.

34. The eight panels are 46 cm wide. The central square area of the choir traceries is less than 40 cm.

35. *Le Vitrail en Lorraine*, 155, 357 (Bay 0). Saint Stephen, patron of Toul Cathedral, was included in the hemicycle windows (see chapter I, pages 12–13).

36. This paragraph draws on the following: Boudet, xxvi, 12–19; Louis Duchesne, *Fastes épiscopaux de l'ancienne Gaule*, Paris, 1899, ii, 483–84; Ch. Pfister, "Les Légendes de saint Dié et de saint Hidulphe," *Annales de l'est*, iii, 1889, 377–408, 536–88; L. G. Gloeckler, "Saint Déodat, évêque de Nevers, apôtre des Vosges," *Revue catholique d'Alsace*, vii, 1888, 1–13, 65–74, 130–42.

37. Published several times before—and many times following—the Bollandistes in *Acta Sanctorum*, 19 June, iii, 869f. Useful lists of these many sources are provided in Boudet, 12 n. 2; Pfister, 551 n. 1, 552 n. 1. The author has been variously hypothesized to be the monk Humbert or the monk Valcandus.

38. Pfister, 561; Boudet, 19, states that the *Vita Deodati* is a document of no historical value. Its author's method was to invent narratives related to locations in Alsace and the Vosges where the chapter of Saint-Dié controlled land in the eleventh century.

39. Richer's text, *Gesta Senoniensis ecclesiae*, has been published only once in its entirety, by G. Waitz in *Monumenta Germaniae Historica, Scriptorum*, XXV, 249–348. The travels of Saint Dié in Alsace-Lorraine are related in Bk. I, chaps. 5–9, 16. Pfister, 577 n. 1, provides a list of many publications of excerpts of Richer's work; see also note 139 below.

40. On the twelfth-century chronicle of Ebermunster (Ebersheim near Sélestat in Alsace) edited by Weiland in *Monumenta Germaniae Historica, Scriptorum*, XXIII, 431f., see Boudet, 19, and Pfister, 572–75.

41. Pfister, 578–79; Boudet, 20; Gloeckler, passim.

42. Attempts to identify the scenes of the life of Saint Dié have been made by Gaston Save (see references in note 30 above); Baumont and Pierrot, 5, 17, 19, 25, 37, 39, pl. VIII; Laurent, 12. My identifications are somewhat different.

43. See François Garnier, *Le Langage de l'image au moyen âge, signification et symbolique*, Paris, 1982, 141, 175 ("Relation de supérieur à inférieur"), 142–45.

44. Pfister, 562 n. 2; Boudet, 16.

45. Garnier, 165, 175 and 179, 141.

46. Boudet, 17; Pfister, 563–65; Gloeckler, 71–73, 131.

47. Pfister, 564; Gloeckler, 72–73.

48. Garnier, 209, 211(A), 165–69, 174.

49. Garnier, 167. The blessing of Saint Dié by his junior may indicate his humility.

50. Pfister, 567–71; Gloeckler, 133–37.

51. Pfister, 570; Gloeckler, 134–35.

52. See, for example, pls. 67 and 124 in Louis Grodecki, *Les Vitraux de Saint-Denis*, Corpus Vitrearum France, Etudes I, Paris, 1976.

53. The only author to attempt an identification of these scenes was Gaston Save (see publications in note 30), who recognized the Jewish hats and therefore stated that his suggested interpretation of the scenes as part of the Hunus/Huna story was uncertain.

54. Solomon Grayzel, *The Church and the Jews in the XIIIth Century*, New York, 1966, 308–9, 317 (Council of Narbonne, 1227); Robert Chazan, *Medieval Jewry in Northern Europe*, Baltimore, 1973, 149–50, notes that only in the 1260s was the badge decreed in northern France.

55. It was decreed in Strasbourg and Austria in 1267. Gérard Christmann, "L'Image du juif dans la société chrétienne de la fin du moyen âge . . . ," *Saisons d'Alsace*, 20e année, n.s. nos. 55–56, 1975, 31.

56. See Freddy Raphael and Robert Weyl, *Regards*

nouvelles sur les juifs d'Alsace, Strasbourg, 1980, 68; Bernhard Blumenkranz, *Le Juif médiéval au miroir de l'art chrétien*, Paris, 1966, 13, 71, and many references in the index under "chapeau juif; chapeau pointu." The moralized Bibles (Oxford, Bodl. MS 270b; Paris, Bibl. nat., Lat. 11560) are illustrated in figs. 38, 52, 81, and 83. The double-line decoration is common, for example, fig. 98.

57. Gilbert Cahen, "Les Juifs dans la région lorraine des origines à nos jours," *Le Pays lorrain*, LIII, 1972, 59. Jewish moneylending was a development of the twelfth century in northern Europe, reaching a zenith c. 1200: Gavin I. Langmuir, "Medieval Anti-Semitism," in *The Holocaust: Ideology, Bureaucracy, and Genocide*, eds. Henry Friedlander and Sybil Milton, Millwood, N.Y., 1980, 31.

58. N.-F. Gravier, *Histoire de la ville épiscopale et de l'arrondissement de Saint-Dié*, Epinal, 1836, 123, 145, 159–60; Ruyr, 445–46. William C. Jordan has pointed out to me that the exile of Jews was usually accompanied by seizure of their goods and outstanding debts; see his book *The French Monarchy and the Jews from Philip Augustus to the Last Capetians*, Philadelphia, 1989, chaps. 2, 11, 12. No evidence remains to establish whether such a windfall would have benefited the chapter or the duke.

59. Langmuir, 32–33.

60. These are the titles of chapters in the useful book of Joshua Trachtenberg, *The Devil and the Jews*, New Haven, 1943. The friars have been deemed culpable in the rise of Gothic anti-Semitism: Jeremy Cohen, *The Friars and the Jews: The Evolution of Medieval Anti-Judaism*, Ithaca, 1982. So has Saint Louis: William Jordan, *Louis IX and the Challenge of the Crusade*, Princeton, 1979, 85–86, 154–57. On the accusations of the church against thirteenth-century Jews, see Grayzel, 72–75.

61. A similar event occurred in Wissembourg, Alsace, dated 1260 by the Dominican archives of Strasbourg, but 4 July 1270 according to Jewish sources such as the Memorbuch of Nuremberg. The tomb of the "murdered" boy, locally known as "Saint Henri," remained in the Wissembourg church until the Revolution. See the bibliography in Emmanuel Haymann, "Wissembourg, histoire d'une accusation," *Tribune juive, édition est et familiale*, monthly supplement of *Tribune juive hebdomadaire*, Paris and Strasbourg, December supplement to no. 236 (12 January 1973), ii–iii. For the "blood accusa-

tion" recounted by Richer, see *Gesta Senoniensis ecclesiae*, Bk. IV, chap. 38. Richer, writing from hearsay, got the city wrong (it was Fulda) and the date wrong (it was 28 December 1235). See Trachtenberg, 133–35; "Blood Accusation," *The Jewish Encyclopedia*, New York, 1903, III, 263. The earliest accusation of Jewish ritual murder was in 1144 at Norwich: Langmuir, 32; Marie Despina N.D.S., "Les Accusations de profanation d'hosties portées contre les juifs," *Rencontre chrétiens et juifs*, XXII, 1971, 164.

62. Ruyr, 445–50. On Ruyr's excellent reputation as a historian, see Boudet, xxix.

63. Langmuir, 33.

64. Since the hiring of Christian servants by Jews was so often forbidden in the thirteenth century, it can be presumed to have been common: see Grayzel, 25 and documents on 104–7, 199, 253, 299, 317, 323–25, 329–33. Chazan, 149, 155–56. Jewish documents also mention it as common: for the twelfth century, Chazan, 43; for the thirteenth century, Trachtenberg, 89.

65. Garnier, 117, 119, 184. Gaston Save identified this figure tentatively as Huna, wife of Count Hunus: Save, "Iconographie et légendes rimées," 29.

66. Garnier, 165–66; 161–63; 151.

67. Garnier, 141; 174, 177.

68. John F. Benton, ed., *Self and Society in Medieval France: The Memoires of Abbot Guibert of Nogent*, New York, 1970, 10, 115.

69. Chazan, 121; Grayzel, 74 n. 146, 335–37 (XLII).

70. Trachtenberg, 140. See also 88, 141–44; Grayzel, 73–74 n. 145; Salo Wittmayer Baron, *A Social and Religious History of the Jews*, 2d ed., New York, 1958, VIII, 230–62.

71. There is a lengthy literature on medieval Jewish physicians as well as on the history of abortion. I am grateful for much help on bibliography from Professor Katherine Park Dyer of Wellesley College, Dr. Nigel Allan of the Wellcome Institute for the History of Medicine, and to Dr. Ruth Mellinkoff.

72. Grayzel, 74–75, documents on 333, 337; Eliakim Carmoly, *Histoire des médecins juifs*, Brussels, 1844, 236.

73. Jacques D. Zancarol, *L'Evolution des idées sur l'avortement provoqué (Etude morale et juridique)*, Paris, 1934, 112, 95–96.

74. The moment of ensoulment was discussed by Aristotle (*De animalibus historiae* VII, 3) and in the Septuagint. It is an Augustinian position repeated in the *Decretum Gratiani* (1140) and

the Decretals of Gregory IX (c. 1241), as well as by Aquinas. Zancarol, 70, 74, 76–77, 96–97; see also John R. Connery, S.J., *Abortion: The Development of the Roman Catholic Perspective*, Chicago, 1977, chap. 7 to p. 112, and 304–7. See the useful summary of the development of Christian as well as rabbinical doctrine in David M. Feldman, *Birth Control in Jewish Law*, New York, 1968, 254–59, 268–73; also Maxime Laignel-Lavastine, "Histoire de l'avortement provoqué des origines à 1810," *Mémoires de la Société française d'histoire de la médecine*, I, 1945, 9–12.

75. Zancarol, 97. The Jesuit Connery's position to the extreme right (see, for example, 313) slants the facts summarized in this paragraph but does not alter them significantly for purposes of this study: "For centuries . . . the beginning of human life was associated with the formation of the fetus. . . . In this context homicide was limited to the abortion of the formed fetus," that is, at forty or eighty days (306).

76. Feldman, 271–73; Fred Rosner, "L'Attitude juive devant l'avortement," *Revue d'histoire de la médecine hébraïque*, XXIII, 1970, 49. Halakhic (Palestinian) theory, though somewhat complicated and seemingly harsh, has often allowed abortion even of a gentile woman by a Jewish physician: J. David Bleich, "Abortion in Halakhic Literature," *Tradition* (Rabbinical Council of America), X, no. 2, 1968, 85, 105f. See also Norman Kass, "Abortion in Jewish Law," *Koroth* (Israel Society of the History of Medicine and Science), VIII, 1983, 326–27.

77. Feldman, 263, 276.

78. Gravier, 160 n. a.

79. Garnier, 145–46 and n. 1 (listing many illustrations published by Blumenkranz of Jews shown in profile); also 165, 167 (finger pointing in command); 175 (gesture of buying/selling).

80. Margaret Wood, *The English Mediaeval House*, London, 1965, 1 and chap. 1 passim.

81. Illustrated in *Vitraux à l'exposition universelle internationale de 1900* (as in note 31), fig. 6.

82. Garnier, 167; 140, 209–10; 142; 174.

83. This paragraph is based on Despina, 154–60, and Chazan, 181–82. Later examples of host desecration in art have been studied by Eric Zafran, "The Iconography of Antisemitism," Ph.D. diss., Institute of Fine Arts, New York University, 1973, chap. III.

84. Trachtenberg, 117. Such red spots, it is now assumed, were caused by the bacterium Micrococcus Prodigiosus, which grows readily on

wafers stored in a damp, dark place: "Micrococcus Prodigiosus," *The Jewish Encyclopedia,* New York, 1904, VIII, 543.

85. Jordan (1979), 86 n. 151 (citing Blumenkranz). The actions of Louis IX regarding the Jews are discussed in Jordan, 85–86, 154–57; also Chazan, 121–52.

86. Chazan, 155–57, 180–82.

87. Cahan, 59–61. On the influences of France and the Empire on the province of Lorraine in the thirteenth century, see *Histoire de la Lorraine,* ed. Michel Parisse, Toulouse, 1977, 155–56, 177–79, 190–93. Toul and the western areas tended to be more "French," while the lands east of the Moselle were aligned more with Basel and Germany.

88. See note 33 above. Nineteenth-century visitors reported such debris in the windows: see note 27 above.

89. The beardless Saint Nicholas is found in Lorraine in the ex-voto window at Saint-Gengoult, Toul, almost contemporary with Saint-Dié. See chapter III, pl. III.22.

90. See the bibliography on Saint-Nicolas-de-Port and on the pilgrimage in Meredith Lillich, "The Ex-Voto Window at Saint-Gengoult, Toul," *Art Bulletin,* LXIX, 1988, nn. 11–18.

91. Richer's section on Saint-Nicolas-de-Port is Bk. II, chap. 25, on 284 of the MGH edition (see note 39 above).

92. The date is given as 1257 by Auguste Marguillier, *Saint Nicolas,* Paris, n.d., 57–58; 1240 is the date in Abbé J.-B.-Edmond L'Hote, *La Vie des saints, bienheureux, vénérables et autres pieux personnages du diocèse de Saint-Dié,* Saint-Dié, 1897, I, 59, and in Pierre Marot, *Saint-Nicolas-de-Port,* Nancy, 1963. The latter is the source acknowledged by Charles W. Jones, *Saint Nicholas of Myra, Bari and Manhattan,* Chicago, 1978, 276–77 and n. 4, who believes that the ex-voto of Cuno's collar iron was first reported in 1537.

93. *The Golden Legend of Jacobus de Voragine,* ed. Granger Ryan and Helmut Ripperger, New York, 1969, 22.

94. Jones discusses *Iconia* (his no. 34) on 78–83 and *Broken Staff* (his no. 61) on 228–29. The non-Christian who flogs the statue in *Iconia,* a Vandal or barbarian in the original legend, has become a Jew in the *Golden Legend* and before that in the Fleury play: see Otto E. Albrecht, *Four Latin Plays of St. Nicholas,* Philadelphia, 1935, 43–46.

95. Jones, 259; Emile Mâle, *Religious Art in France,*

The Thirteenth Century, Princeton, 1984, 327; Virginia Raguin, *Stained Glass in Thirteenth-Century Burgundy,* Princeton, 1982, 158–60. Examples of *Iconia* in thirteenth-century art are given in Albrecht, 71–73. Jones, 227, has traced *Broken Staff* to the *Vita* in the Battle Abbey manuscript of the eleventh century (Brit. Lib., Cotton Tiberius B v, fols. 55r–56r), and to the twelfth-century sources he cites could be added the play by Wace at lines 722–805: Wace, *Life of St. Nicholas,* ed. Mary Sinclair Crawford, Philadelphia, 1923, 31.

96. Chartres: *Les Vitraux du centre et des pays de la Loire,* Corpus Vitrearum France, Recensement II, Paris, 1981, 33 and 30. Auxerre: *Les Vitraux de Bourgogne, Franche-Comté et Rhone-Alpes,* Corpus Vitrearum France, Recensement III, Paris, 1986, 118.

97. The York panel: Metropolitan Museum of Art, *The Year 1200: I,* ed. Konrad Hoffman, New York, 1970, 220–21. The Beverley panel: David O'Connor, "The Medieval Stained Glass of Beverley Minster," in *Medieval Art and Architecture of the East Riding of Yorkshire,* The British Archaeological Association Conference Transactions for 1983, IX, Norwich, 1989, 64–65, 76, pl. XIIF. The Dreux panel is a fragment showing the Christian swearing falsely, not the cart accident discussed below: Recensement II, 66–67; illustrated in Yves Delaporte, "Vitraux anciens récemment découverts dans l'église Saint-Pierre de Dreux," *Bulletin monumental,* XCVII, 1938, 429. The Tarragona cloister capital: Francese Vicens, *Catedral de Tarragona,* Barcelona, 1970, pl. 180; José Puig y Cadafalch et al., *L'Arquitectura romànica a Catalunya,* III, Barcelona, 1918, fig. 689. The relief at San Nicola, Bari: Rüdiger Müller, *Sankt Nikolaus, der Heilige der Ost- und Westkirche,* Basel, 1982, color pl. 35; Karl Meisen, *Nikolauskult und Nikolausbrauch im Abendlande,* Düsseldorf, 1931, fig. 48. Two Italian fourteenth-century frescoes show *Broken Staff* in a very different form from the examples here given: Florence, Santa Croce, Castellani chapel, school of Agnolo Gaddi, illustrated in fig. 861 of George Kaftal, *Iconography of the Saints in Tuscan Painting,* Florence, 1952; and Udine Cathedral, frescoes of Vitale da Bologna, 1349, shown in fig. 1000 of George Kaftal, *Iconography of the Saints in the Painting of North East Italy,* Florence, 1978. I would like to thank Dr. Nigel Morgan for good advice in my research on Saint Nicholas.

98. While I am aware that such a flat statement is

asking for trouble, a careful search through iconographic guides and the Princeton Index of Christian Art has led me to this conclusion. On *Broken Staff,* see Meisen, 282f.; *Lexikon der christlichen Ikonographie,* ed. Braunfels, Freiburg, 1976, VIII cols. 53–57, where the scene (no. 19) is called rare; Louis Réau, *Iconographie de l'art chrétien,* III: Iconographie des saints, Paris, 1958, II, 986.

99. Jean Rott, "La Légende de saint Nicolas et les fresques de l'église de Hunawihr," *Archives de l'église d'Alsace,* II, 1947–48, 312 n. 3, cites a bull of Pascal II (Arch. dépt. Vosges G 241).

100. Rott, 309–12. He explains that he is examining the perfunctory identification found in Joseph Walter, "Les Peintures murales du moyen âge en Alsace, III," *Archives alsaciennes d'histoire de l'art,* XIII, 1934, 24. See also Christmann (as in note 55), 23–46, esp. 29–31.

101. A Saint Nicholas chapel existed by 1437: see André Philippe, *Inventaire des sceaux de la Série G (Clergé séculier) des Archives départementales,* Collection des Inventaires sommaires des Archives départementales antérieures à 1790, Vosges, Epinal, 1919, 58, no. 444.

102. Jones, 260–61. My discussion also draws from 262–64.

103. See notes 11 and 12 above.

104. They are ignored in the description of Saint-Dié glass in *Le Vitrail en Lorraine,* 329.

105. In time the *aiglettes* of Lorraine lost their claws and beaks and, from the fifteenth century, became *alérions,* though that term is frequently applied to medieval examples by extension. See the blazons of seals of Duke Mathieu II (1225) and Duke Ferri III (1256f.) in Philippe, 3. My examination of the four shields from front and back established that, while several are modern, enough old glass remains to establish their authenticity.

106. A larger shield in the Musée historique lorrain in Nancy (Rez-de-chaussée, salle V) avoids the complicated cutting of the *aiglettes* by painting them on three circles of white glass, the ground around them painted with a black matte. As the craft developed, such a heraldic design could be produced by using a flashed red glass and engraving it back to the white layer to produce the *aiglettes.* Such a technique is extremely rare before the fourteenth century: in addition to examples of 1260–80 in the cathedral of Cologne and at Sankt Dionys, Esslingen, extremely precocious engraving has recently been identified in bays SII and NIII

(1245–55) at Strasbourg Cathedral: see Victor Beyer et al., *Les Vitraux de la cathédrale Notre-Dame de Strasbourg,* Corpus Vitrearum France IX–1, Paris, 1986, 294, 300, 328 and nn. 281, 423. The technique, however, was not developed immediately in Strasbourg; the early fourteenth-century glass in the west window of Saint-Guillaume in Strasbourg reveals several small cruciferous haloes laboriously leaded, though the thin flashed red used there in great abundance has now often worn back to its white layer. Since someone trained in the shop of Strasbourg Cathedral bays SII/NIII, I believe, produced the medallions of the Jewish incidents at Saint-Dié, one might wonder why he did not employ the engraving technique known to his shop for the border shields. The answer, I suggest, is that the engraving of a simple circle, which is about as far as the technique goes at Strasbourg, is in no way comparable in difficulty to the engraving of the outlines of three tiny *aiglettes* with all their wing feathers, beaks, and claws.

107. See at notes 17–21 above. On the 1291 excommunication: Boudet, 50–51; de Pange, nos. 975, 1054, 1056.

108. Edouard Ferry and Gaston Save, "Sigillographie de Saint-Dié," *Bulletin de la Société philomatique vosgienne,* XIV, 1888–89, 128.

109. Although the cross was maladroitly carved and is now badly weathered, I could still make out the coat of arms in 1984. It is illustrated following p. 358 of Léon Germain, "La Croix de Frouard," *Mémoires de la Société d'archéologie lorraine,* 3d series X, 1882, 358–400. Provost Ferri was elected bishop of Auxerre in 1293 but never installed; he is still referred to as provost of Saint-Dié and bishop-elect of Auxerre in Arch. Meuse B 256, fol. 77 (4 January 1296), cited by de Pange, no. 1232, and in a bull of Boniface VIII (4 February 1296), in Bernard Barbiche, *Les Actes pontificaux originaux des Archives nationales de Paris,* II, Vatican, 1978, 398, no. 2011. He relinquished his Saint-Dié provostship upon his installation as bishop of Orléans, no later than the start of 1297, and he died in mid-1299. See Germain, 379–80; Sommier, 155–59; de Pange, nos. 1261, 1338, 1352.

110. Jean de Fontenoy (d. 1274), Ferri's predecessor as provost, was a grandson of Duke Mathieu I; his father was count of Toul. See Michel Parisse, *Noblesse et chevalerie en Lorraine médiévale: Les familles nobles du XIe au XIIIe siècle,*

Nancy, 1982, 252, 438, 450; Germain, 383. Jean d'Arguel, who had been Ferri's *gouverneur*, succeeded him as provost and was not related to him: Parisse, 255; Sommier, 159f.

111. Ferry and Save, 142 and figs. 35–41; Philippe, no. 436 (seal of 1663). Save, "Vautrin Lud" (as in note 1 above), gives these arms in the sixteenth century.

112. Ferry and Save, 142, 157, and fig. 45.

113. Ferry and Save, 154–55, 157, and fig. 44; Philippe, no. 444bis (1291) and 445bis (1359). The *Cour aux causes* had jurisdiction similar to a *cour d'assises*. A list of the types of documents so sealed beginning in 1274, compiled from a total of 226, appears on 149–51 of Ferry and Save.

114. See the references in his index (Jones, 501) under "Patronage, commercial, financial, legal."

115. On *France-Castille* borders, see Meredith Lillich, "Stained Glass from Western France (1250–1325) in American Collections," *Journal of Glass Studies*, XXV, 1983, 126 n. 25.

116. Philippe le Bel's quick reversal of Spanish policy seems to reflect personal affection for the family of his deceased mother, Isabelle of Aragon, his father's first queen, coupled with antagonism toward causes espoused by his stepmother, Queen Marie de Brabant. See Elizabeth A. R. Brown, "The Prince Is Father of the King: The Character and Childhood of Philip the Fair of France," *Mediaeval Studies*, XLIX, 1987, esp. 300, 323, 331.

117. Marguerite de Navarre married Ferri III, duke of Lorraine, in 1255 and lived until at least 1304. Her brother Henri, count of Champagne by 1271, was the father of Jeanne de Navarre (married to Philippe le Bel in 1284 and queen of France in 1285). See Père Anselme, *Histoire de la maison royale de France*, 3d ed., Paris, 1726, II, 844–45.

118. Ferry and Save, 140–41.

119. List of officers of Saint-Dié from Epinal: Ferry and Save, 196, also 176, 178, 192; arms of the house of Epinal, 179; arms of the town of Epinal, 193.

120. Save, "Iconographie et légendes rimées," 18; Save, "Vitraux du XIIIe siècle . . . ," 116.

121. The Lyon border is illustrated in Charles Cahier and Arthur Martin, *Monographie de la cathédrale de Bourges*, Paris, 1841–44, pl. Mosaïques K6. An example from Reims Cathedral, apparently no longer extant, appears in Louis Ottin, *Le Vitrail*, Paris, 1895?, 149, fig. 148.

122. Grodecki and Brisac (as in note 2 of Introduction), fig. 76.

123. Dol: Grodecki and Brisac, fig. 158. Clermont-Ferrand: Raguin (as in note 95), fig. 135. Circular medallions floating on a lozenge ground also appear at Freiburg: Ingeborg Krummer-Schroth, *Glasmalereien aus dem Freiburger Münster*, Freiburg im Breisgau, 1967, Taf. VI and 58–63.

124. See chapter III, pages 64–65.

125. Grodecki and Brisac, fig. 186 (cf. to the more elaborate medallion frame of fig. 193, from Wimpfen im Tal).

126. For example, Grodecki and Brisac, fig. 183 (Mönchengladbach), fig. 184 (Cologne), etc.

127. *Strasbourg Corpus Vitrearum*, 305–6. Wild-Block further characterizes the atelier on 286, 300, 324–37 (bay SII) and 418–34 (bay NIII).

128. See *Strasbourg Corpus Vitrearum*, fig. 372. The birds are noted in: Robert Bruck, *Die Elsässische Glasmalerei vom Beginn des XII. bis zum Ende des XVII. Jahrhunderts*, Strasbourg, 1902, 54; Rüdiger Becksmann, *Die Architektonische Rahmung des Hochgotischen Bildfensters*, Berlin, 1967, 115, 146. Birds (and gargoyles, as at Strasbourg) appear in the canopywork from the Dominikanerkirche (c. 1280), now in Cologne Cathedral: Herbert Rode, *Die mittelalterlichen Glasmalereien des Kölner Domes*, Corpus Vitrearum Deutschland IV–1, Berlin, 1974, 145, Abb. 346. For another nice example, see Brigitte Lymant, *Die Glasmalereien des Schnütgen-Museums, Bestandskatalog*, Cologne, 1982, 32–35. An ornamental panel with birds in Sankt Dionys, Esslingen (c. 1300), is close to Saint-Dié: Hans Wentzel, *Die Glasmalereien in Schwaben von 1200–1350*, Corpus Vitrearum Deutschland I, Berlin, 1958, 62, fig. 131 (bay nIII).

129. *Strasbourg Corpus Vitrearum*, fig. 309 (another octafoil is in fig. 145).

130. *Strasbourg Corpus Vitrearum*, fig. 262 (NII borders) and 263 (NVb and d borders).

131. *Strasbourg Corpus Vitrearum*, fig. 372.

132. Bruck, 52–54, related Westhoffen to Strasbourg bay NIII, discussing them one following the other; Becksmann, 144–47. The fundamental study of Westhoffen is Christiane Block, "Les Vitraux de Westhoffen," *Bulletin de la Société d'histoire et d'archéologie de Saverne et environs*, IV, 1967, 1–5.

133. On the architecture of Westhoffen, drastically altered in the nineteenth century, see Théodore Rieger and Robert Will, "L'Eglise protestante Saint-Martin de Westhoffen," *Pays*

d'Alsace, Société d'histoire et d'archéologie de Saverne et environs, Bulletins trimestriels, LXXIX–LXXX, 1972, 7–16; Rieger, "L'Eglise-halle en Alsace du XIIIe au XVIIIe siècle," Cahiers alsaciens d'archéologie, d'art et d'histoire, XVIII, 1974, 89–93; Rieger and Will, "Nouvelles recherches sur l'église Saint-Martin de Westhoffen," Pays d'Alsace, Société d'histoire et d'archéologie de Saverne et environs, revue trimestrielle, CII, 1978, 37–42.

134. While Block (1967) questioned if the foliate ground was entirely modern, a few old bits remain just above several of the medallions. A similar ground appears in the Dominican panels now in the Saint-Laurent chapel of Strasbourg Cathedral; see Schwaben Corpus Vitrearum, 33, fig. 23, and Beyer, (as in note 135 of chapter III), 76–86.

135. Block (1967), 2, 4, n. 126.

136. In the 1901 restoration the canopy fragment was extended and copied to provide the lancet-head decoration for the Saint Dié medallions. The Westhoffen panels are no longer in their original positions.

137. See note 78 above.

138. See note 1 above; Arthur Benoit, "Notes sur les commencements de l'imprimerie à Saint-Dié (1507–1790)," Bulletin de la Société philomatique vosgienne, XIII, 1887–88, 183–208. The seventeenth-century provost François de Riguet and the early eighteenth-century provost Jean-Claude Sommier both wrote histories of Saint-Dié, the former remaining in manuscript until 1932 and the latter published in 1726: see notes 8 and 10 above. Boudet, xxvi–xxxi, assesses the early chroniclers and historians of the church.

139. In his introduction to the sections of Richer appearing in his preuves, Dom Augustin Calmet, Histoire ecclésiastique et civile de Lorraine, 2d ed., Nancy, 1748, III, cols. cxxxix–cxl, excuses his selectivity because the chronicle was published in Spicilegium, adding: "Ce que l'Auteur [Richer] raconte d'histoires étrangeres ne regardant pas mon sujet, & pouvant se recontrer aisement ailleurs, & même mieux digéré & plus exact que dans cet Auteur." D'Achery omitted the Jewish incident of Saint-Dié (Bk. IV, chap. 37), no doubt because the story is indelicate; he included the Jewish incidents of chap. 36 (Cologne) and chap. 38 (Hagenau, see at note 61 above). Waitz, 250, and Pfister (as in note 39 above) list the appearances of Richer's text in manu-

script and in print; several more references appear in Dom Augustin Calmet, Bibliothèque Lorraine, Nancy, 1751, col. 821, including one to Paul Colomiès (1638–92), Opera theologici, critici et historici argumenti . . . , Hamburg, 1709, 295–96, which publishes Richer, Bk. IV, chap. 18, omitted by D'Achery.

140. I am grateful to Alyce Jordan, who brought the Joinville text to my attention: Jean de Joinville, (as in note 86, chapter III), 326.

Chapter V: Saint-Gengoult (Toul) and Avioth

1. Meredith Lillich, "European Stained Glass around 1300: The Introduction of Silver Stain," Akten des XXV. Internationalen Kongresses für Kunstgeschichte, Vienna, 1986, VI, 45–60, with bibliography. Silver stain is a yellow produced by painting silver oxide or sulphide on the glass and then firing it, when the color appears; it produces varying shades of yellow depending on the length of firing, and only stains the spot that is touched by the silver preparation, thus allowing for two colors on one piece of glass. Previously yellow glass, like all colors, was produced by various metallic oxides mixed with the molten potmetal during the glassmaking process.

2. See chapter II at note 36.

3. Unlike the others, the twelve o'clock lobe has a clear, unpatterned ground, and emerald green among its colors. The subject is the archangel Michael holding the scales, a soul's head in one of them and a devil pushing on the other. Only the soul's head and the devil match the fourteenth-century style of the other lobes. Michael's draperies relate to the earliest glass in Saint-Gengoult, the series by the Infancy Master in the axial bay, while his head is an even older type, that of the 1230s in Toul Cathedral. While one immediately suspects a restorer's pastiche of elements, it is not impossible that the early parts of this lobe (the ground and the archangel) were recycled by the early fourteenth-century glazier discussed in this chapter.

4. See Eugène Müntz, La Tiara pontificale du VIIIe au XVIe siècle, offprint from Mémoires de l'Académie des inscriptions et belles-lettres, XXXVI, 1st part, Paris, 1897, 10–17, 35. The tiara of

Saint Sylvester had a heavy gemmed and enameled band at its base and originally a huge ruby button at the top.

5. On Boniface VIII: Müntz, 38 n. 2; Nancy Rash, "Boniface VIII and Honorific Portraiture," *Gesta*, xxv/1, 1987, 57 n. 31. On Benedict XI: J. Nabuco, "Tiara," *The New Catholic Encyclopedia*, New York, 1967, xiv, 150. *Unam sanctam* (18 November 1302) was the most famous medieval document on spiritual and temporal power: Brian Tierney, "Boniface VIII," *New Catholic Encyclopedia*, ii, 672; E. J. Smyth, "Unam Sanctam," *New Catholic Encyclopedia*, xiv, 382.

6. Müntz, 41–47; for a slightly different interpretation, see Donald Galbreath, *Papal Heraldry*, London, 1972, 20.

7. Müntz has pointed out that artists did not, of course, have to see the new type of tiara, and that one should understand their representations as approximations from hearsay in many cases. At Saint-Père de Chartres, the papal tiaras in Bay 21 (south nave) are of the old type, with a large button at the top (the ruby, already lost at the coronation of Clement V in 1305, according to Müntz, 12). The donor Laurent Voisin, an intimate of the king's brother, died in the winter of 1314–15: see Lillich, *The Stained Glass of Saint-Père de Chartres*, Middletown, Conn., 1978, 121–22, color pl. vii; Lillich, *The Armor of Light*, chap. ix at n. 29.

8. See note 1 above. The dowager queen Marie de Brabant, who, I believe, possessed a Spanish manuscript containing the silver-stain recipe, returned to residence in the capital following the death of the king, her stepson.

9. The earliest suggested date is c. 1250 (for west facade sculpture): Dorothy Gillerman, "Avioth and Reims: The Creation of Gothic Sculptural Style in Lorraine," *Akten des XXV. Internationalen Kongresses für Kunstgeschichte*, Vienna, 1986, vi, 236. She cites all relevant bibliography (238–41). See also *Dictionnaire* (as in note 16, chapter II, 7–9; Marie-Claire Burnand, *La Lorraine gothique*, Paris, 1989, 53–67. Avioth had 200 parishioners in 1570 and 287 in 1876: Auguste Longnon, *Pouillés de la province de Trèves*, Paris, 1915, xvii–xviii, 105; Claude Bonnabelle, "Les Comtes de Chiny et la ville de Montmédy," *Mémoires de la Société des lettres, sciences et arts de Bar-le-Duc*, vii, 1877, 68.

10. The Avioth medallions were catalogued in *Le Vitrail en Lorraine*, 193. See also color illustrations in *Avioth (Meuse)*, Images du Patrimoine no. 70, Nancy, 1989, 31–33.

11. Such *sanctuaires* appear to have been a specialty of France and its border regions (Belgium, south and Rhineland Germany, Switzerland, and northern Italy). The earliest miracles—excepting the one referred to by Augustine in Sermon 324—are no earlier than the end of the fourteenth century. The earliest diocesan statute forbidding the practice dates 1452 (Langres), while the most recent incident dates 1908. See the articles cited in the bibliography of Stephen Wilson, *Saints and Their Cults*, Cambridge, 1983, 392 (nos. 998–1001), also 17 n. 84.

12. The south tympanum is dated c. 1300 by Gillerman (238, fig. 164); its subjects are listed and illustrated in Maurice Dumolin, "Avioth," *Congrès archéologique*, xcvi, 1933, 458.

13. Gillerman, 239 n. 5; Dumolin, 447. The storm of February 1819 is documented in the Actes de la Fabrique d'Avioth kept at the presbytery, according to Jean de Mousson, "Les Vitraux du choeur d'Avioth," *Bulletin des Sociétés d'histoire et d'archéologie de la Meuse*, no. 15, 1978, 14.

14. Compare M. Ottmann, "Esquisse archéologique et historique de l'église Notre-Dame d'Avioth," *Mémoires de la Société dunkerquoise*, vi, 1858–59, 167–71; Heribert Reiners and Wilhelm Ewald, *Kunstdenkmäler zwischen Maas und Mosel*, Munich, 1921, 227.

15. In the Annunciation to the Shepherds, the angel holds a scroll upon which is written NATUS.EST.OPV(ER?); the third word has been variously interpreted by Ottmann (169) and Louis Schaudel, *Avioth à travers l'histoire du comté de Chiny et du duché de Luxembourg, Description de l'église Notre-Dame*, Arlon, 1903, 202–3. The illustration is reversed in *Le Vitrail en Lorraine*, 194. Gabriel's scroll in the Annunciation is a restoration; Ottmann (167) read only MAR and Schaudel (201) only MA.

16. Dumolin, 450; Reiners and Ewald, 216; Lisa Schürenberg, *Die kirchliche Baukunst in Frankreich zwischen 1270 und 1380*, Berlin, 1934, 221–22.

17. This paragraph is composed of my own observations and notes augmented by the measurements given in Ottmann (167) and the architectural comments of Simonin (8) and Dumolin (passim) for the areas not accessible. The building is so irregular and reworked as to defy analysis, but clearly the early fourteenth-century grisaille debris *in situ* in the ambulatory has been overlooked in previous assessments. It was noted in a restoration proposal of 1931 by Jean-Jacques

Gruber (Dossiers of Monuments historiques, "Eglise Avioth [Meuse]").

18. I could find no examples of a nude Child in the Flight to Egypt. On the Chapelle Saint-Julien at Petit-Quevilly, originally a leprosarium chapel: Yves Bonnefoy, *Peintures murales de la France gothique,* Paris, 1954, 8, 157, pl. 4; Pierre Gélis-Didot and H. Laffillée, *La Peinture décorative en France du XIe au XVIe siècle,* Paris, 1883–90, I, unpaginated ("XIIe siècle, L'échiquier") and pl. 10. Images du Patrimoine no. 70, p. 32, notes the nursing Virgin in several Metz manuscripts.

19. Illustrated in *Le Vitrail en Lorraine,* 194. The *damasquiné* grounds of all the medallions are entirely foliate otherwise. The dragon was noted by Ottmann (171) and Schaudel (205).

20. Otto von Simson, "*Compassio* and *Co-Redemptio* in Roger van der Weyden's *Descent from the Cross,*" *Art Bulletin,* xxxv, 1953, 12, 13. My gratitude to Colin Eisler for this reference.

21. Dated c. 1310–20 by Lucy Sandler, *Gothic Manuscripts 1285–1385,* Oxford, 1986, II, 64–66 (no. 56); illustrated in Gertrud Schiller, *Iconography of Christian Art,* Greenwich, Conn., 1972, II, fig. 514.

22. Yolande de Soissons Psalter: Karen Gould, *The Psalter and Hours of Yolande of Soissons,* Cambridge, Mass., 1978, pl. 36. Stained glass (Berlin, Schlossmuseum, destroyed in 1945) of c. 1175, with gothic dragon inserted below the cross: Hans Wentzel, *Meisterwerke der Glasmalerei,* Berlin, 1951, 19, 85, Abb. 21. See Schiller for illustrations: dragons (figs. 449, 451) and index, 688 passim, under "Serpents (Crucifixion)."

23. See at note 40 below.

24. *Meditations on the Life of Christ,* ed. Isa Ragusa and Rosalie Green, Princeton, 1961, 361.

25. I am greatly indebted to Helmut Nickel for this observation and for much of the information that follows.

26. Alain Girardot in *Histoire de la Lorraine,* ed. Michel Parisse, Toulouse, 1977, chap. VII, 189, see also 191–93.

27. Bonnabelle, 26–28; E. Biguet, "L'Eglise et la Recevresse d'Avioth (Meuse) (monuments historiques)," offprint of *Mémoires de la Société des naturalistes et archéologues du Nord de la Meuse,* Montmédy, 1906, 6. On the local warfare involving the counts of Chiny, see Hippolyte Goffinet, *Les Comtes de Chiny, étude historique,* Brussels, rpt. 1981 (facsimile of six articles 1874–80 with distinct pagination), chap. XII (Arnulphe IV),

192–95, and chap. XIII (Louis VI), 214–15, 224–26.

28. Eugène Viollet-le-Duc, *Dictionnaire raisonné du mobilier français,* V, Paris, 1874, 266–67.

29. Wentzel, 90, Abb. 107. I owe to Helmut Nickel the references in the Manesse Codex (Heidelberg, Universitätsbibliothek), MS pal. germ. 848, 14th century): scenes of Graf Albrect von Hegerloh (fol. 42r), Christian von Luppin (fol. 226v), and Der Thüring (fol. 229v). The latter is illustrated in *Minnesänger, Vierundzwanzig farbige Wiedergaben aus der Manessischen Liederhandschrift,* intro. Kurt Martin, Aachen, 1974, vol. I, Taf. 14.

30. Conclusion based on an exhaustive search employing the ordinary of Léon Jéquier, "Tables héraldiques de dix-neuf armoriaux du moyen âge," *Cahiers d'héraldique,* I, 1974. However, *trois annelets* were the arms used by the lord of Thil-Châtel (near Longwy, east of Avioth) in the poem describing the Tournoi de Chauvency, a tournament given in 1285 by the count of Chiny: Jacques Bretel, *Le Tournoi de Chauvency,* ed. Maurice Delbouille, Liège, 1932, xcii, line 649.

31. The examples geographically nearest to Avioth, all near Cologne/Aix-la-Chapelle, appear c. 1365–80 in the *Armorial Bellenville,* ed. Léon Jéquier, *Cahiers d'héraldique,* V, Paris, 1983: Bufful, *marche* Juliers (fol. 45v, 1); Bobbe, *marche* Berg (fol. 49v, 15); Drachenfels, *marche* Cologne (fol. 18r, 6).

32. See scale armor at Chartres, socle of north porch; also inner facade of Reims (c. 1250–60) and Auxerre (c. 1260), illustrated in Willibald Sauerländer, *Gothic Sculpture in France 1140–1270,* London, 1972, pl. 230, ill. 105. Thanks again to Helmut Nickel for information about the Manesse Codex. Scale armor appears in fol. 229v (Der Thüring); for an illustration, see note 29 above.

33. See note 10 above.

34. Zakin, (as in note 66 of chapter II), 140–51, figs. 1–10.

35. Jacques de Luz (d. 8 September 1327) made his will on 18 August in the presence of Jean, curé of Avioth, the abbot of Orval and other witnesses; he was buried at Orval, where he had founded a chapel. Goffinet, chap. XIII, 223, 226–27. The gift of 1328 is mentioned by C. Vigneron, "Les Curés d'Avioth de 1237 à nos jours," *Bulletin des Sociétés d'histoire et d'archéologie de la Meuse,* no. 13, 1976, 94–95.

36. This is the opinion of Gillerman (239 n. 4) and of Vigneron (95).

37. Ottmann, 166–72; Abbé Jacquemain, *Notre-Dame d'Avioth et son église monumentale au diocèse de Verdun (Meuse)*, Sedan, 1875, 100–102; Schaudel, 200–205.

38. Last Supper: Christ's head, missing 1858–1903, is on modern tan glass matched to that of the apostles' faces. Flagellation: Christ's drapery was previously yellow (1858–1903), and of course may have been silver stained.

39. Annunciation: the present stained heads are modern; the angel wore yellow in 1903, which could have been stained; see also note 15 above. Visitation: the Virgin wore purple in 1903. Entry to Jerusalem: Christ and the boy with the robe are new; according to Schaudel, this medallion was the most seriously degraded. Crucifixion: Christ's head and torso, new, match the tan glass of the rest of his body. Noli me tangere: Christ's face is on tan glass, in contrast to the Magdalene with stained halo and hair on white glass.

40. Only the left and right soldiers are mentioned from 1858 to 1903. See text at note 23 above.

41. Jean Lafond, *Le Vitrail*, Paris, reissue 1978, 82.

42. Joseph's face (and his modern hand) are tan glass. The Virgin is modern (the figure was missing from 1858 to 1903).

43. The illustration in *Le Vitrail en Lorraine* is reversed. The bust and head of the left shepherd were missing in 1903.

44. *Les Vitraux du centre et des pays de la Loire*, Corpus Vitrearum France, Recensement II, Paris, 1981, 33 (Bay 36). Color illustration: Jean Rollet, *Les Maîtres de la lumière*, Paris, 1980, 392.

45. Lillich, *Saint-Père*, 60, color pl. XII (note particularly the Noli me tangere in the lancet head and the Three Marys at the Tomb just beneath it).

46. The east window of Saint-Alban (Côtes-du-Nord), which dates between 1316 and 1328 and includes sloppy patches of *jaune d'argent*, is modeled after the great east window of Dol Cathedral, the multiple lancets filled with elaborately shaped medallions. See Lillich, *The Armor of Light*, end of chap. V; René Couffon, "Contribution à l'étude des verrières anciennes du département des Côtes-du-Nord," *Bulletin et mémoires de la Société d'émulation des Côtes-du-Nord*, LXVII, 1935, 87–93.

47. Meredith Lillich, "Bishops from Evron," *Studies on Medieval Stained Glass*, Corpus Vitrearum United States, Occasional Papers I, New York, 1985, 93–106. Newly discovered panels from this glazier's late work are illustrated in *Stained Glass before 1700 in American Collections: Midwestern and Western States*, Corpus Vitrearum Checklist III, *Studies in the History of Art*, XXVIII, Washington, D.C., 1989, 23, 51.

48. Jean Lafond, *Les Vitraux de l'église Saint-Ouen de Rouen*, Corpus Vitrearum France IV–2, Paris, 1970. See also chapter I, page 11, and chapter II, page 32 (round medallions), and chapter III, page 64 (*damasquiné* grounds).

Chapter VI: The Loss of Metz

1. Rose-Villequey (as in note 1 of Introduction), 33; Jean Schneider, *La Ville de Metz aux XIIIe et XIVe siècles*, Nancy, 1950, 233.

2. Rose-Villequey, 35, 218; Meredith Lillich, "Gothic Glaziers: Monks, Jews, Taxpayers, Bretons, Women," *Journal of Glass Studies*, XXVII, 1985, 75, 77–78.

3. Letter of 1833: Jean-Baptiste Pelt, *Etudes sur la cathédrale de Metz: Documents et notes relatifs aux années 1790 à 1930*, Metz, 1932, 201–2, no. 429. On the chapter's cache of stained-glass panels: Emile-Auguste Bégin, *Histoire de la cathédrale de Metz*, Metz, 1840, I, 86–91. A devastating recital of the eighteenth- and early nineteenth-century restorations appears in *Le Vitrail en Lorraine*, 256–57.

4. Guilhermy, Bibl. nat., N. acq. fr. 6103, fols. 337v–338r. Bégin noted them in 1840 (I, 118–19). The Saint Paul fragments are catalogued in *Le Vitrail en Lorraine*, 262 (Bay 14), illustrated on 35 and 257; for the fragments *in situ*, see *Vitraux de France du moyen âge à la Renaissance* (as in note 2 of Introduction), 155.

5. As reported by Marcel Aubert in Aubert et al., *La Cathédrale de Metz*, Paris, 1931, 217.

6. Otto Demus, *The Mosaics of Norman Sicily*, New York, 1950, pls. 40A, 41A, 78A–B, 79; Herrad of Hohenbourg, *Hortus Deliciarum*, ed. Rosalie Green et al., London, 1979, I, 187–88; II, pl. 107. On these scenes, see also Luba Eleen, *The Illustrations of the Pauline Epistles in French and English Bibles of the Twelfth and Thirteenth Centuries*, Oxford, 1982, 39–40, 85f., where she states that the Conversion of Paul *not* on horseback was old-fashioned after 1200.

7. Portative Bible, London Brit. Lib., Add. 27694, fol. 426v, and Paris, Bibl. nat., lat. 13142, fol. 632r. Eleen, 24–26, 98–99, 113–14, fig. 232.

Compare ships in the Moralized Bible, London, Brit. Lib., Harley 1527, fols. 89r–91r, and Peter Lombard's Commentary on the Epistles, New York, Pierpont Morgan, MS 939, fol. 194r, initial to Colossians (dated 1189): illustrated in Alexandre de Laborde, *La Bible moralisée conservée à Oxford, Paris et Londres*, Paris, 1911–27, III, pls. 560–62, and Eric George Millar, *The Library of A. Chester Beatty: A Descriptive Catalogue of the Western Manuscripts*, Oxford, 1927–30, II, pl. CII.

8. Jean-Baptiste Pelt, *Etudes sur la cathédrale de Metz: Texts extraits, principalement des registres capitulaires (1210–1790)*, Metz, 1930, 54, no. 206. For the appearance of Saint-Paul before 1754, see chapter II above at note 16.

9. Aubert et al., 216–17. His opinions have been repeated without nuance by many, including Lisa Schürenberg, *Der Dom zu Metz*, Frankfurt, 1942, 25–26.

10. Aubert et al., 217.

11. Aubert et al. (217) mentioned "Chartres, Bourges, Châlons and Troyes," but the Sens window is much closer. See illustrations in Grodecki and Brisac, *Vitrail gothique*, 82; Madeline Caviness, *The Early Stained Glass of Canterbury Cathedral, Circa 1175–1220*, Princeton, 1977, fig. 45. Grodecki suggests that this style came from the Ile-de-France, while Caviness (90–93) suggests that the source was Canterbury.

12. *Le Vitrail en Lorraine*, 264 (Bays 28 and 33). Aubert's analysis of the Notre-Dame-la-Ronde fragments (Aubert et al., 218–19) is totally confused, since he seems not to have understood that they once formed one window or that the surrounds of the standing figures had been concocted by the restorer Mayer of Munich. He seems to date the rosace 1220–30 and the standing figures in the early fourteenth century. He compared the rosace to those in the choir clerestory of Châlons-sur-Marne, of similar shape and, he believed, coloration. The color is not similar and they are otherwise unrelated in style. Schürenberg (26) preferred a late thirteenth-century date and related them to Alsace-Lorraine without specifying monuments, which indeed would be impossible.

13. Jean Vallery-Radot in Aubert et al., esp. 188–89; see also 10–12. A document of 1633 mentions repair of the stained glass of Notre-Dame-la-Ronde: Pelt, *Etudes . . . 1210–1790*, nos. 798, 799 (203).

14. Bégin, II, 350–51; Guilhermy, fols. 335r–v; Pelt, *Etudes . . . 1790–1930*, no. 636 (315).

15. Hans Wentzel, *Meisterwerke der Glasmalerei*, 2d ed., Berlin, 1954, 90, Abb. 83. The series of old photographs of the Notre-Dame-la-Ronde glass is now in the Corpus Vitrearum archive at Freiburg-im-Breisgau. I am grateful to Dr. Ulf-Dietrich Korn and particularly to Prof. Dr. Rüdiger Becksmann for helping me locate these photos.

16. Wentzel, *Meisterwerke*, 34–35; Hans Wentzel, *Die Glasmalereien in Schwaben von 1200–1350*, Corpus Vitrearum Deutschland I, Berlin, 1958, pls. 7, 8, 39–62.

17. Grodecki, *Le Vitrail roman* (as in note 1 of Introduction), 169, 230–31; *Les Vitraux de la cathédrale Notre-Dame de Strasbourg*, Corpus Vitrearum France IX–1, Paris, 1986, 49, 79, 81, 128–40 (especially the New Testament rose).

18. Willibald Sauerländer, *Gothic Sculpture in France 1140–1270*, London, 1972, 496, states that the Coronation at the top of the Notre-Dame-la-Ronde tympanum is still in the linear style of the first decades of the thirteenth century, while the rest of the tympanum is more recent, in the 1240s. A date earlier than Strasbourg south for the Notre-Dame-la-Ronde sculpted Coronation would seem untenable. The latter is illustrated and discussed by Paul Vitry in Aubert et al., 200–202, pls. II and IIIA.

19. Bégin, I, 104–10. Guilhermy also mentions all but the Stoning of Stephen (fol. 335v). They are catalogued in *Le Vitrail en Lorraine*, 264.

20. Illustrated in *Le Vitrail en Lorraine* on 260. The figure is surrounded by unrelated debris, which appears in the 1840 drawing. Aubert (Aubert et al., 219) believed his blue robe was modern; Schürenberg (26) thought the head was modern.

21. Wentzel, Corpus Vitrearum Deutschland I, 55; see also Rüdiger Becksmann in *Vitrea dedicata*, Berlin, 1975, 69–70, Farbtaf. I.

22. Compare pls. 44–49 (Bücken/Weser, Stiftkirche) in Wentzel, *Meisterwerke*.

23. In addition to the cloister, the churches of Saint-Pierre-aux-images, Saint-Pierre-le-vieux, and the parish church of Saint-Gorgon were destroyed. Aubert et al., 24–28.

24. A view of all three installed is in André Bellard, *La Lanterne de Dieu: Cathédrale de Metz, vitraux*, Metz, 1962, third unnumbered plate. See also *Le Vitrail en Lorraine*, 37 (Bartholomew martyrdom) and 260 (Saints Stephen and Paul); Aubert et al., pl. 34 (the two martyrdom roundels). Schürenberg (26) recognized that the Stephen and Paul roundel, though of similar

color to the two martyrdoms, was otherwise unrelated to them.

25. Aug. Prost, *La Cathédrale de Metz,* Metz, 1885, offprint of *Mémoires de la Société d'archéologie et d'histoire de la Moselle,* XVI, 1885, 628–30, preuve 81.

26. See at note 19 above. Schürenberg (26) thought that the heads were modern in the Stoning of Stephen.

27. The only green in the Bartholomew roundel, the hat on the left executioner, matches Ste-

phen's robe and is also probably modern since no hat appears in the 1840 drawing.

28. Noted by Schürenberg, 26.

29. See Grodecki and Brisac, 187, pl. 181 (Namedy, third quarter of thirteenth century); Wentzel, *Meisterwerke,* 32 (Soest, Sankt Pauli, c. 1300).

30. Aubert et al., 219. A comparison closer in time is the Annunciation in Saint-Georges, Sélestat (1290/1300), illustrated in *Strasbourg* Corpus Vitrearum, fig. 290.

31. *Strasbourg* Corpus Vitrearum, 154 and fig. 142.

GENERAL INDEX

A separate Index of Monuments and Works of Art follows this General Index.

INDEX OF MONUMENTS AND WORKS OF ART

ILLUSTRATIONS

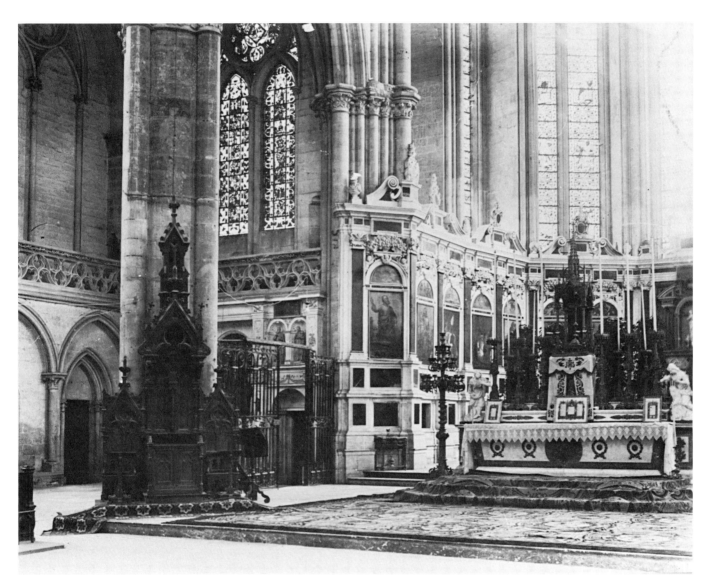

Plate I.1. Toul Cathedral, choir, and north chapel showing debris of medieval glass in Bay 7. Nineteenth-century photograph

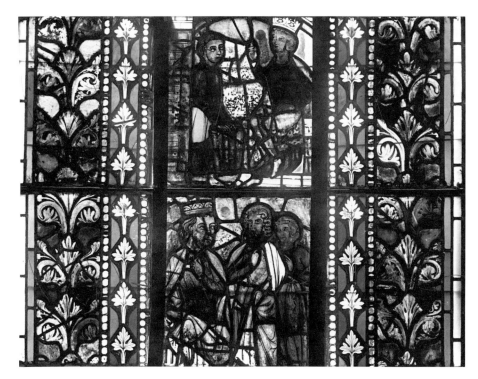

Plate I.2. Toul Cathedral, photomontage of Bay 8 (B8, B9) as now installed

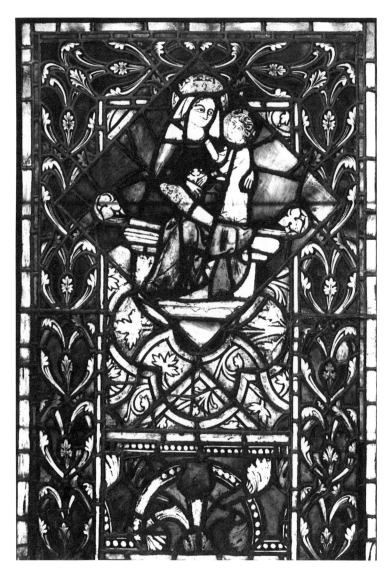

Plate I.3. "Collector's panel" composed of fragments from Toul Cathedral (Virgin and Child, lower border) and Saint-Gengoult (side borders, grisaille), Musée historique lorrain, Nancy

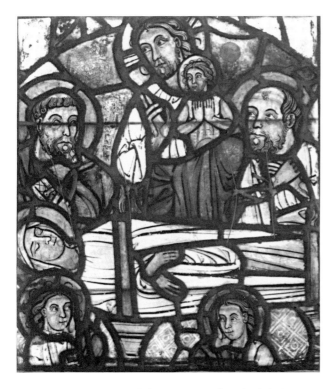

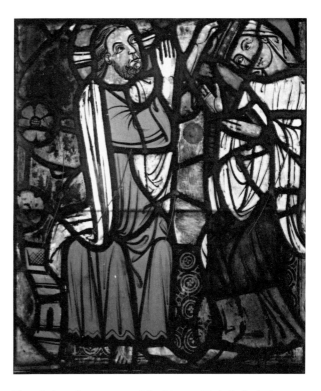

Plate I.4a. Dormition of the Virgin. Toul Cathedral, Bay 7 (A7). Late 1230s–43

Plate I.4b. Coronation of the Virgin. Toul Cathedral, Bay 7 (A8). Late 1230s–43

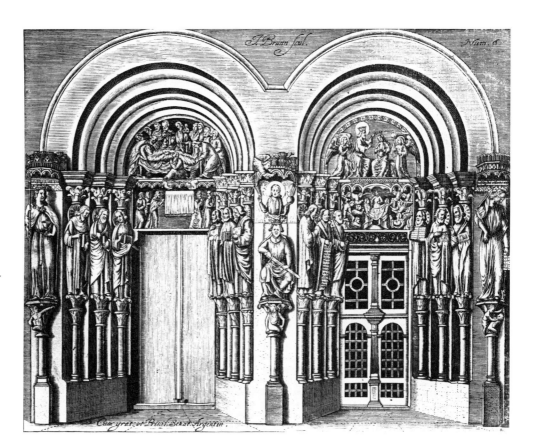

Plate I.4c. Dormition and Coronation of the Virgin. Strasbourg Cathedral, south transept portals. C. 1230. Engraving by Isaac Brun

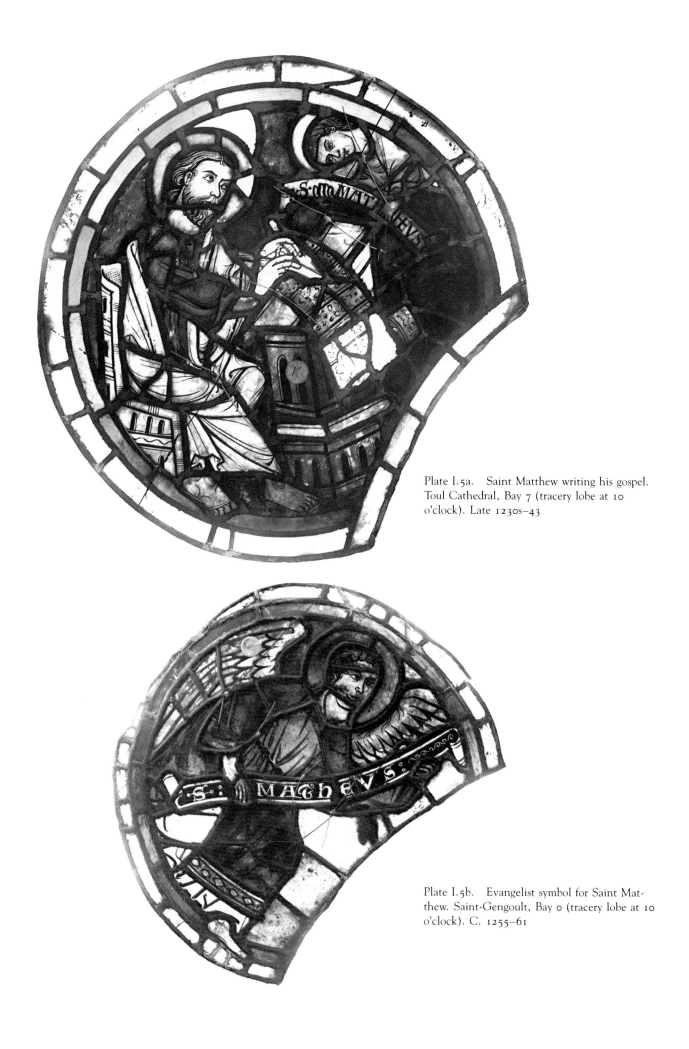

Plate I.5a. Saint Matthew writing his gospel. Toul Cathedral, Bay 7 (tracery lobe at 10 o'clock). Late 1230s–43

Plate I.5b. Evangelist symbol for Saint Matthew. Saint-Gengoult, Bay 0 (tracery lobe at 10 o'clock). C. 1255–61

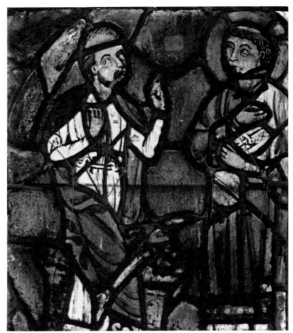

Plate I.6a. Saint Stephen before the Sanhedrin. Toul Cathedral, Bay 7 (A4). 1251f.

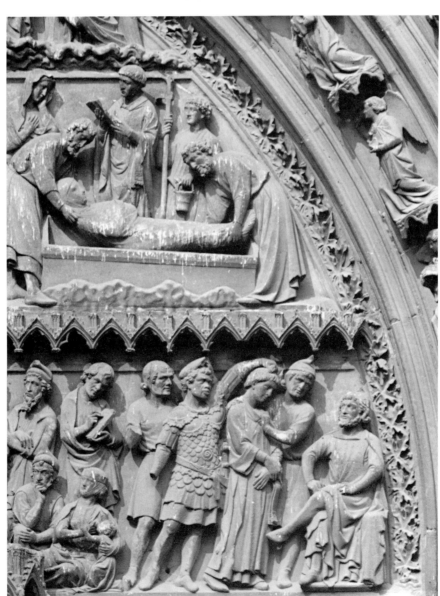

Plate I.6b. Saint Stephen tympanum. Notre-Dame, Paris. South transept portal. C. 1260–65

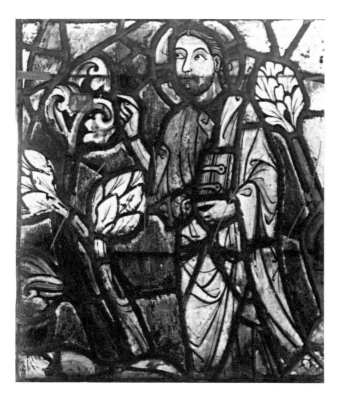

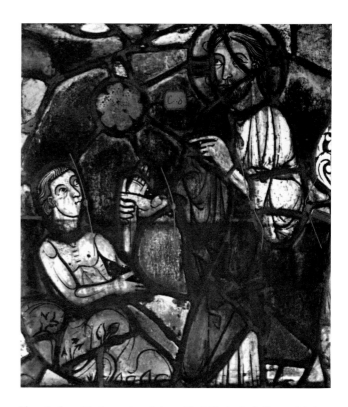

Plate I.7a. God creating the plants. Toul Cathedral, Bay 7 (A1). Late 1230s–43

Plate I.7b. God creating Adam. Toul Cathedral, Bay 7 (A2). Late 1230s–43

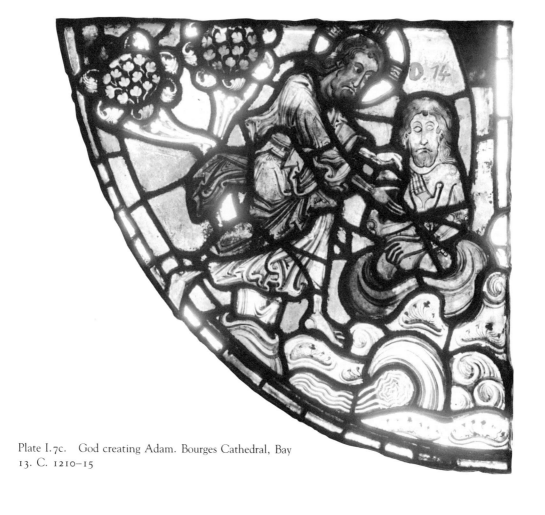

Plate I.7c. God creating Adam. Bourges Cathedral, Bay 13. C. 1210–15

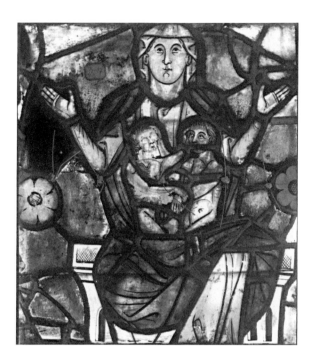

Plate I.8a. Eve with Cain and Abel. Toul Cathedral, Bay 7 (B5). Late 1230s–43

Plate I.8b. Eve with Cain and Abel. From Ferrara Cathedral, Porta dei Mesi, now in Museo del Duomo. C. 1140 (after Krautheimer-Hess)

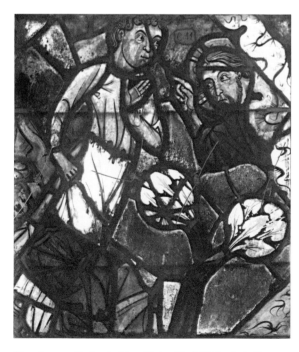

Plate I.9a. God rebuking Cain. Toul Cathedral, Bay 7 (A3). Late 1230s–43

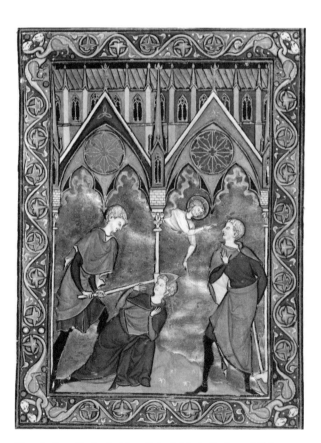

Plate I.9b. God rebuking Cain (right). Psalter of Saint Louis, Paris, Bibl. nat., MS lat. 10525, fol. 2. C. 1255–70

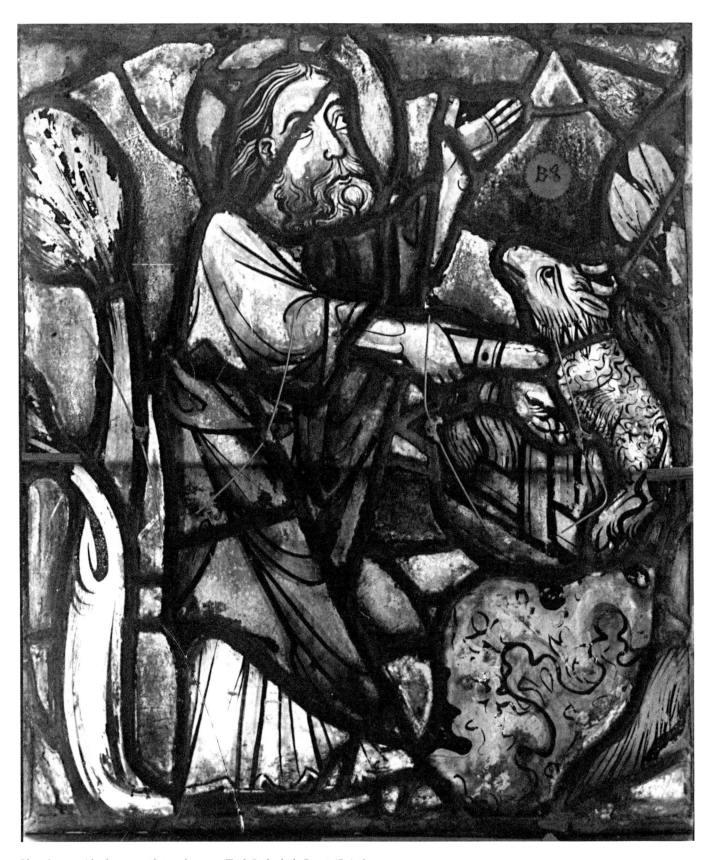

Plate I.10. Abraham sacrificing the ram. Toul Cathedral, Bay 8 (B2). Late 1230s–43

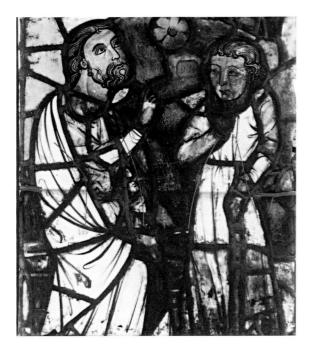

Plate I.11a. Jacob sending Joseph to his brothers. Toul Cathedral, Bay 8 (B4). 1251f.

Plate I.11b. Joseph joining his brothers. Toul Cathedral, Bay 8 (B3). 1251f.

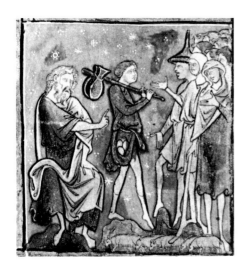

Plate I.11c. Jacob sending Joseph to his brothers. Psalter, Cambridge, Trinity College, MS B.11.4. Early thirteenth century

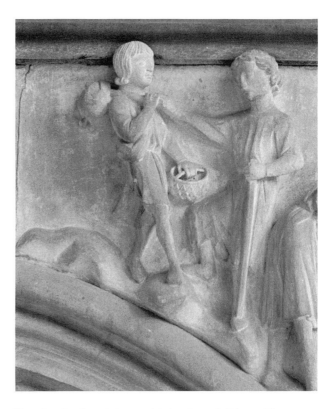

Plate I.11d. Joseph joining his brothers. Salisbury, Chapterhouse, spandrel III, southeast arcade. C. 1280

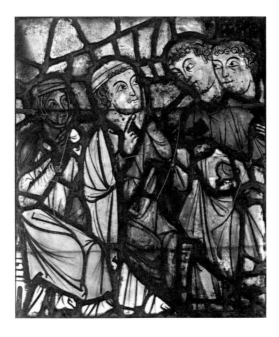

Plate I.12a. Joseph's brothers showing his coat to Jacob and Leah. Toul Cathedral, Bay 8 (B7). 1251f.

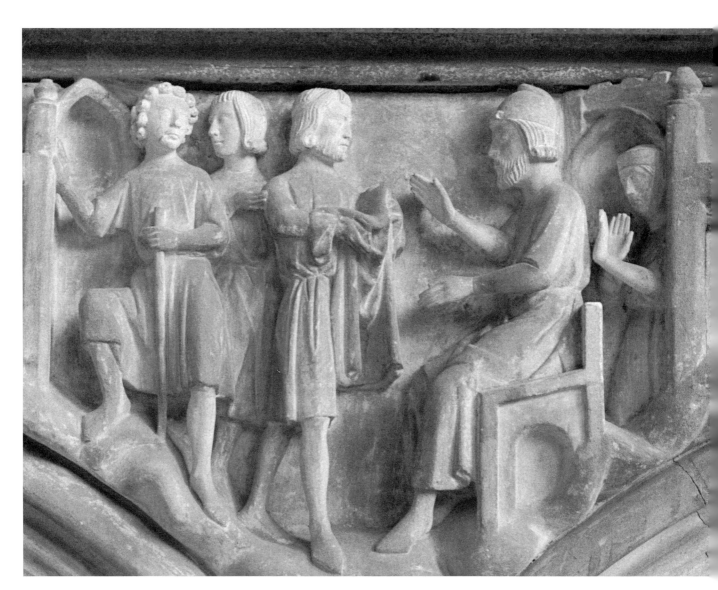

Plate I.12b. Joseph's brothers showing his coat to Jacob and Leah. Salisbury, Chapterhouse, spandrel V, southeast arcade. C. 1280

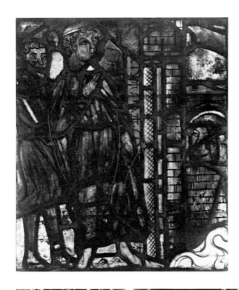

Plate I.13a. Joseph imprisoned by Potiphar's guard. Toul Cathedral, Bay 7 (B3). 1251f.

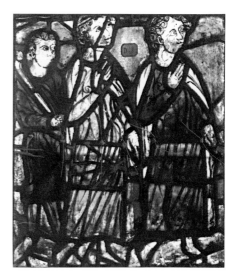

Plate I.13b. Joseph in prison (?). Toul Cathedral, Bay 7 (B2). 1251f. with later restorations

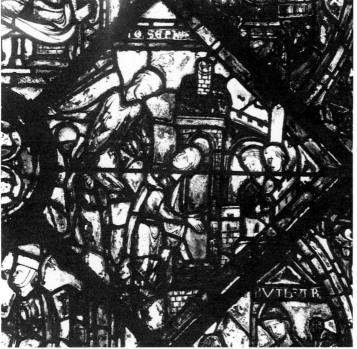

Plate I.13c. Joseph imprisoned by Potiphar's guard. Chartres Cathedral, bay 41. C. 1205–15

Plate I.13d. Joseph imprisoned by Potiphar's guard. Salisbury, Chapterhouse, spandrel 1, south arcade. C. 1280

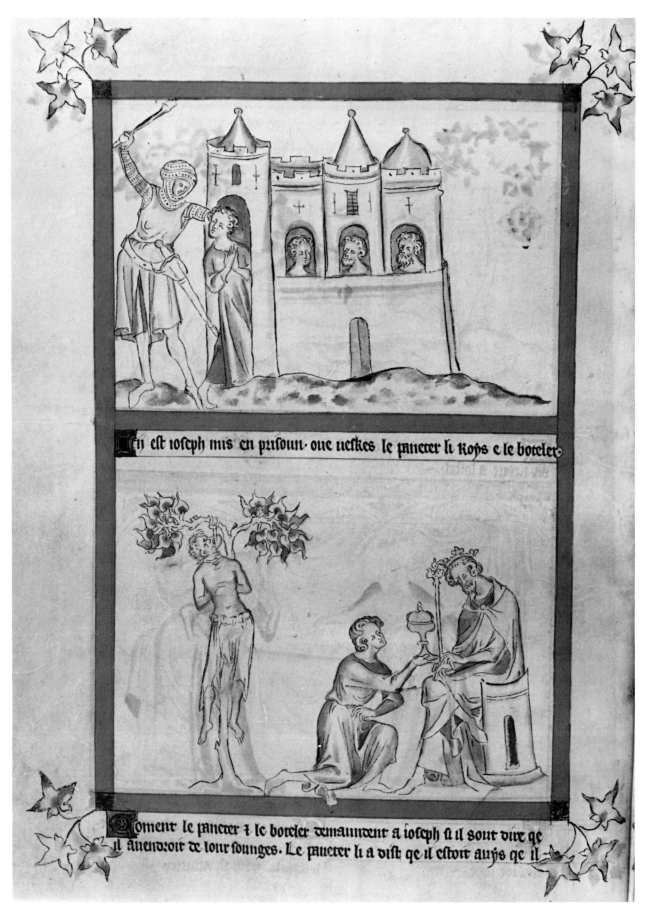

Plate I.14. Joseph imprisoned by Potiphar's guard, the Baker hanged, the Butler reinstated. Queen Mary Psalter, London, Brit. Lib., Roy. MS 2 B.VIII, fol. 16v. C. 1310–20

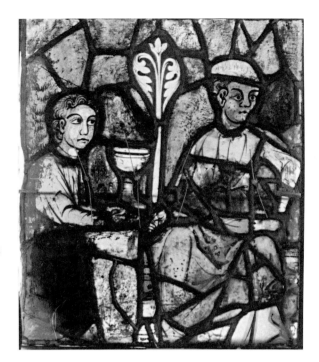

Plate I.15a. The Butler reinstated. Toul Cathedral, Bay 8 (A2). 1251f. (Pharaoh's head is a stopgap)

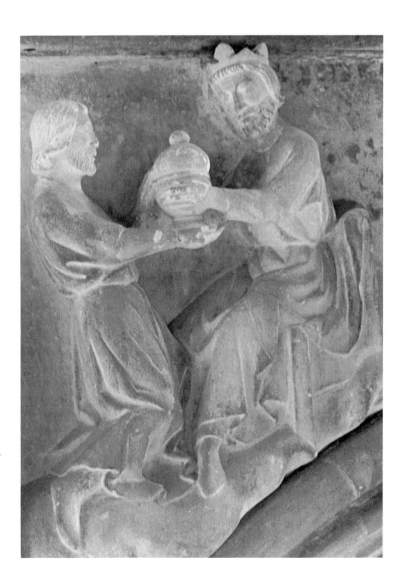

Plate I.15b. The Butler reinstated. Salisbury, Chapterhouse, spandrel II, south arcade. C. 1280

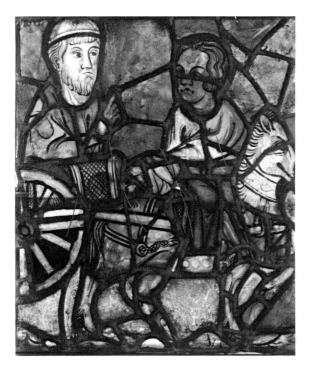

Plate I.16a. Joseph's triumph: Joseph rides in Pharaoh's chariot. Toul Cathedral, Bay 8 (A8). 1251f.

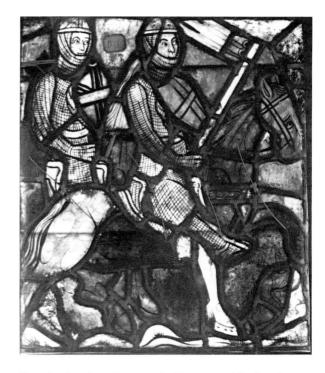

Plate I.16b. Joseph's triumph: Honor guard for Joseph. Toul Cathedral, Bay 8 (B1). 1251f.

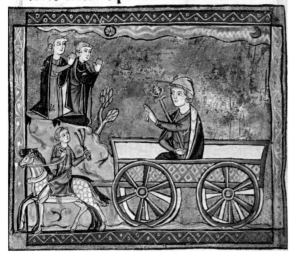

Plate I.16c. Joseph's triumph. Histoire universelle, Paris, Bibl. nat., MS fr. 20125, fol. 68v. Before 1250

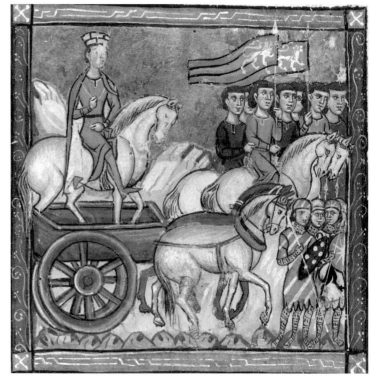

Plate I.16d. Joseph's triumph, with honor guard. Histoire universelle, Dijon, Bibl. mun. MS 562, fol. 51r. C. 1260–70

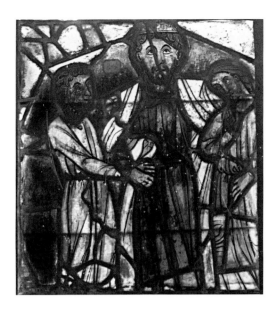

Plate I.17a. Marriage of Joseph and Asenath.
Toul Cathedral, Bay 8 (B5). 1251f.

Plate I.17b. Marriage of Joseph and Asenath (bottom right).
Bibbia istoriata Padovana, Rovigo, Biblioteca dell' Accademia
dei Concordi, MS 212, fol. 32v. Late fourteenth century

Plate I.18a. Joseph inspects Pharaoh's granaries (?).
Toul Cathedral, Bay 8 (A6). 1251f.

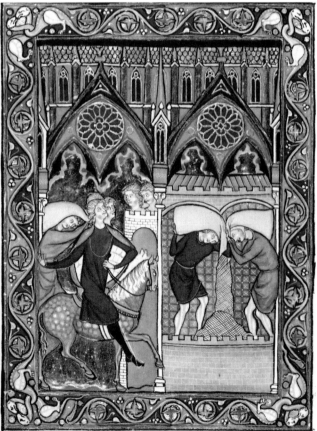

Plate I.18b. Joseph inspects Pharaoh's granaries. Psalter of Saint
Louis, Paris, Bibl. nat., MS lat. 10525, fol. 23r. C. 1255–70

Plate I.19a. Joseph supervises grain storage. Toul Cathedral, Bay 8 (B10), 1251f.

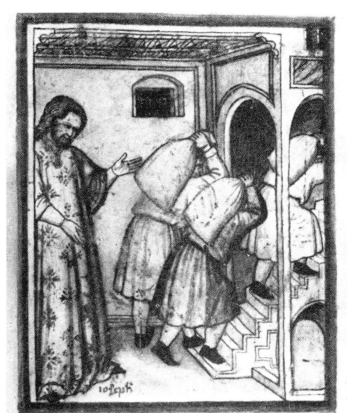
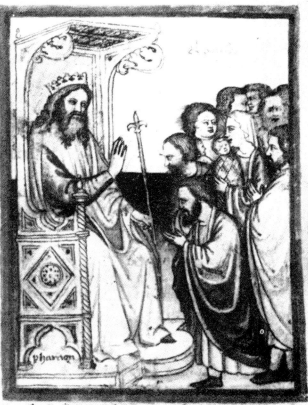

Como a li fece agui vela granoiffima fame tuti li ponoli ve egypto homoni e femene negunia a en
raliemno al fo ... re phamon cheh moua va fame. Et re phamon fili mercala va Joseph
Como Joseph li vaue il ponolo ve egypto biana per ominn
Capitoli . xlij . ve Genefis .

Plate I.19b. Joseph supervises grain storage (left); People ask Pharaoh for grain (right). Bibbia istoriata Padovana, Rovigo, Biblioteca dell' Accademia dei Concordi, MS 212, fol. 33r. Late fourteenth century

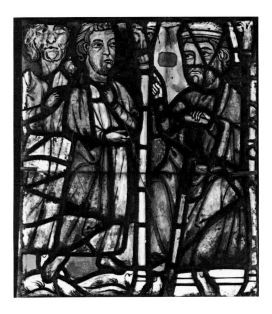

Plate I.20a. Jacob sends his sons to buy grain. Toul Cathedral, Bay 8 (B6). 1251f.

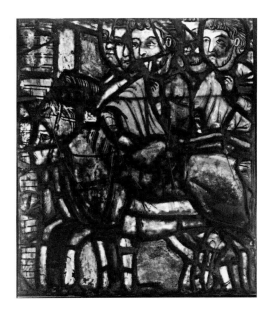

Plate I.20b. The brothers ride to Egypt to buy grain. Toul Cathedral, Bay 8 (A3). 1251f.

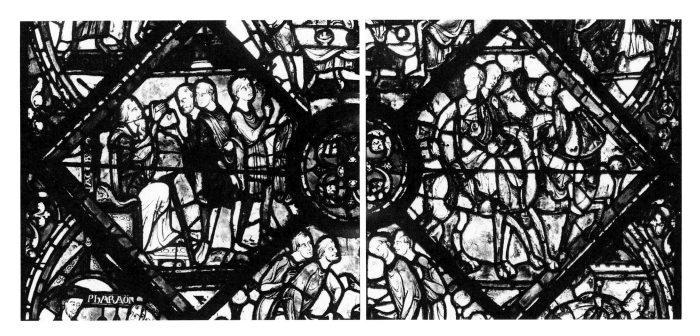

Plate I.20c. Jacob sends his sons to buy grain (left); the brothers ride to Egypt (right). Chartres Cathedral, bay 41. C. 1205–15

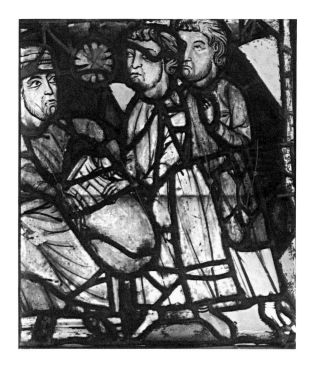

Plate I.21a. Joseph sells grain to his brothers. Toul Cathedral, Bay 8 (A4). 1251f.

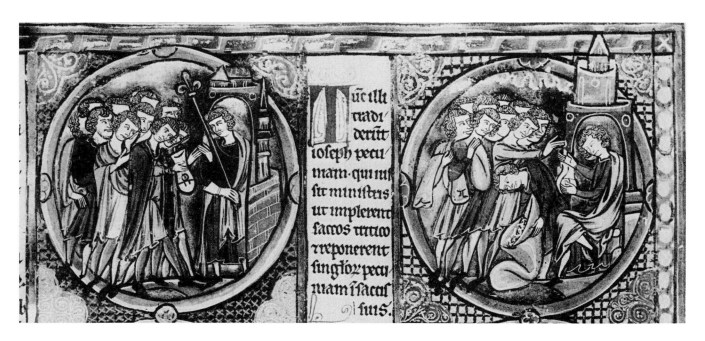

Plate I.21b. Joseph sells grain to his brothers. Bible moralisée, Oxford, Bodl. MS 270b, fol. 29v. C. 1235–45 (after de Laborde)

Plate I.22a. The brothers give Joseph a present. Toul Cathedral, Bay 8 (A5). 1251f.

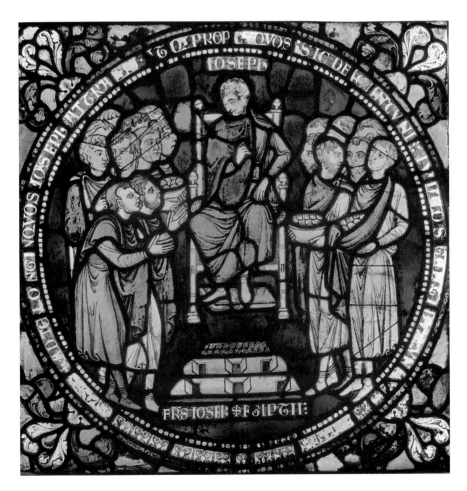

Plate I.22b. The brothers give Joseph a present. Canterbury Cathedral, Bay n:XV (9). 1179–80

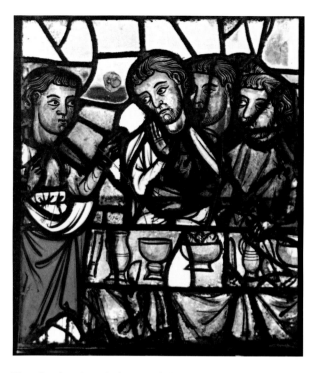

Plate I.23a. The brothers tell Jacob that Benjamin must go to Egypt (?). Toul Cathedral, Bay 8 (A7). 1251f.

Plate I.23b. Joseph dines with his brothers. Toul Cathedral, Bay 8 (A10). 1251f.

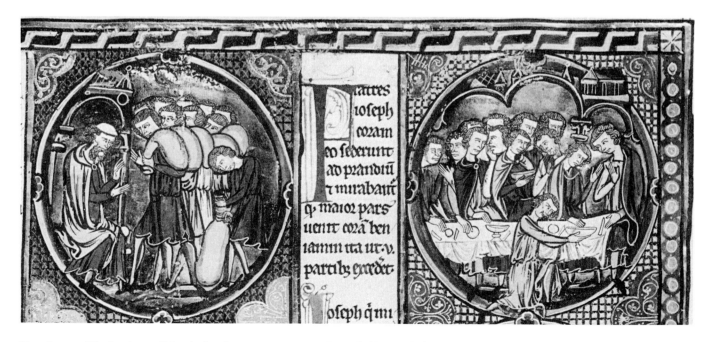

Plate I.23c. The brothers tell Jacob that Benjamin must go to Egypt (left); Joseph dines with his brothers (right). Bible moralisée, Oxford, Bodl. MS 270b, fol. 30r. C. 1235–45 (after de Laborde)

Plate I.24a. Death of Jacob. Toul Cathedral, Bay 8 (B1). 1251f.

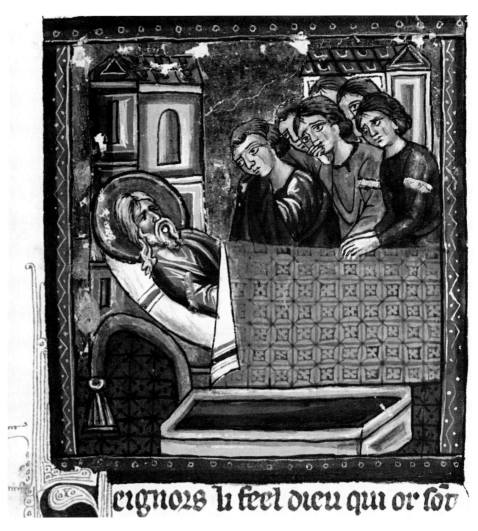

eignozs li feel dieu qui oz sõz

Plate I.24b. Death of Jacob. Histoire universelle, Brussels, Bibl. roy. MS 10175, fol. 84r. C. 1270–80

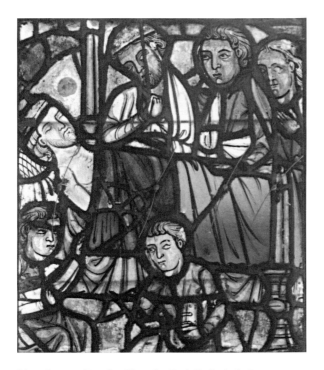

Plate I.25a. Death of Joseph. Toul Cathedral, Bay 8 (A9). 1251f.

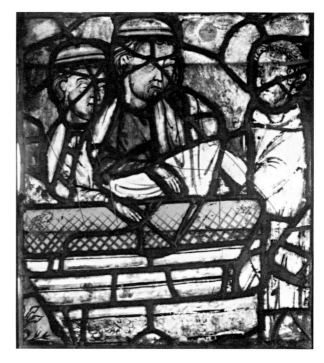

Plate I.25b. Burial of Joseph. Toul Cathedral, Bay 8 (A1). 1251f.

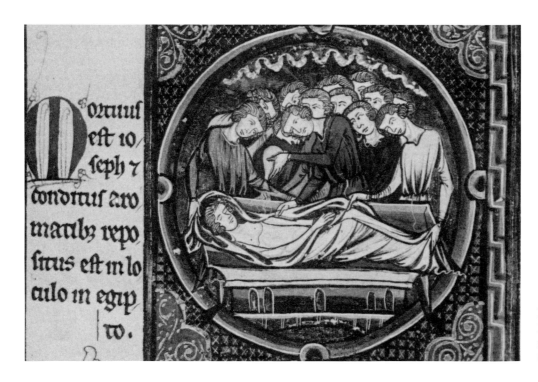

Plate I.25c. Burial of Joseph. Bible moralisée, Oxford, Bodl. MS 270b, fol. 35v. C. 1235–45 (after de Laborde)

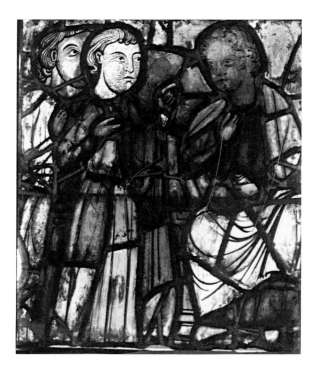

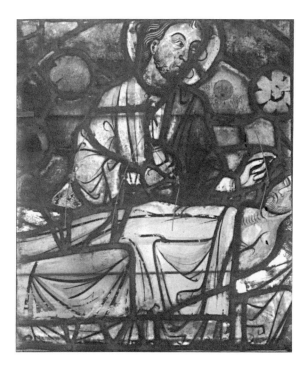

Plate I.27a. Miracle of Christ. Toul Cathedral, Bay 7 (B7). First Toul style, late 1230s–43

Plate I.26. Unknown scene, figure with red face on the right (stopgap?). Toul Cathedral, Bay 8 (B4). 1251f.

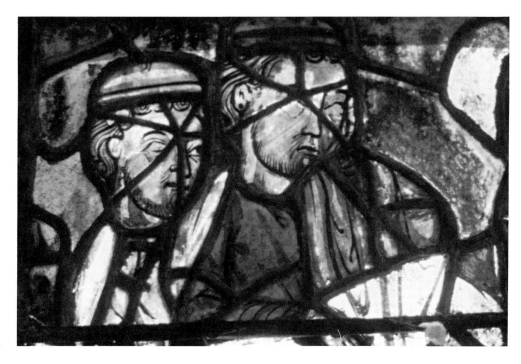

Plate I.27b. Burial of Joseph (detail). Toul Cathedral, Bay 8 (A1). Second Toul style, 1251f.

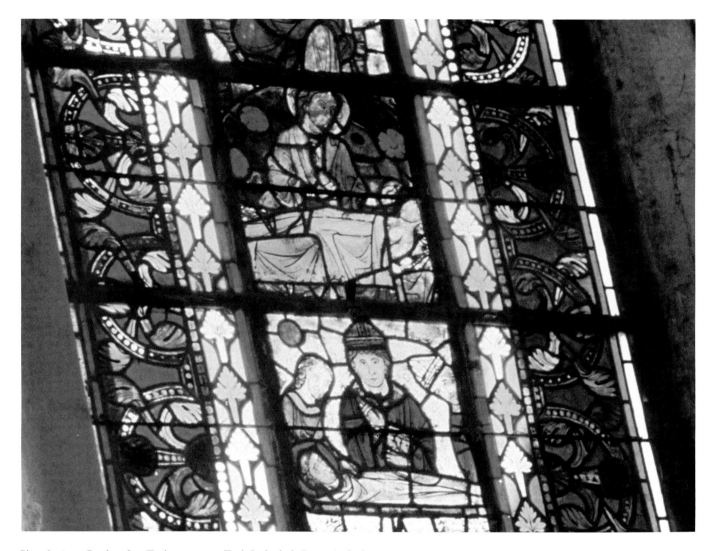

Plate I.28a. Border, first Toul campaign. Toul Cathedral, Bay 7 (right lancet). Late 1230s–43

Plate I.28b. Romanesque borders. Strasbourg Cathedral. Drawings by E. Haas, archives of L'Oeuvre Notre-Dame, Strasbourg (after Zschokke)

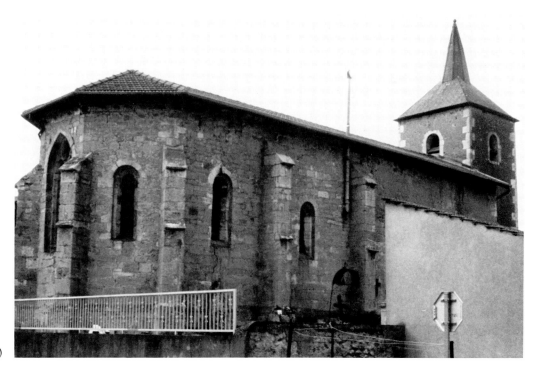

Plate II.1. Ménillot-près-
Choloy (Meurthe-et-Moselle)

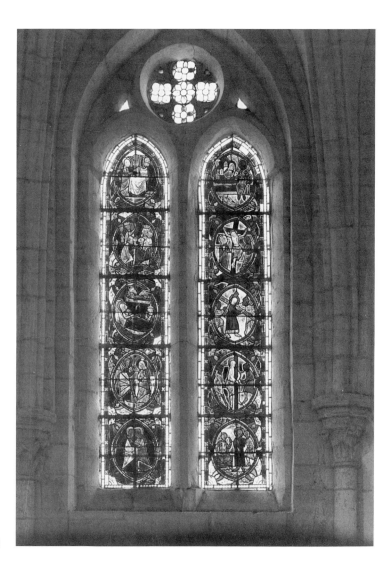

Plate II.2. Ménillot, axial bay. After 1263

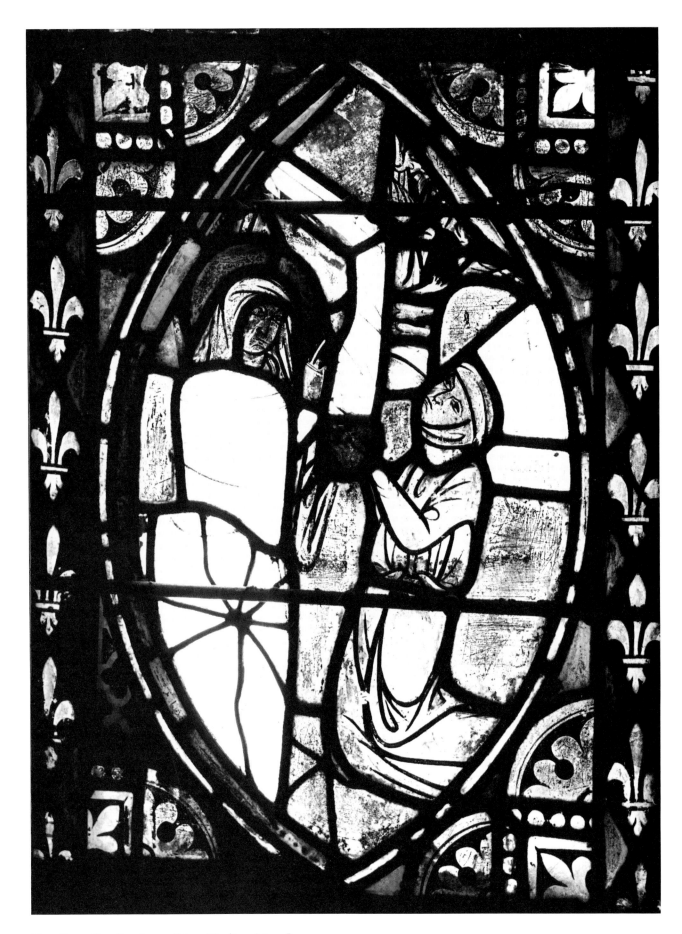

Plate II.3. Kneeling donor. Sainte-Ségolène, Metz, Bay 9. 1251–54

Plate II.4a. Flight to Egypt. Toul Cathedral, Bay 7 (A5). Late 1230s–43

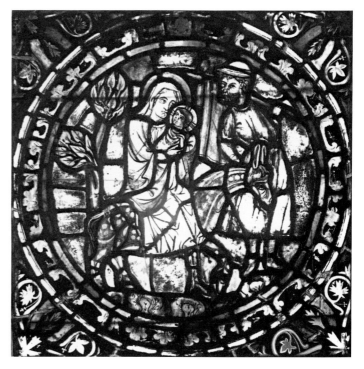

Plate II.4b. Flight to Egypt. Saint-Gengoult, Bay 0 (B4). Infancy Master, c. 1255–61

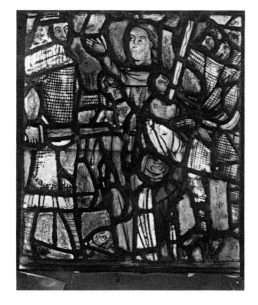

Plate II.5a. Massacre of the Innocents. Toul Cathedral, Bay 7 (A6). Late 1230s–43

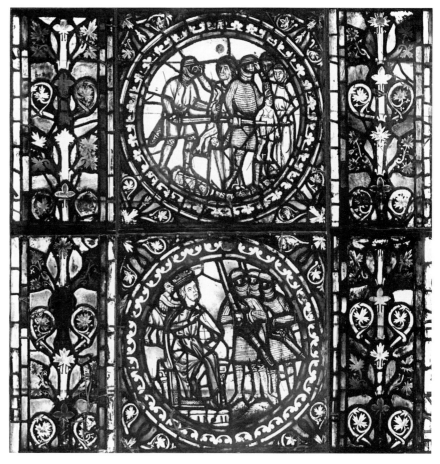

Plate II.5b. Herod ordering Massacre of the Innocents (bottom); Massacre (top). Saint-Gengoult, Bay 0 (B5 and B6). Infancy Master, c. 1255–61; borders and surrounds by Gengoult Master, late 1260s

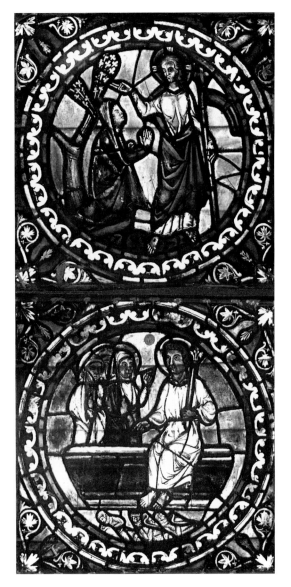

Plate II.6a–b. Three Marys at the Tomb (bottom, Infancy Master, c. 1255–61); Noli me tangere (top, Gengoult Master, late 1260s). Saint-Gengoult, Bay 0 (B12 and B13)

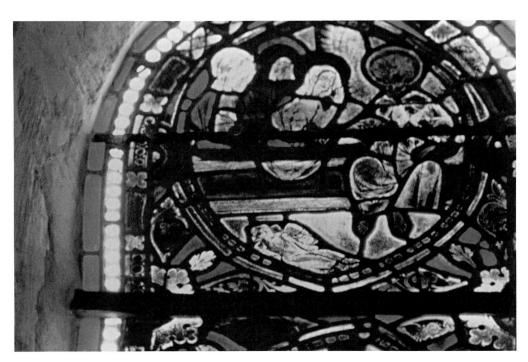

Plate II.6c. Three Marys at the tomb. Ménillot. After 1263

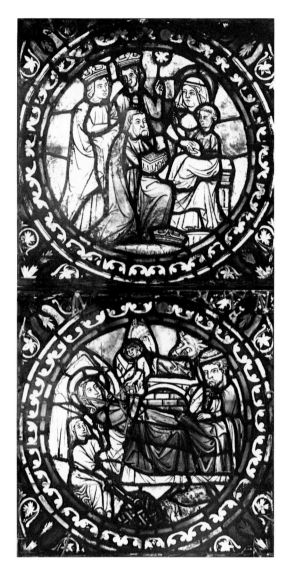

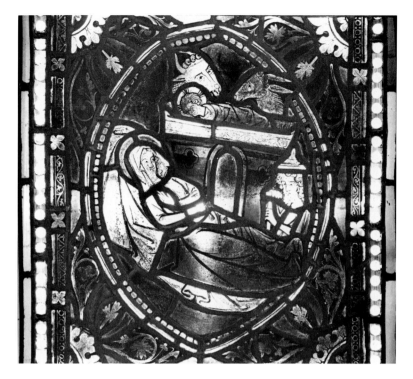

Plate II.7b. Nativity. Ménillot. After 1263

Plate II.7a. Nativity (bottom); Adoration of the Magi (top). Saint-Gengoult, Bay 0 (B1 and B2). Infancy Master, c. 1255–61

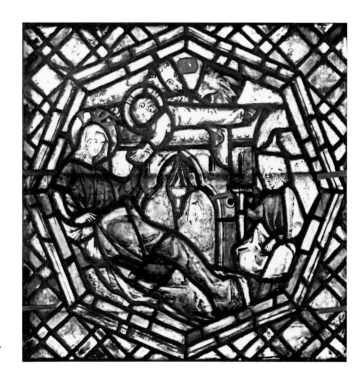

Plate II.7c. Nativity. Saint-Gengoult, Bay 8. Gengoult Master, c. 1270–79

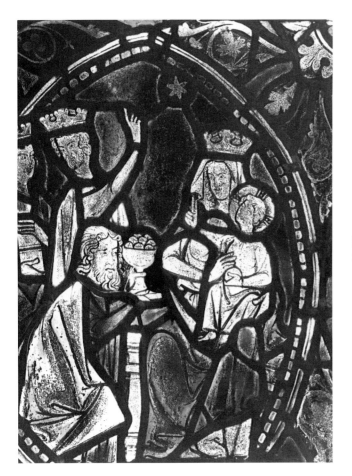

Plate II.8a. Adoration of the Magi. Ménillot. After 1263

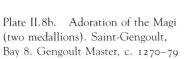
Plate II.8b. Adoration of the Magi (two medallions). Saint-Gengoult, Bay 8. Gengoult Master, c. 1270–79

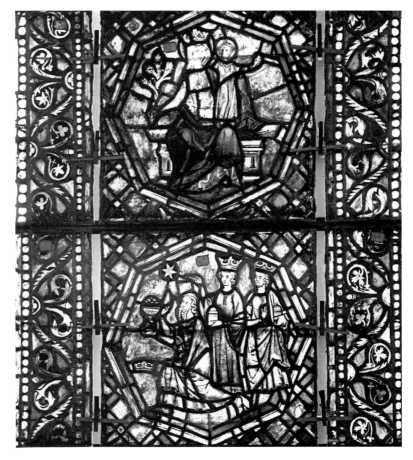

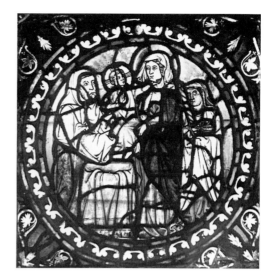

Plate II.9a. Presentation in the Temple. Saint-Gengoult, Bay 0 (B3).
Infancy Master, c. 1255–61

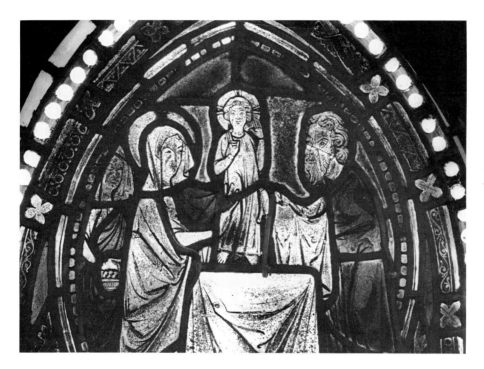

Plate II.9b. Presentation in the
Temple. Ménillot. After 1263

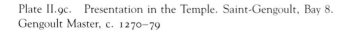

Plate II.9c. Presentation in the Temple. Saint-Gengoult, Bay 8.
Gengoult Master, c. 1270–79

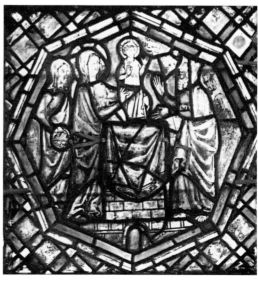

Plate II.10a. Christ appears before Pilate. Ménillot. After 1263

Plate II.10b. Christ appears before Pilate. Saint-Gengoult, Bay 0 (B8). Gengoult Master, late 1260s

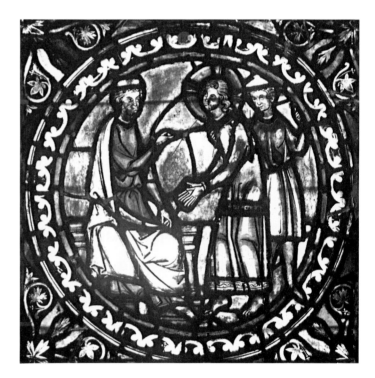

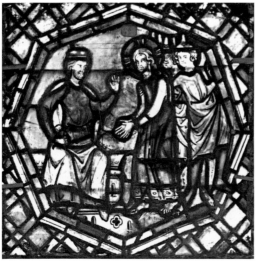

Plate II.10c. Christ appears before Pilate. Saint-Gengoult, Bay 8. Gengoult Master, c. 1270–79

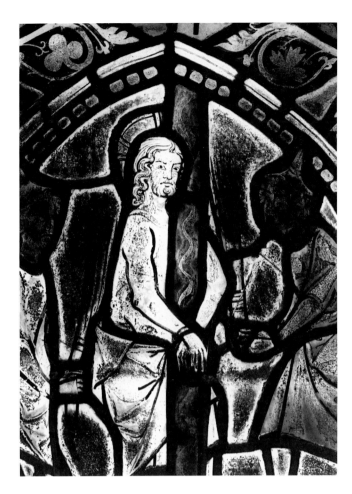

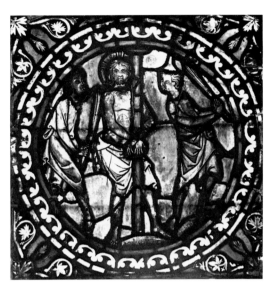

Plate II.11a. Flagellation. Ménillot. After 1263

Plate II.11b. Flagellation. Saint-Gengoult, Bay 0 (B9). Gengoult Master, late 1260s

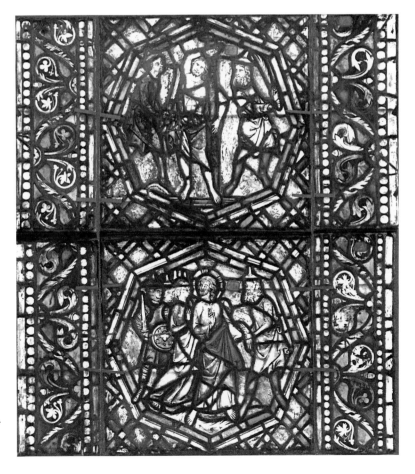

Plate II.11c. Betrayal (bottom); Flagellation (top). Saint-Gengoult, Bay 8. Gengoult Master, c. 1270–79

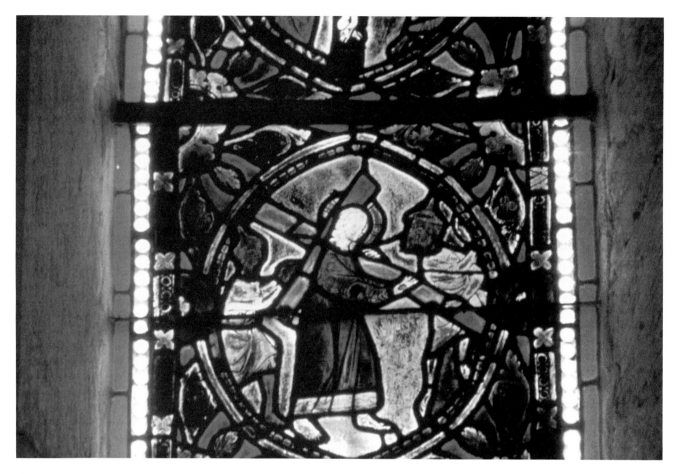

Plate II.12a. Carrying of the Cross. Ménillot. After 1263

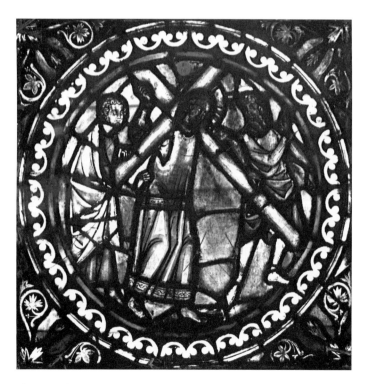

Plate II.12b. Carrying of the Cross. Saint-Gengoult, Bay 0 (B10).
Gengoult Master, late 1260s

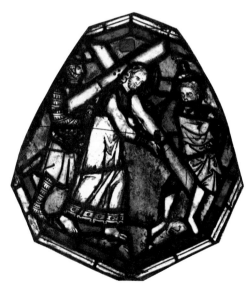

Plate II.12c. Carrying of the Cross. Saint-
Gengoult, Bay 8. Gengoult Master, c. 1270–79

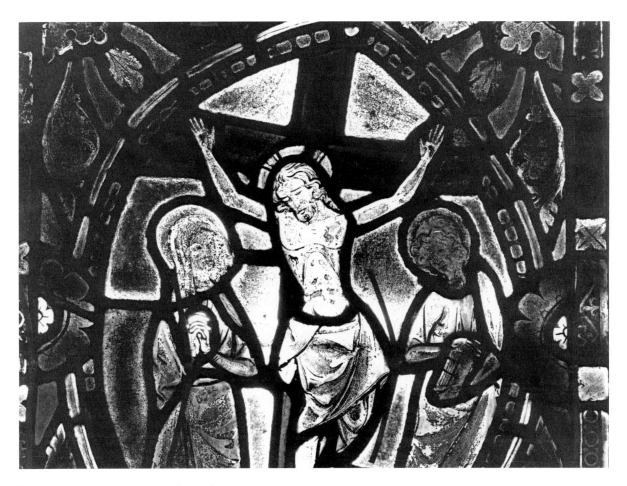

Plate II.13a. Crucifixion. Ménillot. After 1263

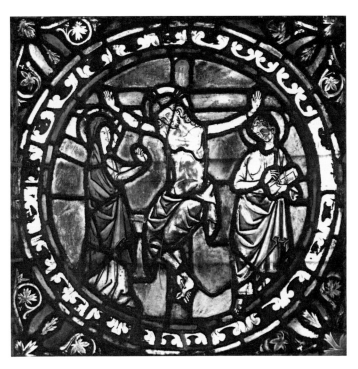

Plate II.13b. Crucifixion. Saint-Gengoult, Bay 0 (B11). Gengoult Master, late 1260s

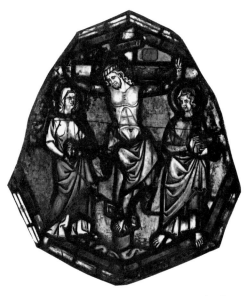

Plate II.13c. Crucifixion. Saint-Gengoult, Bay 8. Gengoult Master, c. 1270–79

Plate II.14a. Saint-Gengoult, Bay 8. Drawing published in 1837 (after Grille de Beuzelin)

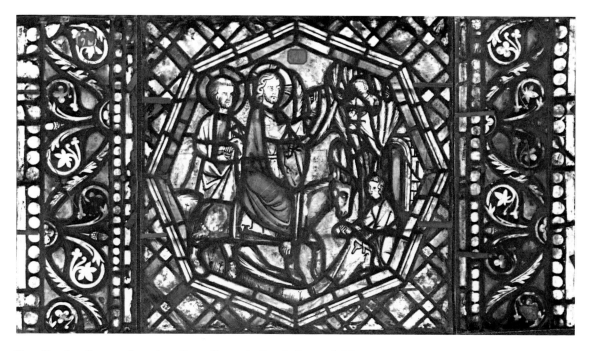

Plate II.14b. Entry to Jerusalem. Saint-Gengoult, Bay 8. Gengoult Master, c. 1270–79

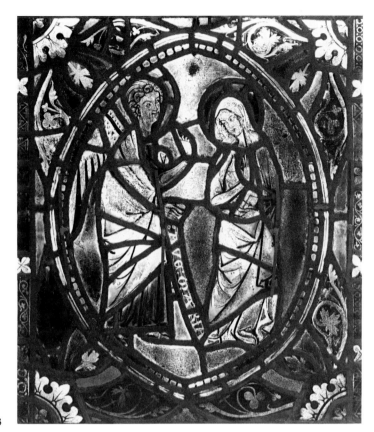

Plate II.15a. Annunciation. Ménillot. After 1263

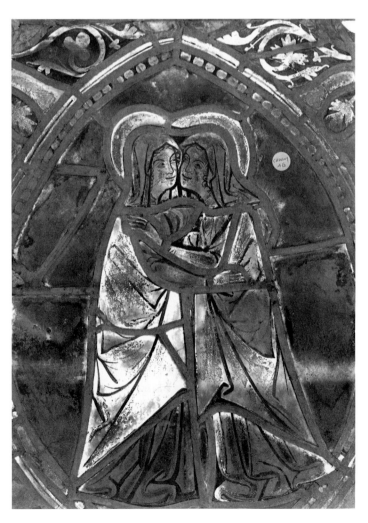

Plate II.15b. Visitation. Ménillot. After 1263

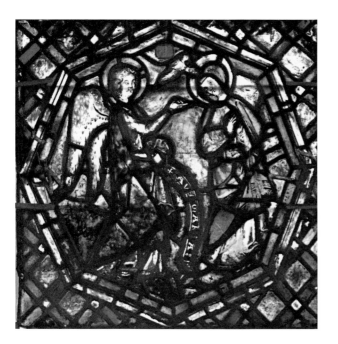

Plate II.16a. Annunciation. Saint-Gengoult, Bay 8.
Gengoult Master, c. 1270–79

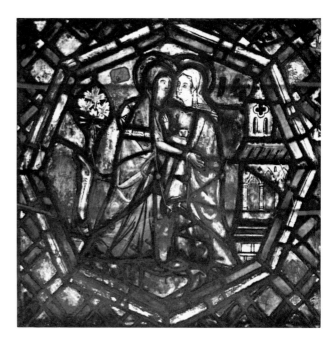

Plate II.16b. Visitation. Saint-Gengoult, Bay 8. Gengoult
Master, c. 1270–79

Plate II.17. Grisaille with borders of fleurs-de-lys and castles. Saint-Gengoult, Bay 101. C. 1255–61

Plate II.18a. Grisaille with Saint Catherine. Saint-Gengoult, Bay 1 (now in left lancet). C. 1265–70

Plate II.18b. Grisaille with Saint Gengoult. Saint-Gengoult, Bay 2 (now in right lancet). C. 1265–70

Plate II.19. Grisaille from Saint-Gengoult, photographed in Leprévost's studio in late nineteenth century (see also Plate III.23).
Now reinstalled in Bay 5. C. 1270–79

Plate II.20a. Grisaille with grotesque. Reinstalled in Saint-Gengoult, Bay 6. C. 1280–85

Plate II.20b. Grisaille with grotesque (detail). Saint-Gengoult, Bay 6. C. 1280–85

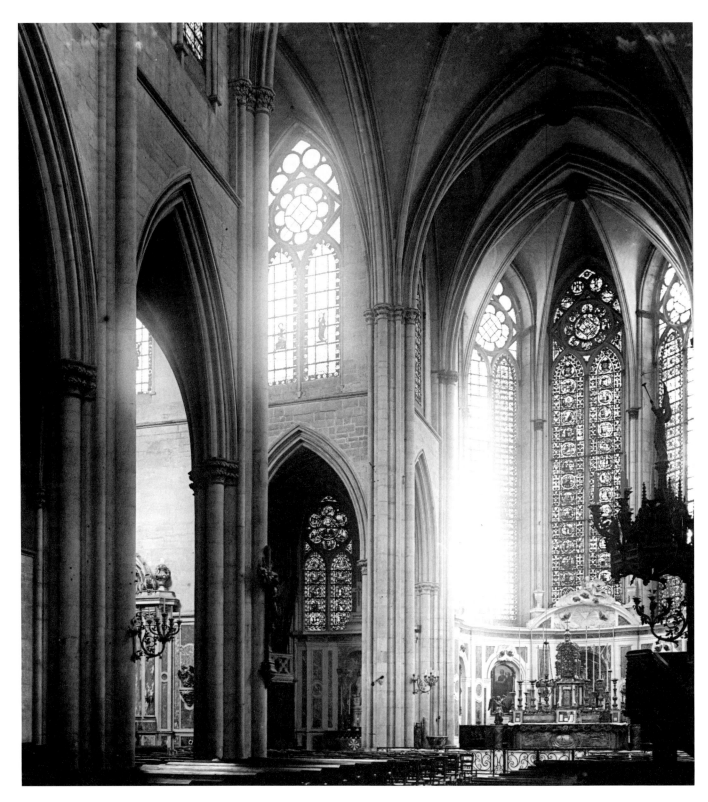

Plate III.1. Saint-Gengoult, Toul, choir and north chapel. Nineteenth-century photo

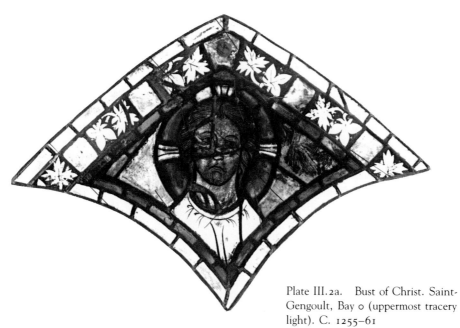

Plate III.2a. Bust of Christ. Saint-Gengoult, Bay o (uppermost tracery light). C. 1255–61

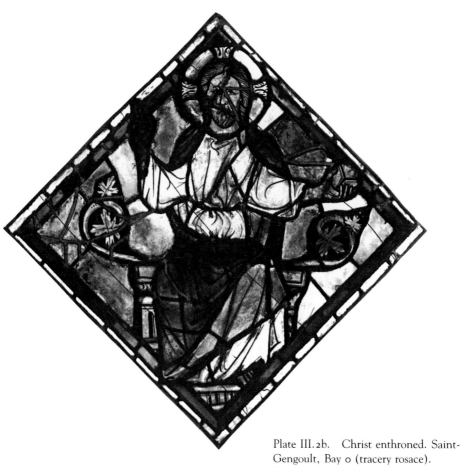

Plate III.2b. Christ enthroned. Saint-Gengoult, Bay o (tracery rosace). C. 1255–61

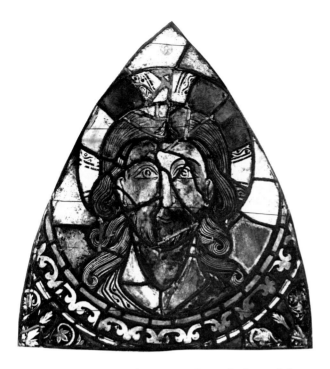

Plate III.3a. Bust of Christ. Saint-Gengoult, Bay 0 (left lancet-head). C. 1255–61

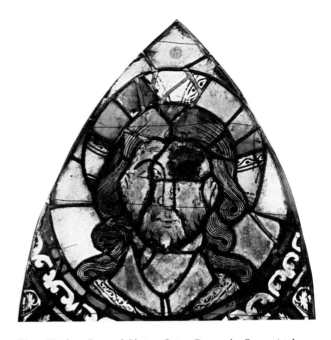

Plate III.3b. Bust of Christ. Saint-Gengoult, Bay 0 (right lancet-head). C. 1255–61

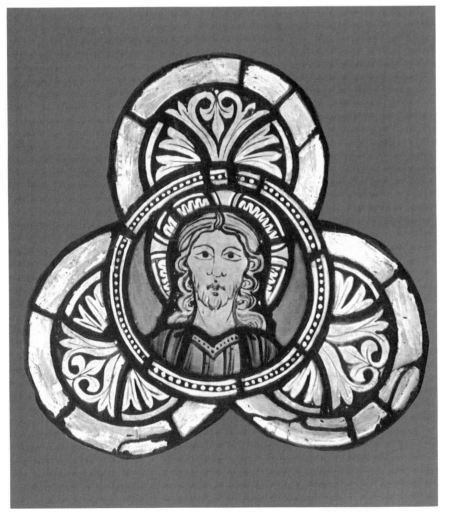

Plate III.4. Bust of Christ. Wettingen, cloister, bay n VII. C. 1280

Opposite:

Plate III.5. Bust of Christ. Psalter, Besançon, Bibl. mun. MS 54, fol. 18r, c. 1260

Ds misereat totu
metu dne signu in
me oderut et esun
e sup nos lumen
distu leaui
meo. no?
bis signatu
uult tuu
ale tuu

cu l'a pat. Fac
bono ut uideat q
dant. Signatu
uult tuu dne de
a i corde
s qno
lumine
memori
ad

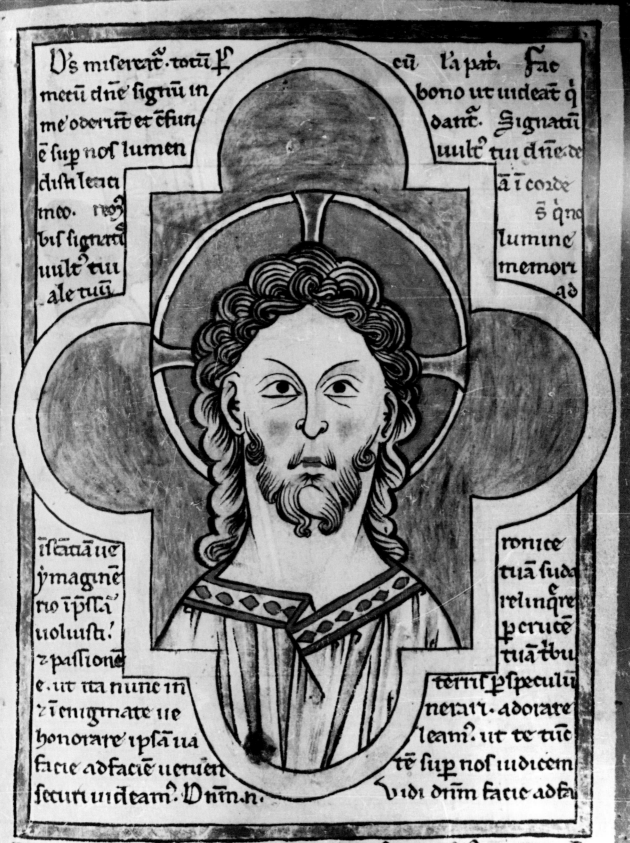

ilentia ue
ymagine
rio ipsta
uoluisti
z passione
e ut ita nunc in
zi enigmate ue
honorare ipsa ua
facie adfacie ueuen
securi uideam. Dnm n

ronice
tua suda
e relinqre
p cruce
tua tbu
terril pspeculu
nerar. adorare
leam? ut te tuu
te sup nos iudicem
uidi dnm facie adfa

cie et salua facta e anima mea. ago. Amey. Amey.

Plate III.6. Display of the Veronica at Saint Peter's, Rome. *Mirabilia Romae* blockbook. Late fifteenth century (after facsimile of Gotha, Herzogliche Bibliothek)

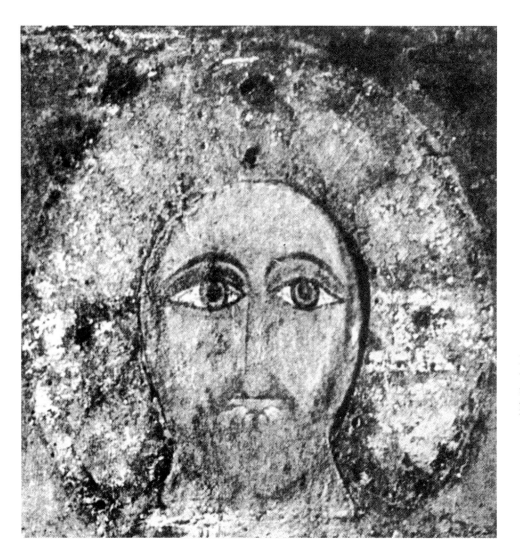

Plate III.7. "Uronica," S. Giovanni in Laterano, Sancta Sanctorum chapel. Head glued onto panel in twelfth century (?) (after Wilpert)

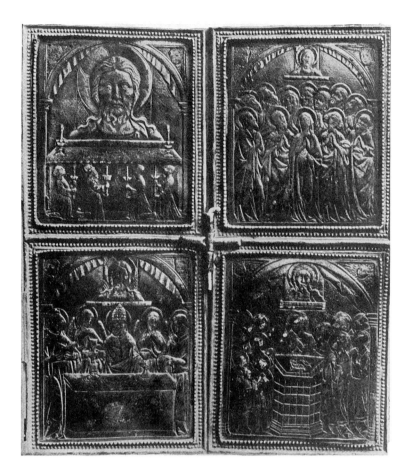

Plate III.8a. Four views of the "Uronica." *Portacina,* added in mid-fourteenth to fifteenth century to the silver cover of Innocent III (1198–1216) hiding the body of the "Uronica." S. Giovanni in Laterano, Sancta Sanctorum chapel (after Wilpert)

Plate III.8b. View of the "Uronica." *Portacina* (detail) (after Wilpert)

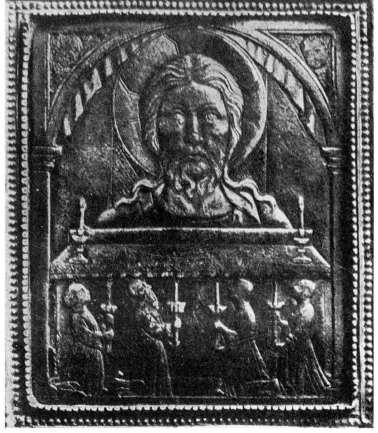

Plate III.9. The marriage of Saint Gengoult. Saint-Gengoult, Bay 0 (A2). Late 1260s

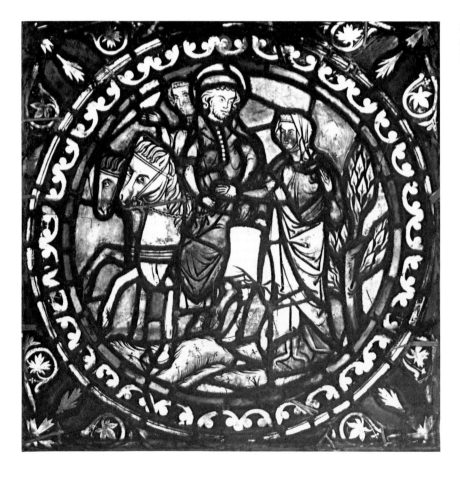

Plate III.10. Gengoult leaving to serve King Pepin. Saint-Gengoult, Bay 0 (A5). Late 1260s

Plate III.11a. Gengoult serving King Pepin.
Saint-Gengoult, Bay 0 (A3). Late 1260s

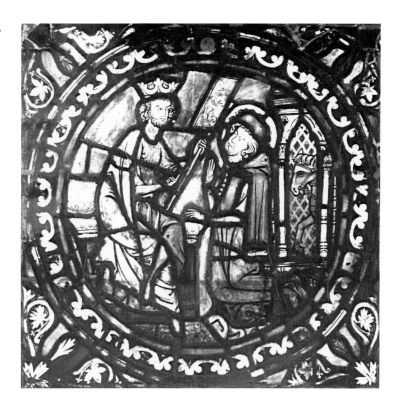

Plate III.11b. Detail of Pepin's "coat of arms."
Saint-Gengoult, Bay 0 (A3). Late 1260s

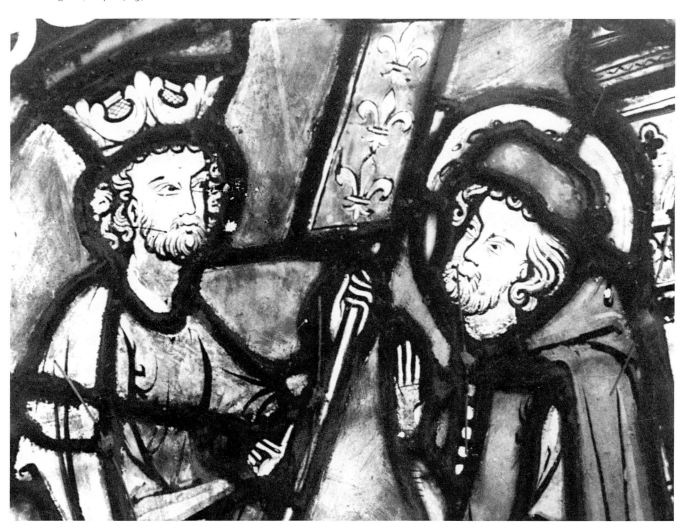

Plate III.12. The Miracle of the candle. Saint-Gengoult, Bay 0 (A1). Late 1260s

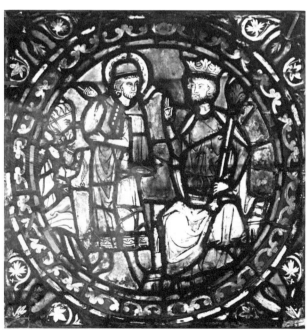

Plate III.13. Gengoult leaves King Pepin. Saint-Gengoult, Bay 0 (A4). Late 1260s

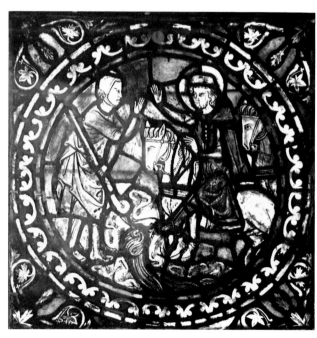

Plate III.14. Miracle of the spring. Saint-Gengoult, Bay 0 (A6). Late 1260s

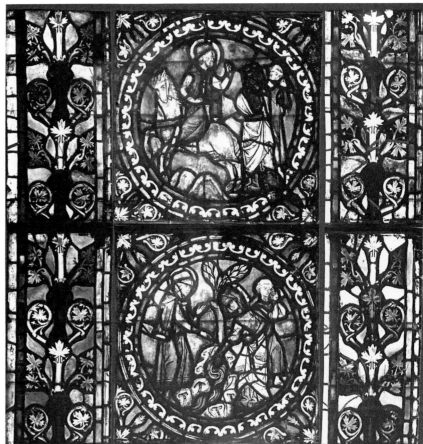

Plate III.16. Miraculous trial by water (bottom); Gengoult leaves his wife (top). Saint-Gengoult, Bay 0 (A9 and 10). Late 1260s

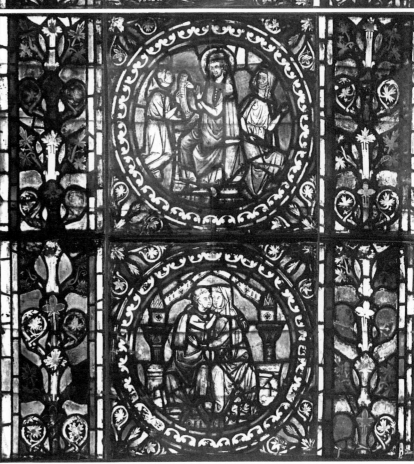

Plate III.15. Adultery of Gengoult's wife and her cleric lover (bottom); Gengoult hears of his wife's infidelity (top). Saint-Gengoult, Bay 0 (A7 and 8). Late 1260s

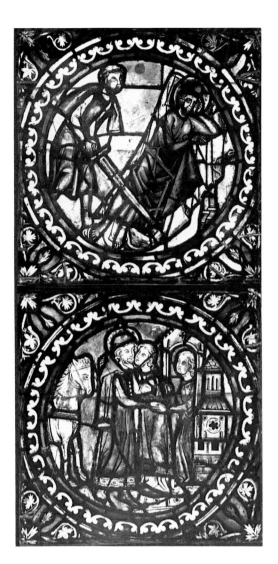

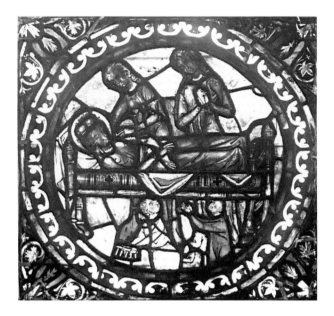

Plate III.17. Gengoult visits his aunts (bottom); Murder of Gengoult (top). Saint-Gengoult, Bay 0 (A11 and 12). Late 1260s

Plate III.18. Funeral of Gengoult. Saint-Gengoult, Bay 0 (A14). Late 1260s

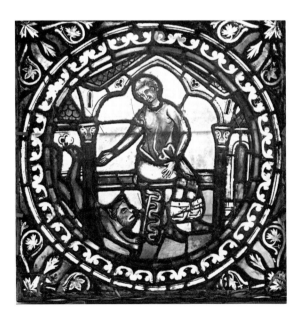

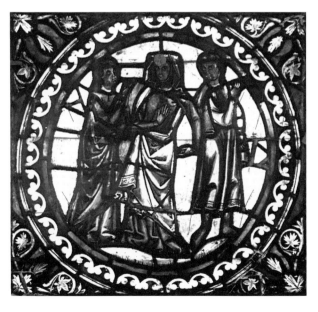

Plate III.19. Death of the cleric lover. Saint-Gengoult, Bay 0 (A13). Late 1260s

Plate III.20. Punishment of Gengoult's wife. Saint-Gengoult, Bay 0 (B14). Late 1260s

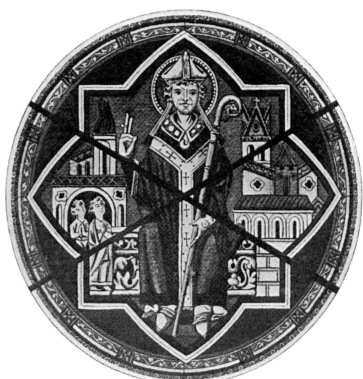

Plate III.21. Saint Nicholas with two boys in a burn-
ing building. Saint-Gengoult, Bay 7 (tracery rosace).
Watercolor by L. Brouhot (After *Les Marches de l'est*,
1911–12)

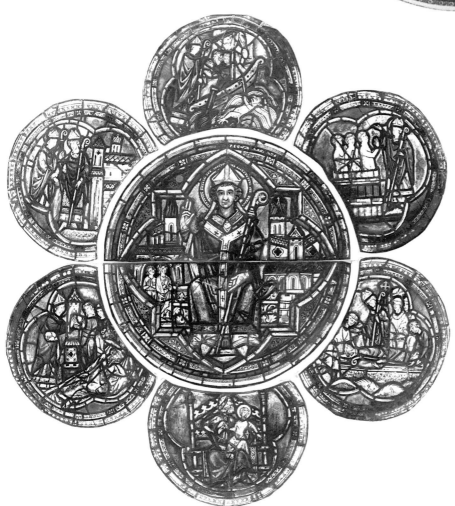

Plate III.22. Life of Saint Nicholas. Saint-Gengoult, Bay 7 (tracery rosace).
1270–85

Plate III.23. The lancets of Saint Agatha and Saint Agapit (Saint-Gengoult, Bay 7) photographed in Leprévost's studio in late nineteenth century

Right:

Plate III.24. Life of Saint Agatha. Saint-Gengoult, Bay 7 (right lancet). 1270–85

Left:

Plate III.25. Life of Saint Agapit. Saint-Gengoult, Bay 7 (left lancet). 1270–85

Plate III.26a–b. Agapit tortured upside
down over flames; Agapit beheaded. Hirsau
Passional. Stuttgart, Württembergische
Landesbibl., Bibl. Fol. 56, fol. 63v.
C. 1120–40

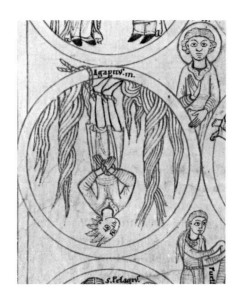

Plate III.26c. Agapit tortured upside down over flames. Usuard Martyrology, Stuttgart, Württembergische Landesbibl., Hist. Fol. 415, fol. 56v

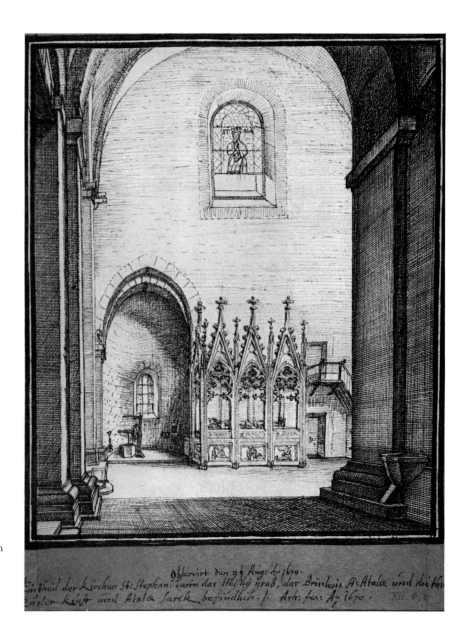

Plate III.27. Window of Sainte Attale, south transept of Saint-Etienne, Strasbourg. Late twelfth century, destroyed 1719. After J.-J. Arhardt (1613–74). Strasbourg, Cabinet des Estampes

Plate III.28. Jonah emerging from the whale. Augsburg Cathedral, c. 1100. (Border and composition after Gottfried Frenzel)

Opposite:

Plate III.29. Saint Peter crucified upside down. Frankfurt, Städelsches Kunstinstitut. C. 1250–60

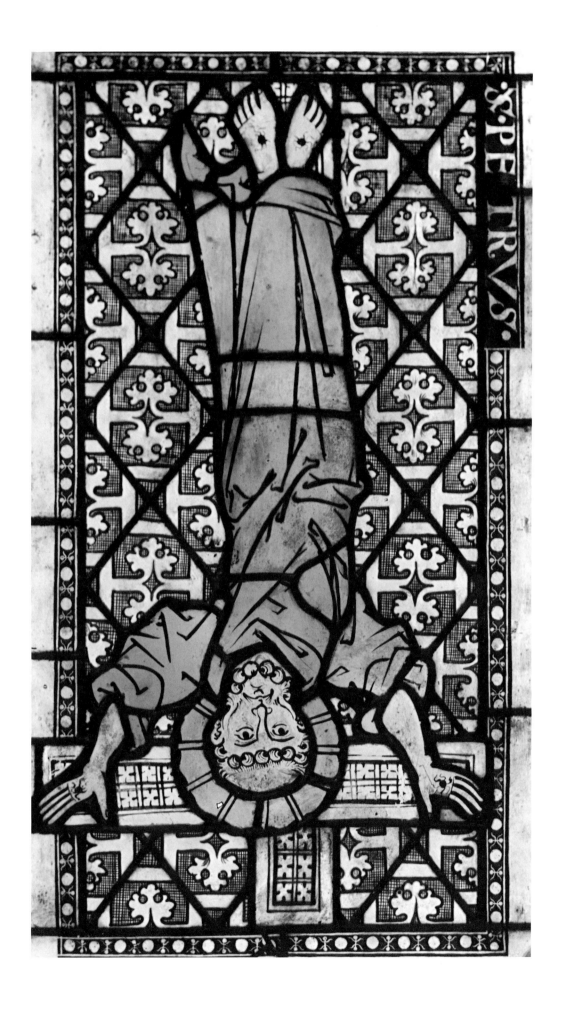

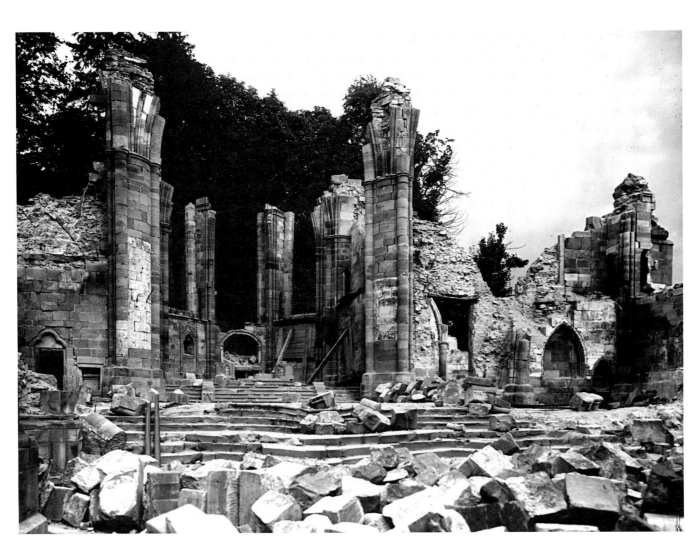

Plate IV.1. Saint-Dié (Vosges), 1944

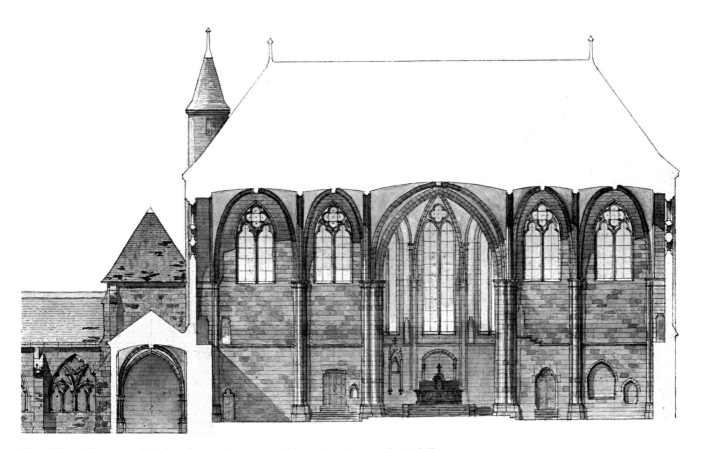

Plate IV.2. Elevation of Gothic choir and transepts of Saint-Dié. Drawing by Barbillat

Plate IV.3. Five medallions on grounds of fleurs-de-lys and castles, borders with birds and coats of arms, one fragment of canopywork (left lancet, upper right). Arrangement since 1901. Saint-Dié, north nave

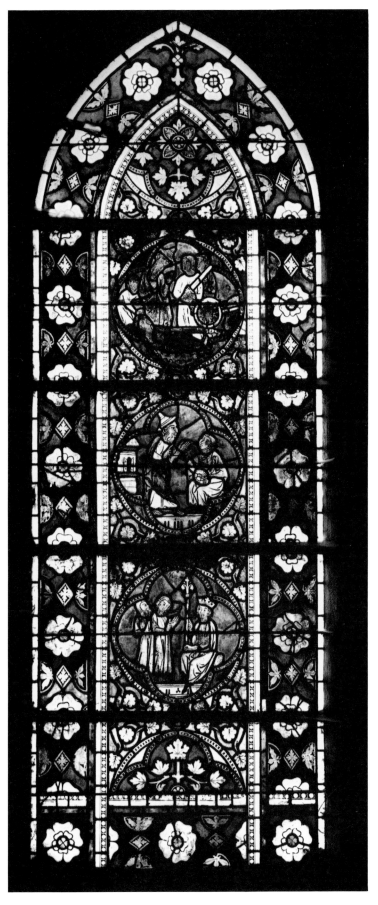

Plate IV.4. Three medallions on foliage grounds, borders of roses and loz-
enges. Arrangement since 1901. Saint-Dié, north nave

Plate IV.5. Photo of axial bay in 1893, showing eighteenth-century grisaille in the lancets and a lost Crucifixion and surviving Gothic borders filling in the traceries. Saint-Dié, Bay 0

Plate IV.6. North transept and choir, about 1895. Gothic panel has been removed from tracery rosace. Saint-Dié

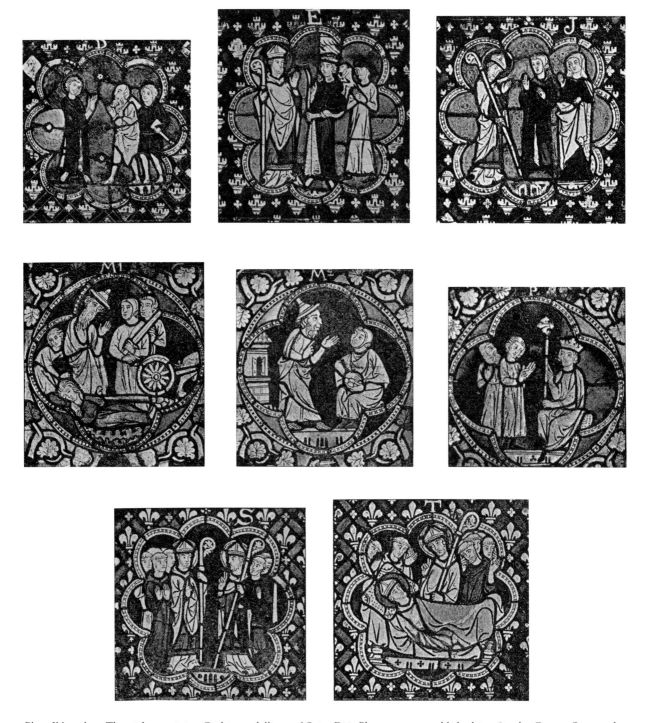

Plate IV.7a–h. The eight surviving Gothic medallions of Saint-Dié. Photogravures published in 1895 by Gaston Save and arranged in his suggested order (after *Bulletin de la Société philomatique vosgienne*)

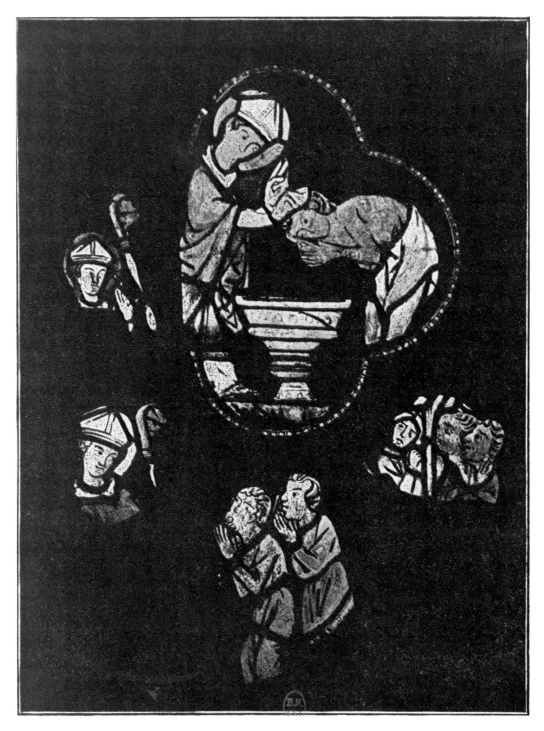

Plate IV.8. A damaged medallion and four fragments from Saint-Dié, Musée municipal de Saint-Dié.
Published in 1936, destroyed in 1944 (after Baumont and Pierrot)

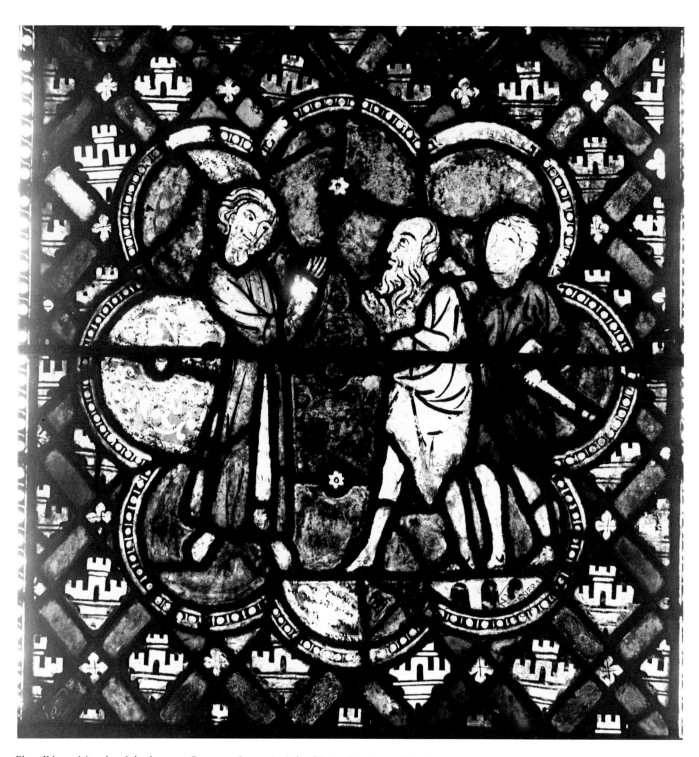

Plate IV.9. Miracle of the beam at Romont. Scene A, Life of Saint Dié. Saint-Dié. Late 1280s

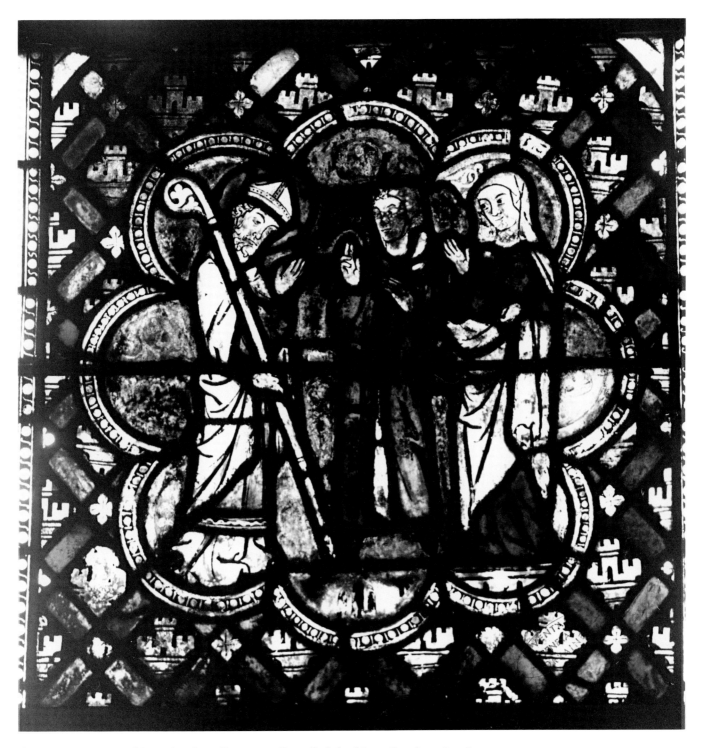

Plate IV.10. Hunus and Huna beg Saint Dié to stay. Scene B, Life of Saint Dié. Saint-Dié. Late 1280s

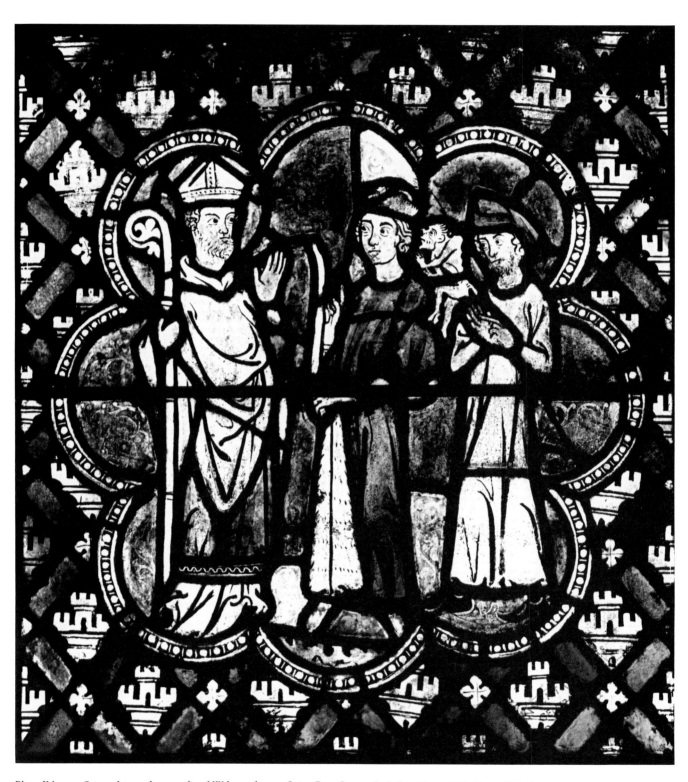

Plate IV.11. Satan drives the people of Wilra to harass Saint Dié. Scene C, Life of Saint Dié. Saint-Dié. Late 1280s

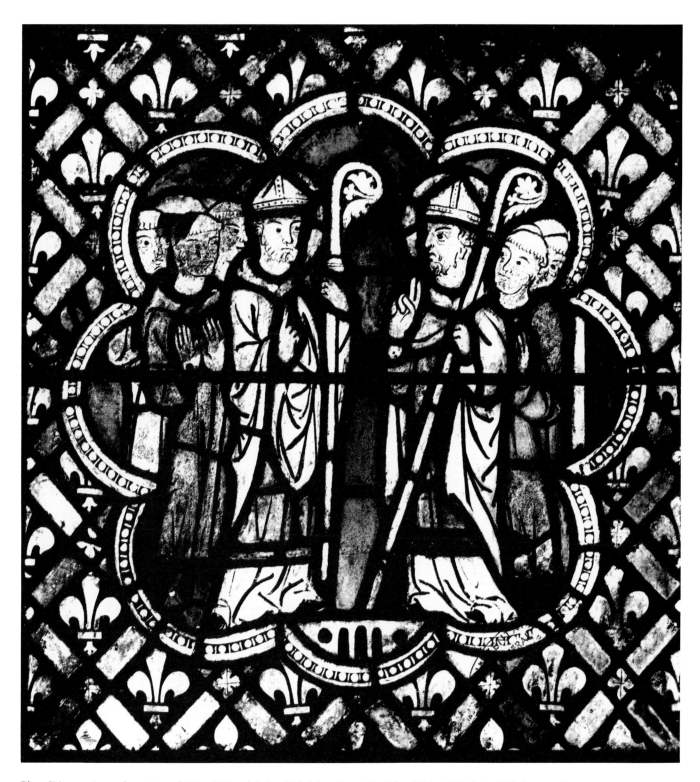

Plate IV.12. Annual reunion of Saint Dié and Saint Hidulphe. Scene D, Life of Saint Dié. Saint-Dié. Late 1280s

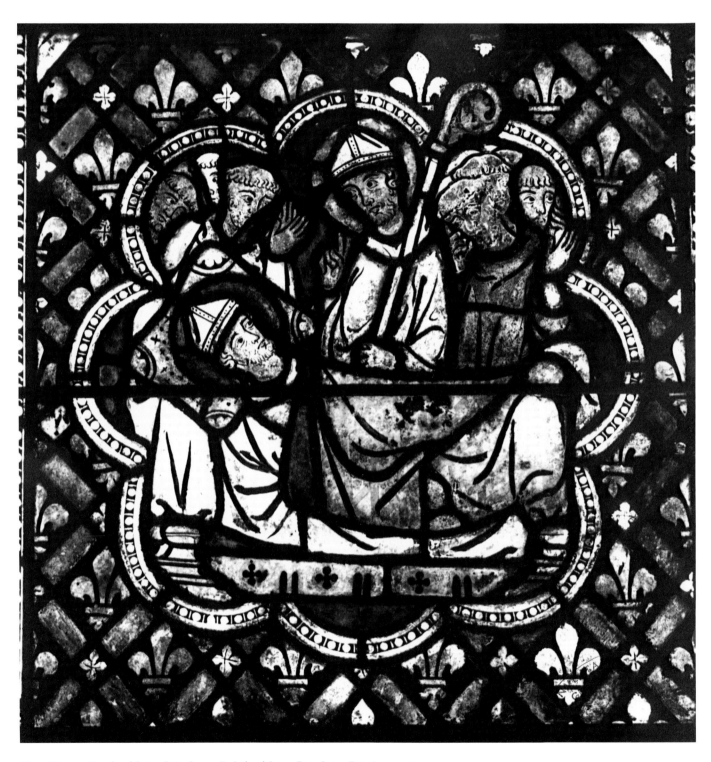

Plate IV.13. Death of Saint Dié. Scene E, Life of Saint Dié. Saint-Dié. Late 1280s

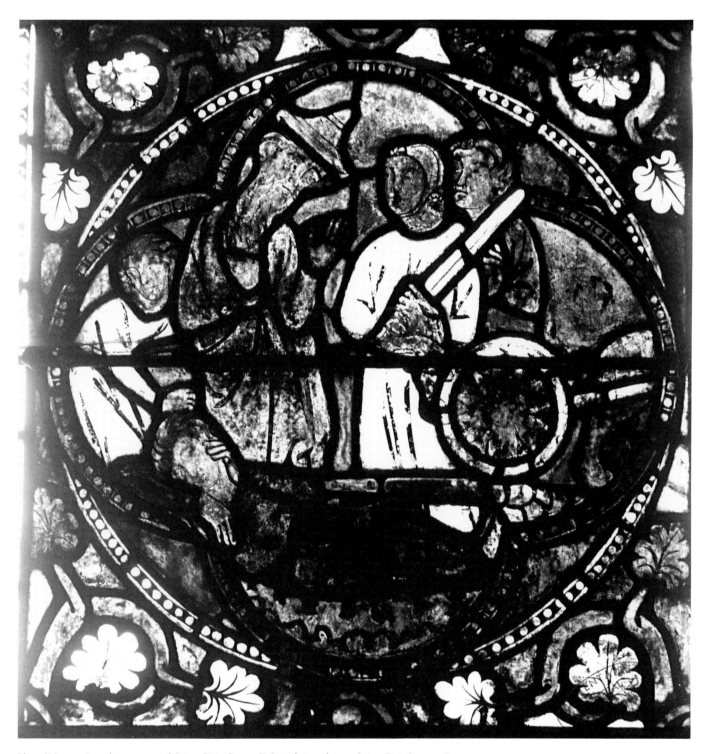

Plate IV.14. Jewish sorcerer of Saint-Dié. Scene F, Jewish incidents. Saint-Dié. Late 1280s

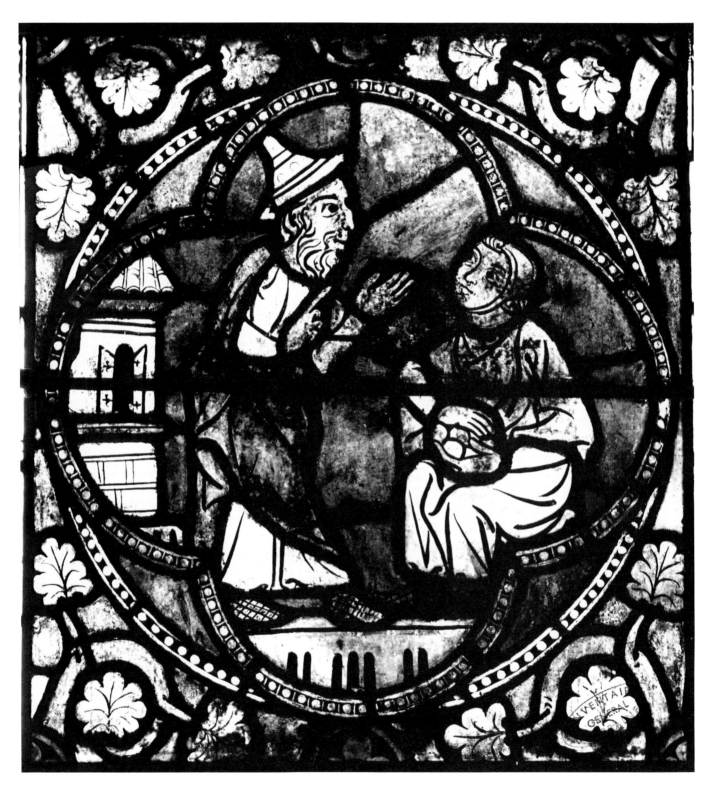

Plate IV.15. Desecration of a host in Saint-Dié. Scene G, Jewish incidents. Saint-Dié. Late 1280s

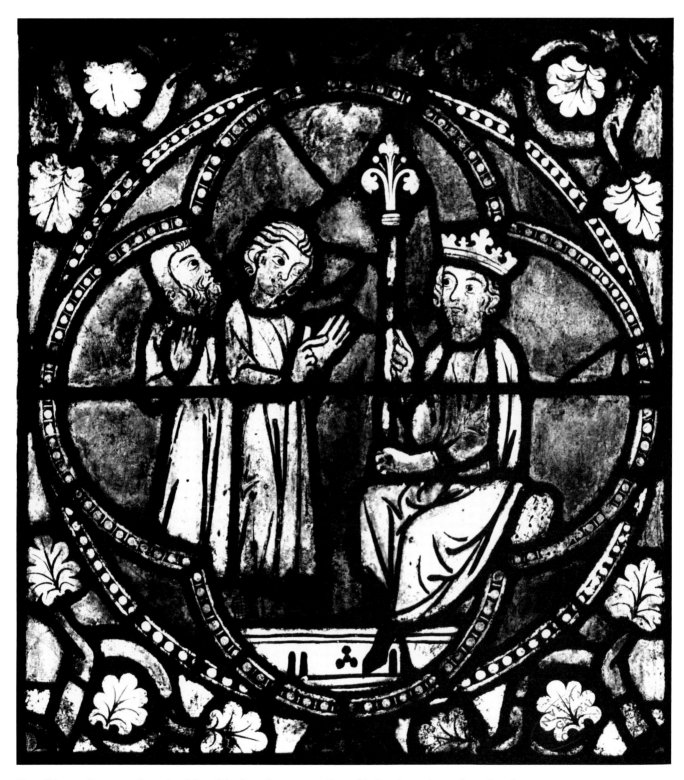

Plate IV.16. Citizens inform the duke of the host desecration. Scene H, Jewish incidents. Saint-Dié. Late 1280s

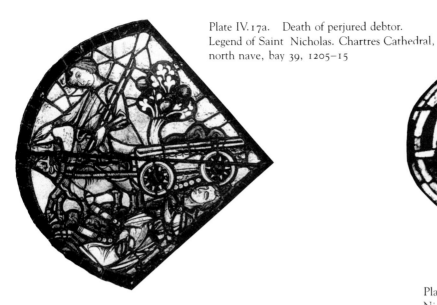

Plate IV.17a. Death of perjured debtor. Legend of Saint Nicholas. Chartres Cathedral, north nave, bay 39, 1205–15

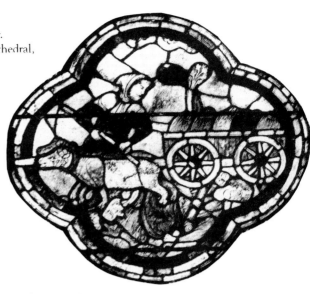

Plate IV.17b. Death of perjured debtor. Legend of Saint Nicholas. Chartres Cathedral, south choir, bay 14, 1215–25

Plate IV.17c. Death of perjured debtor. Legend of Saint Nicholas. Auxerre Cathedral, bay 18, 1235–50

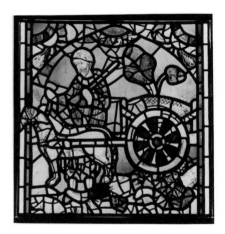

Plate IV.17d. Death of perjured debtor. Legend of Saint Nicholas. York Minster, nave, c. 1190.

Plate IV.17e. Death of perjured debtor. Legend of Saint Nicholas. Tarragona Cathedral cloister, capital, early thirteenth century

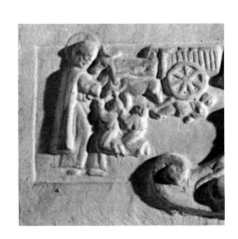

Plate IV.17f. Death of perjured debtor. Legend of Saint Nicholas. San Nicola, Bari, relief on east facade. Late thirteenth century

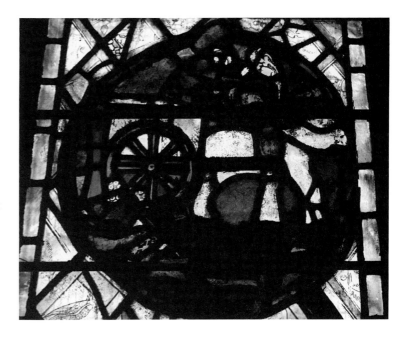

Plate IV.17g. Death of perjured debtor. Legend of Saint Nicholas. Beverley Minster, bay 1, 1230s

Plate IV.18a. Death of perjured debtor. Legend of Saint Nicholas. Fresco, Hunawihr (Haut-Rhin), 1492

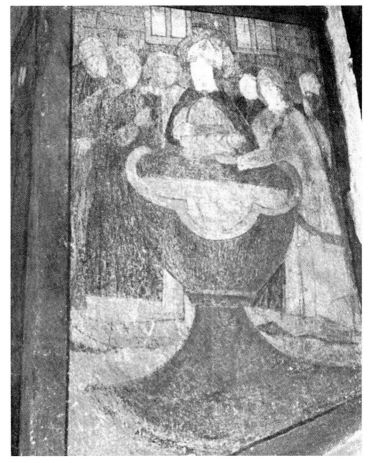

Plate IV.18b. Baptism of the Jew's child. Legend of Saint Nicholas. Fresco, Hunawihr, 1492

Plate IV.19. Border with foliage, birds, and coats of arms of Lorraine. Saint-Dié. Late 1280s

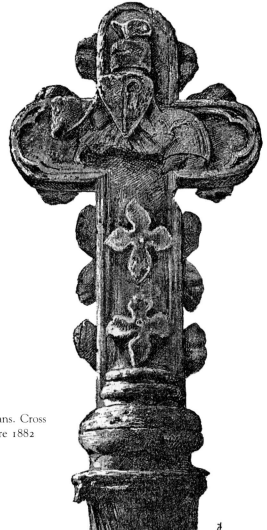

Plate IV.20. Equestrian figure of Ferri (son of Duke Ferri III) as bishop-elect of Orléans. Cross of Frouard (1297–99), now in garden of Musée historique lorrain, Nancy. Photogravure 1882 (after *Mémoires de la Société d'archéologie lorraine*)

Plate IV.21. Border with roses and lozenges. Saint-Dié. Late 1280s

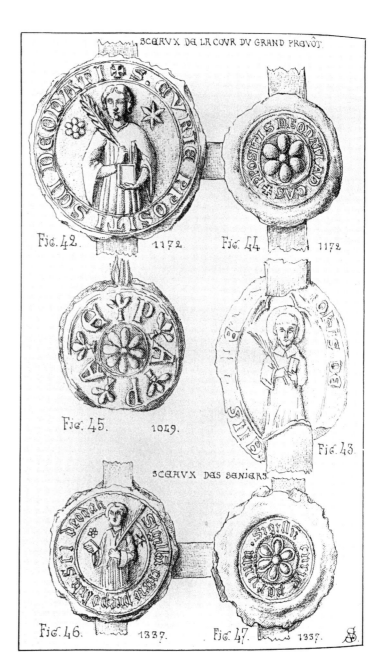

Plate IV.22. Seals related to Saint-Dié (after *Bulletin de la Société philomatique vosgienne*)

Plate IV.23a. Annual reunion of Saint Dié and Saint Hidulphe, detail of Scene D. *Lorrain* glazier. Saint-Dié. Late 1280s

Plate IV.23c. Border with foliage, birds, and coats of arms. French pattern painted by Alsatian glazier. Saint-Dié. Late 1280s

Plate IV.23b. Desecration of a host (detail of Scene G). Alsatian glazier. Saint-Dié. Late 1280s

Plate IV.24a. Canopywork with birds. Westhoffen (Bas-Rhin),
Saint-Martin. C. 1280–95 (after Bruck)

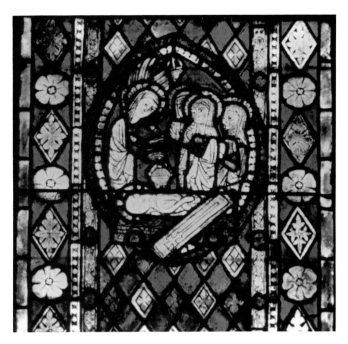

Plate IV.24b. Three Marys at the Tomb (with Christ still in it!),
border of roses and lozenges. Westhoffen, Saint-Martin.
C. 1280–95

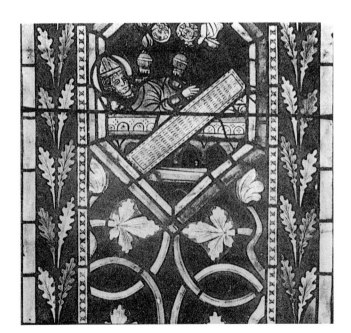

Plate IV.24c. Death of a bishop-saint (Martin?), medallion set
in foliage ground. Westhoffen, Saint-Martin. C. 1280–95 (after
Bruck)

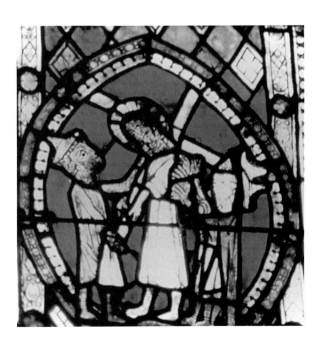

Plate IV.25. Carrying of the Cross. Westhoffen, Saint-
Martin. C. 1280–95

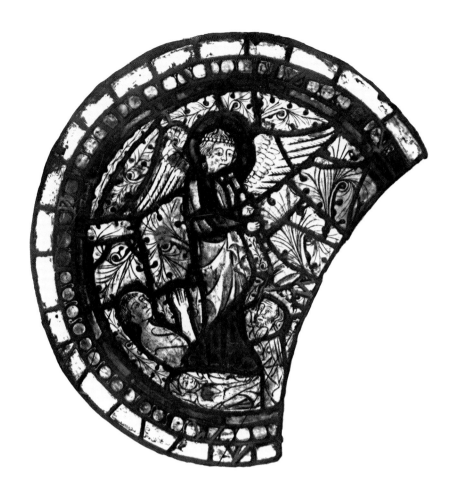

Plate V.1a–b. Angel blowing oliphant and dead rising; souls in hellmouth. Saint-Gengoult, Bay 8 (tracery lobes at 10 o'clock and 6 o'clock). C. 1315

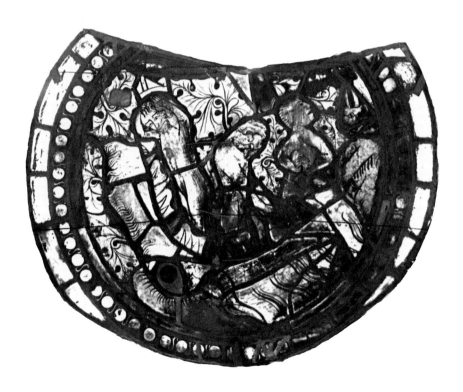

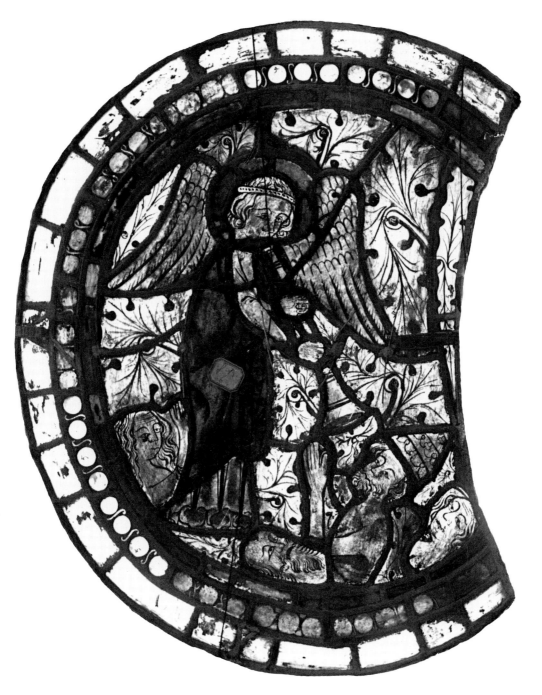

Plate V.2. Angel blowing oliphant and dead rising, including pope in *triregnum* tiara. Saint-Gengoult, Bay 8 (lobe at 8 o'clock). C. 1315

Plate V.3. Avioth (Meuse). Gothic panels now in north nave clerestory, Bay III. C. 1315–25

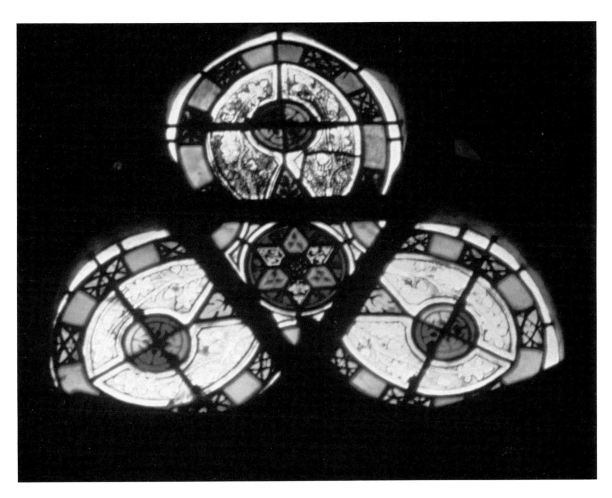

Plate V.4. Grisaille with silver stain. Avioth, ambulatory. C. 1320

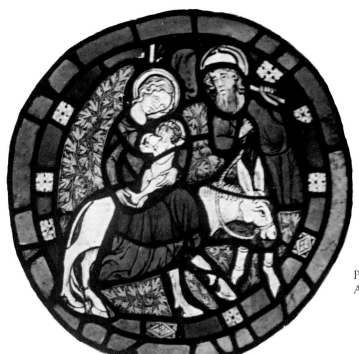

Plate V.5a. Flight to Egypt, with nursing Virgin. Avioth, Bay 111. After 1315

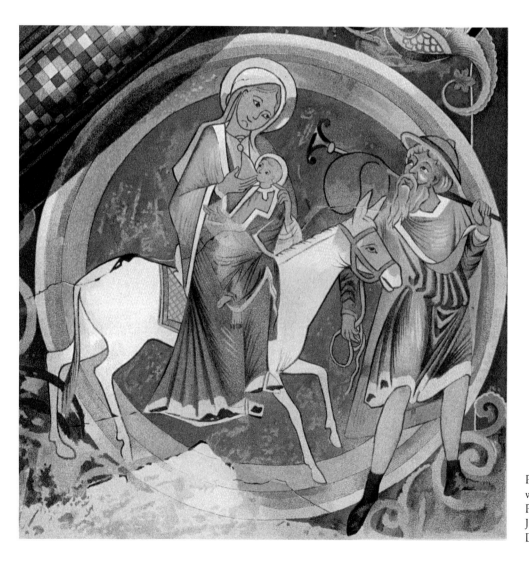

Plate V.5b. Flight to Egypt, with nursing Virgin. Fresco, Petit-Quevilly, Chapelle Saint-Julien. C. 1200 (after Gelis-Didot and Laffillée)

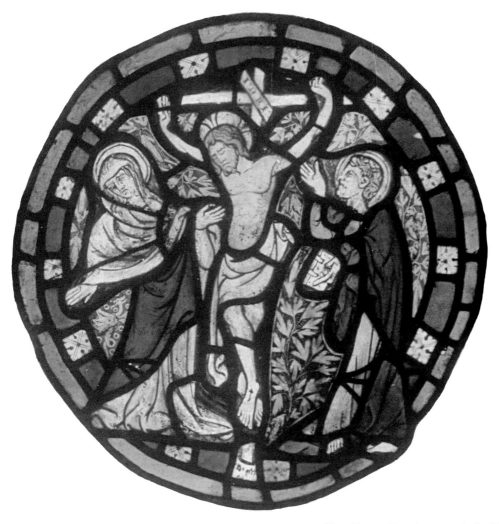

Plate V.6a. Crucifixion, with the Virgin swooning (at sight of dragon in the ground pattern). Avioth, Bay 111. After 1315

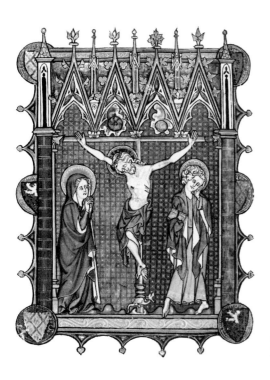

Plate V.6b. Crucifixion, with dragon at the base of the cross. Psalter/Hours of Yolande de Soissons, The Pierpont Morgan Library, New York, M729, fol. 337v, c. 1280–85

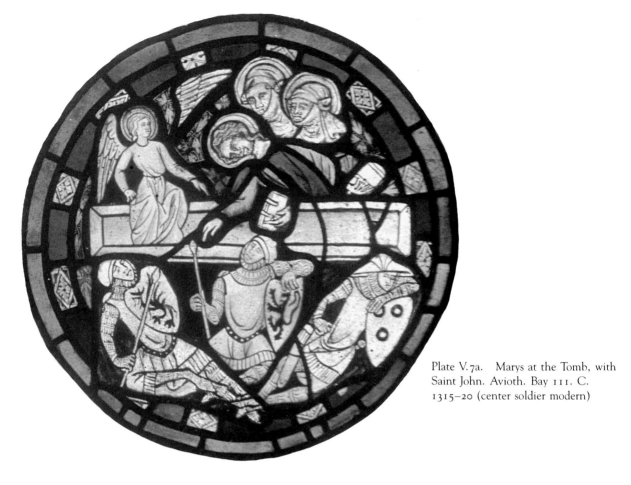

Plate V.7a. Marys at the Tomb, with Saint John. Avioth. Bay III. C. 1315–20 (center soldier modern)

Plate V.7b. Chapel-de-fer helmet. Beginning fourteenth century (after Viollet-le-Duc)

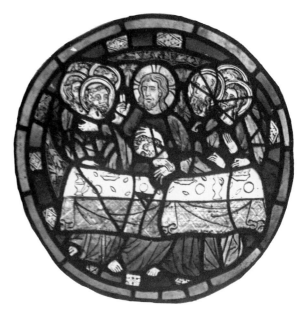

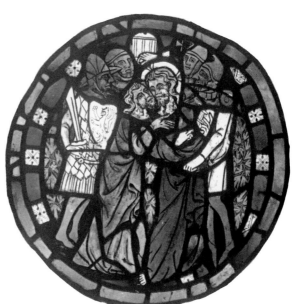

Plate V.8a–c.　Last Supper, Betrayal, Flagellation. Avioth, Bay
III. C. 1315

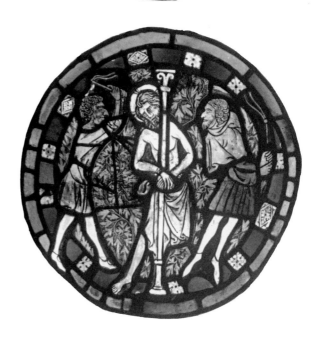

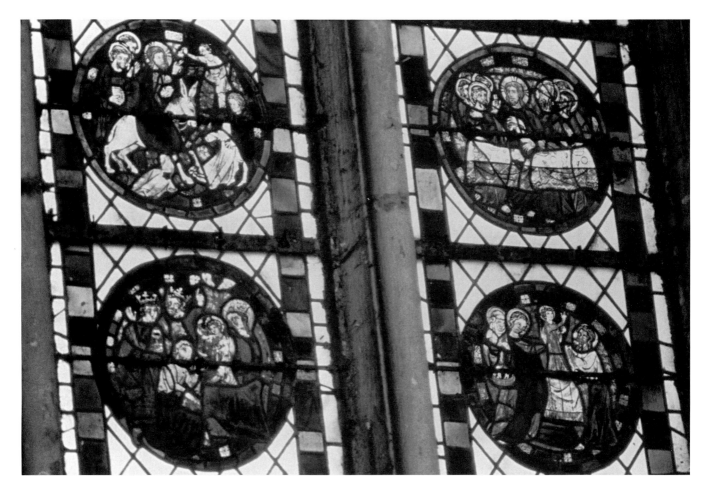

Plate V.9. Adoration of the Magi, Presentation in the Temple (lower row); Entry to Jerusalem, Last Supper (upper row). Avioth, Bay III

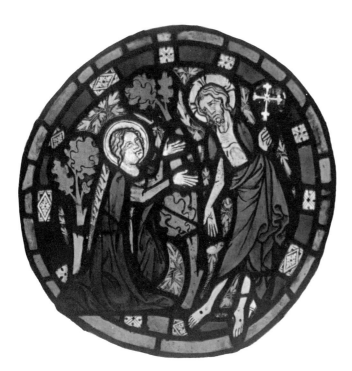

Plate V.10. Noli me tangere. Avioth, Bay III. After 1315

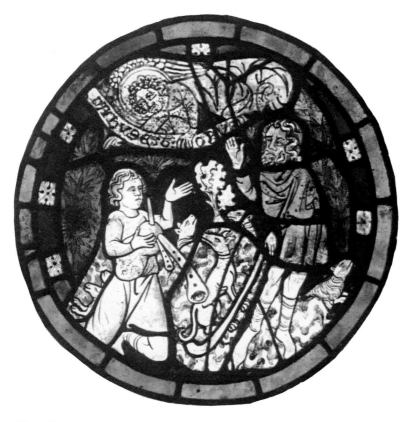

Plate V.11a. Annunciation to the Shepherds. Avioth, Bay 111. C. 1320–25

Plate V.11b. Inscription from Annunciation to the Shepherds. Avioth (after Ottmann, 1858/59)

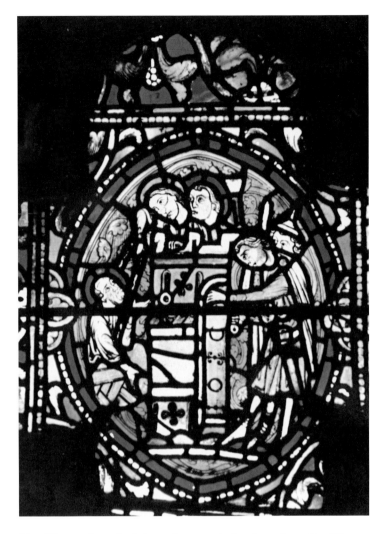

Plate VI.1a. Saint Paul descending in a basket from the walls of Damascus. Fragment now in Metz Cathedral, south transept, Bay 14. C. 1215?

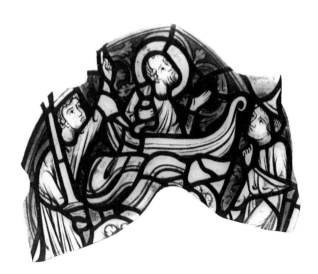

Plate VI.1b and c. Scenes of Saint Paul: (b) preaching in Damascus (?); (c) shipwrecked off island of Melita. Fragments now in Metz Cathedral, south transept, Bay 14. C. 1215?

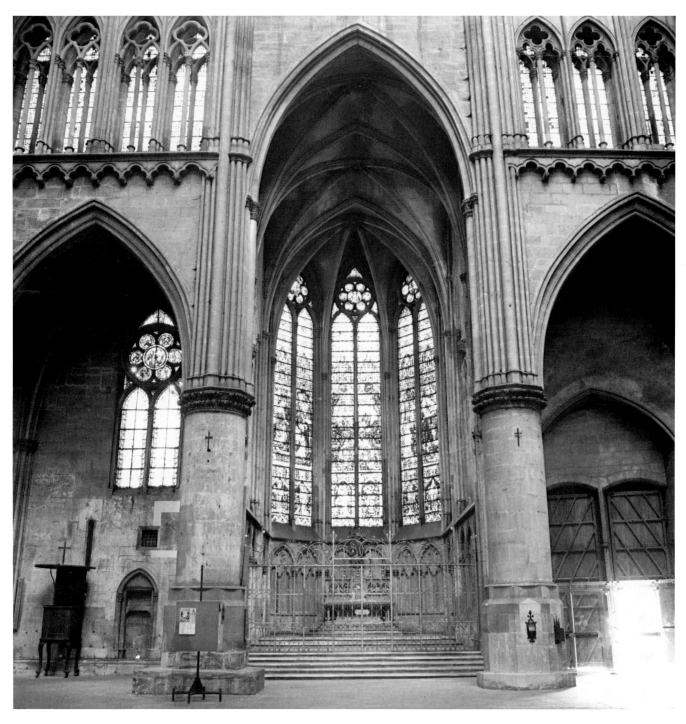

Plate VI.2. Notre-Dame-la-Ronde, choir and left aisle window. Now Metz Cathedral, south nave, chapelle du Mont-Carmel and Bay 28. The Gothic glass now in the rosace of Bay 28 (left) was removed from the axial bay (center) in 1885

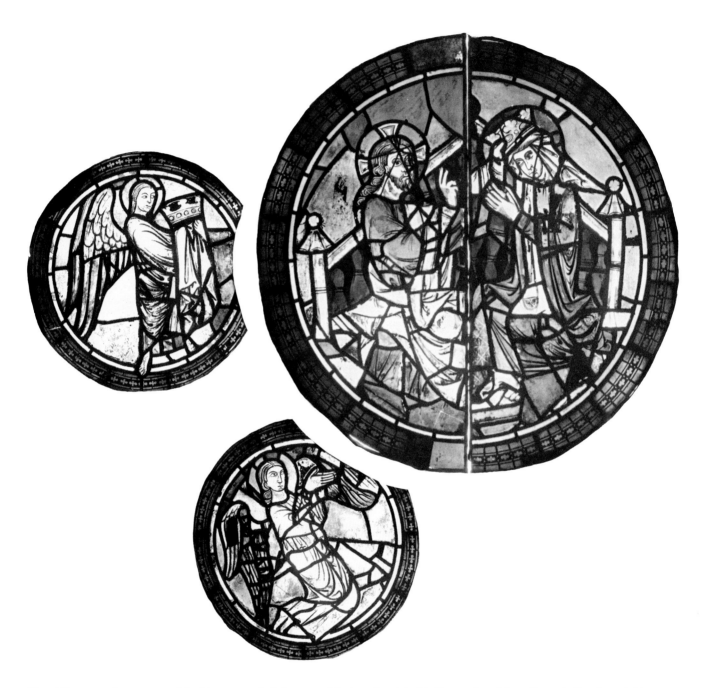

Plate VI.3a–c. Coronation of the Virgin, angels (lobes at 7 o'clock and 9 o'clock). Rosace from Notre-Dame-la-Ronde, axial bay, now in Bay 28, Metz Cathedral. Late 1230s? Photos before 1950.

Plate VI.4. Standing figures from Tree of Jesse, from axial bay of Notre-Dame-la-Ronde, shown after 1887 installation in Metz Cathedral, north nave, Bay 33. Late 1230s? (after F. X. Kraus)

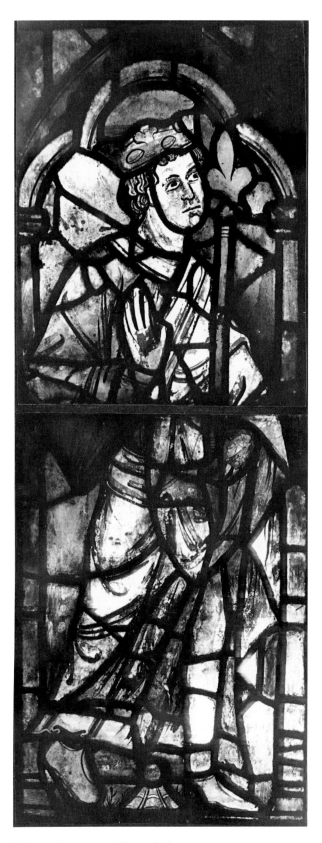

Plate VI.5a–d. Virgin, King, two Apostles from Tree of Jesse. Metz Cathedral, Bay 33. Late 1230s? Photos before 1950

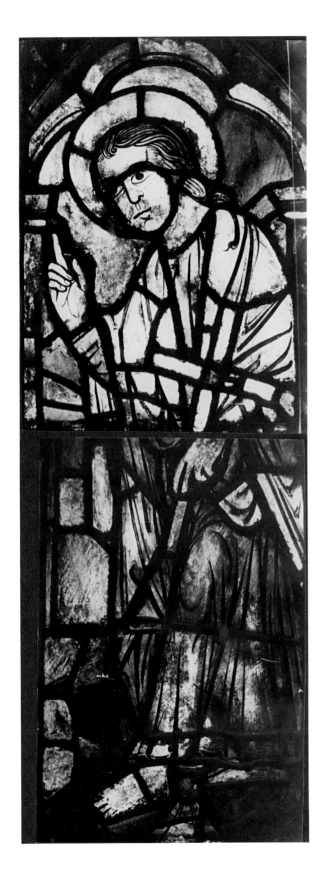
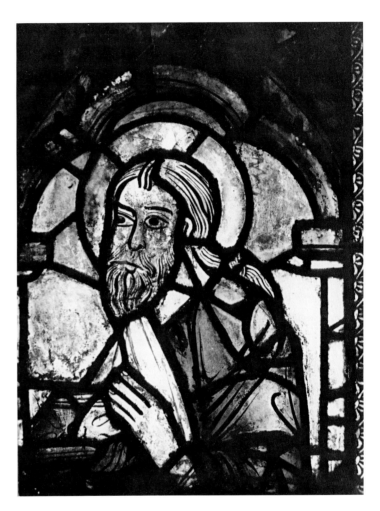

Plate VI.6. Donor, Annunciation, grisaille lobes: Gothic glass in south nave of Metz Cathedral. Drawing published by Bégin in 1840

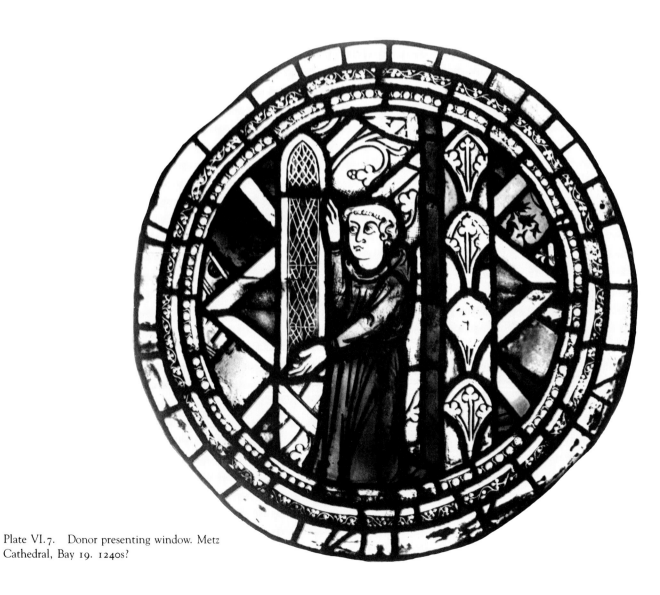

Plate VI.7. Donor presenting window. Metz Cathedral, Bay 19. 1240s?

Plate VI.8a. Flaying of Saint Bartholomew. Metz Cathedral. Drawing published by Bégin in 1840

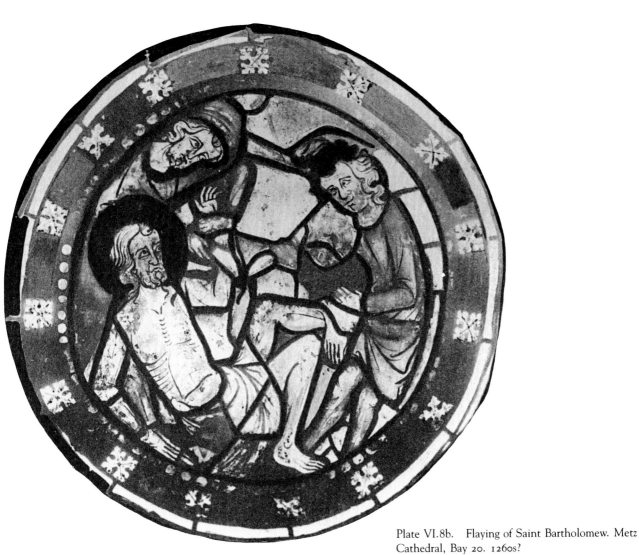

Plate VI.8b. Flaying of Saint Bartholomew. Metz Cathedral, Bay 20. 1260s?

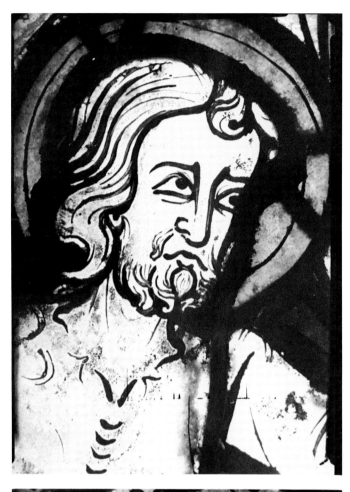

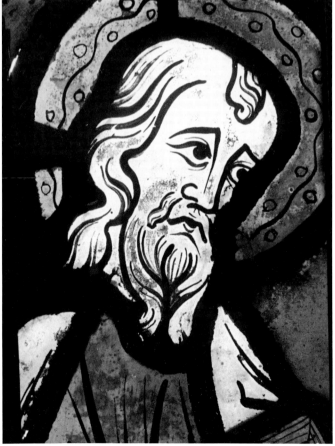

Plate VI.9a–b. Heads of Saint Bartholomew and
the standing Saint Paul. Metz Cathedral, Bay 20

Plate VI.10a. Standing Saint Paul and Saint Stephen. Metz Cathedral. Drawing published by Bégin in 1840

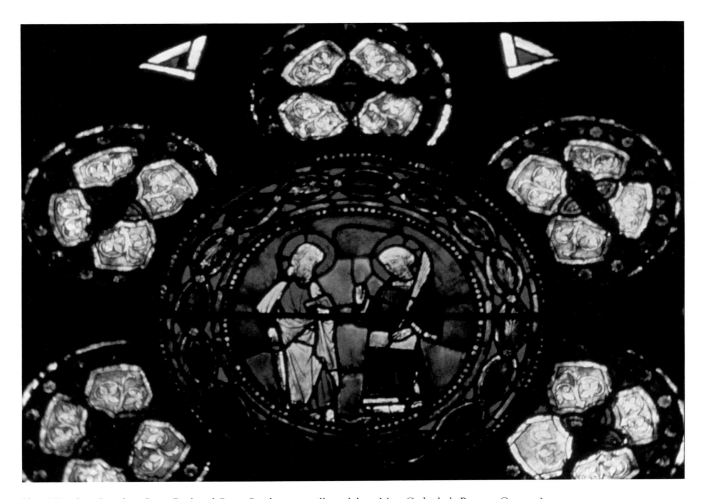

Plate VI.10b. Standing Saint Paul and Saint Stephen, grisaille in lobes. Metz Cathedral, Bay 20. C. 1275?

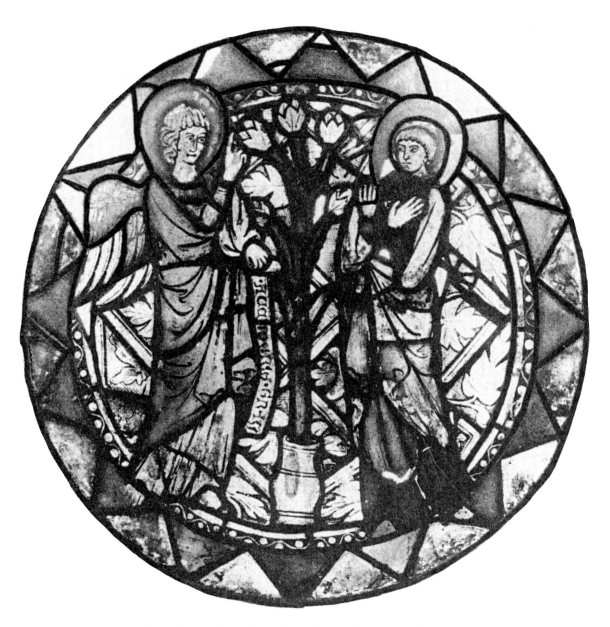

Plate VI.11. Annunciation. Metz Cathedral, Bay 19. After 1300